Designing Brand Experiences

Designing Brand Experiences

By Robin Landa

THOMSON

DELMAR LEARNING

Australia Canada Mexico Singapore Spain United Kingdom United States

THOMSON

DELMAR LEARNING

Designing Brand Experiences
Robin Landa

Vice President, Technology and Trades SBU:
Alar Elken

Editorial Director:
Sandy Clark

Senior Acquisitions Editor:
James Gish

Development Editor:
Jaimie Wetzel

Editorial Assistant:
Niamh Matthews

Marketing Director:
Dave Garza

Channel Manager:
William Lawrensen

Marketing Coordinator:
Mark Pierro

Production Director:
Mary Ellen Black

Senior Production Manager:
Larry Main

Production Editor:
Thomas Stover

Art & Design Specialist:
Nicole Stagg

Full Production Services:
Liz Kingslien,
Lizart Digital Design

Cover Design:
Concept: Robin Landa
Creative Directors: Denise Anderson and Robin Landa
Designers: Christopher J. Navetta and Laura F. Menza
Photographer: Christopher J. Navetta
Hand Lettering:
Denise Anderson
Back cover design:
Christopher J. Navetta

The illustrative use of the common-law and registered trademarks of various business entities herein shall not be deemed to imply the endorsement or sponsorship of this product. Except as otherwise noted herein, this product has not been prepared, approved, or licensed by any such entity.

Library of Congress Cataloging-in-Publication Data

ISBN 1-4018-4887-7

NOTICE TO THE READER

Publisher does not warrant or guarantee any of the products described herein or perform any independent analysis in connection with any of the product information contained herein. Publisher does not assume, and expressly disclaims, any obligation to obtain and include information other than that provided to it by the manufacturer.

The reader is expressly warned to consider and adopt all safety precautions that might be indicated by the activities herein and to avoid all potential hazards. By following the instructions contained herein, the reader willingly assumes all risks in connection with such instructions.

The publisher makes no representation or warranties of any kind, including but not limited to, the warranties of fitness for particular purpose or merchantability, nor are any such representations implied with respect to the material set forth herein, and the publisher takes no responsibility with respect to such material. The publisher shall not be liable for any special, consequential, or exemplary damages resulting, in whole or part, from the readers' use of, or reliance upon, this material.

Contents

Foreword

Steve Liska

From craftsmen's marks, to heated irons pressed into cows, to tattoos, to the feeling you get after walking into Notre Dame Cathedral, to the Nike™ swoosh®, to running a Nike-sponsored race—these are all examples of how branding has evolved over time. Brand experiences are powerful, often misdirected, and essential to understand if you want to use branding as a tool. After clearly defining the branding process, Robin Landa's *Designing Brand Experiences* addresses how to communicate a brand experience—and how to judge whether that experience accurately portrays the brand it represents.

Branding is a word that many designers and clients may feel is overused. But when a carefully monitored and consistent experience is factored into the strategic success of a coffee company; when millions of dollars can be raised for cancer research with a simple yellow rubber wristband; and when symbols can instantly trigger a range of emotions based on our perception of what they stand for—you begin to understand the power of a brand's meaning and how it can shape our daily lives.

Although the concept of a brand experience is nothing new in the world of marketing, our industry is faced with an unprecedented convergence of media and disciplines. Traditional marketing roles are blurring. Designers who once created a graphic symbol for a client are now also creating interactive web experiences for that client. They may be asked to design elements such as interior graphics, televised signage, or other interactive media. They may also develop an editorial voice for their clients, an advertising campaign, or product packaging. Ad agencies no longer live in the bubble of the medium being the message. Architects and space planners are dealing with defining an experience for the visitor, the employee, or the shopper that can transcend physical space, geography, and culture. Because of this convergence in a variety

Steve Liska founded Liska + Associates in 1980. As a leading communication design firm, Liska + Associates helps clients like Motorola, Hubbard Street Dance Chicago, Lancôme, and Douglas Elliman build awareness of their products and services through strategic communication tools. Steve's design work has received the most distinguished awards and has been featured in every leading design journal. He is presently chairman of the prestigious "27 Chicago Designers" and contributes his time to the national chapter of American Institute of Graphic Arts (AIGA); he is a founding member of AIGA's Brand Council. A frequent keynote speaker and design competition judge, Steve has also taught master's programs at The School of the Art Institute of Chicago, Kent State University, and Syracuse University.

of fields, there has never been a more opportune time to design a holistically accurate brand experience that becomes a continuous link across all media. Through real-world case studies, this book illustrates the importance of approaching brand design and development in a more comprehensive way that looks beyond traditional marketing boundaries.

Meanwhile, we poor humans have to deal with a barrage of messages that try to stimulate, control, embed, manipulate, and make friends with who we think we

are. We make major decisions based on our acceptance or rejection of these messages: which religion, political party, style of clothes, mode of travel, and lifestyle we embrace. Our beliefs are constantly evolving based on interactions with friends, family, cultural cues, and physical experiences, as well as storytelling in movies, television, books, or on the Internet. Everything is laced with a message—which eventually translates into a brand perception. How you feel about the shoes you wear, or the Amazon rainforest, or an architecturally controlled town in Florida, or your favorite beverage is part of the brand experience. These perceptions come from your general observations and your personal interactions with a brand. Brand experiences are designed to help us make decisions about how we choose to live, shop, and go about our daily lives. As the book explains, the brands that differentiate themselves well through the experience they offer are the ones with the strategic advantage.

As media steps up its level of persuasion through product placement in movies, brand-driven TV content, and the proliferation of one-to-one marketing messages, how do brand experiences continue to fit into our instant-messaging lives? *Designing Brand Experiences* responds to this question. Robin Landa dissects the origins, explores the process, and shows examples of broad-based branding programs that culminate in a tailored, valuable experience for their intended audience.

Products, places, people, businesses, and organizations all have a brand experience associated with them. Musicians, CEOs of companies, an exhibition at a museum, your cell phone, a visit to the grocery store—even you, based on the choices you make—are all judged by others as a brand. For a designed brand experience to have meaning and value and to accurately reflect the essence of its subject, it has to be an honest rendition of what it represents. When a politician lies, a musician lip syncs, a product fails, or a charity is investigated, your perception changes, and you stop believing the brand's implied promise. You lose faith and make other choices—sometimes in direct response

to something negative, or sometimes subconsciously, as a reaction to a comment, the quality of the package design, or an advertisement that doesn't seem right. From a design and marketing perspective, how do you craft visual and verbal messages that solve a strategic problem while being honest to the core attributes of the brand? And how do you make sure they are in sync with the products, the retail spaces, the service levels, the online messages, etc. that are associated with that brand? When designed correctly, the brand experience should feel completely seamless and natural for its audience. It should touch the audience on an emotional level and should inspire their trust.

This book outlines the steps to take in creating an accurate brand experience that touches its audience. It walks you through a process that will help you and all of the brand's stakeholders understand the essence of the brand. Through this discovery, you will develop the basis for communicating what is unique and what is important—the brand promise. Then the process extends to the experience: how every point of contact with the brand needs to work together to be meaningful; how all sensory experiences must work in harmony to bring a message to the audience about what the brand is; how to fit the brand within the world of its audience; and how to determine what the audience can consistently expect from it. You will learn how to develop a framework for this messaging that graphics and language can be applied to, which will also help you monitor a complete view of the brand experience.

Developing a systematic approach to creativity based on a deep cultural understanding of a subject is the only way our converging disciplines will succeed in the world of designed experiences. A brand is not one thing. It is not just a logo or a package. It is a complex set of visual, verbal, and experiential cues supported by media messages. Learning how to reach people by designing an experience that cuts through all the messages they are required to filter on a daily basis and gets them excited is a powerful responsibility and challenge for all involved. And that's exactly what *Designing Brand Experiences* will help you understand how to do.

Preface

Intended Audience

Designing Brand Experiences is the most informative book available on conceiving, designing, and guiding a comprehensive branding experience. Every major brand application is covered. This book was created in response to several audiences.

- The many needs of a student's visual communication education
- A creative professional's need to fully plan and design effective brand experiences
- A client's need to fully understand the complex creative process involved in brand experience design
- Both a creative professional's and a client's need to understand establishing and stewarding a "singular voice" (anti-isolated applications) approach
- The instructor who seeks a comprehensive text on branding

This book serves several purposes, aimed at intermediate to advanced students in visual communication programs majoring in graphic design and advertising, marketing majors in business programs, and practicing designers, art directors, copywriters, marketing professionals, their clients, and CEOs. *Designing Brand Experiences* contains:

- A thorough guide to conceiving and designing comprehensive branding
- A thorough guide to key graphic design and advertising branding applications, from concept through design
- An overview of branding
- A thorough explanation of strategy with an emphasis on the various creative and design briefs used by esteemed creative professionals
- Two chapters devoted to formulating branding concepts and brand constructs
- Promotional design, advertising, unconventional advertising, and web design discussions, covered as part of integrated branding experiences
- A historical framework that puts the theories in this book into a broader context
- A design process for solving any branding problems
- A presentation of the concept of a brand voice across applications as the underpinning to any individual application
- Instruction on the cause and effect of visual communication
- Case studies for instruction throughout the text
- Sidebars and diagrams of information
- Discussion regarding ethics and sustainable "green" design

The information contained here has been highly valuable to a range of audiences with whom I work—from students to marketing executives to creative professionals. It has greatly aided their comprehension of branding and facilitated effective branding programs.

Emerging Trends

There are always emerging trends and, more importantly, design movements and theories. The ones that seem most vital *to the most people* are discussed here.

On Strategy. We often hear that clients desire more contact with creative professionals in every aspect of branding—that their work together should be more collaborative. Equally, we hear creative professionals feeling that they'd like to be "on board" from the outset, when setting the strategy.

It is usual industry practice for clients to set strategy. Now, more and more, progressive clients are calling upon designers, art directors, copywriters, interactive teams, and creative directors to formulate strategy. Some collaborate with clients. Some formulate strategy as members of conventional creative teams. Some are members of brand teams which include a variety of professionals from both the studio or agency side and the client side. *Designing Brand Experiences* encourages a full partnership between clients and creative professionals at the outset. It also encourages students to quickly learn the importance of strategy to the creative process, and of writing and using design or creative briefs to solidify the branding plan.

Designers and art directors solve visual/verbal communication problems. Although a portion of the work created is aesthetically compelling, provokes us, and is expressive, designers are not creating art as a pure matter of self-expression. Clients want their visual communication problems solved and they want creative professionals who understand the true nature of the discipline. Using strategy formulation and the importance of an *all-inclusive* strategy keeps everyone on course.

On Collaboration. Clients want to be heard, to have a creative professional who can actively listen and respond. Sure, some clients want you to "design" their ideas, but that is not desirable. Most clients want a designer or art director who will work in partnership, forming strategy to best solve the problem. Being able to listen is a key asset, for both the designer and the client.

On Selling Creative Concepts and Solutions. One of the most frequently asked questions at my conference lectures to creative professionals is: "How do I convince a client to buy a creative solution?" There are several parts to my answer.

Using a creative or design brief at the outset allows a creative professional to have a rationale for the solution. A logical defense of a creative solution—one based on strategy—is far more likely to be accepted. Simply asking for the client's trust in a creative professional's expertise, unfortunately, isn't enough to sell a highly creative solution that a client may perceive as risky.

The main goals of any branding effort are to differentiate and be unique. These goals beg a creative solution—one that doesn't look and feel like others. Often, clients want a "safe" solution, one that might be similar to what already exists in the marketplace. Using the goals of differentiation and owning a uniqueness will help sell a creative solution.

The "cool" quotient should never be underestimated. Creative solutions are often the coolest.

Creative solutions break through the bland clutter of the marketplace.

Finally, imagine what the strongest argument against your creative solution could be. Then, think through and formulate an answer to that argument. All other arguments will be more easily addressed.

On Branding Specialists. There is an ever-growing convergence of specialized areas of visual communications. Advertising agencies are creating branding programs. Design studios are creating advertising. Certainly, interactive agencies, packaging design firms, and environmental design studios are also involved. A client should expect a common thread throughout all work. It is important for everyone to realize that no application is isolated—it must be part of a larger plan. Design management is critical.

On Education. For any student or novice it is imperative, first and foremost, to develop sophisticated problem-solving skills, to be grounded in liberal arts,

to have excellent communication skills, and to be a good "information-gatherer" and a careful listener. Those attributes will serve you best for the long career. This book fully addresses developing problem-solving skills.

On Ethics. Responsible design is good design. Visual communication professionals have an ethical responsibility to communicate truthfully and to respect their audience's humanity. Of course, advertising communicates in broad stokes; however, it is possible to communicate and still avoid ethnic, racial, religious, and gender stereotyping, negative portrayals of cultures and communities, veiled negative messages, and scare tactics, among other critical ethical issues. Ethics are addressed in depth in this text.

Background of this Text

Whenever I consult with marketing directors, I begin by explaining my point of view about branding. Interestingly, they are eager for more, especially for any insights into the creative process, so that they can best work with creative professionals, as well as acquire highly effective brand solutions. The same is true for my students, who don't get this information in other courses; this content will enable them to design effectively across experiences and applications.

I have written *Designing Brand Experiences* to serve as a guide for my own teaching and for my clients' branding efforts; hopefully, others will find it helpful, as well.

If you teach or if you are studying branding or marketing, then you're most likely as fascinated by visual communications as I am. Absolutely, I believe that graphic design and advertising matters. From public service advertising to driving economies—creative solutions become important vehicles.

Teaching branding is very challenging. Strategy, ideation, design, writing, and social responsibility are taught simultaneously. Students must become critical and creative thinkers very quickly, learning to visually and verbally express and represent their creative ideas.

In order to thrive in a fast-paced marketplace, any visual communication professional must stay current with technology, design theory and movements, economic trends, and culture. Knowing and respecting one's audiences and clients is crucial. Today, collaboration is becoming more and more a necessity. A designer collaborates with clients, IT professionals, and many other creative professionals in order to best solve communication problems.

My research into visual communications is ongoing. Like any conscientious physician, I must stay abreast of all current research, work, theories, trials, discourse, and papers. By interviewing hundreds of the world's most esteemed branding practitioners, I am completely familiar with many viewpoints and solutions. By being privy to their individual design briefs and creative strategies, I possess a remarkable umbrella view of how studios and agencies formulate strategy to create effective, creative solutions. In fact, by reviewing work for inclusion in this book (and for my other nine books), I am in a unique position to have a comprehensive overview of international solutions and points of view. As a practitioner, I understand what clients need; as an educator, I know how to break down enormous amounts of complex information into digestible bits.

To best utilize this text, a reader should have completed prerequisite courses, such as visual basics, and beginner levels of graphic design and advertising. Certainly, a basic knowledge of the necessary tools, materials, and techniques (both hand skills and tools, as well as computer skills) would facilitate learning.

Textbook Organization

Chapter Content

The major portion of this book covers all content necessary to design effective, creative branding. The foreword, written by the distinguished designer Steve Liska, founder of Liska + Associates, offers profound insights into branding. A historical perspective is included, at the beginning of this book, in order to view contemporary thinking in perspective. To set the stage for discussion, Part I covers strategy; an introduction to the subject and an examination of the branding process comprise the first two chapters, including a thorough discussion of creative and design briefs. For some readers, these chapters may be the only introduction to branding strategy they receive; thus, I have tried to make it as full of vital information as possible.

The third and fourth chapters, which comprise Part II, cover concept generation. I've tried to best present a very abstract process that many find elusive. Part III is about designing brand experiences. I felt it necessary to include a chapter on what makes for effective designing; since this book is about designing, there is great merit in a review of design essentials as they apply to branding and are utilized across all applications.

Chapters six through eight cover major graphic design and advertising applications; they are easily used in any order that is appropriate for the reader or which best suits the educator. The breakdown is as logical as possible, starting with the visual language elements that make up a brand identity, followed by identification graphics, and then by advertising and promotional design. In Chapter 9, I've included five very different case studies to demonstrate the range of possibilities at a glance, and an astute essay addressing the crucial issue of brand management by Denise Anderson, director of Marketing Services at Pershing. The book concludes with Chapter 10—an in-depth look at the very important topic of ethics in branding. At the back of the book are the glossary to help with terminology, a selected bibliography to encourage further study, a subject index to aid in detailed research, and an index of all brands, groups, creative professionals, agencies, and studios discussed in this book.

As some educators have mentioned to me, there is far too much in this book to be covered in one semester. What I have done is allow for at least three scenarios.

• An instructor may pick and choose what to teach, whether it is applications or strategy.
• This book can be used in several courses, as many instructors do to make the investment in a textbook worthwhile.
• Students and designers can also use this book as a resource for a very long period of time, due to the abundance of information, great examples by venerated designers, and the large number of case studies.

Each chapter provides substantial background information, as well as sidebars, diagrams, and many informative case studies created by highly respected visual communication professionals, intended to add different voices and greater wisdom to the reader's education.

Understanding the Illustrations

There are innumerable solutions to any branding problem. The examples here are only as an idea of what is possible and what is in the ballpark; they are not meant to be imitated, nor are they by any means the only "correct" solutions. Creativity in any visual communications discipline is not measured in terms of right and wrong, but rather by the degree of success demonstrated in problem solving, communicating, applying visual skills, expressing appropriate personal interpretations, designing responsibly, and efficacy in the marketplace.

Every example in this book is excellent; they were all chosen with great thought toward illustrating effective and creative work. The work and information in this book represents the best of what is being produced today. When you look at the examples of the greats—the highly respected professionals in the various design fields—do not look at them and think, "Oh, I could never do that." Instead, think, "This is great stimulation. I could learn a lot from these people." We can and should learn from the creativity of others. Creativity can be enhanced by study. It is simply a matter of deciding you can be creative and having someone guide the way.

Overview of Features

The following list provides some of the salient features of the text:

- Foreword by renowned designer, creative director, and branding expert Steve Liska
- Historical timeline with representative images
- Examples of work from the most esteemed designers and art directors in the world
- State-of-the-profession overview of branding
- In-depth discussion on branding concepts
- Clear explanation of the major branding design applications
- "How-to" explanations of the applications
- Numerous bulleted lists and sidebars that enable student comprehension
- Comprehensive, edgy chapter on advertising and the brand identity
- Case studies
- Essay on brand management by award-winning designer Denise Anderson
- "A friendly read"
- Supplemental package providing instructors with key tools

E.Resource

The guide on CD was developed to assist instructors in planning and implementing their instructional programs. It includes sample syllabi for using this book in either an 11-week or 15-week semester. It also provides chapter review questions and answers, PowerPoint slides highlighting the main topics, and additional instructor resources.

ISBN: 1-4018-4887-7

About the Author

Robin Landa is the author of ten published books about art and design, including *Advertising by Design* (John Wiley & Sons), *Thinking Creatively* (North Light Books), the best-selling *Graphic Design Solutions,* 3rd edition, and *Visual Workout Creativity Workbook* (Thomson Delmar Learning), co-authored with Rose Gonnella, and *Creative Jolt* and *Creative Jolt Inspirations* (North Light Books), co-authored with Rose Gonnella and Denise Anderson, and the upcoming *In2Design* (Thomson Delmar Learning). Several of Landa's books have been translated into Chinese. Most recently, *Advertising by Design* was translated into Spanish: *El Diseño en la Publicidad* and published by Ediciones ANAYA Multimedia (Grupo Anaya, S.A.), Spain 2005.

George Lois, famed advertising creative and graphic designer, said about Landa's book that "Robin Landa's *Advertising by Design* is the best who, when, why, and how-to book on creativity in advertising and design available today to students of the media and popular culture."

Robin Landa's article on ethics in design, "No Exit for Designers," was featured in *Print* magazine's European Design Annual / Cold Eye column. Her articles were featured in *HOW* magazine and *Icograda*.

Landa has won many awards for writing and design, including the New Jersey Authors Award, The National League of Pen Women, National Society of Arts and Letters, Art Directors Club of New Jersey, The Presidential Excellence Award in Scholarship from Kean University, Rowan University Award for Contribution to Design Education, Graphic Design USA cover design award, Creativity 26, and Creativity 34.

Landa is a professor in the Department of Design at Kean University of New Jersey. She is included among the teachers that the Carnegie Foundation for the Advancement of Teaching calls the "great teachers of our time." Also highly interested in the issues of social responsibility, Landa worked on an Alcohol Awareness Grant received by Kean University, to create a print and web advertising campaign to promote awareness among university students about alcohol abuse. Annually, Landa directs a student project to create an unconventional public service advertising campaign to solicit donations for various charities and raise awareness for social causes.

Landa has lectured across the country, including very positively reviewed lectures at the HOW International Design conferences, and has been interviewed on radio, television, in print, and the World Wide Web on the subjects of design, creativity, and art. In 2002, Landa was the keynote speaker at the Graphic Artists Guild conference in Philadelphia, and in 2003, she participated on a panel about graphic design education at the College Art Association conference in New York City. In 2004, Robin Landa gave a lecture at the Art Directors Club of New Jersey about the creative side of advertising. At the One Club 2004 Summit for Educators in Advertising and Design, Landa participated in a panel discussion on textbooks and defining the needs of college and university curricula.

In addition, Landa is a Branding and Creativity Strategist with Design Management Associates, Inc., Jersey City, New Jersey. Robin Landa's freelance work includes graphic design, copywriting, and working as a consultant to corporations on creativity and branding. She also is a member of The One Club, Art Directors Club of New Jersey, AIGA, and Art Directors Club of New York. Robin resides in New York City with her husband and their daughter.

Acknowledgments

Without the brilliantly creative graphic design and advertising solutions that inhabit these pages, my book would be an entirely different study. Humbly and gratefully, I thank all the creative professionals who granted permission to include their work in *Designing Brand Experiences*. Thank you. Thank you.

Great thanks to the clients and corporations who also granted permission and to all the generous people whose help was so valuable. Thank you to Emma Banks, Strawberryfrog; Katie Dishman, Corporate Archivist, General Mills; Hans Engebretson, Olson; Sabine Gilhuijs, KesselsKramer; Ann Marie Gray, Liska + Associates; Richard Grefé, president, AIGA *(www.aiga.org)*; Natasha Spring, vice president, Publishing and Research, IABC (International Association of Business Communicators, *www.iabc.com*); and Rachel Thomas, Mires for their invaluable help.

My humble thanks to Steve Liska, whose brilliant work has graced my other books; now his foreword offers insight and wisdom for readers. To Denise Anderson, thank you for contributing your perceptive essay on brand management; working with you is always gratifying.

At Kean University, I am indeed fortunate to work alongside such consummate educators and experts (and the kindest of friends): Steven Brower, Rose Gonnella, Martin Holloway, Michele Kalthoff, Dawnmarie McDermid, Laura F. Menza, Richard Palatini, Alan Robbins, and Michael Sickinger. To Lou Acierno, Dr. Michael Balogh, Tricia Boffice, Paula Bosco, John Chaffee, Patty Ceruzzi, Gregory D'Amico, Frank Holahan, Michael O'Keefe, Christopher J. Navetta, Andrea Pedolsky, Evelina Trzeciak, and Stephen Vaccaro, thank you for your expertise and support.

Writing a book such as this one is a huge undertaking. Without exceptional professionals Jim Gish, senior acquisitions editor, and Jaimie Wetzel, development editor, at the helm of this project, and every other skilled, talented, dedicated professional on the Delmar team to support this endeavor, I'd still be writing and gathering images. Great, grateful thanks to the following people at Delmar whose hard work and intelligence made this book happen: Larry Main, senior production manager; Tom Stover, production editor; Mary Beth Vought, art and design specialist; Nicole Stagg, art editor; Niamh Matthews, editorial assistant; Peter Illenberg, permissions specialist; Laura Molmud, permissions editor; Liz Kingslien, graphic designer; Mardelle Kunz, copyeditor; and Lisette Cook, production assistant. Not only is the Delmar team a stellar group, they are genuinely kind. Thank you one and all.

A grand thank you to Denise Anderson (Kean University alumna), Steven Brower, Rose Gonnella, Liz Kingslien, Laura F. Menza (Kean University alumna), and Christopher J. Navetta (Kean University alumnus), for their design contributions.

Warm thanks to former students—now responsible, highly creative professionals—who have made me proud, and great thanks to my current students. Teaching all of you over these many years has been rewarding beyond expectation, as well as being an ongoing learning experience for me. In fact, I admire my former students so much that I have worked on branding projects with an illustrious alumna from Kean University—Denise Anderson.

Loving thanks to my friends and family. Great thanks to Linda Freire, Edmund, Michelle and Cynthia Alcantara. And finally to my handsome and brilliant husband, Dr. Harry Gruenspan, and to our precious daughter, Hayley, thank you my two loves for your help, creative input, hot soup, and TLC.

Robin Landa

2005

Delmar Learning and the author would also like to thank the following reviewers for their valuable suggestions and expertise:

Susan Cotler-Block
Department Chair, Communication Design
Fashion Institute of Technology
New York, New York

Alice Drueding
Graphic and Interactive Design Area Head
Tyler School of Art
Temple University
Elkins, Pennsylvania

Sam Grant
Miami Dade Community College
Design and Entertainment Technology Department
Miami, Florida

Rhonda Levy
Kingsborough Community College
Art Department
Brooklyn, New York

Tammy Knipp
Art Department
Florida Atlantic University
Boca Raton, Florida

John McVicker
Advertising Design and Graphic Arts Department
New York City College of Technology/ CUNY
Brooklyn, New York

Larry Stultz
Department Chair, Graphic Design & Advertising
The Art Institute of Atlanta
Atlanta, Georgia

Questions and Feedback

Delmar Learning and the author welcome your questions and feedback. If you have suggestions that you think others would benefit from, please let us know and we will try to include them in the next edition.

To send us your questions and/or feedback, you can contact the publisher at:

Delmar Learning
Executive Woods
5 Maxwell Drive
Clifton Park, NY 12065

Attn: Graphic Communications Team
800-998-7498

Or the author at:
RLANDA@KEAN.EDU
Robin@Designmanagementassociates.com
www.designmanagementassociates.com

Dedication

For my precious Hayley, who dearly loves her brands.

A Brief Overview of the History of Branding

If you think that the idea of branding is relatively modern, starting with the industrial age in England, then moving to the rest of Europe and the U.S., then you're in for an interesting surprise.

Since the time people created goods to trade or sell, or as far back in time as when people owned cattle, there have been trademarks, symbols, signs or posters, pictorial signs, and hawkers.

In order to distinguish their goods, craftsmen imprinted trademarks on their goods and creations to signify the maker and origin. Ultimately, trademarks assured the buyer or trader of the quality of the merchandise.

To denote ownership of property, at first cattle were branded with paint or pine tar; later, unfortunately, cattle and sheep were branded with hot irons. Humans were also branded for various reasons. Slaves were branded to mark ownership; criminals were branded with disgrace. During World War II, victims of Nazi persecution who were interned in concentration camps were branded with numbers. Horrifically, people have used branding to indelibly mark people and animals. For a sound purpose, tradesmen have used branding to mark possessions and goods. Although some terms and connotations stay in our vernacular, for the most part, the negative connotation of branding has been abandoned for one that is positive and commercial, referring to the use of distinguishing brand name goods and services.

Ancient Marketplace

In ancient Babylon, to entice buyers to purchase goods that had arrived on ships, barkers solicited customers with a verbal (barked out) sales pitch describing spices, rugs, wines, and other goods. Announcements written on papyrus were posted in ancient Egypt for a variety of reasons, including lost items and rewards for runaway slaves. To explain their offerings and goods to a mostly illiterate mass—as early as ancient Egypt, Greece, and Rome—merchants hung pictorial signs (using symbols and pictures) and painted their storefronts. Writing was also used to advertise, as evidenced by writing on walls from the ancient city of Pompeii.

Dating back to over 3,000 years ago, in the Western Zhou Dynasty of China, trade fairs were held, where hawkers pitched displayed wares. Although the early Egyptians invented papyrus, it was in China that paper was invented. Along with block printing, these two inventions would set the stage for mass communication.

Medieval Marketplace and the Sung Dynasty

With the fall of the Roman Empire and the onset of the Middle Ages, commerce fell precipitously. For the most part, the level of craftsmanship declined miserably. With the exception of the clergy and a rare few others, people were largely illiterate. Although initially their roles were restricted by officials, town criers fulfilled the need for the spreading of information.

In the thirteenth century, the Magna Carta, the decline of feudalism, and trade between east and west, among other things, helped to change lives and towns for the better. There was a revival of crafts with the formation of craft guilds and the emergence of a middle class. During this period, to control trade, guilds made *proprietary marks* mandatory. Town criers were paid to advertise a merchant's goods. Hand-lettered handbills were hung and

distributed to advertise and attract customers. Signs were hung to help identify both a merchant and the merchant's type of business; for example, a boot-shaped sign denoted a shoemaker.

In China, during the Sung dynasty (960–1279, an enormously rich artistic and technological period), block-printing for printing entire pages and movable type cast in clay paved the way for mass communication. During this dynasty period, due to a shortage of copper for coins, paper money was invented and issued in China. In Korea, in 1403, movable type was cast in metal, further refining the technology.

Also in China, a wide variety of early forms of branding and advertising were utilized, including printed wrappers, banners, painted lanterns, painted pictures, and signboards, as well as printed advertisements. The high quality of and the great interest in painting—and the known printing technology—allowed the Chinese to create these early forms of brand identification and advertising.

The Gutenberg Printing Press and the 1400s

Although the first form of movable type was invented in China, it was the invention of the Gutenberg printing press by Johannes Gutenberg, in Germany in 1448, and its popular rise in Europe that allowed the distribution of information to the public to flourish. From then on, printed information could be easily distributed, and the rise of advertising was ensured. By the late fifteenth century, the first English language announcement in the form of a handbill (which one could consider an advertisement) promoting the availability of a book appeared. Soon thereafter, great quantities of posted advertising, announcing information and hawking goods, hung in the streets of London.

The 1600s to the 1700s

In 1625 in England, the first ad appeared in a newspaper—the first modern mass media. The very early eighteenth century (1704) marked the appearance of the first known newspaper advertisement in America, in the *Boston Newsletter*. Unlike today's newspaper ads, early newspaper advertisements were limited to one section of the newspaper, and most were simple announcements. In order to attract readers' attention, many newspaper advertisements repeated a line of copy several times. One could think of this as the predecessor to the ad slogan and a latter-day advertising giant's notion of the power of repetition in successful advertising solutions. Later on, advertisements would appear throughout the newspaper, as they do today.

By the 1700s, trademarks and stamps were becoming standard practice. A trademark became crucial to governments, producers, and consumers. Governments saw the need to institute patent, trademark, and copyright laws as incentives to encourage development and progress in science, technology, and the arts. The first patent laws were developed in Italy in the late 1400s, and it was the craft guilds in Europe that prompted the first trademark laws to ensure the distinction and identification of goods and services. Not only did trademarks identify and distinguish products, they aided consumers by citing origin and thereby quality. Today, trademarks must be registered with national governments. The first copyright laws were passed in England in the 1700s.

The Industrial Revolution

Beginning in England in the mid 1700s and reaching North America in the early 1800s, the Industrial Revolution—the great thrust toward a modern, industrialized society—caused a great impact on the future of branding and advertising. Mass production allowed for goods to be produced in a cost-effective way. Early forms of advertising and branding aided the dissemination of information about goods, identifying goods and quality, and stimulating demand. This early advertising was aimed not just at the rich, but also at the burgeoning middle class—as a mass market. Many people didn't read newspapers, so inventive advertisers and their advertising agencies (which started to crop up in England in the 1800s) found other ways to reach potential consumers, including men wearing placards, banners streaming from hand-held poles, and even umbrellas sporting signs.

The mass manufacturing and marketing of the Industrial Revolution spurred the growth of visual identification and trademarks. It also pointed out the importance and value of visual identification systems and trademarks.

Before the U.S. Civil War (1861–1865), bulk goods were sold by weight from barrels and open containers. These products weren't offered as "brand names" as we know them today—although some manufacturers, such as producers of tobacco, wine, and ale, did brand their trademarks onto wooden packages or casks—but, rather were sold as commodities. The Civil War-time economy created a ripe climate for technological advances and for the start of a "packaged goods" society. Soldiers needed canned goods and uniforms. People began to buy ready-made clothing and shoes. More and more, people were drawn away from commodities sold out of barrels to attractively packaged goods that promised "sealed freshness" and more sanitary products.

Before the 1880s, people simply bought crackers from a cracker barrel (or any other example of unpackaged product), and didn't really know the name of the manufacturer. Companies had to find ways to promote their "brand names" to customers through more earnest visual identities and attractive packaging—labels, boxes, wrappers—and heavier promotion through advertising. During this period, advertising took on a rather dramatic flavor, utilizing over-blown copywriting styles and melodramatic headlines. Infamous advertising for patent medicine (that gave advertising a lingering bad reputation) was strong, and introduced numerous brands, each vying for a larger share of the customer base. At first, tobacco companies burned their "brand names" into the wooden barrels sold to shopkeepers; later tobacco was sold in packages. Patent medicine manufacturers and tobacco companies led the way with proprietary names, uniquely decorative labels, and packaging.

The folding box enabled the cereal industry to flourish. "A manufacturer put a commodity in a small box, injected 'personality,' added information to increase its usefulness, and turned the goods into something both desirable and extremely profitable. The success of selling packaged goods also depended on advertising a 'name.' Yet it was something more than a name—it was the established identification of a 'brand name.' This identity differentiated the product from others of the same category and enabled buyers to appraise its value before buying."[1]

The role of the brand name's brand mark, label, packaging, and advertising designers was to stimulate sales and make the brand desirable. Thus it began that people wanted brand names, names that were impressive and reliable, names they could trust for a variety of reasons, such as freshness, quality, and sanitary packaging. They wanted brands that would make their lives easier and more pleasurable; they wanted brands that would make them more attractive, socially acceptable, and desirable.

A convergence of modern factors—such as the invention of photography and typewriters, a rising literacy rate, the rise of mass media, the increase in railways, the telephone, and better postal systems—would all greatly facilitate the success of brands.

Corporate executives and owners quickly recognized the important role that visual communications played in the success of their business, of driving consumers to use their brands and to create a loyal customer base. Whether it was the early advertising success story of Lydia Pinkham's Vegetable Compound® or the meticulously planned campaign and launch of the Uneeda® biscuit, brand manufacturers realized how integrated branding programs could stimulate sales. Advertising for Lydia Pinkham's Vegetable Compound, a tincture of alcohol and roots for women's ailments, greatly increased its sales. In the 1880s, when Pinkham's son decided that he didn't need to spend any more money on advertising since sales were very good, he stopped advertising. Sales precipitously dropped.

Uneeda biscuit, a packaged brand-name cracker made by the National Biscuit Company (now Nabisco), hired the advertising agency N. W. Ayer & Son to create an integrated brand campaign for their product. The agency suggested the brand name, the character (a little boy in a raincoat to suggest air-tight freshness and crispness), and the slogan "Lest you forget, we say it yet, Uneeda biscuit." This historic campaign, launched in 1899, was the first multimillion-dollar ad campaign; it would change everyone's perception of the critical role of branding and advertising.

The Twentieth Century

During the first twenty years of the twentieth century, America prospered. Industrial growth was great. Many people had enough income to spend some on goods, services, and luxuries, small and big.

Graphic design, advertising, and marketing stimulated this "consumer" economy. People with extra money spent it on branded goods, from automobiles to phonographs to soft drinks such as Coca-Cola®, and to condiments such as those manufactured by Heinz.

The rise of mass media in industrialized countries contributed greatly to the rise of a "brand world" and the desire for brands. Radio sponsorships by brands, and later radio advertisements, paved the way for people to embrace the notion that brands could bring them happiness, both directly and indirectly. Not only would a brand name soap clean your clothes better than the others, it also paid for a broadcast radio program that was entertaining. Television would be the next big venue for brands. Imitating radio marketing, brand names sponsored television programming and later paid for television commercial spots. Besides the brand identities created for consumer goods and services, it was the identification systems for corporations that set certain standards for the creation of all identification systems, comprehensive programs that went far beyond the design of a logo or trademark. A cohesive image created by a unified, consistent, professional visual communication program was the goal. Corporations wanted an advantageous visual image that could be used to represent the huge entity that is a corporation. Visual identity or corporate identity programs could give a corporation a "look," a style, an image, a personality.

Early on, print advertising was still king. And, rather unbelievably, it would take corporate executives until the late twentieth century to understand what N. W. Ayer & Son knew in 1899: just how effective *integrated branding experiences* can be.

Designing brand experiences that are strategic and relevant will resonate—and that is simply smart business.

Notes on Inventions

- In 105, it is believed that Ts'ai Lun, a Chinese court official, invented papermaking from textile waste using rags.
- Chinese papermaking techniques reached Korea early on, and in 610 were introduced to Japan.
- In 1810, the invention of the can by British merchant Peter Durand allowed for better food preservation and canned goods. The subsequent invention of the can opener, in 1858, by American Ezra J. Warner, facilitated the use of canned goods. William W. Lyman's newer model introduced in 1870 was easier to use, and therefore household use increased.
- In 1833, the first sewing machine was invented by Walter Hunt, but it went unpatented. Elias Howe secured a patent, but didn't manufacture or sell it. Howe also invented the safety pin. Isaac Singer produced Singer® sewing machines.
- In 1846, Richard M. Hoe changed printing by inventing a cylinder printing press; by rolling a cylinder over stationary plates of inked type, then using the cylinder to make an impression on paper, he eliminated the need to make impressions directly from the type plates.
- In 1865, William Bullock invented web offset printing, a process whereby paper could be fed into a printing press, on a continuous roll, and printed on both sides at once.
- In 1870, Robert Gair made his first plain-paper folding box.
- In 1908, cognizant that the upper-class market for automobiles was now saturated, Henry Ford introduced the term "mass production" to economics and began manufacturing his Model T®.

Notes:

[1] John McDonough and Karen Egolf, *The Advertising Age Encyclopedia of Advertising,* vol. 2 (New York: Fitzroy Dearborn Publishers, 2003), p. 755.

Showcase: Heinz®

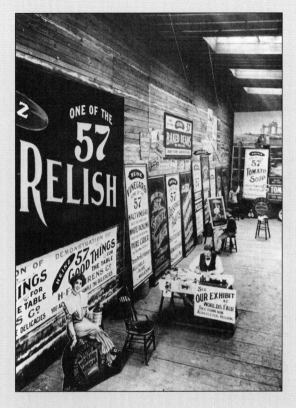

H. J. Heinz Company.

In 1896, "Henry Heinz turns more than 60 products into '57 Varieties®.' The magic number becomes world-renowned and now is virtually synonymous with the H. J. Heinz Company."

— www.heinz.com

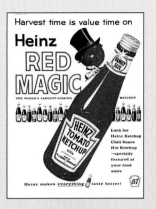

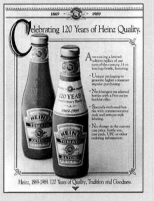

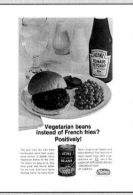

The pickle pin, 1893. H. J. Heinz Company.

Heinz introduces the pickle pin at the Chicago World's Fair, known as The Columbian Exposition. It becomes one of the most popular promotional pieces in the history of American business.

— www.heinz.com

Historical advertisements: Heinz.

Advertising helped make H. J. Heinz Company a household name.

In 1869, Henry J. Heinz and L. Clarence Noble launched Heinz & Noble. The first product is Henry's mother's "pure and superior" grated horseradish, bottled in clear glass to show its purity.

In 1876, ketchup is added to the company's condiment line, which also includes celery sauce, pickled cucumbers, sauerkraut, and vinegar.

— *www.heinz.com*

Showcase: Ivory™ Soap

"In 1878, James N. Gamble developed the formula for a white soap; appropriately enough, the product would be called P&G White Soap. But Harley Procter insisted the new white soap deserved a more distinctive name, one that people would remember when they went to the store. Finally, after weeks of consideration and rejection of a variety of names, Mr. Procter had a sudden flash of inspiration while attending Sunday church service. The search for a name ended when the minister read from Psalms 45:8—'All thy garments smell of myrrh and aloes and cassia, out of the ivory palaces whereby they have made thee glad.' In October 1879, the first bar of Ivory was sold."

— *www.ivory.com*

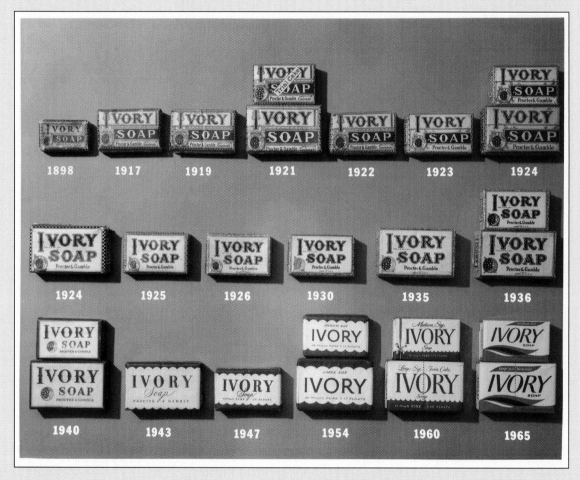

Ivory Soap Evolution, 1898–1965. Courtesy of Procter & Gamble Co.

Contemporary Packaging for Ivory. Courtesy of Procter & Gamble Co.

Showcase: Campbell's® Soup

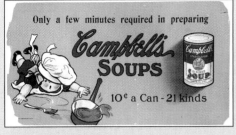

Placard: "Only a few minutes required in preparing."

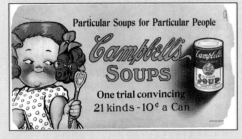

Placard: "Particular Soups for Particular People."

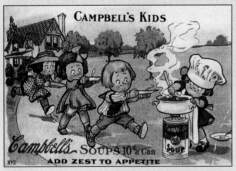

Poster.

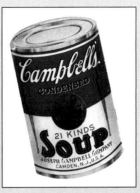

Soup can.

Charlie Chaplin.

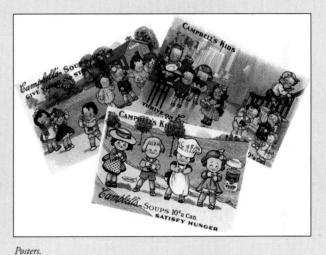

Posters.

Courtesy of Campbell Soup Company.

"Advertising helped trumpet the benefits of soup to consumers and contributed to the success. In 1904, the cherubic Campbell Kids™ were introduced in a series of trolley car advertisements, as a way to appeal to working mothers. Around this same time, the first magazine print ad boasted 21 varieties, each selling for a dime. In the 1930s, Campbell entered into radio sponsorship, using the familiar 'M'm! M'm! Good!®' jingle to captivate listeners. When television made its way into American homes in the 1950s, Campbell introduced TV commercials, and some forty years later, the Campbell Kids were found dancing to rap songs on the small screen. Today, Campbell remains one of the leading advertisers in the U.S."

— *www.campbellsoupcompany.com/history.asp*

Showcase: Campbell's® Soup

continued

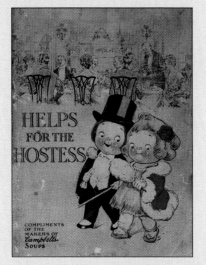

Hostess book, 1916.

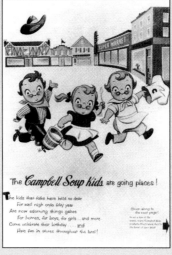

50th Anniversary.

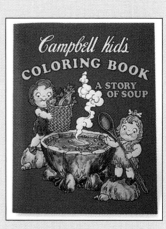

Coloring book, 1970s.

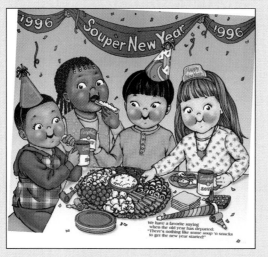

Party, 2000.

Logo, 100th Birthday.

Cornerstone logo.

Campbell's round logo.

Showcase: Trix® 1954–1991

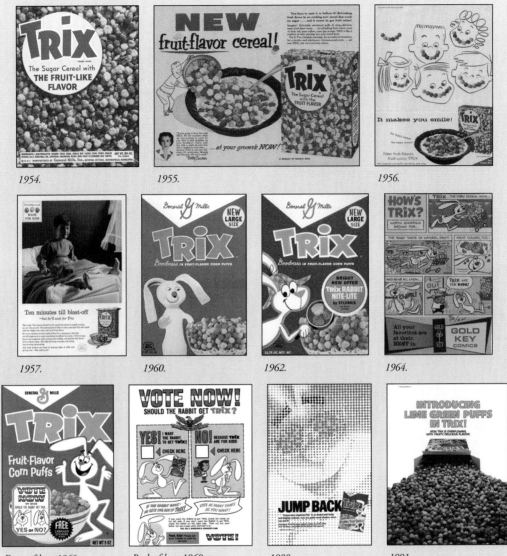

1954. *1955.* *1956.*

1957. *1960.* *1962.* *1964.*

Front of box, 1968. *Back of box, 1968.* *1988.* *1991.*

Courtesy of General Mills Archives.

General Mills first introduced Trix® cereal in 1954. The rabbit was first used on packaging beginning in 1960. The rabbit is a wonderful device—an icon that gives the brand great personality.

"There is a reason the Trix® rabbit is always trying to get his hands on great-tasting Trix® cereal. He just can't resist those fruity flavors: raspberry red, lemony lemon, orangey orange, wildberry blue, grapity purple, and watermelon.

Fortified with 12 vitamins and minerals, Trix® is also a good source of calcium, making Trix® a fun and healthy way to start the day.

Try as he might, that rabbit still can't get his hands on delicious fruity Trix® cereal."

"Silly rabbit! Trix are for kids!"

— *www.generalmills.com*

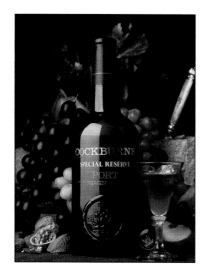

Packaging design: Cockburn's® Port, 1969. Design studio: Blackburn's Ltd., London, U.K. Creative director/Designer: John Blackburn.

This was a launch of the world's first popular port brand. This is a design classic; it is unchanged since inception.

"New product development aimed at opening up port to a younger mass audience. 'Special Reserve' redefined imagery of market with accessible populist personality."

— www.blackburnsdesign.com

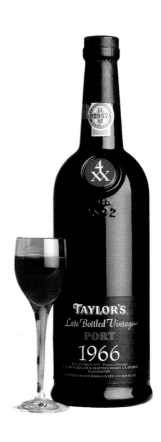

Packaging design: Taylor's™ Late Bottled Vintage Port™, 1966–1970. Design studio: Blackburn's Ltd., London, U.K. Creative director/Designer: John Blackburn.

"The benefits of being first—NPD creating now buoyant 'Late Bottled Vintage' port segment. Still brand leader in category it founded."

The inspiration, according to Blackburn's, was "Hidden in the small print of the brief, the now famous phrase: 'late bottled vintage'."

— www.blackburnsdesign.com

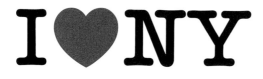

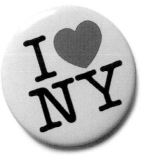

Logo and button: I LOVE NEW YORK®. Design: Milton Glaser, New York, NY.

Showcase: Historic Ad Council Campaigns

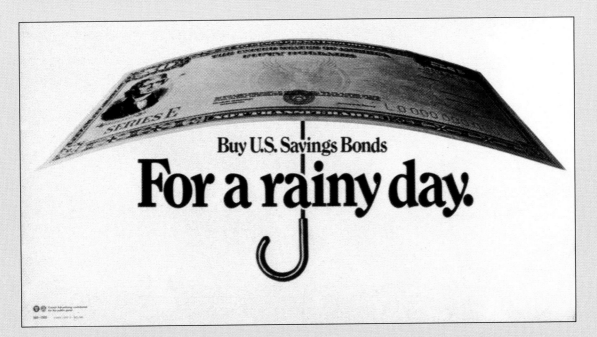

Savings Bonds, 1942–1980. Sponsor: U.S. Department of Treasury, War Finance Agency. Volunteer agency: Leo Burnett, Chicago, IL.

The War Advertising Council's first campaign, the Savings (or War) Bonds campaign, encouraged Americans to support the war effort by purchasing war bonds. The bonds were referred to as Defense Bonds until 1942, when agency executive Walter Weir decided it was more logical to call them War Bonds.

From January 15, 1942, to August 14, 1945, the organized power of advertising focused on informing the American people about what needed to be done to win World War II quickly and that buying War Bonds was near the top of that list. In that time, American advertising and media businesses contributed an estimated $350 million worth of space and time in support of War Bond promotion and approximately 85 million Americans bought more than 800 million War Bonds.

After World War II, the bonds were called Savings Bonds, and the ads promoting them appealed to prudent investment, rather than patriotism.

By the time the U.S. Government Savings Bond campaign ended in 1980, the campaign drew $75 million annually in donated media.

— Ad Council *(www.adcouncil.org)*

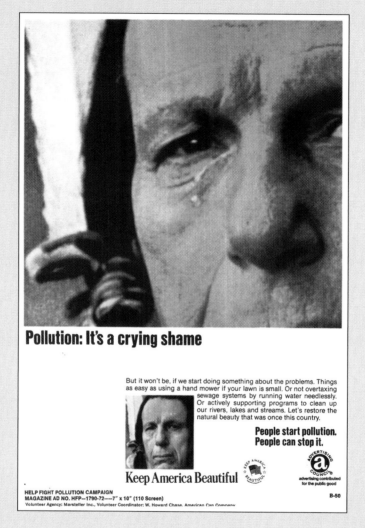

Historic Ad Council Campaign: Pollution: Keep America Beautiful®—"Iron Eyes Cody" (1961–1983). Sponsor: Keep America Beautiful. Volunteer agency: Marsteller, Inc., New York, NY. Used with permission of Keep America Beautiful, Inc. All rights reserved.

On Earth Day, 1971, a PSA (public service advertisement) featuring Native American actor Chief Iron Eyes Cody and the tagline, "People Start Pollution. People can stop it." aired for the first time. Iron Eyes Cody became synonymous with environmental concern. The PSA won two Clio awards, and the campaign was named one of the top 100 advertising campaigns of the twentieth century by *Ad Age* magazine.

During the height of the campaign, Keep America Beautiful reported receiving more than 2,000 letters a month from people wanting to join their local team. By the end of the campaign, local Keep America Beautiful teams had helped to reduce litter by as much as 88 percent in 300 communities, 38 states, and several countries. The success of the Keep America Beautiful anti-litter campaign led to hundreds of other environmental messages through the years, from many different sources, including the Ad Council.

— Ad Council *(www.adcouncil.org)*

PART I • Strategy

Chapter 1

What is Branding?

"Products are made in the factory; brands are created in the mind." — Walter Landor

Think of all the choices on a supermarket shelf. Choices among brands of pasta, cereal, beverages, cleansers, and toilet paper continue to proliferate by the day. Most of us have ample brands of automobiles, clothing, phone services, electronics, banks, and stock brokerages to choose among. Why choose one over another?

In today's overcrowded marketplace, almost all of the brands are **parity goods and services**—products that are equivalent in value. In essence, without brand names, each product or service is a commodity. It is the branding that distinguishes each one. For example, if a consumer wants to purchase tea—a packaged commodity—there are a great variety of brands from which to choose, all offering the same type of quality and flavors, more or less. Aside from price differences, why a consumer chooses to buy one brand of tea over another has mostly to do with her brand experience—her reaction to the packaging, visual identity, advertising, and perception of the brand.

What is a Brand?

Very basically, a **brand** is a proprietary name for a product, service, or group. (In this book, the term "group" is used to denote a company, organization, corporation, social cause, issue, or political group. For the sake of brevity, all branded entities—whether a product, service, or group that has benefited from any type of branding—will be referred to as a brand.) On a more multifaceted level, a brand is the sum total of all functional and emotional assets of the product, service, or group that differentiate it among the competition.

Diagram I-I. *The three integrated meanings of brand.*

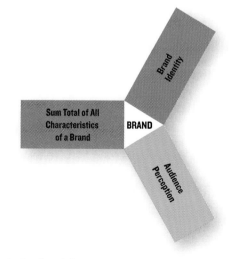

The term *brand* could be thought of as having three integrated meanings:

- The sum total of all characteristics of the product, service, or group, including its physical features, its emotional assets, and its cultural and emotional associations;
- The brand identity as applied to a single product or service, an extended family of products or services, or a group; and
- The ongoing perception by the audience (consumer or public) of the brand.

Let's break down these three integrated meanings of a brand.

All Characteristics of the Brand

Each product, service, or group has functionalities, features, or capabilities, which may or may not be unique to the product or service category. Also, each product, service, or group—due to its heritage, parent company, logo, visual identity, advertising, and audience perception—carries or assumes emotional assets. Emotional (as well as cultural) associations arise in response to the spirit of the brand identity, the emotional content or spirit of the advertising, and the

communities and celebrities who adopt the brand or support the group as part of their lives.

Hence, a brand is the sum total of all functional and emotional assets that differentiate it among the competition and distinguish it in the audience's mind.

The Brand Identity

The **brand identity** is the visual and verbal articulation of a brand, including all pertinent design applications, such as logo, business card, letterhead, or packaging. It also usually includes a tagline and web site. Brand identity can also be called corporate identity or visual identity. A brand identity is a program that *integrates* every visual and verbal element of a company's graphic design, including typography, color, imagery, and its application to print, digital media, environmental graphics, and any other conventional or unconventional media. It is a *master plan* that coordinates every aspect of graphic design material in order to attain and sustain an identifiable image and status in a multinational marketplace of brands.

Every hugely successful brand has maintained a loyal individual base due, in large part, to its clearly defined brand identity and the brand experiences it builds. Through a very carefully planned strategic brand identity that is memorable, consistent, and distinctive, companies such as The Coca-Cola Company (Figure 1-1), Sony, The Walt Disney Company, 3M, Honda, and FedEx (Figure 1-2) have been able to maintain consumer loyalty and positive consumer perception.

A consistent brand identity presents a memorable public face, such as the identity for United Airlines[SM] (Figure 1-3).

A brand identity usually consists of the following integrated components:

- Brand name
- Logo
- Letterhead
- Business card
- Packaging
- Web site
- Any other application pertinent to a particular brand

Figure I-I. *Coca-Cola is a registered trademark of The Coca-Cola Company and is used with its express written permission.*

The brand identity is applied to a single product, service, or group carrying the name brand. **Brand extension** is applied to a new product, service, or group with a different benefit or feature that is related to the existing brand (and extends the range of the existing brand); the target audience may be different.

Corporation

Express

Ground

Home Delivery

Freight

Office and Print Services

Custom Critical

Trade Networks

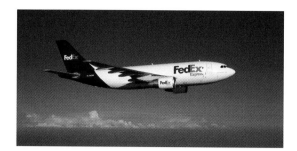

Figure I-2. *Used with express written permission from the FedEx Corporation.*

The Audience's Ongoing Perception of the Brand

The **audience** is whoever is on the receiving end of a brand experience, brand advertising, or social cause communication—whether it is a large number of people or an individual. A **target audience** is a specific group of people or consumers targeted for any brand application or experience, whether it's a brand identity, traditional or unconventional advertising, public service advertising, or entire brand experience.

The scope of an audience can be:

- Global
- International
- National
- Regional
- Local

In his autobiography *Songs My Mother Taught Me,* celebrated actor Marlon Brando wrote that he didn't ask for "power and influence"—people bestowed it upon him. Audiences decide whom they like, and it

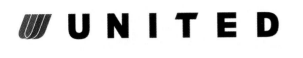

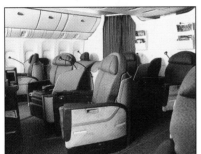

Figure I-3. *Identity program. Design firm: Pentagram, New York, NY. Client: United Airlines.*

Ambitious new identity program for the leading U.S. carrier, providing customers with a consistent experience that looks and feels "united."

— Pentagram

extends to inanimate objects, as well. Ultimately, it is the public who decides which brands are stars. It is the opinion and perception of the audience that can make or break a brand.

What people think of a brand is what counts. A brand is what it *actually* is—plus the user's perception and beliefs about the brand. An individual's perception of a brand, in most part, is based on the brand identity and the advertising, which constitutes the brand's public image and the brand promise. When an individual finds a brand identity engaging, that person is more likely to patronize the brand. For example, if you find the brand identity for United Airlines attractive or you find the advertising appealing, you're much more likely to fly United. Also, the action or response of a large audience—of a large number of people—can very well influence the response of an individual to a brand. For example, if everyone (the collective audience) in a person's "community" likes to drink bottled water, such as Evian®, it will positively influence that individual toward Evian.

There are other contributing factors to brand perception, such as the communities or celebrities who "adopt" the brand, but the **brand promise** is the functional and emotional advantage and value pledged to the user. Due to the nature of the cumulative experiences with a brand, people may perceive the brand as delivering or not delivering on its brand promise; and if they deem it to be not delivering, they will move on to another brand. The brand promise

has always been an important part of what makes a brand desirable, dating back to one of the first American brands, the National Biscuit Company's Uneeda biscuit, where the consumer was offered an "inner-seal package," promising sanitary packaging and fresh, crisp crackers.

Everything contributes to perception of a brand, and whether a popular celebrity is a brand devotee or if the advertising is entertaining goes a long way toward how we perceive it. Everything that a brand is contributes to an individual's perception of it, and perception is an extremely important branding component.

There is the actuality of a brand, and then there is the audience's perception of it. How an individual perceives a brand depends upon several factors:

• Whether a brand delivers on the brand promise
• The individual's response to the brand identity
• The bond between consumer and brand generated by the advertising, as well as the general response to the advertising
• Brand placement and positioning in films, television programs, and sports events
• Celebrity endorsers and users (paid and unsolicited)
• Testimonials
• The public image and behavior of the company or group
• Any public relations crisis, incident, or scandal involving the brand
• Each separate experience a user has with the brand

What is Branding? What is a Brand Experience?

When brands were first introduced, it was the brand name, brand promise, and logo and packaging that established the brand identity. Now, **branding** has grown to include the entire development process of creating a brand, brand name, brand identity, and, in some cases, brand advertising.

A **brand experience** is an individual audience member's experience as he or she interacts with a brand—every time he or she interacts with that brand. Every interaction a person has with a brand contributes to his or her overall perception of the brand. It is either a positive, negative, or neutral experience. In a consumer society, where we all come into contact with advertising (in print, on radio and television, and online), with visual identity applications (such as logos, packaging design, and corporate communications), and with branded environments (in stores, malls, zoos, museums, and in public spaces), each visual communication application builds our perception of a brand and is an individual experience that contributes to the overall brand experience.

A program of comprehensive, consonant, strategic, unified, integrated, and imaginative solutions for a brand, including every graphic design and advertising application for that brand, results in consonant brand experiences for the audience. Focus must be on how individuals experience the brand (of the product, service, or group) as each interacts with it. It entails understanding how to weave a common thread or voice—seeming like one voice, across all of an individual's experiences with that brand—to integrate the common language into all experiences with the brand. It includes **brand harmonization**—the coordination or harmonization of all the elements of a brand identity throughout all experiences.

Designing integrated brand experiences entails coordinating the entire branding program, from logo to advertising, with the consideration that each and every application is an experience for a consumer or individual; for example, the comprehensive brand experience including logo, advertising, web site, brochures, and promotional applications by Liska + Associates (Figure 1-4). Each experience an individual has with a brand impacts how that individual perceives the brand and its parent company. The *main goal* of the brand experience is to gain an individual's interest and trust in and loyalty to the brand.

"We don't just want people to buy a brand, we want people to buy into a brand, to make it part of their lives."
— Stan Richards, The Richards Group

Case Study from Liska + Associates

NN

NORTHWESTERN NASAL + SINUS

NN

NORTHWESTERN NASAL + SINUS

John T. McMahan, M.D., FACS
Daniel G. Carothers, M.D.

676 North Saint Clair, Suite 1575 Chicago, IL 60611
t 800.313.NOSE t 312.266.NOSE f 312.266.3680
www.nwnasalsinus.com

Figure I-4. *Logo. Design firm: Liska + Associates, Chicago, IL. Designer: Hans Krebs. Art directors: Steve Liska and Kim Fry. Client: Northwestern Nasal + Sinus.*

Letterhead and business card. Designer: Kristen Merry. Art directors: Steve Liska and Kim Fry.

Web site: www.nwnasalsinus.com. Designers: Kristen Merry and Hans Krebs. Programmers: Kristen Merry and Hans Krebs. Art directors: Steve Liska and Kim Fry. Copywriter: Ann Marie Gray. Photographer: Wayne Cable.

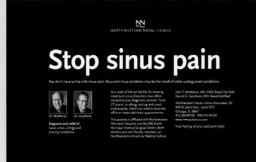

Ads. Designers: Kim Fry and Kristen Merry. Art directors:
Steve Liska and Kim Fry. Copywriter: Ann Marie Gray.

Northwestern Nasal + Sinus

Challenge

Our first project for NN+S was a series of ads marketing their specialties: treating allergies, sinus problems, and snoring. Up to that point, the well-established practice relied almost exclusively on word of mouth from current patients to promote its expertise. Because the practice has such a specific focus, it wanted to raise awareness throughout the Chicago area and become the top-of-mind specialist for treating nasal, sinus, snoring, and related conditions.

We recommended running ads in *Chicago* magazine. Each ad featured one of the ailments treated at the practice (allergies, sinus problems, and snoring), then reinforced the benefits patients would receive from expert care in the diagnosis of ongoing problems. The ads directed readers to the NN+S web site for further information.

What began as three ads led to a popular, long-running campaign that appeared in *Chicago* and a number of other local and national publications. While the campaign was running, the practice expanded its facilities.

Brand Strategy

Our challenge was to reposition the practice as a state-of-the-art, full-service specialty center. We needed to communicate this to both existing and potential patients, as well as to other doctors who refer patients to specialists

Case Study from Liska + Associates
continued

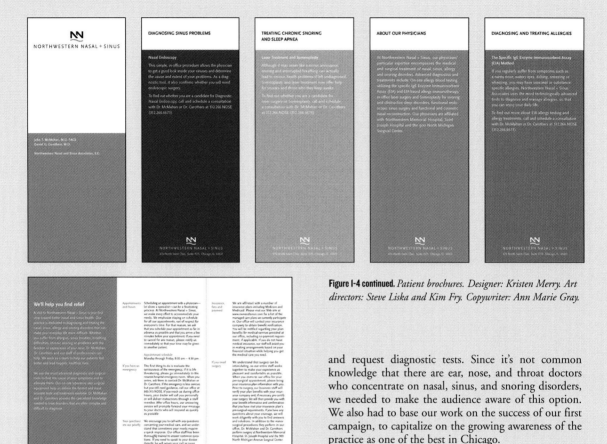

Figure I-4 continued. *Patient brochures. Designer: Kristen Merry. Art directors: Steve Liska and Kim Fry. Copywriter: Ann Marie Gray.*

and request diagnostic tests. Since it's not common knowledge that there are ear, nose, and throat doctors who concentrate on nasal, sinus, and snoring disorders, we needed to make the audience aware of this option. We also had to base our work on the success of our first campaign, to capitalize on the growing awareness of the practice as one of the best in Chicago.

Audience

The audience for this brand evolution included the practice's existing patients and new patients who require specialty care. NN+S also wanted to reach other doctors to make them aware of the full capabilities of the practice. Some of these doctors might refer patients in need of a specialist, while others might send their patients to NN+S for diagnostic tests.

Our Strategy

Once NN+S transitioned into a full-service specialty center, it needed a new brand and visual identity that communicated its size and capabilities. But the shift in its brand needed to be evolutionary, so that it wouldn't alienate those who had already grown familiar with the practice through previous successful ad campaigns.

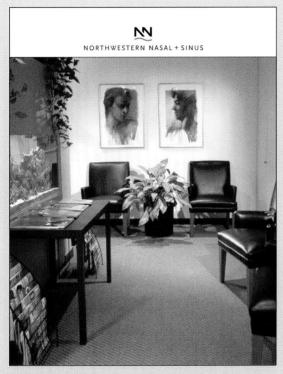

Practice brochure. Designer: Kristen Merry. Art directors: Steve Liska and Kim Fry. Copywriter: Ann Marie Gray. Photographer: Wayne Cable.

Promotional items. Designer: Kristen Merry. Art directors: Steve Liska and Kim Fry.

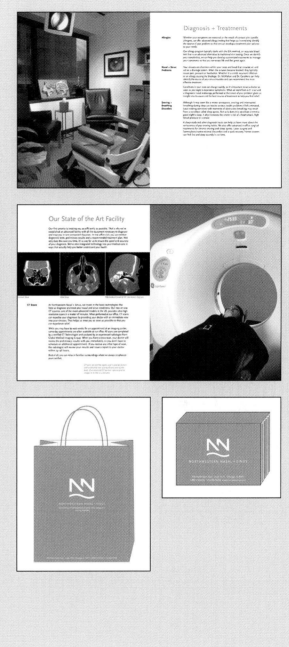

Since the initial ad campaign had already raised awareness of NN+S, we started our branding efforts by developing a new ad campaign that would inform current audiences about the changes. The new campaign retained the same visual direction as the previous ads, but it addressed the expanded on-site services through new messages. Our goal for the branding campaign was to reach new and existing patients who were unaware of the full-service offerings, while sending out messages to other doctors who were looking for reputable specialists' offices where they can refer patients in need of additional treatment.

— Liska + Associates

What are the Types of Branding?

Visual communication professionals solve different types of branding problems. These problems can be sorted into types: consumer, corporate, digital, organizations, cause-related marketing, global branding, and branded environments.

- **Consumer:** Brand applications aimed directly at consumers. Consumer product and service categories include household goods, home electronics, automobiles, automotive services, computer hardware and software, food and beverages, beer, wine and spirits, apparel, beauty aids and services, health products and services, over-the-counter and prescription medications, pet products, and sports team products, among many others.

With any trip to a supermarket, one can realize just how glutted the market is with competing brands. If a product doesn't have a relevant and strong brand experience (as shown in Figure 1-5), it is almost sure to be lost to the consumer.

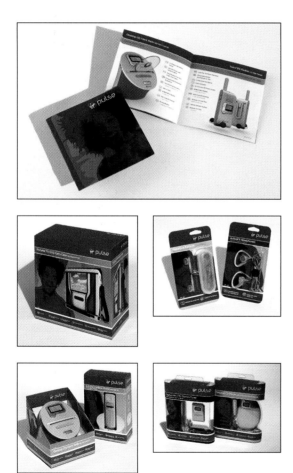

Figure I-5. *Mass market packaging. Product: a new Virgin*SM *personal electronics brand called Virgin Pulse*™*. Design firm: Design Guys, Minneapolis, MN. Client: Virgin.*

In this competitive market niche, surprisingly no one has been making a consistent brand statement. We wanted to do that, first and foremost. Next, we wanted packaging to speak very directly to the consumer in plain talk as much as possible. Personal electronics typically are sold by the technology and esoteric features. Even product names are in code. We wanted the technology to be assumed by the high quality and care of the presentation and speak directly about the attributes of the products themselves.

Just as we wanted to change the conversation away from tech terminology, we flipped the script on the packaging. The standard for mass electronics packaging is a plastic clamshell with a printed card sealed inside. While this type of package is protective and functional, it looks cheap. Our clams have an outer paper wrap. This affords extra branding space and allows the opportunity to create multiple gloss and dull textures, as opposed to the shiny plastic clamshell. In addition, we designed the Virgin Pulse packaging strategy to harmonize with the form factors of the products themselves, creating a continuity of brand.

The language that is used on the packaging is the beginning of a conversation that continues through the quick start instructions, manual, and style guide and is written in a distinctive, personal, and witty voice throughout. All the internal paper enclosures are carefully concealed by being wrapped in a white folder that hides them from view and presents them in the correct sequence. Icons give visual cues to the features and benefits to simplify and clarify each point.

— Design Guys

• **Corporate:** Branding created for corporations or corporate groups, rather than for products and services. Brand identities and experiences are created for new companies, company mergers, and companies that go through name changes or want to be revitalized.

When companies or nonprofit groups (organizations, issues, causes) merge, often the old visual identities of both entities are discarded in favor of a new one to reflect the merger. To stay relevant in the marketplace, corporations revitalize or redefine their identities.

Certainly, the identity must be appropriate for the new entity, convey the brand spirit, and differentiate it; for example, Sibley Peteet Design's "straightforward and conservative logotype" for The 401(k) Company (Figure 1-6).

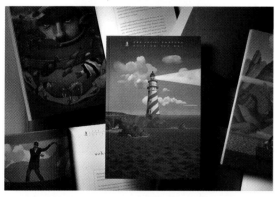

Figure I-6. *Identity: The 401(k) Company. Design studio: Sibley Peteet Design, Austin, TX. Art director: Rex Peteet. Designers: Rex Peteet, Carrie Eko, and Kristianne Kossler. Illustrators: Rex Peteet and Wilson McClain.*

The 401(k) Company is a full-service retirement plan company—hence its name. We created a comprehensive identity for them, beginning with a straightforward and conservative logotype. We extended the ID into a corporate paper system and modular presentation pieces that introduced the first in a series of character icons (e.g., Sower, Mariner), underscoring "self-reliance"—a message that is of utmost importance to the CEO. Other applications include their "Request For Proposal" binder and monarch stationery system. We extended the brand look into a comprehensive collateral system and trade advertising campaign, as well as a "self-reliant" positioning that has successfully served them for over five years.

— Sibley Peteet Design

- **Digital: Digital branding** utilizes digital media—that is, on-screen—to form, launch, and strengthen relationships between a brand and the users. It is web-based and also can include any digital or on-screen format for CD-ROMs, kiosks and other electronic exhibit systems, interactive posters, intranets, extranets, rich-media banners, and software interfaces for mobile devices and networked appliances. Almost every major brand employs web sites, either corporate, brochure-ware, and/or specialty web sites (Chapter 8 will discuss specialty web sites in more detail). Digital branding should be in harmony with all other brand applications; for example, the branding for Enlace™ by Ideograma (Figure 1-7).
- **Organizations:** Branding and advertising for organizations, both national and international, can include medical research, humanitarian, social or environmental issues, political, and nonprofit organizations—anything that is in the public interest; for example, the identity for "Move Our Money^SM" (Figure 1-8).
- **Cause-related marketing and advertising:** Funding for nonprofit organizations can be sponsored by brands and corporations; for example, Ford Motor Company raising funds for breast cancer research through the sale of Lilly Pulitzer® silk scarves.
- **Global:** Branding can also be designed for an international audience. A **monolithic brand strategy** is one that presents the brand the same way in all markets. A **diversified** (or customized) **brand strategy** adjusts and tailors the brand experience for cultural differences among its various global target audiences.
- **Branded environment:** A **branded environment** is a visual identity that is formulated, tailored, constructed, and applied to a three-dimensional physical space for a variety of environments and for a variety of purposes, including to educate, entertain, endear, inspire, or promote. Applications include retail design, sign and wayfinding systems,

Figure 1-7. *Branding. Design firm: Ideograma, Mexico. Client: Enlace.*

Digital branding is crucial, and web sites serve a variety of functions for different clients; however, all functions must be consonant with all other brand applications, in terms of voice, graphics, tone, and brand personality. Ideograma ensured integrated communications in all the applications—logo, corporate folder, web page, and reception area environmental graphic—for Enlace.

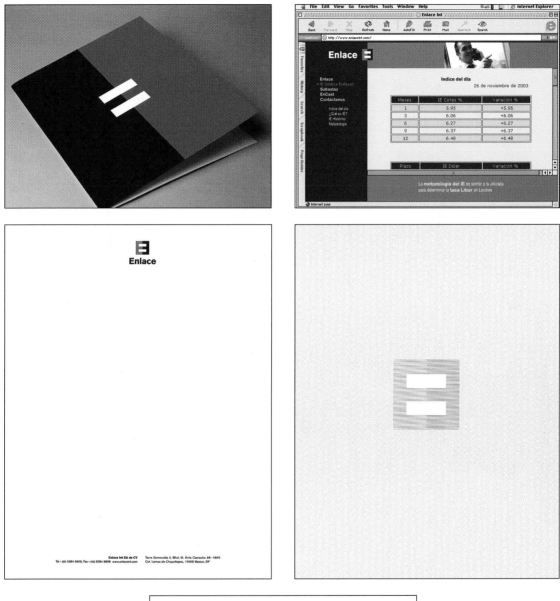

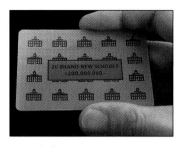

Figure I-8. *Identity: "Move Our Money." Design firm: Sagmeister Inc., New York, NY. Art director: Stefan Sagmeister. Designers: Stefan Sagmeister and Hjalti Karlsson. Client: Business Leaders for Sensible Priorities.*

"Move Our Money" is an initiative by Ben Cohen of Ben & Jerry's ice cream fame. He assembled a group of two hundred business leaders, CEOs, and military advisers with the goal to cut 15 percent of the Pentagon budget and move it over to education and health care. Instead of a formal logo, we designed extremely simplified charts illustrating the currently out-of-bounds military budget.

Some of these charts are designed as huge inflatable sculptures as part of a traveling road show featuring the Move Our Money mobile.

— Sagmeister Inc.

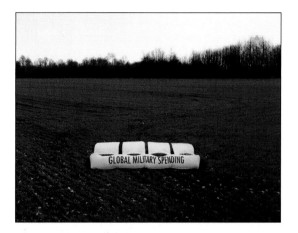

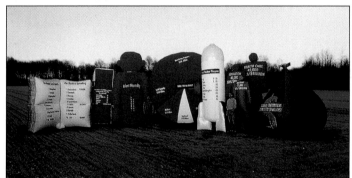

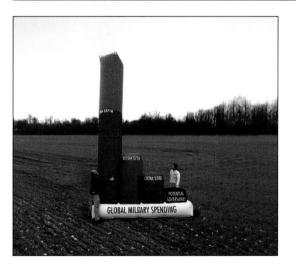

exhibit design, arts or museum design, themed environments, sports arenas, parks, zoos, aircraft environments, and corporate environments. Since an individual's experience in a three-dimensional environment is, on a critical level, visceral and sensory, a branded environment can play a key role in determining an audience member's brand perception (Figure 1-9).

Figure I-9. *Identity. Design firm: Doyle Partners, New York, NY. Client: Barnes & Noble.*

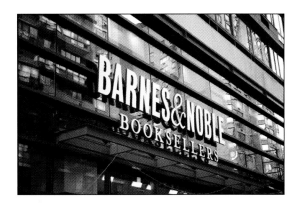

An identity and an environment that would take them into the future: this was the design brief for redesigning the world's largest bookstore. Their old logo had become indecipherable, stretched, redrawn, and made bolder by just about every vendor who got their hands on it. The new logotype needed to be bold and modern, and easy to read from a highway, while retaining its "bookseller" heritage. Our new logo accomplishes this by marrying its bold face with a traditional, lyrical ampersand. The intentional use of an old-fashioned ampersand imparts a familiarity and subtly underscores tradition.

Store interiors were part of this all-over branding program, with signage, wallpaper, floor covering, furniture, posters, and promotion filling out this system. Steel and frosted glass signage, lit from within, gives a simple and authoritative tone to the new stores, while wallpaper designed with the signature ampersand gives a feeling of warmth—a sense of home. The in-store experience continues the dialog between classic and modern.

Another aspect of this dialog comes to life with color: a sophisticated green is used on the modern typeface, while a distinctly modern orange is used for the classic ampersand. The result is a vibrant and vital signature that is appropriate to their brand positioning. The graphic language for the store has grown out of the logo itself, and the type begins to act like shelves full of books, overflowing with information—and energy.

The Barnes & Noble web site echoes the offline brand experience. To link yet distinguish this sub-brand, we worked with the same typographic family, but with lowercase letterforms, derived from the lowercase vocabulary of the Internet. This identity is also tied to its "parent" company through color. The dot-com "dot" gets the emphasis that the ampersand gets in the store. Illustrating the "dot" of dot-com, this dot conceptually connects just as the ampersand does literally. This identity, too, is elastic by allowing other concepts to inhabit the dot. Here, "dot-com" is synonymous with books, ideas, speed, ease, and even self. These expand and enrich the envelope of the brand.

— Doyle Partners

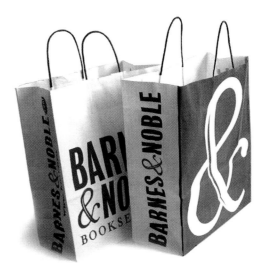

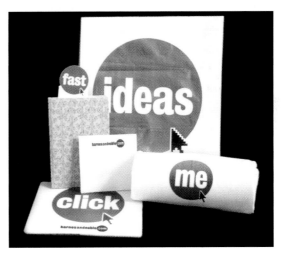

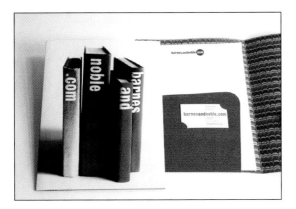

Who Creates Brand Experiences?

Sometimes one design firm creates the whole brand experience; just as often, different firms create different parts of the brand experience. A branding firm might set the brand strategy. A design firm might design the identity. A packaging firm might design the packaging. An ad agency might design the advertising, and an interactive firm might design the digital applications. Sometimes there is a lead firm that sets the strategy, and controls and shepherds the brand applications. (The lead firm is also called the firm or agency of record.) At other times, there is no lead firm, and the client's team is in charge of ensuring brand consonance across all applications.

The fact that there are many visual communication professionals who are qualified to create brand applications is part of what confuses everyone, from students to marketing executives. Creative professionals are needed to design successful brand experiences. In the mix of visual communication businesses, there are individual graphic designers, art directors, graphic design studios (small, medium, and large sized), branding firms, communications firms, interactive studios, marketing firms, and advertising agencies. Some of these professionals are capable of creating every possible visual communication application; some are not.

Often, a client will employ different visual communication companies—a design studio, an advertising agency, an interactive agency—employing all of these professionals to create work for a brand. At times, there is a lead branding firm, design studio, or ad agency that sets the strategy. Other times, all the different professionals work together from the ground floor up (which, unfortunately, is the least likely scenario). Professor John McVicker, Advertising Design & Graphic Arts Department, New York City College of Technology, advises that "Most often, a client will go to each type of visual communication professional for their specialty, which can invite branding chaos."

Branding is a focused business for graphic design studios or companies that specialize in various creative functions—brand strategy, branding programs or brand identity systems, and brand experience design—and for advertising agencies who are able to perform the same function of the graphic design specialists in addition to creating advertising. Most graphic design studios have the ability to design brand applications, and some provide brand consulting, as well as creative services. Many advertising agencies have special branding units or groups.

Brand identities are designed by **creatives**—graphic designers, interactive designers, design directors, art directors, writers, creative directors—who work in branding design firms, advertising agencies, interactive studios, or graphic design studios in conjunction with the brand company's marketing professionals. Figure 1-10 shows an identity program that was created by Pentagram, a design firm.

The brand campaign for Penguin Books was created by London-based agency Mustoes (Figure 1-11). Take special note of their strategy concerning the audience for this campaign.

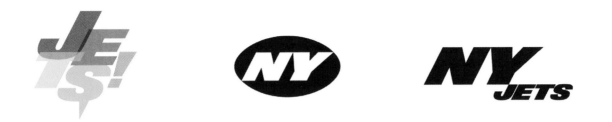

Figure 1-10. *Identity. Design firm: Pentagram, New York, NY. Client: The New York Jets.*

Pentagram designed new graphic elements and branding guidelines for the National Football League team affectionately known to fans as "Gang Green."

Case Study from Mustoes

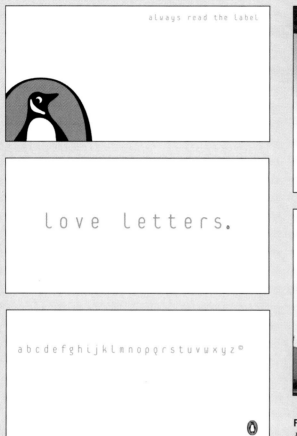

Figure 1-11. *Brand campaign. Agency: Mustoes, London, U.K. Client: Penguin Books.*

Penguin Books

What was the challenge facing the brand?

Penguin® was a brand that everyone knew and loved, but somehow it had become old-fashioned and stuffy. People associated Penguin with their school days, the classics, children's books, and orange spines. This dusty image was handicapping Penguin Books in their efforts to attract new authors.

Whose behavior did we need to affect?

Strangely enough, our primary audience were not the readers of the books (people buy authors, not publishing houses). Our key audience were, in fact, the authors themselves. Our ambition was to make Penguin Books a company that authors wanted to be associated with.

What was our insight?

By becoming a publisher that authors wanted to be associated with, we could attract new talent to the Penguin brand. Their books would in turn attract new readers and increase sales. This would (if only subconsciously) create the consumer perception that Penguin Books publishes the best books . . . which in turn would attract new authors. A perfect virtuous circle.

The obvious approach would have been to develop a trade campaign targeted at authors and agents. However, we believed that this wouldn't give Penguin the step change required. Instead, we decided to create a campaign that looked and felt like a major consumer campaign.

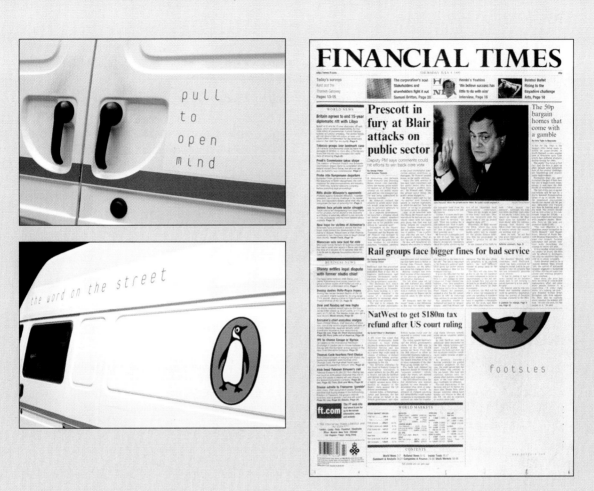

Why go to such lengths?

Because authors need good marketing by their publishers to help launch and promote them on an ongoing basis, if they are to survive. For all authors, the marketing capabilities of their publishers are an incredibly important factor in choosing which publisher to go with. By developing what appeared to be the first (and only) brand campaign by a publisher, we helped Penguin present itself as being at the very vanguard of marketing and communication in this sector.

Did we do anything in particular to arrive at this insight?

A major piece of qualitative and quantitative research amongst readers, authors, and agents.

How did we execute this strategy?

Although the most high-profile aspect of the campaign were the 96-sheet and 48-sheet posters,* the master stroke was to use the style of the advertising across all of Penguin's corporate communications and collateral materials. This included everything from trade stands, to Christmas cards, to mailers, to delivery vans. It was perhaps these materials more than any other that gave the campaign scale within the publishing community and directly connected with authors and agents alike.

— Mustoes

*This is outdoor board terminology: a 96-sheet poster is made up of twenty-four 60 x 40-inch sections joined to create a 10 x 40-foot sheet; a 48-sheet poster is twelve 60 x 40-inch sections joined to create a 10 x 20-foot sheet.

The Brand Team

The brand company's marketing directors can contribute enormously to the creative process; successful marketing directors have vision and insight and realize the importance of creative professionals to their mission. Many advertising agency heads create integrated ideation teams that include a brand's marketing executives. There are other ways that agencies and design studios form unconventional creative teams. Some agencies see other firm members, such as account managers or media people, as also being critical to a team. Therefore, you may see the unconventional collection of designer(s), art director, copywriter, media expert, strategic expert, and, perhaps, the client comprising what is often called a **brand team**. (The brand team will be discussed further in Chapter 2.)

Certainly, it is in the best interest of the brand to have a consistent voice across all applications, to create consonance. A brand is a huge company asset—it has value and means profits. In order to maintain its brand, a company should have a brand asset management team or hire a branding specialist to:

• Shepherd the brand
• Make a company commitment (dedicated funds, research, development, creative work) to the brand
• Foster brand harmonization
• Deliver on the brand promise and provide the value indicated by the brand experience
• Coordinate marketing initiatives and create a focused effort
• Focus on distinction
• Ensure relevance
• Monitor the brand in private (as it is produced or manufactured)
• Build in **sustainability**—the ability to maintain a long, fruitful life in a dynamic marketplace (sustainability does not hold the same meaning as sustainable design, which is eco-conscious design; this will be discussed further in Chapter 10)
• Monitor the brand in public (how it is expressed in a brand identity, advertised, and perceived by the public)
• Earn standing in the marketplace or in the audience mind
• Utilize sustainable design (eco-conscious design)

A company or group, or the firm it hires, is responsible for **brand stewardship**—for shepherding the brand, for brand management. Brand stewards must be responsive to market trends, economic climates, public opinion, and every slight change in consumer behavior, and be able to anticipate trends, and reinvent or revitalize a brand accordingly.

The Functions of Branding Experts

A branding expert's goal is to best represent a company's marketing goals for its brand. Brand identity experts—whether a graphic design studio or an advertising agency—perform the following host of creative functions:

- Name a new brand—create a name that has meaning, one that is distinct, memorable, and can be legally owned for a new brand.
- Create a new branding campaign or program—create comprehensive brand experiences, from brand identity through appropriate graphic design, environmental design, digital design, and advertising applications.
- Design a brand identity—conceive and design the visual and verbal articulation of a brand.
- Conceive a name change—renovate a name, due to obsolescence, merger, or new benefits of a brand.
- Reinvent or revitalize a brand identity—completely renovate a brand, starting with the strategy and repositioning, and going from logo through to the brand identity.
- Relaunch a brand—rethink the geographic or demographic market, and then reposition, reconceive, and redesign accordingly.
- Revitalize a brand—reposition and reenergize a brand through visual and verbal applications; clarify the brand.
- Rebrand for a new geographic market or demographic—rethink strategy and the visual/verbal articulation of a brand for a different audience and/or culture.
- Brand harmonization—bring together all visual and verbal elements of brand identity, and possibly across brand extensions and/or geographic markets.
- Create an integrated system, that is, brand architecture—analyze the company's brands and their interdependencies, and then structure how all their values can be maximized at every level of the company and throughout the strategic positioning of the brand; ensure consonance across applications for the brand.
- Lead an identity change for a merger—conceive and create a new identity based on the value and assets of two existing companies, one that will retain the best equity of both companies; determine whether an entirely new logo/name is needed or which logo/name has more brand equity.
- Understand and utilize trends and developments, and anticipate trends and developments—be adept at information-gathering and using research to benefit visual and verbal brand applications.
- Design additional applications as needed—determine and design applications and determine media to best serve the brand.

Chapter 2

The Branding Process

Rather than approaching individual applications as isolated brand solutions, it is imperative to see every application—a comprehensive brand identity, every appropriate graphic design application, and an advertising campaign, including traditional and new media—as a contributor to the entire brand experience.

Mires established Invitrogen™ as one of the industry's most cohesive, powerful, and widely recognized brands—shaping virtually every point of contact between the company and the marketplace (Figure 2-1). Following competitive research, company interviews, and a review of Invitrogen's existing communications and nomenclature, a master brand strategy for the company was developed. Mires defined the brand's personality, positioning, and promise and provided top-level guidelines for integrating acquired brands. This strategy applied to everything from identity, packaging, and advertising to audio branding for the company's call management system.

In a marketplace overcrowded with goods and services, a relevant and engaging brand experience can make or break a brand. "Branding, in effect, helps answer the customer question: Why should I do business with you? From the moment a customer reads your brochure, walks into your store, looks at your web site, or holds your product, he or she begins to form an opinion about your brand and its value. Is it reliable? Is it effective? Is it up to date? Is it innovative? Is it better than the others? Is it worth the price? In a world where customers have less and less time to consider options, branding helps them make a decision that often occurs in a split second."[1]

The branding process is a complicated one, but it can be broken down into four comprehensible stages:

1. Strategy
2. Concept
3. Applications
4. Implementation

Strategy

Brand strategy is the core tactical underpinning of branding, uniting all planning for every visual and verbal application. The **brand strategy** defines the brand's personality and promise, differentiates the brand from the competition by defining the brand's positioning, and codifies the brand essence; it is a conceptual plan providing guidelines—for both client management and creative professionals—to drive all brand applications from identity and packaging to advertising. Essentially, the brand strategy is how you are conceiving, creating, and positioning your brand in the marketplace to achieve differentiation, relevance, and resonance.

Research and Analysis

During this initial phase of the branding process, gathering information and performing research is vital. Research allows both the client and the creative team to best understand the brand. If a brand is new, then it's important to research the marketplace, the competition, the need for the brand, and the perception of the parent company among consumers, and then to define the brand. If a brand is being revitalized, then research allows the creative

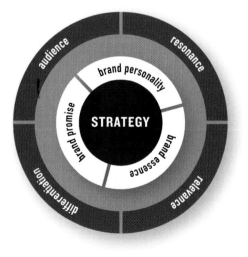

Diagram 2-1. *Brand strategy is the core tactical underpinning of branding, uniting all planning for every visual and verbal application.*

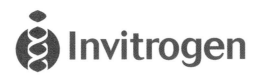

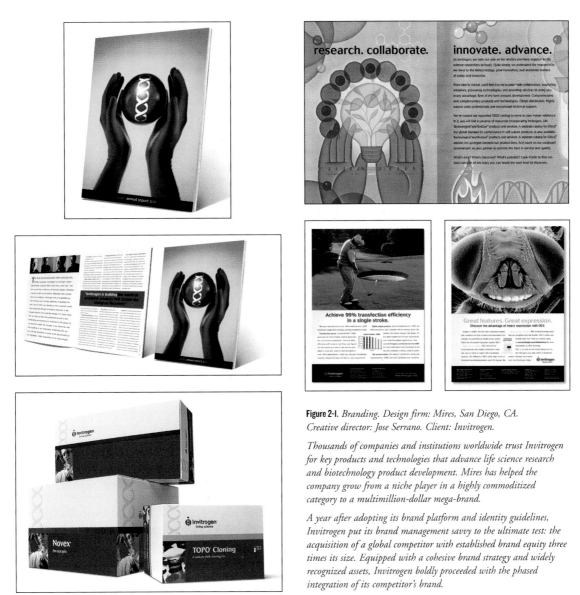

Figure 2-1. *Branding. Design firm: Mires, San Diego, CA. Creative director: Jose Serrano. Client: Invitrogen.*

Thousands of companies and institutions worldwide trust Invitrogen for key products and technologies that advance life science research and biotechnology product development. Mires has helped the company grow from a niche player in a highly commoditized category to a multimillion-dollar mega-brand.

A year after adopting its brand platform and identity guidelines, Invitrogen put its brand management savvy to the ultimate test: the acquisition of a global competitor with established brand equity three times its size. Equipped with a cohesive brand strategy and widely recognized assets, Invitrogen boldly proceeded with the phased integration of its competitor's brand.

— Mires

team to understand what needs to be changed, or redefined, in order to keep pace, or in fact, keep ahead of the marketplace. Predesign research is the most important research.

Clients value postdesign research, as well, which usually takes the form of **focus groups**, a targeted group of people (potential audience) gathered by market researchers, to "critique" the work the creative team

has created. Postdesign research can raise important red flags, especially when dealing with a global audience. For example, a pictorial logo depicting a flower sounds like a no-brainer. However, if the number of petals on the flower is an unlucky number in some countries, the logo will be problematic globally.

Focus groups are asked to criticize, and criticize they do, which can take some of the "creative life" out of designs and ads. This is where marketing executives can get nervous about innovative or highly creative work (that could potentially break through the competitive clutter), and where greatly creative work sometimes gets killed or diluted. Naturally, marketing executives who don't understand the need for differentiation—and sometimes are justly concerned for their job security—will often opt for work that is familiar or like the competition in order to play it safe. More savvy clients and designers realize that focus groups can offer guidance or be used as a point of reference. Focus groups are as whimsical and critical as any group of people gathered together to discuss anything.

After the problem has been researched and materials are collected, an in-depth analysis of the information needs to be done. Here are some discussion points:

- What is the function of the product, service, or group?
- What does this industry or group do? How does it function in the economy and marketplace?
- Do we want it to be regional, national, or global?
- Who is the competition?
- What is the company's vision?
- How can we best define the brand's essence?

Communication between the client's team and the creative team should be full and clear, especially at this point. Creative professionals need to learn how to ask penetrating questions and how to listen to clients, which will help make meetings as beneficial as possible. When the client feels that he has been heard, things tend to go more smoothly. Equally, when the client has been heard and understood by the creative team, the creative team will have a better understanding of the goals and the problem that needs to be solved. That doesn't mean that the creative team

should design the client's ideas. It means that no one knows the brand in question better than the client, and the client team possesses critical information that the creative team needs in order to pursue a sound strategy. Also, the client team probably knows the audience fairly well, and their insights into audience perception, needs, and fancies can contribute greatly to the creative team's understanding.

Paul Allen, owner of the Portland Trail Blazers®, wanted to upgrade the identity of his Portland-based NBA team, and selected Sandstrom Design for this important and high-visibility project. Sandstrom began with an informal but very insightful meeting with Paul Allen and Bob Whitsitt, where they came to agreement on the motivation, general direction, and objectives of the new identity. Over the course of a year, Sandstrom worked closely with the Portland Trail Blazers' management team, developing and refining concepts—and eventually seeking and receiving approval from Paul Allen during halftime of a game at the Rose Garden[SM] (Figure 2-2).

Brand Essence and Differentiation

In the strategy formation stage of the process, most brand teams solidify the brand essence, if it has not yet been defined. The **brand essence** is the combination of the essential points or aspects of a brand condensed into a central core conception, which is brought to life through the branding concept and the visual articulations of the concept.

Another critical goal is to **differentiate**—to establish a difference between your brand and the competition, to create a position or a niche in the market. Differentiation is particularly important for parity goods or services. There is no value in being like the others, because consumers won't be able to differentiate and will most likely buy the one they've bought before or heard of first. (More about differentiation will be discussed in Chapter 4.) For new products or services, it is necessary to understand a market niche and then carve it out for a brand. A good example is

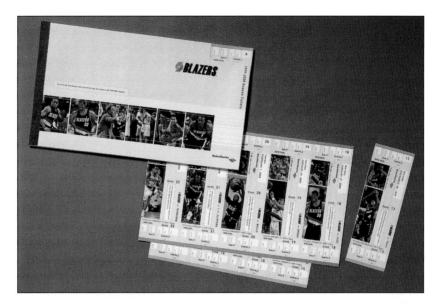

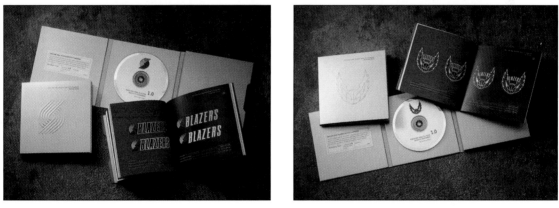

Figure 2-2. *Identity: Portland Trail Blazers. Design firm: Sandstrom Design, Portland, OR. Client: Paul Allen.*

Implementation of the new identity, upon approval by the NBA™, was complex but well coordinated. First we developed a very comprehensive set of graphic guidelines for the new identity (actually two identities, since we recommended and got approval on a secondary mark as well). Then we applied the new system to uniforms, court graphics, stationery, marketing materials, web site, broadcast graphics, and signage within the Rose Garden and throughout the Rose Quarter SM.

Although fan response is hard to measure, the new identity was received positively and provided the team with a more contemporary and sophisticated identity. Merchandise sales are climbing, and all materials are finally coordinated and consistent.

— Sandstrom Design

the PowerBar™, an energy bar. Brian Maxwell and Jennifer Biddulph encouraged athletes to embrace and promote their PowerBar brand; they also asked athletic retail stores to display the PowerBar products on their counters. Combined with their own great efforts and fully understanding the power of buzz and their audience, the results were terrific for their brand.[2]

Know your brand. It's as important to know a brand's true assets, strengths, and weaknesses, as it is to know your own in the workplace. There are so many brands available that, in reality, no brand is irreplaceable—as much as companies would love for people to think that of their brand. If a brand has weak points or limitations, that doesn't necessarily spell disappointment

in the marketplace; it means that the creative team needs to know how to openly manage the facts about the brand. The public can't be deceived, nor should they be. Ethical practice is crucial. A brand doesn't even have to be superior—it just has to be relevant and captivating. Defining a related, charismatic "voice" is the goal.

Develop Brand Architecture

In order to be successful, a brand must be understood in relation to the parent company and the company's entire portfolio of brands. **Brand architecture** is the analysis of the company's brands and their interdependencies, including structuring how all their values can be maximized at every level of the company and throughout the strategic positioning of the brand. The goal of brand architecture is the most advantageous relationship of the brand to the company, the brand to other company brands and sub-brands, and the brand to the public.

At this point, it is vital to write a **positioning statement**, also called a strategy statement, which is a succinct written statement delineating the strategic concept, and demarcating the vital characteristics of the brand and the marketplace. In a nutshell, the positioning statement defines the strategic plan: what the brand is, what it stands for, and where it wants to be. This provides the springboard for designers, art directors, and writers. Instead of—or in conjunction with—a strategy statement, some creative professionals employ a creative brief.

The Creative Brief

Essentially, a **creative brief** is a strategic plan—a type of map—that both the client and design firm, or advertising agency, agree upon and from which the creative team works as a strategic springboard; it is also called a **design brief** or creative work plan.

Most creative briefs are made up of questions and answers, which are used in an attempt to fully understand the brand, the objectives of the branding, the branding context, and the audience. And finally, the creative brief becomes the strategic plan for implementing the objectives. It is a verbal standard against which creative solutions can be measured. Both the client and the creative professionals can go back to the brief to support their concepts and/or solutions.

The answers to the questions are usually based on pre-design research, plus information gathered about the brand, audience, and budget. Most often, a brief is written collaboratively between client and design firm or ad agency. The creative brief can be initiated by the client's marketing team, or by the design firm or ad agency's account team or creative director—and may include input from the creative team, strategic planners, research or media department in the design firm or agency, or any related media unit. Everyone on the

STRATEGY CHECKLIST
- What is the brand's particular value, voice, and spirit/personality?
- Define the brand essence.
- How can we be both honest and appealing?
- How will we position the brand in the marketplace?
- Define the brand promise.
- How is the competition positioned?
- What do we want in the future?
- How can we differentiate our brand?
- How can we account for change?
- How can we anticipate trends?

Staying with social trends is important; foreseeing or being ahead of the curve or setting trends is invaluable. Often, a very large group of people will buy into something, someone, or a brand as a whole, at the same time. A good example is the current popularity of teeth whitening among baby boomers. Trend analysis, reading an audience's collective mind and mood, and basic understanding of human nature can assist a company in predicting what people are apt to embrace next.

brand team, both marketing and creative professionals, should know the brand intimately.

A thoughtful, clear brief can foster focused, critical thinking and lead to creative concept formulation.

Sample Creative Brief #1

- What is the project title?
- What is the challenge?
- Who comprises the key audience?
- What is our understanding?
- How did we arrive at this realization?
- What is the brand essence?
- What is our strategy?
- What should our execution be?

Sample Creative Brief #2

- Project title
- Goal
- Brand strategy
- Brand essence
- Audience
- Our plan

Sample Creative Brief in Detail

- What is our branding project title?
 The project could be anything from the design of any part of a brand experience to the design of a complete brand experience. It could be for a new brand, an established brand, or a brand merger.
- Why are we creating branding experiences?
 This is a short, succinct statement of your objective, plus a short summary of the background and marketplace comparison. Questions to answer might include: What effect do we want to have on people? Do we want to sell or launch a brand? Is our aim to motivate, inform, or persuade people?
- Who is our brand aimed at?
 Define your audience; this can be wide scope, a specific demographic, or psychographic of the population. Determine the type of person and age group: adults, seniors, children, teens, males, or females.

Determine users of the brand: heavy, infrequent, or nonusers. Determine education level, lifestyle, and income.

- What does the audience currently think about this brand?
 The answer should be a short statement that reflects the current opinion of this particular brand, if it is an established one. If it is a new brand, this should reflect current thinking about the product, service, or group type.
- What would we like the audience to think about this brand? How will this be communicated?
 This section contains the hard facts and information to be used and considered by the creative team in their development of creative work. The brand essence should be codified here. Usually, it ranks the facts and information by importance to further focus the creative development. "It's great for critique of the creative work, as well, by asking if the creative solutions address the real issues that need to be communicated so as to influence the audience," advises Richard Palatini, senior vice-president and associate creative director of Gianettino & Meredith Advertising.
- Why should the audience believe us?
 These are your supports—that is, the functional and/or emotional benefits of the brand—the reasons to believe any part of the brand experience, from advertising tagline to packaging. This follows up on "what we would like the audience to think."
- What do we want the audience to do?
 This is the action we'd like the audience to take.
- What is the one critical message we can convey?
 This should define the brand spirit and visual/verbal communication. This is usually written as the single most important notion to convey. What do we want the audience to remember, to take away with them?
- How should we execute this brand strategy?
 An outline of the message that should be conveyed, to whom, and with what tone—this provides the guiding principles for designers, art directors, and copywriters who are assigned to develop the brand experiences and visual style. Within the context of

that assignment, any design for the brand—that is then created—should conform to that strategy. The written statement of creative strategy is sometimes called a "copy platform." Again, the brand strategy is how you are conceiving, creating, and positioning your brand in the marketplace to achieve differentiation, relevance, and resonance.

- What are our creative guidelines?
 Creative guidelines can include which visuals must be included, the tone, tagline, sign-off, main copy messaging, features, rules or regulations, promotions, values, expiration dates, 800 numbers, web site addresses, and games, as well as the timing, media, and budget.

Sample Design Brief

Design briefs may take a different form from creative briefs, emphasizing the application.

- Project title
- Product information
- Market information
- Communication objectives
- Format and size
- Media
- Constraints
- Deadlines
- Budget
- Approval process

Concept

This is the most difficult phase: generating the gripping concept that will resonate, engage, and endear a brand to people. The core brand concept must be flexible and broad enough to be the foundation—the rock—of the whole branding plan, and to work across all brand applications, yet not become diluted, antiseptic, common, or so broad that it doesn't possess specificity and interest. The concept is the critical and creative thinking underpinning all design applications; it is also the stable rock plus the thread that connects the thinking throughout all the brand applications.

A **concept**, also called an idea in advertising, is the unique thinking behind a brand, setting its visual style and (often) uniting its visual identity and applications. A core concept usually communicates the strategy (creative brief), brand spirit, or style; it can also create or highlight an emotional or a functional benefit that distinguishes a brand, endears it to the audience, and motivates the viewer to run out and buy the product, use the service, or act on behalf of a social cause, issue, or group. (Please note that some professionals might define a core concept that powers an entire branding program differently from a concept for a single application where there is no cohesive branding program.)

- The concept is the foundation of the visual style of all branding.
- The concept powers an individual application.
- The concept should be expressed through the visual style and design of an application.

Applications

Now it is time to determine the practical visual and verbal applications that will best represent a brand to the audience, and choose the media that will be the most advantageous carriers of the content (with the most contact and impact for the money). The strategy and concept are now expressed in actual applications.

Identify the specific applications—name, logo, tagline, letterhead, packaging, corporate literature, retail environment, interior and exterior design, signage, banners, web sites, promotional design, and advertising media—that are appropriate carriers of the content for the brand. Identify the media that will be most focused and powerful in carrying the brand message to the public and in influencing brand perceptions. Choices of media include print, digital media, broadcast television and radio, direct mail, unconventional promotional design and advertising, and supports.

Every point of positive experience that an audience has with a brand goes toward building up the brand in the audience's mind, such as:

- Brand identity
- Television
- Tagline
- Print ads
- Web sites
- Web banners and floater ads
- Annual reports
- Radio
- Outdoor boards
- Viral marketing
- Unconventional advertising
- Direct marketing
- Branded environments
- Public relations
- Intranet
- Sponsorships
- Telemarketing
- Training manuals
- Promotions
- Sales force
- Publicity
- Buzz (word of mouth)
- Signage
- E-mails
- Ephemera
- Events or happenings

Diagram 2-2. *Every point of positive experience that an audience has with a brand goes toward building up the brand in the audience's mind.*

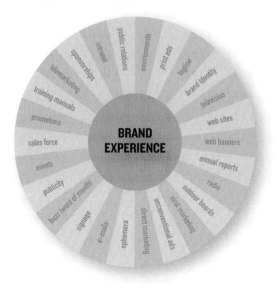

Implementation

Final designs are now created and utilized. Depending upon the creative provider—a branding firm, graphic design firm, advertising agency, marketing agency, unconventional marketing agency, interactive agency, or partners thereof—the team will specify how the brand applications should be utilized and plan the launch of the new brand, revitalized brand, or brand merger into the marketplace or public.

Creative professionals also provide guidelines and specifications, as well as support for the installation of environmental branding.

Denise Anderson, director of Marketing Services for Pershing, Jersey City, New Jersey, developed the "Five Ps" model for implementation.

1. Prioritize
 - Implement the most needed items first. For example: identity including logo, stationery, business cards, and brochure would be the most essential items for a start-up company.
2. Pictures
 - Determine the source of the images for your concept/program.
 - Ascertain what will be the best source of imagery, based on budget and concept. For example: the client can provide images; or you can purchase stock photography or illustration from stock houses; or you can hire an illustrator or photographer for custom images.
3. Production
 - Determine the most appropriate programs for use to most efficiently implement the program.
 - a. For example: it is easier to create mechanicals for an 8-page brochure in a page layout program (such as QuarkXPress℠ or Adobe® InDesign®) instead of in a drawing program (such as Adobe Illustrator®).

> **IMPLEMENTATION**
> - Prioritize applications to be produced
> - Acquire images
> - Produce digital files in the most efficient way
> - Have client proof and approve comps
> - Complete final comps and have approved
> - Hire best provider: printer or interactive programmer/studio
> - On-press guardianship
> - Create and deliver standards for design guidelines and specifications to client
> - Realization: launch into the marketplace or public arena
> - Make recommendations for the future

b. It is part of a designer's responsibility to know how to best utilize the most current tools and processes, manage digital files, and produce quality end products.

- Determine how your clients will proof the projects.
 a. Determine the most manageable and cost-effective way for a client to proof and approve successive stages of each component of the branding.
 b. Ascertain if the client can handle proofing PDFs (which are very cost-effective and worth teaching the client how to do), or if the client needs to proof full-color mock-ups (which is time consuming and expensive each time the client makes a change).

4. Printing and programming
- Once the mechanicals for your branding project are complete, you need to select a printer (for print materials) or a programmer or interactive provider/studio (for web sites, interactive CDs, etc.).
- Make sure the print or programming/interactive provider is knowledgeable in and highly skilled at their craft. If not, they will diminish the value of the concept and brand image.

- Being present to supervise press runs and new media programming allows creative professionals to have control over the final look of the applications. Design changes may still be occurring during programming or on-press, such as the tweak of a color or the possible addition of a varnish. During this stage, art direction is key in judging which printing or programming technique can be applied to enhance the style, execution, or concept of the applications.

5. Protect
- Once final production of the applications has been implemented, the creative team should be the guardian of the branding. Providing design and branding guidelines and specifications allows the creative team to aid the client in maintaining the guardianship of the branding's value after realization. Providing a standards manual is critical to protecting the integrity of the brand identity and the value of the brand.

The romance of designing a brand identity is in the designing. The less romantic part, but a very essential part, is determining the priority order of producing various applications, acquiring images, production management (managing digital files and having clients proof work), having applications printed or produced online by experts, and finally, protecting your design through shepherding the brand identity. Overseeing the implementation process, in this manner, will safeguard your design and ensure success.

The following case study by Liska + Associates for RAM clearly defines the strategic objectives of the branding (Figure 2-3).

Notes

[1] Hayes Roth, "Wielding a Brand Name," *Landor.com,* 19 October 2001, *<http://www.Landor.com>.*

[2] Jon Gertner, "The Power of the PowerBar," *The New York Times Magazine,* Sunday, 26 December 2004, p. 16.

Case Study from Liska + Associates

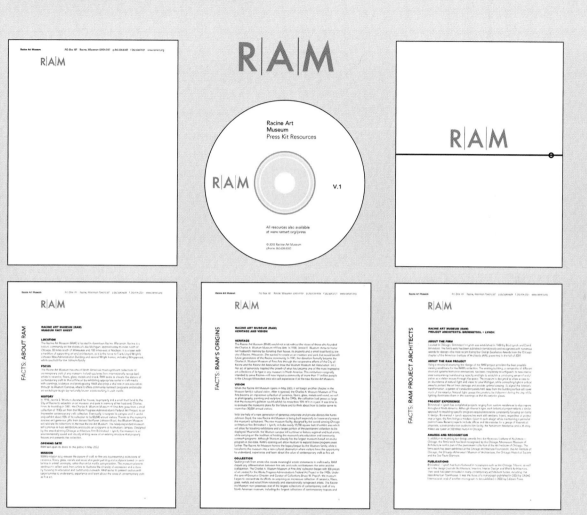

Figure 2-3. *Brand: Racine Art Museum (RAM). Design firm: Liska + Associates, Chicago, IL.*

Logo. Designer: Hika Gupta. Art director: Steve Liska.

Interactive press kit. Designers: Tim Messman and Paul Wong. Programmer: Tim Messman. Art director: Steve Liska. Copywriter: Ann Marie Gray.

About the RAM Brand

Racine Art Museum (RAM) is home to one of the nation's most impressive contemporary craft collections from internationally recognized artists. Based in Racine, Wisconsin, RAM grew from the Charles A. Wustum Museum of Fine Arts, a 60-year-old gallery and community art center located on the former Wustum family estate. Over the years, the Charles A. Wustum Museum of Fine Arts evolved from a small collection of WPA-era art into an impressive contemporary craft collection. The collection continued to outgrow the Wustum campus until only about 10 percent of it could be exhibited in one year.

Case Study from Liska + Associates

continued

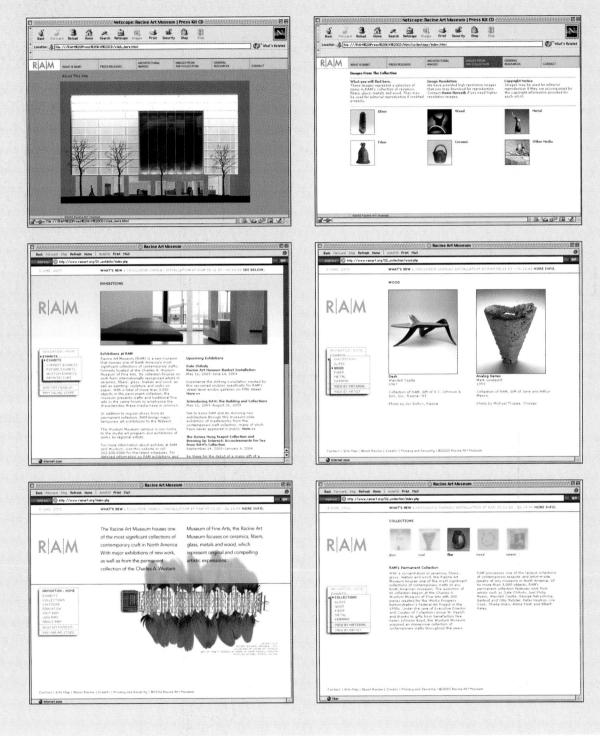

Figure 2-3 continued. *Web site (opposite page):* www.ramart.org. *Designer: Tim Messman. Programmer: Tim Messman. Art director: Steve Liska. Copywriter: Ann Marie Gray. Photographers: Michael Tropea and Jon Bolton.*

RAM opening exhibition catalogue. Introducing RAM: The Building and Collections. *Designer: Hika Gupta. Art director: Deborah Schneider. Copywriter: Terry Ann Neff. Photographers: Michael Tropea (objects), Chris Barrett (building), Grubman Photography (covers), Steve Liska, Skip Simonsen, Jan Cook, Doug Van De Zande, and Jon Bolton.*

When RAM planned a move to a space designed especially to complement its permanent collection, Liska worked with RAM's architects, Brininstool + Lynch, and curators to promote the museum and position it as a world-class destination. We developed a brand strategy to attract art lovers of all kinds to experience RAM's collection and distinctive architecture.

Since a museum's brand is reinforced in the experience it offers visitors, our challenge was to develop a complete, experiential brand based on RAM's architecture, collection, and heritage. The brand had to communicate what it would be like to visit the museum and why it's worthwhile, in order to attract a constant flow of new visitors and to inspire them to return to RAM for new exhibitions and events.

Case Study from Liska + Associates

continued

Figure 2-3 continued. *RAM gift shop materials. Designer: Hika Gupta. Art director: Steve Liska.*

The objectives for the RAM brand were to:

- Make RAM a destination for local, national, and eventually international visitors
- Attract visitors and then get them to come back again for new exhibitions
- Raise money and influence donors and sponsors
- Expand and evolve the collection through donations from artists and art owners

— Liska + Associates

PART II • Concepts

Chapter 3

Formulating Relevant Branding Concepts

"It took millions of years for man's instincts to develop.
It will take millions more for them to even vary.
It is fashionable to talk about changing man.
A communication must be concerned with unchanging
man, with his obsessive drive to survive, to be admired,
to succeed, to love, to take care of his own." — Bill Bernbach

Most branding experts offer multiple laws about conceiving and creating effective branding. Unless you start out with a *relevant* brand concept—one that will resonate with an audience—those laws are meaningless. When a brand is relevant to its audience, it has a much greater chance of success and reverberation. In the past, brands were established—given a name, a voice, an identity—and all of that was supposed to endear a brand for decades. No more. Brands must be constantly rethought in order to stay salient. The world we live in is dynamic—extremely dynamic. Most audiences are savvy; some are jaded. (Some say there are few brand loyalists any more.) Most of all, many audiences are fickle.

Furthermore, a brand concept must aim at and connect with the right audience, as shown in the campaign for the BC Lions® (Figure 3-1).

Branding is, certainly, about the product, service, group, or cause itself; it is also *about the audience,* its users and potential users. Research and information gathering needs to be conducted to determine:

• What do brand users think?
• What is relevant to the audience?
• What do you want them to think about your brand?

And this type of information gathering must be ongoing, with an eye toward frequent brand reenergizing, to keep a brand thriving.

Know Your Audience

People are extremely, extremely complicated. There are many famed psychologists, psychiatrists, philosophers, anthropologists, physicians, scientists, and even advertising experts, such as legendary Bill Bernbach, who have theories that offer us some insights into human behavior. There are no absolutes, yet, but we can do our best to figure out what will be relevant to a specific audience.

Relevant concepts can come from *insights* into human behavior. When you have insight into how people think, what they want/need/desire, and how they act, then you're either an astute social psychologist, a sharp social anthropologist, or a top designer or creative director. Branding and advertising professionals must have a handle on the human psyche. Creative professionals rarely have training in psychology, but, like many of us, are drawn

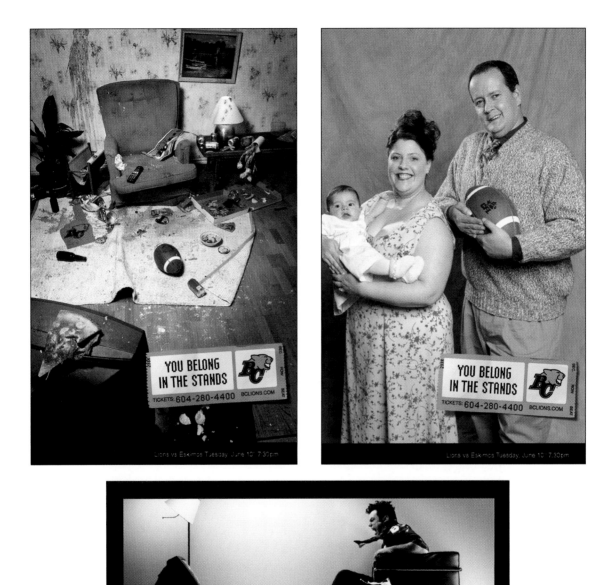

Figure 3-1. *Ad campaign. Agency: Rethink, Vancouver, British Columbia, Canada. Client: BC Lions Football Club.*

Established in 1953, the BC Lions Football Club began playing in the Canadian Football League (CFL^SM) in the summer of 1954. The CFL consists of nine member teams, all vying for the annual Grey Cup^SM title, played in November of each year. The Lions fan base has dwindled over the past decade, but a committed marketing effort is being made to revive the team's brand image and increase game attendance. A standout television, print, radio, outdoor, and restaurant/bar advertising campaign was developed for the 2003 season to reignite the passion amongst the group of 25-to-40-year-old football fans.

— Rethink

to branding and advertising for the reason that it combines design, creative thinking, and keen perception into people. It is usual practice to utilize research about the target audience. The research methods may take various forms: focus groups, information gathering, questionnaires, consumer stories, demographics, consumer panel discussions, or test groups. There are market research companies that specialize in such research. Some advertising agencies and design firms conduct research on their own; usually, account managers take on this function.

Social Psychologists' Studies

Branding, advertising, and marketing professionals often turn to social psychologists' studies on consumer behavior—how consumers make decisions about which brand to purchase, and how consumers make choices in the short term and over a long period. Studies of how consumers perceive brands and advertising are also of value to advertisers and marketing professionals. These studies are usually part of market research and taken into account in the formulation of the strategy. Other psychological factors that may come into play stem from people's cultures, groups to which they belong (from consumer groups to family groups), economic class, age, gender, and brand communities. Social anthropologists are often called upon to determine how consumers make brand decisions through the different stages of their lives.

Basically, the social psychologists are saying that "all you are" factors into your decision-making process. Your family, culture, values, friends, aspirations, basic drives, ability to process information, cognitive abilities and defenses, rituals, habits, communities, and problem-solving abilities—these all go into why you buy one brand of shampoo over another, or why you'll respond to a particular public service message.

After all, most manufactured goods are interchangeable and there are plenty of them. Why choose one brand over another? Various nonprofit organizations make pleas for money or attention; why choose to give to one over another?

After subsistence—the minimum food, shelter, air, water (and some type of human contact) needed to survive—physiologically, people don't need anything else. *Psychologically*, however, people in prosperous industrialized countries seem to need more to feel satisfied and have a sense of well-being. Probably the need to have more than the minimum to survive is an ego/narcissistic/exhibitionistic impulse. We can only speculate. Conditions and experience play the biggest role.

According to Abraham Maslow, who has been called both a humanistic psychologist and an existentialist, we have a hierarchy of needs that absolutely influence our behavior. Maslow arranged these needs into a hierarchical pyramid. At the bottom of the pyramid are the basic or physiological needs, such as air, water, food, sex, sleep, etc. As the pyramid ascends, physiological needs are followed by safety, love, and then esteem. Finally, at the pinnacle, we find self-actualization, which is defined as "the desire to become more and more what one is, to become everything that one is capable of becoming." In his book written with Stephen Fenichell, *A New Brand World: 8*

WHAT ARE WE REALLY BUYING?		
THIS	THAT	THE OTHER THING
Luxury watch	Quality	Status
Cosmetics	Enhanced appearance	Self-esteem
Insurance	Protection	Security
House paint	Durability	Less work
Financial publication	Investment advice	Being an "insider"
Mouthwash	Clean breath	Social acceptance

Principles for Achieving Brand Leadership in the 21st Century, branding expert Scott Bedbury points out the importance of Maslow's thinking to branding.

Many other insights into human behavior have been contributed by Sigmund Freud (psychoanalyst pioneer), Alfred Adler, Carl Rogers, B. F. Skinner (psychologists), Jennifer Crocker (social psychologist), Ruth Benedict (social anthropologist), Anna Freud and Jean Piaget (child psychologists), and a host of other well-respected professionals; their contributions are extremely helpful in understanding what motivates people and what people want.

Motivations

Do you need more than one pair of shoes? Do you need more than one coat? Are you lacking if you don't have more than one television? Just take a look in your closet and think about how much you have and how much you need.

We experience some type of relief when a need is fulfilled. The need may be extremely insignificant, such as needing a premoistened wipe to remove eye makeup. Or the need may be more significant, such as toothpaste with fluoride or a vehicle with four-wheel drive. Certainly, the significance of any need is subjective.

Most consumers in industrialized nations buy much more than they need. Why? We like to browse, hunt, gather, and shop. We like to keep up with our neighbors. We like to outdo our neighbors. We want status. Our children must have every toy ever made. When we're teens, we desire an acne remedy that will clear our skin; when we're aged, we seek a face cream that will recapture youth.

We gain status by what we wear, drink, and drive. For some, consuming luxury goods is an elevating experience. According to James B. Twitchell, for some, luxury consumption can be a "transcendent experience." Many want the good things in life that brands and ads offer us. Fundamentally, besides earning college and university degrees (which seem unattainable to many), the one effectively democratizing way to achieve status and move up in standing is through affluence, which can be validated by brands.

There is much trial and error to understanding this motivation, and even some of the greatest creative minds have been known to mistake the audience's current leanings. Take this remarkable case in point. In the 1980s, did people wear expensive brand athletic footwear as a fashion statement or because they liked to think they could *just go out there and do it*? Advertising critic Bob Garfield explains in "Reebok Fiasco" why the celebrated Jay Chiat's campaign for Reebok[SM] failed. In 1987, the Chiat/Day advertising agency created the "UBU" campaign for Reebok. It was a simply stunning visual and imaginative campaign, but it positioned Reebok footwear as fashion items that could enable consumers to express their individuality—unlike the Nike® "Just Do It™" athletic positioning. As it turned out, people preferred to think of themselves as athletic, even if they only wore their athletic footwear to the supermarket. The Nike brand cachet of athleticism was much more appealing.[1] On the other hand, Chiat/Day got it right with their strategy for Nike (which preceded Wieden+Kennedy's "Just Do It" campaign). During the 1984 Los Angeles Olympics, Chiat/Day's dramatic "murals" painted on buildings became contemplative objets d'art—each a no-copy homage to an athlete.[2]

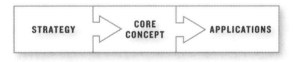

Diagram 3-1. *What links brand experiences is a unique core concept that grows from the strategy and on which applications are based.*

Finding the Concept

The concept is the central underlying, unique (proprietary) creative idea; it is the thinking behind the graphic design or advertising that *distinguishes* and *differentiates* a brand, *communicates a message* about a brand, *brands* it in the mind of the audience, and *motivates* the audience to purchase the product, try the service, or act on behalf of the social cause or in response to the social cause's message.

A concept is a formulated thought that communicates meaning and promotes action. A concept comes as a result of reflecting on the research, strategy, audience, advantages of the client's brand, intuition, feeling, and visualization. To reinvent the AMC[SM] network, design firm Trollbäck + Company turned to American film's most important component: the fans (Figure 3-2).

Concepts across Brand Experiences

A concept must be strong enough to be a foundation for all the planning and flexible enough to adjust, in a consistently engaging manner, across all applications. Each type of brand application—whether it's digital or print, conventional or unconventional—is its own animal; each application must be carefully considered for how it can best carry the brand concept and create a positive, relevant experience for the user. Each application must also be thought of as part of a whole brand experience, creating a sound that will coordinate sympathetic vibrations with all the other sounds. For Taylor Guitars® (Figure 3-3), Mires shaped the Taylor experience at nearly every point of contact for dealers, distributors, and players alike. No communication escapes notice.

What links the brand experiences? First and foremost: a unique, flexible, differentiated concept that grows from the brand essence, by using the brand voice, and how these collaborate to connect with an audience.

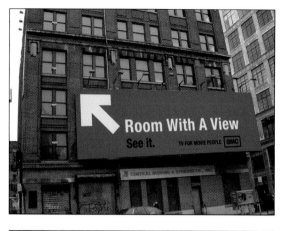

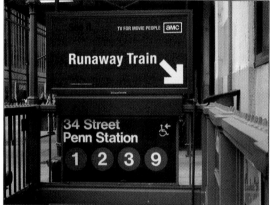

Figure 3-2. *Brand redesign. Design firm: Trollbäck + Company, New York, NY. Creative directors: Jakob Trollbäck, Joe Wright, and Nathalie De La Gorce. Designers: Greg Hahn and Tatiana Arocha. Client: AMC.*

"TV For Movie People[SM]" is the brand's new tagline, and movie people are the branding's foundation. Instead of famous actors and directors, the new look centers on real fans attempting to explain their love of favorite films in the insightful and amusing manner only cinema zealots can.

"We wanted to get to the core of what this community of American film fans love about film without being nostalgic," said Trollbäck creative director Joe Wright. "Rather than using flashy 3D graphics with layered lens flares, we decided to use people on a white background talking honestly to the camera about why they love film."

— Trollbäck + Company

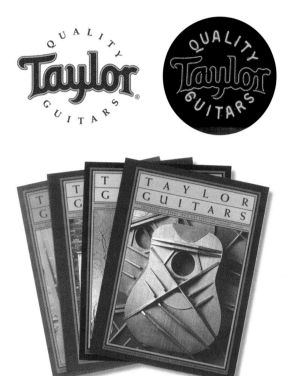

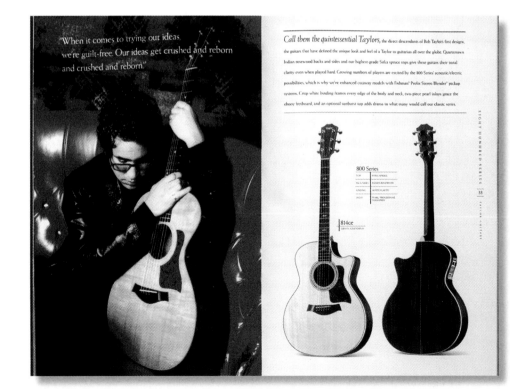

Figure 3-3. *Branding. Design firm: Mires, San Diego, CA. Creative director: Scott Mires. Client: Taylor Guitars.*

Founded in 1974, Taylor Guitars is one of the world's most respected manufacturers of acoustic guitars. For the past several years, Mires has collaborated closely with Taylor to ensure that the quality of its marketing message matches that of its guitars.

Taylor and Mires have something important in common: an intense passion for quality and attention to detail. Building on these shared values, we've established a high level of trust that allows us to evolve the brand organically as new ideas take hold.

From Taylor's web site (www.taylorguitars.com) and catalogs to direct mailers and TaylorWare® clothing, the Taylor experience extends all the way to such frequently dismissed items as price lists, pins, and warranty cards. And because we create most of Taylor's marketing communications, we're in a strong position to deliver a high level of brand consistency, combined with flexibility and innovation where it counts.

Mires has helped make Taylor's marketing materials as smart and hard-working as they are beautiful. Our work has supported the company's fourfold growth since the mid-1990s and helped establish Taylor's reputation as one of the guitar enthusiast's most sought after brands.

— Mires

Brand Essence

The brand essence—the essential points or aspects of a brand condensed into a central conception—can be the point of departure of finding concepts for individual experiences or for an entire brand experience. The central conception relies heavily on how a brand casts itself—how it sets its personality—and what the brand is saying.

Here's what we are about:

- We symbolize something (stability, good health, luxury, prosperity, etc.).
- We embody something (coolness, family values, energy, novelty, inventiveness, etc.).
- This is how much fun we are.
- This is how exciting life can be.
- We have the lifestyle you want.
- You can identify with us.
- We make you laugh.
- We help.
- We work toward solving a social problem.
- We can find a cure for a disease.

You can depend upon us because we are:

- Reliable
- Consistent
- Authentic
- Well-made
- The original
- Stylish
- Cool
- Respectable
- Fast
- Considerate
- Self-effacing
- Honest
- Ethical
- Amusing

How the brand directly affects you:

- Your appearance will improve.
- This is who you can look like.
- Your game will improve.
- Your life will be enhanced.
- You can help yourself.
- You'll save people by not allowing friends to drive drunk.
- You can help save a life.

This is what will happen to you:

- You looked like this before; this is how you'll look after.
- This is who you can look like; you'll be as beautiful as or as handsome as (fill in the celebrity of the moment).
- You'll jump like Kobe Bryant.
- You'll score like Tiger Woods.

Benefits: Starting Points for Developing Concepts

There was a witty and intelligent cartoon strip by Bill Watterson, entitled *Calvin and Hobbes*®. In the strip, Calvin is a six-year-old boy and Hobbes is a stuffed tiger. One particular *Calvin and Hobbes* cartoon strip is very enlightening for those of us interested in human behavior. Calvin answers the telephone and tells the caller that his dad is not home. The caller asks if Calvin will take a message. Calvin's response is: ". . . I don't know—what's in it for me?"

"What's in it for me?" That's the key question a consumer asks when deciding to buy a product, use a service, or support a group. What will this particular brand do for me? What exactly will I gain if I buy this brand of product? Will my contribution be used wisely if I donate to this cause? Fortunately, many people are altruistic. Although, often one's interest is self-interest, the interest about a benefit can be for a loved one. A viewer may think, "What's in it for my child? Husband? Aunt Rose? Uncle Don?"

Functional vs. Emotional Benefits

People want something from a brand. That "something" could be a functional advantage, some practical gain from using the brand; or that "something" could be an emotional gain—or it could be both. For example, Apple claims as a functional benefit of the Mac OS X Tiger™ to be the "world's most advanced operating system." The Apple brand computer also positions itself as the more "imaginative" computer choice, which is manifested in its industrial design and advertising; that is an emotional benefit of buying Apple.

In a testimonial ad for Apple's iMac™, the headline reads: "When's the last time anyone felt this way about a PC?" Various journalists from *Business Week*, the *Detroit Free Press*, and others give testimonial to how much they like the iMac. Notice the ad doesn't read: "When's the last time anyone *thought* this way about a PC?"

The advantage of a brand identity is that the public can easily grasp its essence—it's easily identifiable and it represents both tangible and intangible assets. A good deal of a brand's public image is up to the designers who are creating the brand identity and branding, and then to the advertising creatives. Without them, the brand would be lost, a "nobody" adrift in a huge marketplace; we'd never notice the brand among the competition. As Denise Anderson, design analyst, wisely says, "There is no brand experience without design."

Naturally, it's up to the company to produce a product or service that supports the brand and advertising claims. For example, it's not only the quality of the Starbucks® coffee that you expect—it's the courtesy of their "baristas," and the environmental design and ambience of their shops. Starbucks' corporate management's policies help support the advertising claims and the impact of the branding.

You want people to respond viscerally and emotionally, on a gut level. Branding and advertising that doesn't engage your emotions, that is dehumanized, cold, detached, not in touch by reaching out to people, not relevant, and not accessible will not move an audience. All brand experiences must be markedly human. A brand concept must appeal to our basic human needs and drives, and then to our intellect. Sigmund Freud's theories focused on the unconscious part of the mind. "Freud's fundamental idea is that libidinal urges such as lust and aggression battle it out for supremacy with the super ego's conscience-like agency. It is ultimately the ego's task to reconcile these opposing dynamics in the conscious and unconscious mind," says psychiatrist Dr. Michael Balogh. Freud's premise lends insight into what drives us. Whether you're a Freudian or a critic, one thing is sure: there are human drives.

When a brand experience arouses an emotional response, you are affected, stirred. They've gotten to you, touched your sensibilities, and once you feel something, you're more likely to remember the brand or be motivated to buy it. To appeal to women's sense of adventure, Strawberryfrog created the campaign for the Mitsubishi Colt™ (Figure 3-4).

Brand Trust

A brand embodies "a confidence factor." And it starts very early. I've had the unique opportunity to observe a young child's reaction to brands and bond building with brands (with the eyes of both a mother and a branding expert).

When my daughter Hayley was three, one of her favorite frozen treats went through partial brand identity revitalization; the exterior packaging was redesigned. When Hayley saw me take the package out of the freezer, she cried, "I don't want that one. I want *mine*!" For whatever strange reason or oversight, the company had chosen not to redesign the wrapping paper on the individual frozen treat, so I showed the wrapper to Hayley with the older logo, design, and colors that she remembered. She agreed to taste the frozen treat, though not without some trepidation due to the unfamiliar outside packaging.

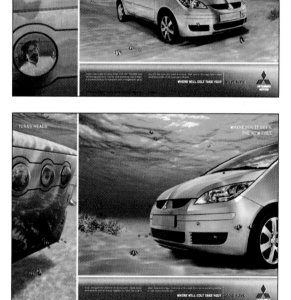

Figure 3-4. *Ad campaign. Agency: Strawberryfrog, Amsterdam. Client: Mitsubishi Colt.*

How to reach independently minded European women by taking the car category into uncharted waters:

Despite critical acclaim and an athletic design, the new Colt had to make a huge splash to compete against higher-profile brands in the European market. Our creative campaign laid down a challenge: Where will Colt take YOU?

The new Colt is the perfect command vehicle for a personal revolution, we said. The car to inspire fantastic journeys. To dramatize this, we took drivers to an environment unique within the category: underwater. To build buzz ahead of the car's launch, we created The Colt Lifestyle Rally—a contest offering incredible weekend journeys around Europe's style capitals in a convoy of Colts. To promote the rally, we designed special aquariums to display the Mitsubishi like a work of art on city streets.

— *Strawberryfrog*

At younger than the age of one, Hayley recognized logos. She now knows what a logo is, and that certain ones stand for brands that amuse her or taste good. Also, Hayley has grown to *trust* the quality that certain brands offer; she dearly loves her brands. So it's easy to see how expectations can develop based on the safety of what we know and like.

Similarly, when Jaimie Wetzel, my editor at Delmar, was shopping for her brand of margarine, she was chagrined to find that the packaging had been redesigned. Not only did Jaimie have trouble locating the package on the shelf, she also had trepidation about the product inside the new packaging. Interestingly, Jaimie pointed out that she would have been reassured by a statement on the new packaging

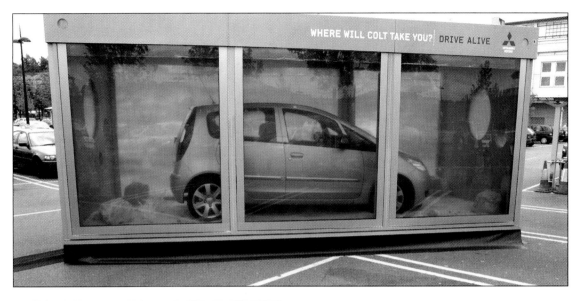

indicating that although the packaging was new, the margarine still had the same taste.

I've also observed my traditional college-age students through the eyes of a branding expert. My students have had heated debates in class about the relative merits of different pizza and cola brands. But, they, as a group, are fickle—more fickle than a young child. (Unlike days past, brand loyalty may be a shorter-lived expectation among certain demographic groups.)

Status seekers aside, when it comes to choosing one brand over another, or a brand product over a generic one, the bottom line for many people is trust. The brand must deliver the quality they expect and what they've become accustomed to expecting.

Brand Association

Why do we wear brand logos on our shirts? Caps? Purses? Why do we proudly carry designer bottled water? Why do we even *buy* designer bottled water? Why do we want to belong to the "club" of people who drive a BMW™ or who wear Tommy Hilfiger™ clothing? To the Harley-Davidson™, or Apple computer communities? To the people who greet each other with "Whassup™"?

Bonds between a brand and the consumer form for many different reasons, such as the preference for the particular nature of the brand, the advertising, the brand identity, the brand association, and the brand positioning in films and television programming.

We borrow some of a brand's panache or celebrity when we buy it or use it. We share its values, as if it were a human being capable of a value system. We want the lifestyle a brand represents. We want the good life a brand offers. We want to have fun or be cool like the people in the ads. Or we simply like the graphic impact of the brand identity.

Certainly, there are class and cultural associations that lend to brand association and "membership." If I drive a Toyota Prius™, I'm one kind of person. If I drive a GM Hummer®, I'm another kind of person. If I drive a Chevrolet Corvette™, I'm yet another kind of person. Class and cultural associations form, in part, due to celebrity endorsements and positioning of the brand in a particular television program or a film.

Of course, the brand identity and advertising engage us, some more successfully than others. Contrary to what people used to think about brand experiences or still do think, branding and advertising don't sell us what we don't want. We know what we want. We—the people—decide which brands make it. For a brand to be a winner, people have to bestow stardom upon the brand! And for us to bestow stardom upon a brand, it has to be relevant to us.

Know your audience.

Notes

[1] Bob Garfield, "Reebok Fiasco," *Adreview.com*, 29 April 2002, *<http://www.adreview.com/article.cms?articleId=888>*.

[2] Ibid.

Chapter 4

Brand Constructs: Strategic Advantages

Defining a Construct

A **brand construct** is a conceptual, strategic platform that has been systematically planned and developed for a brand. It is a point of departure for differentiating and positioning the brand. A brand construct allows a designer to generate concepts—to focus ideas and directions. Implicit in each construct must be the following markers, which are indicators for potential growth and efficacy:

1. Differentiation: no matter which branding expert you read, the one thing they all point to as necessary for success is differentiation. (It's only a shame that many clients don't follow this admonition, and instead value the presumed safety of sameness.) Differentiation means that a brand is distinguished from others; it is different or specialized by how it is *characterized* in terms of its visual and verbal identity, and each and every experience a user has with it. One could simply state that differentiation is what makes a brand different from the rest. A designer's chant should be: distinguish and separate through a unique yet consistent visual and verbal presence. (Interestingly, a brand doesn't have to be the best, just distinguished in the audience's mind. And that distinction should be perceived as an advantage.)

2. Ownership: Claude Hopkins may have been the person to originate the idea of "ownership," of owning a selling point or benefit. In 1923, he wrote a book titled *Scientific Advertising,* which explained his notion of ownership. Although conceived long ago, this principle still works—not only for individual advertising campaigns, but also for branding. Most brands are parity (equivalent) products or services. Thus, you have to "own" or claim a quality, personality, or posture that may preempt the competition, though will surely align a brand with an identifiable attribute(s). Owning a quality, even though others in your category have the same quality, establishes the brand in the audience's mind as the primary possessor of that quality.

3. Consistency: the construct must allow for flexibility in the generation of the individual ideas—whether for a brochure, web site, annual report, or ad campaign, or even the tone of copy—that hold together under the banner of the construct and are built on the foundation of the original construct. A flexible—or elastic—construct permits consistency across brand applications (with necessary variations to maintain interest), and permits a consistent **brand voice**, a consistent tone established in all verbal and visual communication.

4. Relevance: a successful brand must embody a quality that is relevant to an audience. The quality might manifest itself as a brand promise, an appealing attribute, a tangible benefit, a compelling heritage, an entertaining attitude, or even an assurance of worth. It must exemplify something—tangible or intangible—that people find compellingly relevant to their lives. If people cannot relate to what the brand or group is, there is no chance of brand resonance.

Delivering the Brand Promise

To work, any construct must be consonant with the brand promise—the functional or emotional advantage and value pledged to the user. No brand application can exist in isolation, if the brand experience is to resonate. There must be consonance among all applications, and all must deliver on the brand promise. Delivering the brand promise is paramount, as illustrated by VSA Partners, Inc. for Harley-Davidson® (Figure 4-1). As VSA Partners, Inc., comments: "For more than a decade, VSA has ensured that the Harley-Davidson brand experience is as powerful as the Harley-Davidson product experience."

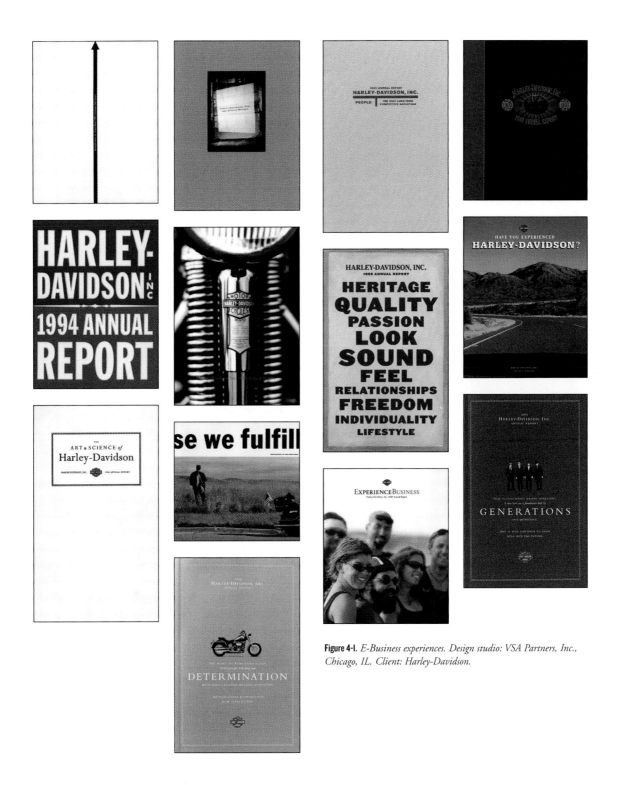

Figure 4-I. *E-Business experiences. Design studio: VSA Partners, Inc., Chicago, IL. Client: Harley-Davidson.*

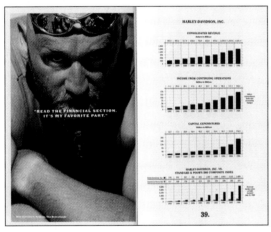

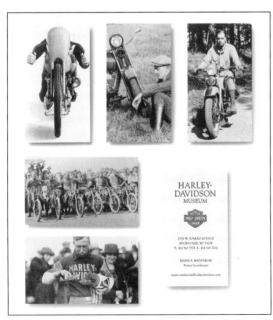

Figure 4-I continued. *E-Business experiences. Design studio: VSA Partners, Inc., Chicago, IL. Client: Harley-Davidson.*

"A Legend lives on."

As one of our longest-standing brand collaborations, our work with Harley involves practically every touch point between the company and its vast audience: motorcycle marketing, catalog merchandising, online (Internet and intranet) communications, investor relations, dealer advertising, licensing development, retail store design, and environmental design for the new Harley-Davidson museum.

VSA brought Harley-Davidson to the Web in 1995 and has been a strategic technology and design partner ever since. From the first glimmer of Harley-Davidson's consumer Web presence (harley-davidson.com), to the interface and content partnering involved in its dealer intranet and e-commerce sites, VSA has evolved Harley's online presence to encourage interaction and deliver experiences that are true to the company's heritage. While these initiatives have earned recognition for our work, a more enduring measure of our contributions is the ongoing value and relevance of Harley-Davidson. To be that kind of business asset, VSA has identified new inroads for the brand, including Rider's Edge, an effort to expand on Harley-Davidson's older core market. Through existing dealerships, Rider's Edge offers classes that teach younger nonriders the basics of motorcycling and introduces them to the brotherhood of Harley.

—VSA Partners, Inc.

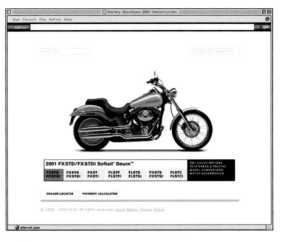

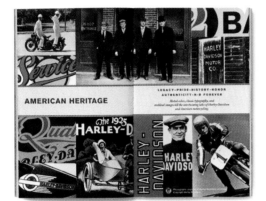

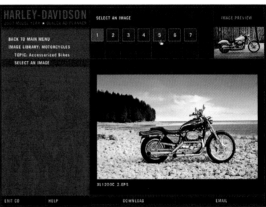

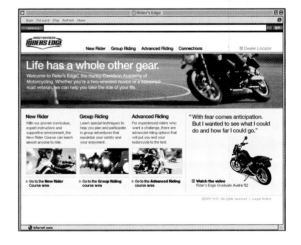

Figure 4-1 continued. *E-Business experiences. Design studio: VSA Partners, Inc., Chicago, IL. Client: Harley-Davidson.*

Branding Construct Approaches

There are as many possible constructs as there are creative tactics to solving any problem. A construct is utilized for *new* brands, brand *mergers*, and brand *revitalizations*. The following are a few respected approaches that are flexible enough to generate different approaches and ideas. There are many more constructs than are included here; these examples are to help you understand constructs, and to show how to formulate a construct.

Heritage

A brand's history can be of considerable interest and value to a current audience (Figure 4-2). The status and character emanating from a particular esteemed company can accrue over time and be emphasized in a brand construct. An esteemed heritage is a positive feature that audiences seem to respect.

Figure 4-2. *Identity. Design firm: VSA Partners, Inc., Chicago, IL. Client: Brunswick™ Billiards.*

"Eight ball, corner pocket."

Brunswick originally came to VSA requesting a new identity for the oldest brand in its portfolio: their billiards division. It was one of the first brands in America, founded in 1845, and it still holds the tremendous equity and heritage that billiard enthusiasts appreciate today.

VSA embarked on a user needs and expectations study at the beginning of the identity process, and through synthesized results and recommendations redefined the way Brunswick's brand experience and marketing communications exist today. Audiences told us they relate to billiard tables as a piece of furniture, which reflects personal taste, choices, and lifestyle. They also look to Brunswick for honesty of materials, integrity of craftsmanship, quality in performance and customer service, and enduring value.

These attributes greatly influenced our redesign of Brunswick Billiards' identity system to recapture their heritage in a very timely, relevant way. The net result is a completely new look, tone, and feel for the brand, which was designed across forty-three applications, including trade presence, packaging, sales and marketing collateral, point-of-purchase display materials, and more. VSA capped off the program with a unique advertising campaign leveraging original Brunswick table owners (identified in records found in a treasure-trove of archives) including Teddy Roosevelt, Mark Twain, Abraham Lincoln, Babe Ruth and others, which strongly reinforced the brand's authenticity and originality in the hearts and minds of target audiences.

— VSA Partners, Inc.

Unique Brand Strengths

Most products or services are not distinguished by their functional benefits or uniqueness—they are parity products, companies, and services distinguished by branding and advertising. If there is a unique brand out there, and it's successful, copies are sure to follow. However, there are brands that have strengths, perhaps even unique strengths, which might be intangible, or acquired by virtue of their history in a product category, by their consistent quality, or by the communities who have adopted them. That type of strength can be the basis of your conceptual platform.

Interestingly, you can take a disadvantage and turn it into a unique strength, as did the Doyle Dane Bernbach (DDB) agency in the late 1950s and 1960s for the Volkswagen® Beetle®. The Beetle was smaller than American cars and not streamlined like American cars of the same period. DDB turned the Beetle's potential drawbacks into selling points: "Think Small," and "It's ugly, but it gets you there."

Trying to position an athletic shoe in today's glutted market would seem almost impossible. Sandstrom Design took on the challenge and succeeded for Converse™ by highlighting the brand's unique strengths (Figure 4-3).

Forward Thinking

For some audiences, the idea that a brand is forward-looking—that is, planning for the future—is crucial. One might think that this type of brand platform would be limited to brands such as biotechnologically based companies or avant-garde arts organizations. In truth, this platform can be a springboard for innumerable brand types and groups with an emphasis on progressive thinking, such as an education consortium (Figure 4-4).

Case Study from Sandstrom Design

Converse

Freshly recovered from near bankruptcy, but carrying a storied sports legacy and counterculture cool factor, Converse came to Sandstrom Design for the development of a new branding strategy. We studied their history, distant and recent, and recommended that they be combined in a manner that would highlight their strengths (heritage, basketball domination, contrarian brand, Chuck Taylor All-Stars™).

First to emerge was a new identity toolkit, which was quickly applied to business papers, product boxes/packaging, and environmental systems. We recommended that several elements from the ubiquitous and long-lasting All-Star shoes become part of the branding, including the rubber patterned sole, white with red line base, and grommeted air vents. These elements appear on their new product boxes, and in some form on their hangtags, point-of-sale fixtures, and collateral.

We have also created a complete store-in-store system for Converse, attempting to win the very competitive battle for mind share and market share in the retail battlefield. Strong graphics and flexible display systems were created to build immediate awareness in the right way—Converse and basketball are permanently and forever linked. They can't outspend the competition, but they can focus on their unique strengths and respond to strong market trends that are turning away from painfully hip and punishingly omnipresent brands like Nike.

The Converse story entered a new chapter in 2003, when the brand—on a steep rise in sales and market share—was purchased by Nike. Converse successfully rebranded itself, took advantage of its unique heritage, and further strengthened its fashion credentials. These all contributed to making them an appealing acquisition, and becoming a strategic sub-brand for the industry leader.

— Sandstrom Design

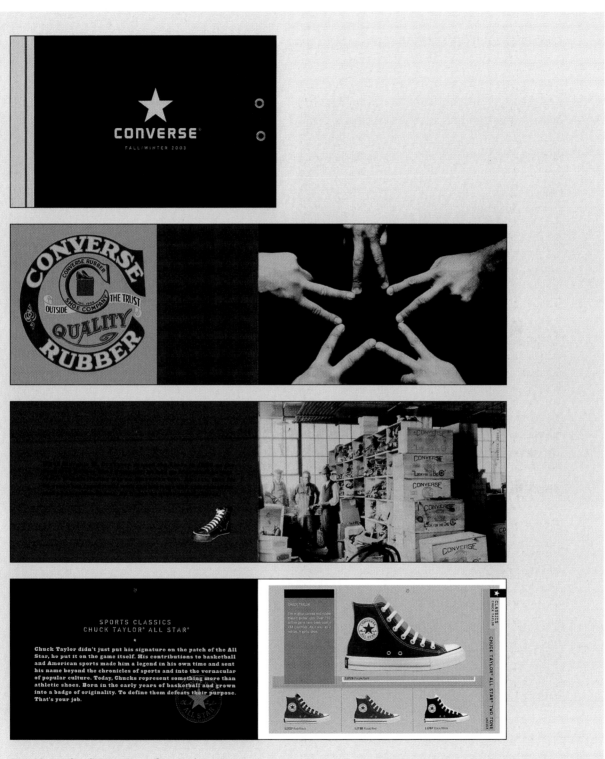

Figure 4-3. *Brand applications. Design firm: Sandstrom Design, Portland, OR. Client: Converse.*

Case Study from Sandstrom Design
continued

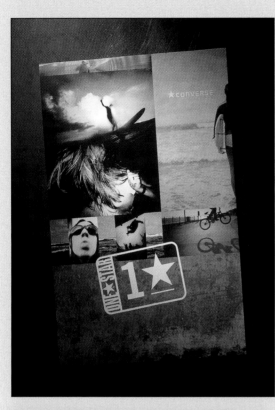

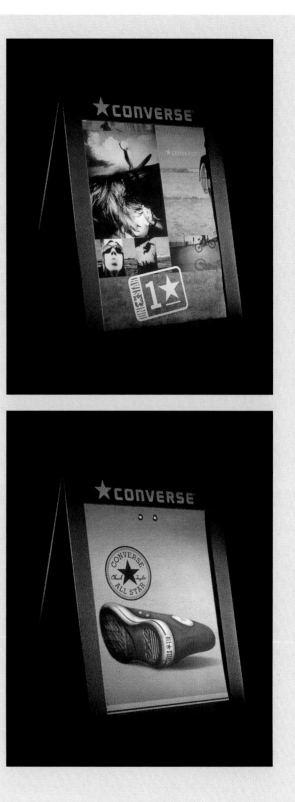

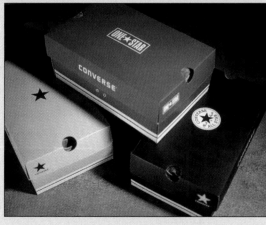

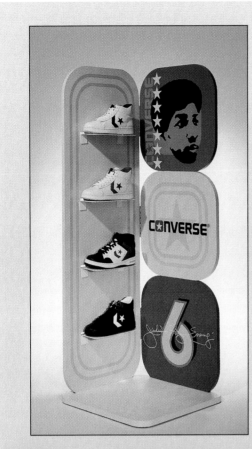

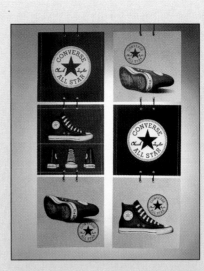

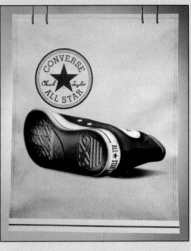

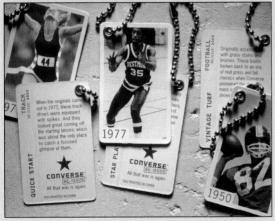

Figure 4-3 continued. *Brand applications. Design firm: Sandstrom Design, Portland, OR. Client: Converse.*

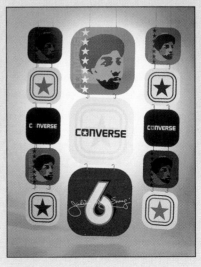

The Edison Project

Figure 4-4. *Identity. Design firm: Doyle Partners, New York, NY. Client: The Edison Project.*

"The Edison Project communicates simply, boldly, smartly."

Doyle Partners created the Edison Project's identity and implemented it throughout its curriculum materials, collateral materials, stationery, on-screen graphics, and offices.

The Edison Project is a consortium of some of the best educational minds in the country, and is a privately sponsored system for managing public schools in partnership with local communities. While Edison installs its curriculum, technology, staff development, and assessment systems, it remains accountable to public authorities for its results. The goal is to provide a world-class education to a cross-section of children at current public school costs.

Doyle Partners' new identity system communicates clearly, on several different levels. Stephen Doyle states: "Our design program must project a voice that is consistent with the academic world while still reflecting the accessible, inquisitive, and forward-thinking nature of an Edison education. The challenge was to create, within traditional parameters, work that reflects the exuberance and buoyancy of The Edison Project." Variable images from the natural and man-made world—including a speckled egg, glass marbles, the moon, postage stamps, and even a NASA spacecraft—subliminally dot the "i" of "Edison," which is relayed in bold, clean, black type. The objects celebrate living, learning, and exploring.

— Doyle Partners

The Standard

Establishing a brand as the authority, the accepted norm of quality—as experts—positions a brand as the benchmark in the category and builds confidence in the brand by the user. For example, many perceive Starbucks® as being the authority on coffee (Figure 4-5).

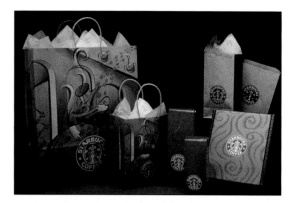

Figure 4-5. *Starbucks Coffee Company Program. Design firm: Hornall Anderson Design Works, Seattle, WA. Art director: Jack Anderson. Designers: Jack Anderson, Julie Lock, Heidi Favour, Jana Nishi, Julie Keenan, Julia LaPine, and Mary Chin Hutchison (Computer people: John Anicker, Alan Florsheim, and Michael Brugman). Photographer: Alan Abramowitz and stock photography. Illustrators: Julia LaPine (catalogs, annual reports, original packaging), George Tanagi (Frappuccino® packaging), John Fretz, and history book stock (Mazagran™ packaging). Copywriter: Pamela Mason-Davey. Client: Starbucks.*

*Starbucks Coffee Company opened their first shop in 1971 in Seattle's Pike Place Market*SM*. The client's belief is "Everything we do begins and ends with coffee." At the end of the 1996 fiscal year, Starbucks had more than 1,000 retail locations in 32 markets throughout North America, with additional new stores located in countries around the world.*

Starbucks has endeavored to create an environment of "constant discovery and self-renewal." Starbucks has taken one neighborhood store and expanded their brand to include mail order; joint ventures with Pepsi-Cola and Dreyer's Grand Ice Cream for Mazagran and Frappuccino coffee drinks and coffee-flavored ice cream; and partnerships with ITT Sheraton Corporate Hotels, Westin Hotels & Resorts, and United Airlines to be their coffee of choice provider.

In addition, Starbucks places a great emphasis on environmental responsibility. They have incorporated practices of using unbleached napkins, earth-friendly cleaning supplies and recycling bins in their stores, and rewarding customers who bring in their own coffee mugs. Community involvement is also important to Starbucks, and they have an extensive list of organizations which they have supported.

Hornall Anderson Design Works was involved for many years in the design of Starbucks' packaging, direct mail catalogs, annual reports, and miscellaneous other facets of their brand identity. Through the use of warm colors and rich illustrations in their designs, HADW has helped Starbucks achieve a look and feel that exemplifies them as being the authority on coffee. Two of the last projects HADW designed for Starbucks was packaging for the highly regarded Frappuccino and Mazagran coffee drinks. This was produced as a join partnership between Starbucks and Pepsi.

— Hornall Anderson Design Works

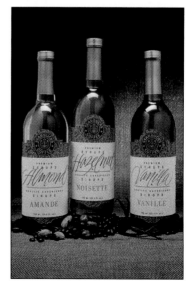

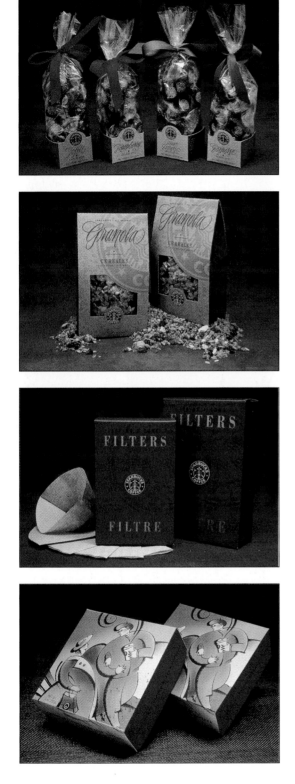

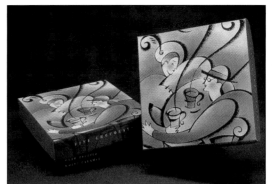

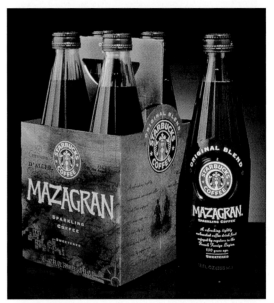

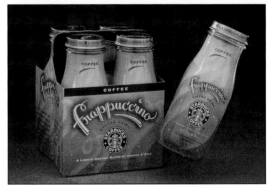

Figure 4-5 continued. *Starbucks Coffee Company Program. Design firm: Hornall Anderson Design Works, Seattle, WA. Art director: Jack Anderson. Designers: Jack Anderson, Julie Lock, Heidi Favour, Jana Nishi, Julie Keenan, Julia LaPine, and Mary Chin Hutchison (Computer people: John Anicker, Alan Florsheim, and Michael Brugman). Photographer: Alan Abramowitz and stock photography. Illustrators: Julia LaPine (catalogs, annual reports, original packaging), George Tanagi (Frappuccino packaging), John Fretz, and history book stock (Mazagran packaging). Copywriter: Pamela Mason-Davey. Client: Starbucks.*

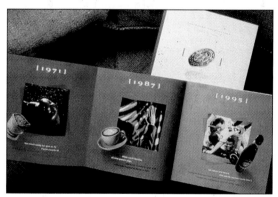

Down to Earth

Sometimes the brand communicates: "We're just regular folks like you." For example, the advertising campaign for Motel 6, featuring on-air personality Tom Bodett, says "We'll leave a light on for you.™" This brand (Figure 4-6) is so friendly and down-to-earth; just like Aunt El and Uncle Bob, they're leaving the light on for us. We can relate.

What this type of construct is really saying is that down deep we're all kin. And we should treat each other with decency and respect and offer tender loving care.

Creative Brief from The Richards Group

Motel 6

Warning: People don't like ads. People don't trust ads. People don't remember ads. How do we make sure this one will be different?

Why are we advertising?

To make people feel good about their decision to stay at Motel 6.

Who are we talking to?

Medium-income (between $30,000 and $50,000) business and leisure travelers who pay for their own accommodations. They intend to spend only a short amount of time in their motel room (either crashing for the night or planning to be out for the entire day). They either don't have a lot of money to spend on a room, or they feel virtuous about saving money.

What do they currently think?

"I feel embarrassed about staying at Motel 6 because it's the lowest price."

What would we like them to think?

"Staying at Motel 6 is the smart thing to do."

What is the single most persuasive idea we can convey?

Motel 6 is the smart choice.

Why should they believe it?

At Motel 6, you get all you really need: a clean, comfortable room at the lowest price of any national chain. You won't get any of those unnecessary features that cost you a fortune, like French-milled soap, chocolates on your pillow, or fancy drapes.

Are there any creative guidelines?

Continue the folksy, down-to-earth style and tone of the current campaign.

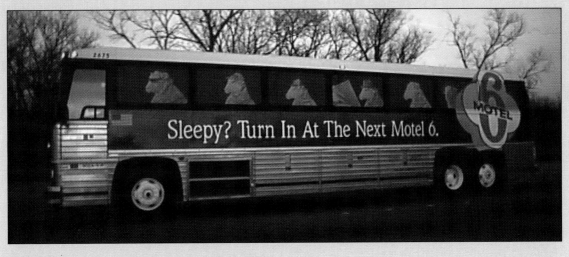

Figure 4-6. *Ad campaign. Agency: The Richards Group, Dallas, TX. Client: Motel 6.*

Creative Brief from The Richards Group

continued

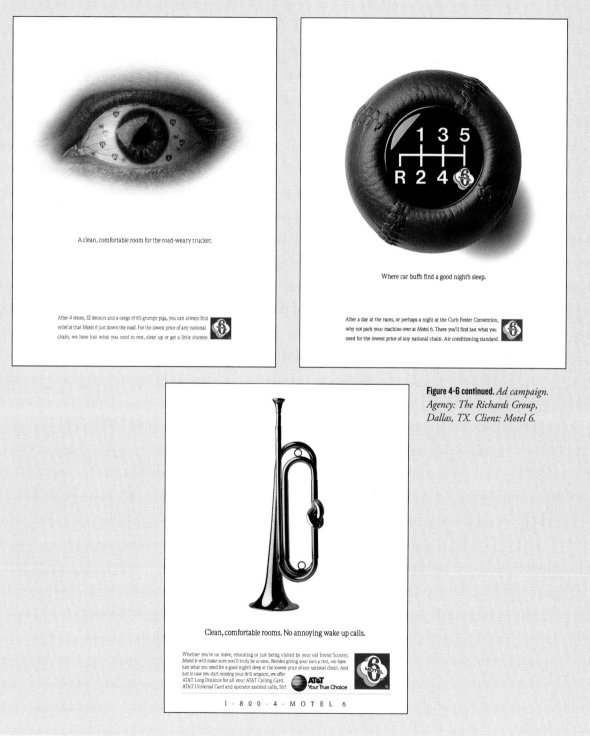

A clean, comfortable room for the road-weary trucker.

After 4 states, 12 detours and a cargo of 65 grumpy pigs, you can always find relief at that Motel 6 just down the road. For the lowest price of any national chain, we have just what you need to rest, clean up or get a little shuteye.

Where car buffs find a good night's sleep.

After a day at the races, or perhaps a night at the Curb Feeler Convention, why not park your machine over at Motel 6. There you'll find just what you need for the lowest price of any national chain. Air conditioning standard.

Clean, comfortable rooms. No annoying wake up calls.

Whether you're on leave, relocating or just being visited by your old friend Scooter, Motel 6 will make sure you'll truly be at ease. Besides giving your ears a rest, we have just what you need for a good night's sleep at the lowest price of any national chain. And just in case you start missing your drill sergeant, we offer AT&T Long Distance for all your AT&T Calling Card, AT&T Universal Card and operator assisted calls, Sir!

AT&T
Your True Choice

1 · 8 0 0 · 4 · M O T E L 6

Figure 4-6 continued. *Ad campaign. Agency: The Richards Group, Dallas, TX. Client: Motel 6.*

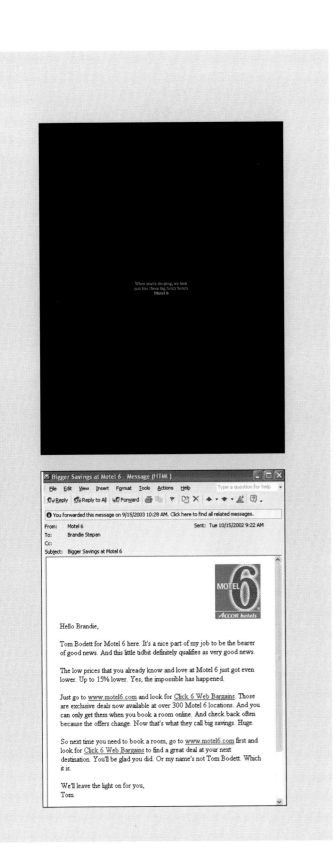

Community

A creative director friend of mine, who is fifty years old, bought a neon green Volkswagen Beetle. One day, as he was driving along, a very young, attractive woman in another car honked her horn at him and waved. "She can't be waving at me because she wants to meet me," he thought. Then he realized that she, too, was driving a Volkswagen Beetle. They belonged to the same "club."

Many of us yearn to belong. And brands can offer us brand communities to belong to. Owning certain brands or utilizing certain brand services also give us official badges or insider passes to certain lifestyles or brotherhoods (see Figure 4-1).

For many, belonging is important. If you can create a believable group, community, lifestyle, or attitude for a brand, it will become identifiable and memorable. And people may just want to belong to the club you've created.

Expressing Company Values

When a company or group has values—a philosophy, principles, or standards—that people respect, those values can be expressed in the brand strategy to an advantage.

For example, a company concerned with environmental issues may base its construct in that viewpoint. Or a company may stress innovation (Figure 4-7).

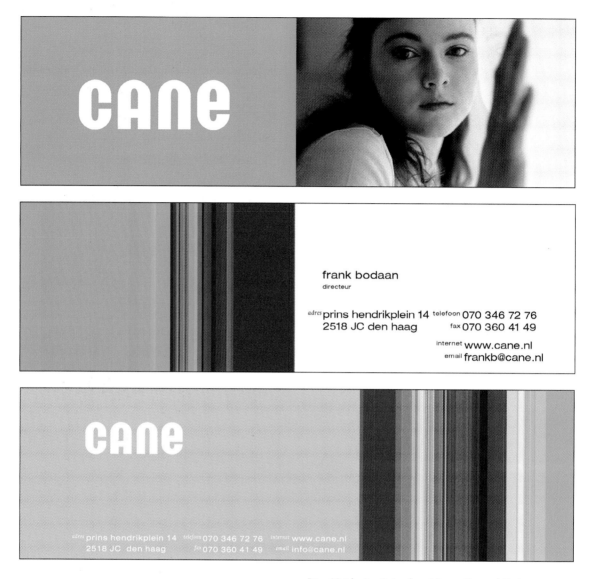

Figure 4-7. *Identity. Design firm: Mattmo Concept | Design, Amsterdam. Client: Cane.*

The greatest innovation takes place where different disciplines overlap. This is the standpoint we took to create a unique identity for this software and consultancy company. Factors like comfort, tactility, taste, smell and ergonomics, emerging from fashion, food, and interior design are combined with Cane services and products. Imagery that stands apart from the product while expressing the qualitative values of the company ensures that clichés are unnecessary. We searched for imagery that was innovative and flexible in its own right because of the composition, colors, sparkling photography, and strong typography.

— Mattmo Concept | Design

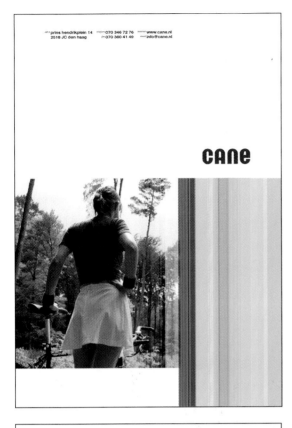

Personal

Any concept that can make a corporation seem more like an individual than a huge, impersonal company is valuable.

"You're talking with a person rather than a company" is the message that KesselsKramer wanted to express in their brand identity for Ben© (Figure 4-8). "This personalized approach, and friendly/understanding tone of voice deliberately veers away from the corporate doublespeak so inherent to the mobile phone industry," comments KesselsKramer.

Provenance

Vodka should be from Russia. "See the U.S.A. in your Chevrolet.™" Kente cloth should be woven in Ghana. Swiss watch movements are more precise. Pasta sauce has to be Italian to taste good. There is something to be said for having a native character—roots, as it were.

Case Study from KesselsKramer

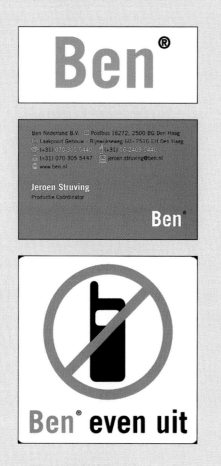

Figure 4-8. *Identity and advertising. Agency: KesselsKramer, Amsterdam. Art director: Erik Kessels. Copywriter: Johan Kramer. Strategy: Matthijs de Jongh and Engin Celikbas. Television producer: Jacqueline Kouwenberg. Director: Lex Brand. Client: Ben©, Werner Schrijver, Huib van der Linde, and Henny van der Heiden.*

Have you heard of Ben©?

The Dutch have. The name is just becoming the most famous one in Holland, thanks to a campaign by KesselsKramer to launch a mobile telephone network.

In the Netherlands, there are four mobile network giants; they all behave like big corporations. Ben© is the new kid on the block, number five.

With such stiff competition, there had to be a sharp change of direction from the other, already introduced companies.

The Name

KesselsKramer first came up with the name on behalf of the client, a joint venture between a Belgian telecommunications company (Belgacom) and a Danish mobile phone company (TeleDanmark). The name was simple, but with a double meaning: Ben©.

In Dutch, Ben means the name Ben, and it also means "am."

So, for example, "Ik ben Ben" means "I am Ben."

Ben©'s mission is to be as simple and personal as possible: he (or she) seeks to create a new voice in mobile phones. The message is: you're talking with a person rather than a company.

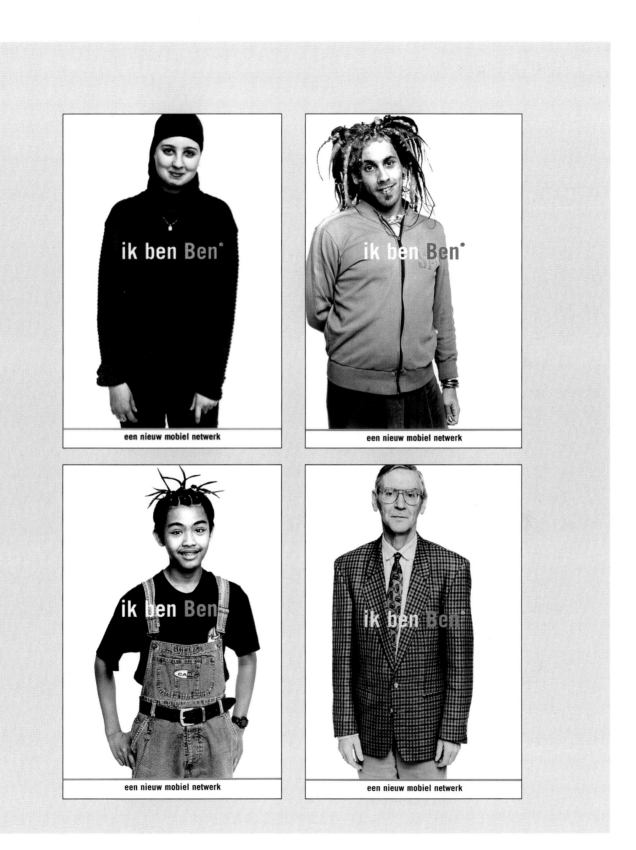

een nieuw mobiel netwerk

een nieuw mobiel netwerk

een nieuw mobiel netwerk

een nieuw mobiel netwerk

Case Study from KesselsKramer

continued

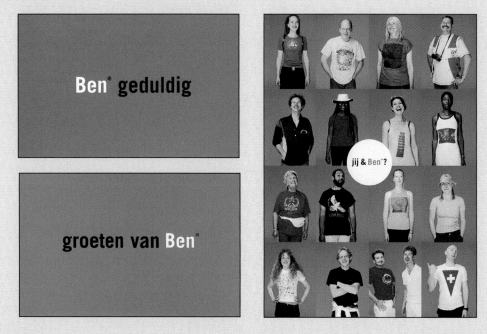

Figure 4-8 continued. *Identity and advertising. Agency: KesselsKramer, Amsterdam. Art director: Erik Kessels. Copywriter: Johan Kramer. Strategy: Matthijs de Jongh and Engin Celikbas. Television producer: Jacqueline Kouwenberg. Director: Lex Brand. Client: Ben©, Werner Schrijver, Huib van der Linde, and Henny van der Heiden.*

The Launch

The first teasers to announce the name Ben© started in 1998. In big adverts and on outdoor posters, the Dutch were confronted with lines like "Ben© nieuw" (I am new), "Ben© blij" (I am happy), "Ik ben, Ben© jij?" (I am, are you?), "Ben© verliefd op je oren" (I am in love with your ears), and "Ben© gek op je mond" (I am crazy about your mouth).

Only later, after everybody wondered who or what Ben© was, ads told the Dutch people that Ben© is a new mobile network—a network that loves to communicate with people in a simple and personal way.

Only in the television campaign were people introduced. First short bursts. A half-dozen different characters (no models), all saying: "Ik ben Ben©" and all saying it with one voice-over. So the voice-over becomes Ben© and the people are speaking through Ben©. In this way Ben© becomes every human person that feels attracted to the ideas of Ben©.

The three different television teasers went on for two weeks. Then the big push: a three-minute commercial shown on all Dutch national channels, on the same evening, the day before February 4th, the real start of the company.

Ben© held a three-minute conversation to introduce itself. Just like any introduction between two people, Ben© started with telling the name, asking who you are and what you do, and ending with telling who Ben© is. Again, this three-minute-long conversation was spoken through many people in one voice.

The Follow-up

After the first introduction, more television ads followed; in those, Ben© behaved in a very responsible and understanding way. In the cinema, it asks the audience to switch off their mobile phones before the movie starts. On television, it asks people to use their mobile phones in a more "responsible" way, instead of talking loud and behaving like you're alone on this planet.

— KesselsKramer

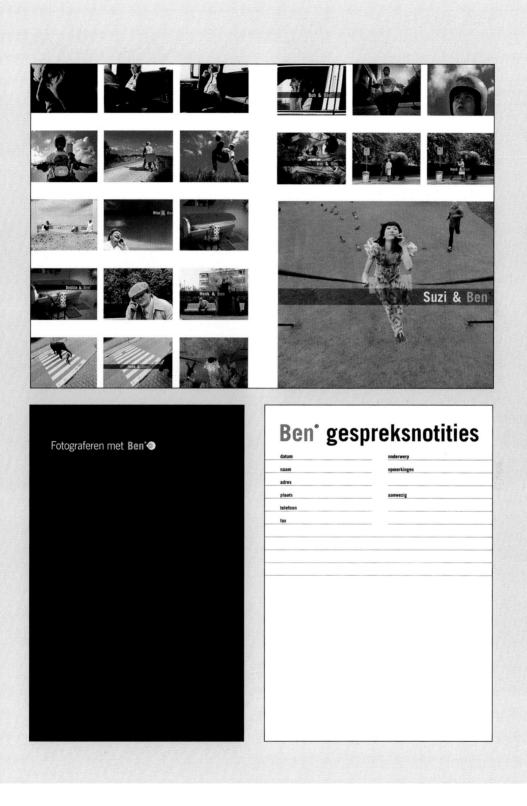

When there's a country behind your brand—the appropriate country, that is—then your brand is perceived to be authentic. A fundamental source or origin is the implication. However, you've got to make sure that you are perceived as *the* all-Russian vodka.

Cutting Edge or Techie

If a brand is technologically based or based in any business that must be current to be viable, and it is not perceived to be on the cutting edge, then it will lose in the marketplace. Believing that the products and services at the forefront of research with the latest information or newest technology are better or ahead of the others, many people prefer them. This entirely reasonable assumption can easily be used to build a construct.

We Understand

"Hey, you understand me!" is a desired response from an audience member. That greatly valued reaction can be prompted by how a brand construct manifests itself in both verbal and visual applications (Figure 4-9).

Humor

When brands don't take themselves too seriously, when they have a sense of humor about themselves, a certain type of audience may find that appealing. Not only does it say something about the brand's attitude, it also immediately identifies its audience—an audience that appreciates a wink and nudge humor or even gross-out humor. Brands using this platform set up a kind of reverse exclusivity; for example, the always amusingly ironic work from the agency KesselsKramer for the Hans Brinker Budget Hotel (Figure 4-10).

Figure 4-9. *Logo, letterhead, interactive. Design firm: Mattmo Concept | Design, Amsterdam. Client: Monkey Business.*

The job a student finds via Monkey Business is uncomplicated, relaxed, specific, and steady. You are free to fill in your own work and Monkey Business understands that studies come first. The graphic line is based on a handwritten, friendly, almost amateurish atmosphere, creating a round, straightforward, and cheerful mood, which makes the brand seem very sympathetic: a homemade atmosphere with black-and-white, hard, contrasting shapes.

— Mattmo Concept | Design

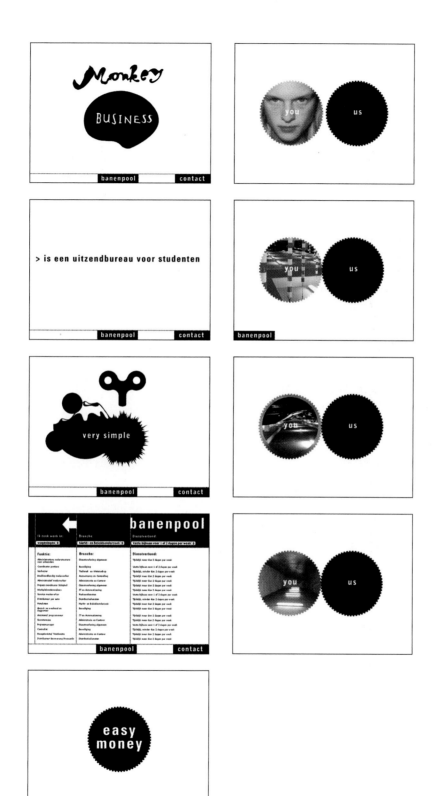

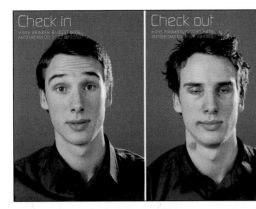

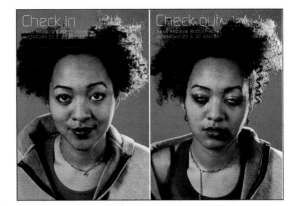

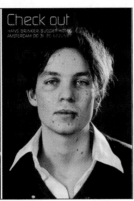

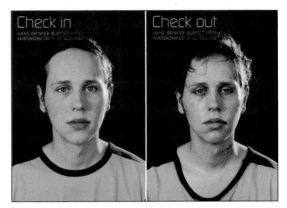

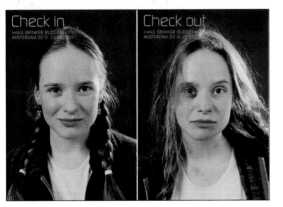

Figure 4-10. *Ads. Agency: KesselsKramer, Amsterdam. Client: Hans Brinker Budget Hotel.*

We did a humorous campaign for Hans Brinker, a budget hotel, that was very open about all the things that the hotel didn't have. The more honest we were about the place, the happier customers were once they got there.

— Johan Kramer, cofounder and creative director, KesselsKramer
www.fastcompany.com/magazine/26/futurist.html

Extreme Fun

When a brand promises and embodies fun, it can have enormous appeal to a wide audience. When Rethink created this ad campaign for Playland, not only were they selling the unique fun one can have on an amusement park ride, they were selling the idea that the feeling lasts (Figure 4-11). Certainly the photographs, colors, and copy of the advertising were speaking to the brand promise.

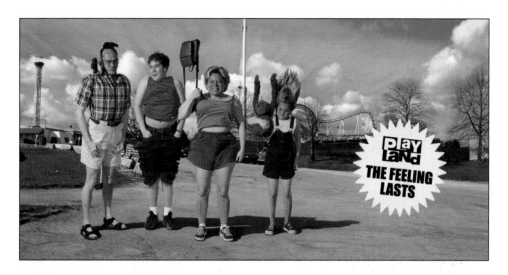

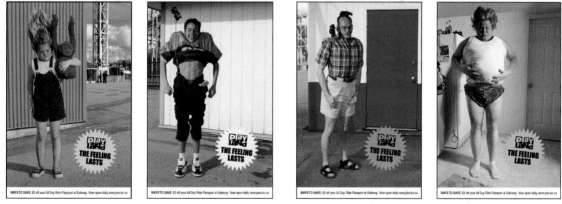

Figure 4-11. *Ad campaign. Agency: Rethink, Vancouver, British Columbia, Canada. Client: Playland.*

Using humorous exaggeration, Rethink creates visual surprises that stop the viewer and entertain, while sending the message that you'll have a great time on the rides at Playland.

Like Mother, Like Daughter . . . or Not

If you ever read Nancy Friday's classic book about mother/daughter relationships, *My Mother My Self,* or any self-help book on parent/child relationships, then you have a good handle on this category. However, the psychology extends to fathers and sons, fathers and daughters, and mothers and sons. Pretty much, it boils down to three categories of how people relate brands to their parents:

- If I use the soap my mother used, then I'm just like Mom. I'm loyal to Mom's values and judgment. Her brand choice is my brand choice.
- I'd never use the soap my mom used. I'm me. I make my own decisions. I want to separate myself a.s.a.p. (This translates to: I don't want to be like Mom. Mom buys the stuff that's on sale. Mom has no taste. Mom has old-fashioned taste—and lots more that's too awful to mention.)
- I'm doing one of the above, but don't know it.

Your client's brand may be suitable for taking a route that involves family tradition or the handing down of family advice. Or it may be relevant to your audience and your client's brand to come off as rebellious, not at all in continuity with the family's social customs or values. On one occasion when I asked students if they use the shampoo that their parents buy, a twenty-year-old female student replied "Are you kidding? I pay fourteen dollars for my shampoo. It's for my hair, so it's worth the price. My mom buys junk." There's a brand platform in there somewhere.

Image

A product has an image in the mind of the consumer; that image is based on and associated with a look, mood, art direction, emotional connotation of the brand, design of the brand identity, ads, or the models cast for the ads.

Image constructs can be based on and form associations with:

- A concept, such as fantasy, ruggedness, or peace
- An individual
- An aesthetic or beauty standard
- A celebrity
- A lifestyle; that is, urban, suburban, corporate, sophisticated, sporty, or country-club
- A mood

Image is virtually a category separate from *conceptual* branding and advertising. What an image construct does is create a mystique or "air" about a brand. Almost always, the reason image branding is employed is that the client's brand is absolutely interchangeable with all the other brands in its class. Products such as fragrance, liquor, beer, low-end sparkling wines, cosmetics, clothing, shoes, jewelry, and soft drinks are all about the same, in terms of quality and benefits—in their product category and class (that is, same price range). The only reason to choose a costly pair of jeans over another is personal, coming down to personal fit, taste, and lifestyle. If you're not sure which high-end lip gloss to buy, then the image construct, brand identity, and packaging may lure you. Perhaps you prefer a sophisticated image. Maybe an urban trendsetter image appeals to you. You have to buy something, so you're buying an image to go with your lip gloss.

Attitude

When models in ads glare at you with a seemingly conceited, bold, or impudent manner, they've got attitude. When models posture themselves, whether it's reflective of fringe culture, music culture, or youth culture, they have attitude. Their attitude is in your face. It's all about presence, demeanor, and an omnipresent air.

It doesn't have to be models; attitude can be expressed through the name of a brand (Dirty Boy soap), the logo, or the design of the packaging. However, it all must be consistent across the brand experience.

Many audiences are totally responsive to brands with attitude, whether the attitude is arrogant, mannered, wry, irreverent, tongue in cheek, chic, or cool. This construct can be related to "image."

Even a bank can have attitude.

Original

There's something about being an original that people seem to like. Whether the product or service was actually the original or not, if it is perceived to be the first or the original, people seem to think that equals superior, more informed, even magical. Being *first* in a category—whether it is a product, service, company, group, individual, issue, social cause, or charity—seems to imply that the brand is a unique entity from which imitations or alternative versions follow.

Interestingly, many brands that are the originals in a category can end up losing to competitors who follow in their footsteps, for a variety of reasons, including improvements made by competitors, better branding and advertising by competitors, and public taste and perception, among many other factors. However, to regain equity and value derived from being an original, this construct can be employed. For example, if a brand positions itself as *not* being derivative or being creative—demonstrated by being first—the public will be reminded of that magical quality that comes with being an original.

If a brand is an original, that brand characteristic could be the seed of the brand construct.

Sophisticated

Some audiences want to buy brands that are folksy. Some want a group to be approachable. Others prefer an upscale look and feel.

Can babywear be sophisticated? Sure. Lieber Brewster was asked to rebrand Absorba® for the U.S. market (Figure 4-12). Anna Lieber, president of Lieber Brewster, comments, "We wanted to create a striking, vibrant mood while focusing on the details of the clothing. The concept emphasizes the worldly, exotic, self-reflective, European sensibility to position Absorba as a desirable, upscale lifestyle brand."

Icon Personalities

When there's a family behind the brand quality, or it's a down-home kind of product, many consumers equate that with quality assurance. Whether it was Frank Perdue, Tom Carvel, Orville Reddenbacher, or Ford Chairman William Ford, these brand owners make us realize that there's a family tradition behind a company facade. Look no further than Wendy's® using Dave Thomas as a spokesman to understand the importance of thinking the owner was standing in each and every Wendy's kitchen, overseeing the food preparation.

Figure 4-12. *Integrated marketing campaign. Marketing firm: Lieber Brewster, Inc., New York, NY. Client: Absorba.*

"Absorba is a well-known French babywear brand that is high quality, well crafted, and playful, with a fashion look and luxurious feel and a history that appeals to gift-givers. In the U.S., Absorba was known because of its heritage, but did not have a contemporary brand image. While we had to retain the logo, its inconsistent use was further breaking down memorability.

After extensive research, we wrote a marketing plan repositioning the brand to appeal to the sophisticated working mom and dad. We also created a Brand Identity Amendment to guide Absorba's art department in the use of its logo.

We developed a unique visual concept for trade ads around the theme of discovery to showcase Absorba as a creative brand. The photos represent "magical" moments as the babies interact with objects and imagery, which was inspired by the outfits they are wearing. The headline we developed—"bebe curious"—communicates the essence of curiosity, combining both French and baby-like characteristics. "Bebe curious" was meant to appeal to a modern mother's sense of her baby: adorable, creative, playful, and intelligent, as well as a bit mischievous.

The flagship store at Bloomingdale'sSM, in New York City, now needed to be aligned to Absorba's new brand vision. Flanked by DKNY™ Baby and Ralph Lauren™ Baby, Absorba had to stand apart and project a contemporary feeling. The makeover had to be accomplished quickly on a tight budget.

Lieber Brewster was strategic in its modernization of the shop, and getting the most impact for the fewest dollars was critical. We softened the look by repainting the shop a creamy, pale yellow and added a new window seat as a rest stop for Mom and baby. We mounted large logo identifiers of the brand and large-format graphic photos of adorable toddlers of different nationalities wearing the latest Absorba collections. We then positioned mannequins sporting the same outfits featured in the adjacent images. The shop's makeover transformed it to contemporary–world status, and Lieber Brewster moved on to the next challenge: hiring a public relations agent and updating the corporate identity and media kit."

— Anna Lieber, Lieber Brewster

"It takes a tough man to make tender chicken."
— Perdue Chicken; Scali, McCabe, Sloves

Icon personalities—such as Betty Crocker®, *Tony the Tiger*™, the Energizer Bunny™, Flat Eric™, and the Aflac™ Duck—work in a similar fashion. In the past few years, there has been a significant reemergence of icon personalities, even nostalgia for them. Icons put a genial face on a faceless product, service, issue, or group, such as Smokey Bear™ for Wildfire Prevention or the Wallie® card (Figure 4-13), and the fascinating history behind the Betty Crocker icon (Figure 4-14) adds even more to the brand.

Figure 4-13. *Identity. Agency: KesselsKramer, Amsterdam. Strategy: Matthijs de Jongh and Edith Janson. Art directors: Erik Kessels and Krista Rozema. Copywriter: Johan Kramer. Illustrator: Ellen Utrecht. Client: Wallie, Paul Hissink.*

The Wallie card is a payment card for the Internet. This playful identity communicates the idea that the Wallie card is a simple and safe payment system for online buying.

Historical Case Study

Betty Crocker signature.

Figure 4-14. *The History of Betty Crocker. Portraits of Betty Crocker, 1936, 1969, 1996. Courtesy of General Mills Archives.*

Betty Crocker

Since 1921, the Betty Crocker name has symbolized the General Mills® continuing tradition of service to consumers. Although Betty was never a real person, her name and identity have become synonymous with helpfulness, trustworthiness, and quality. It all began when a promotion for Gold Medal™ flour offered consumers a pincushion resembling a flour sack if they correctly completed a jigsaw puzzle of a scene of a small town with a Gold Medal sign and truck included in it. The Washburn Crosby Company, a forerunner of General Mills, received thousands of responses and a flood of questions about baking.

"Betty Crocker" was created as a signature to personalize the responses to those inquiries. The surname Crocker was chosen to honor a popular recently retired director of the company, William G. Crocker. Betty was chosen simply as a friendly sounding name. Female employees were invited to submit sample Betty Crocker signatures; the one judged most distinctive is the basis for the one still in use today.

During this same period, the company expanded its commitment to consumer service and product quality by sponsoring cooking schools across the country. In fact, the "Betty Crocker Cooking School of the Air" began on the radio in 1924. The growth of consumer demand for information necessitated the hiring of several more home economists for a total of twenty-one. They were employed to carefully test and demonstrate the company's gold-medal-winning flour. This was the beginning of the Betty Crocker Kitchens™.

Betty Crocker Portraits

Although Betty Crocker was created in 1921, she did not have a real physical identity. In the 1920s, a drawing of a woman was featured in Gold Medal flour advertisements, as well as in ads for the "Cooking School of the Air," Betty's own radio show. When Betty Crocker became so well-known, it was felt there was a need to depict her. A prominent New York artist, Neysa McMein, was commissioned to create a likeness, and Betty Crocker's first portrait was created in 1936. The portrait made its first package appearance in 1937 on Softasilk™ cake flour.

Betty's portrait has been updated seven times since the original, with new portraits being painted in 1955, 1965, 1969, 1972, 1980, 1986, and 1996. In all eight portraits, Betty wears a red dress, jacket, or sweater, with white at her neck. Her latest rendition was created in honor of her 75th birthday. Although she has hardly aged a day, her hairstyles and clothes have changed to reflect the changing fashions of American women. Through the years, Americans have come to trust Betty Crocker for quality, good taste, and value.

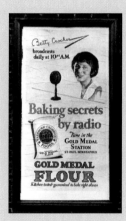

Ad, Gold Medal Flour, "Cooking School of the Air" mid-1920s. Betty Crocker had her own radio show.

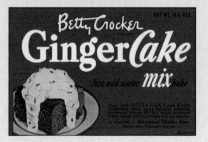

GingerCake mix, 1947.
The first Betty Crocker cake mix came out in 1947; and the red spoon began being used in 1954.

Betty Crocker Cookbooks

In the 1950s, America's growing families were flocking to their new suburban kitchens. The convergence of new appliances with convenience foods created a need for new recipes. Betty met that need with the first of more than two hundred cookbook titles. First issued in 1950, "Big Red" (as the big picture cookbooks have been dubbed in honor of the original) is now in its ninth edition, released in 2000. Millions of copies have been sold over the years, making it one of the all-time best-selling books in the world. Since 1980, Betty Crocker has also published recipe magazines featuring recipes, preparation tips, and presentation ideas for easy, everyday cooking. The magazines are available at supermarkets nationwide.

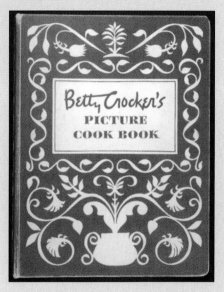

Betty Crocker's Picture Cook Book, 1950.

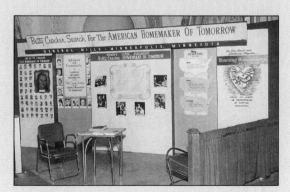

Betty Crocker Search, 1955.
The "Betty Crocker Search for the American Homemaker of Tomorrow" program ran from 1955 to 1977. It was very popular, and scholarship money was awarded to the high school senior

Historical Case Study

continued

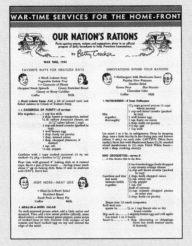

WWII newsletter, "Our Nation's Rations," 1945. General Mills and Betty Crocker were actively involved with the war effort.

Ad, "What's Your Score?" 1951.

Homemaker test, 1955.

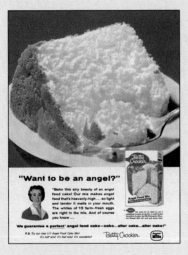

Ad, "Want to be an angel?" 1957.

Narration for Betty Crocker's Filmstrip, "Cooky Wise," 1966.
General Mills's Education Department had a series of Betty Crocker filmstrips for students about baking, meals, nutrition, and other topics.

Betty Crocker Coupon Catalog, 1970. The Betty Crocker catalog has been around longer than forty years.

Figure 4-14 continued. *The History of Betty Crocker. Courtesy of General Mills Archives.*

PART III • Design

On Designing

"You can't have a brand experience without design."
— Denise Anderson, director of Marketing Services for Pershing

Your goal, as a designer, is to conceive and design a brand concept that is based on strategy, is relevant, fresh, and consistent with the brand voice, and that can be practically implemented within the budget limitations.

Designing with Sense and Sensibility

After generating concepts, it's time to visualize them—to design. The concept must be communicated through the brand identity or any other application; graphic design and advertising are visual expressions of the essence of a concept that need to be effectively communicated to an audience.

In order to create a relevant, compelling brand experience—either a single application or a whole program—a designer needs to use good design *sense* in conjunction with design *sensibility*. The novice or aspiring designer must always keep in mind the issue of implementing design principles and remember how form affects function. For seasoned designers, this type of good judgment has already been internalized; however, it can be called upon at any time to ensure success. Design principles, as well as mastering the form/function relationship, can be learned and then effectively evaluated or critiqued and used as guides.

Good design sense is the exercise of good judgment; it entails the ability to use design training, such as:

• Conceptual, visual, and technical skills
• The power to think critically
• Understanding how form and function work cooperatively
• Utilizing design principles for successful visual communication (principles such as balance, visual hierarchy/information architecture, unity, contrast, proximity, alignment, flow, and rhythm)

Design sensibility is different from design sense. Perceptiveness; the power to think creatively and imaginatively; the ability to think of appropriate, fresh, and effective concepts; flexibility, range, and sensitivity; *how* one uses theory and principles; how one's own personal vision is brought into the design—these all fall into what I categorize as *sensibility*. It is your design sensibility that pushes a design solution from being just "solved" into a creative, winning solution for all. It also entails the ability to develop a visual "attitude"—a definitive look and feel that has "oomph" and muscle—for a brand, a single application, or the entire brand experience. It is critical to have good judgment about how each design application ties into the brand voice and strategy when designing for a total brand experience.

Some people refer to design sensibility as talent, creativity, or a designer's intuition; in any case, it's extremely difficult to quantify, yet so critical to designing brand experiences that resonate. When designing, good design judgment and sensibility should be employed together. A case in point is the Blue campaign by Stefan Sagmeister (Figure 5-1), where one can easily note Sagmeister's mastery of judgment and skills, as well as his uncommon sensibility.

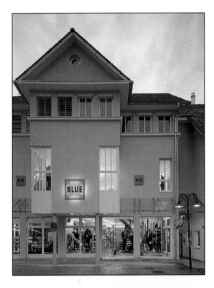

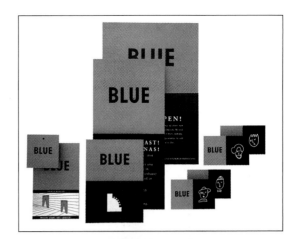

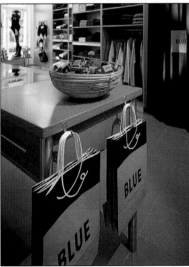

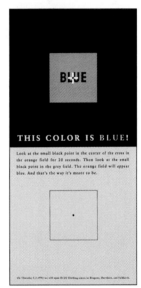

Figure 5-1. *Blue campaign. Design studio: Sagmeister Inc., New York, NY. Art director/Designer: Stefan Sagmeister. Backgrounds: Judith Eisler. Digital art: Kamil Vojnar. Photography: Tom Schierlitz. Client: Blue, Martin Sagmeister.*

Blue is a fashion retailer in Austria. We developed the logo (with a name like that we just had to do it in orange), ad campaign, corporate identity, packaging, and parts of the interior.

The campaign was incredibly successful: three weeks after the opening of the first three stores, the client called and stated that his only problem with the campaign is that there is no merchandise left, the stores are practically sold out.

This being a campaign for my brother's stores (and my brother always pretends to not have any money), we could not afford to hire any gorgeous models; so we just took our ugly friends and put bags over their heads.

— Sagmeister Inc.

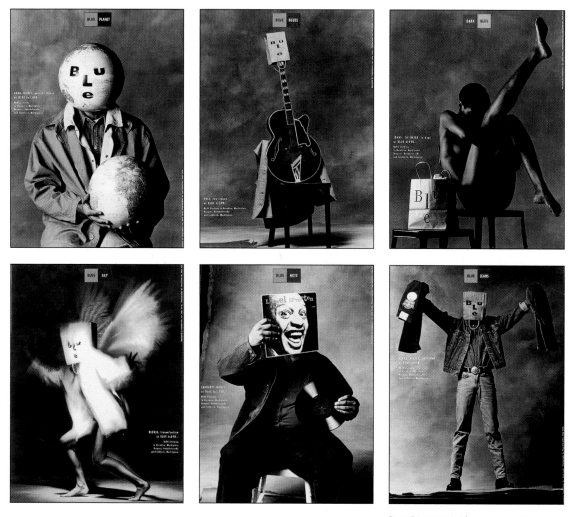

Figure 5-I continued. *Blue campaign. Design studio: Sagmeister Inc., New York, NY. Art director/Designer: Stefan Sagmeister. Backgrounds: Judith Eisler. Digital art: Kamil Vojnar. Photography: Tom Schierlitz. Client: Blue, Martin Sagmeister.*

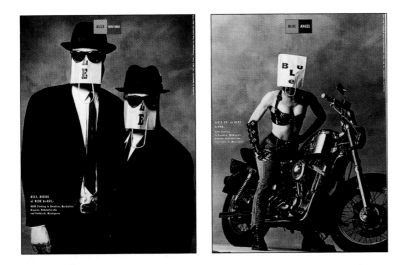

Using Strategy to Design

Use the strategy as your platform for designing; it can take the form of a design brief, creative brief, objectives list, strategy statement, or positioning statement. The essence of the brand personality is stated in the strategy, as well as the target audience, its position in the marketplace, and most other strategy information that you might need. Working from the strategy, it is helpful to write a short, succinct strategy statement to clearly define the essential features of the brand, both functional and emotional, and define its role, in order to differentiate it and position it in the marketplace. These ideas were stated earlier in the text, but they cannot be repeated too often: "What does that brand have to offer the audience?" "What is that brand all about?" "Why should the audience use this brand over all others?" "Why should the audience support this group, issue, or cause?" The creative brief of your client or firm may already include a clear positioning statement; creative brief structures vary. If the brief was drawn up by the marketing team, either on the client side or the agency side, you may want to "translate" this marketing type of statement into words that you can relate to or that may best conjure up workable visuals.

Acting as a guide or foundation, the creative brief and/or positioning statement or design objectives should be reflected in your design concept. A logo, brand identity, ad, or any other application—they should all reflect the personality and benefits of a brand, while distinguishing it among the competition. Liska + Associates considered two primary goals when creating the brand for Hotel 71: to provide guests with a positive and memorable brand experience, and to transform Hotel 71 into an attractive destination (Figure 5-2).

Case Study from Liska + Associates

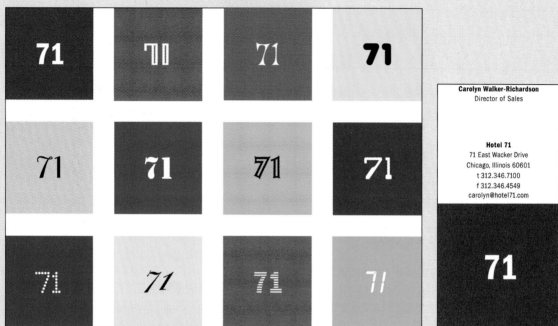

Carolyn Walker-Richardson
Director of Sales

Hotel 71
71 East Wacker Drive
Chicago, Illinois 60601
t 312.346.7100
f 312.346.4549
carolyn@hotel71.com

Hotel 71

Hotel 71 is a 450-room hotel with a single Chicago location. Developed to fill the gap between trendy boutique hotels and chain lodging, Hotel 71 is sophisticated, yet comfortable and friendly. The hotel caters to both business and leisure travelers who want more than a predictably bland lodging experience when visiting Chicago. Although Hotel 71 was a completely new hotel concept, the project began as the rebranding of the Executive Plaza, a midrange business destination with little to differentiate it from other hotels.

Challenge

Hotel 71 is located in the former Executive Plaza, a building with a prominent neon sign that had been a recognized part of Chicago's skyline since the 1960s. Although the interior would be rehabbed and redecorated as Hotel 71, its physical structure would remain the same as before. The new hotel's success depended on whether people would accept the transition and take a chance on the hotel. So it was necessary to completely reinvent the way people perceived the hotel by changing how they experienced the brand. We had to create brand materials that would project Hotel 71's transformation into an extraordinary hotel.

Hotel 71 71 East Wacker Drive www.hotel71.com
 Chicago, Illinois t 312.346.7100
 60601 f 312.346.1721

71

Figure 5-2. *Identity. Design firm: Liska + Associates, Chicago, IL. Client: Hotel 71.*

(Opposite page) Hotel 71 Launch brochure. Designer: Kristen Merry. Art directors: Steve Liska and Kim Fry. Photographer: Rodney Oman Bradley.

Our challenge was to create a brand that would cultivate new business and build loyalty among both leisure and business travelers. We needed to develop brand materials for every aspect of the hotel's operation, from marketing to housekeeping. Besides supporting the brand, these materials also had to be functional and useful for a busy, high-volume business. Since the hotel management planned to open a bar and restaurant, we also had to present the hotel as an appealing destination for local residents for dinner or a drink.

Brand Strategy

Audience:
- Business and leisure travelers looking for a place to stay with the amenities they need and that will enhance their experience in Chicago
- Travel industry professionals, including corporate travel planners and travel agents
- Chicagoans looking for a great bar or restaurant, a hotel to recommend to visitors, or a location for a special event
- Event planners
- The media

Our Strategy

We designed Hotel 71's brand to project a fun atmosphere that isn't too hip or exclusive, yet novel enough to interest a broad audience. As we positioned it, Hotel 71 would be known as a hotel that offered all the extra amenities of a boutique hotel with none of the attitude. Because staying in a hotel can often be a dull, dispiriting experience, we offered Hotel 71 as a lodging option with character.

We considered two primary goals when creating the brand:
- To provide guests with a positive and memorable brand experience
- To transform Hotel 71 into an attractive destination

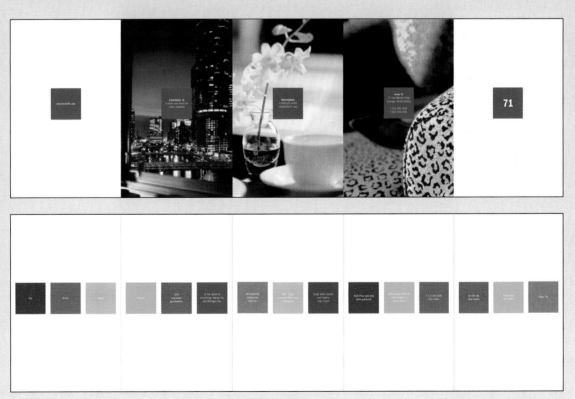

Case Study from Liska + Associates
continued

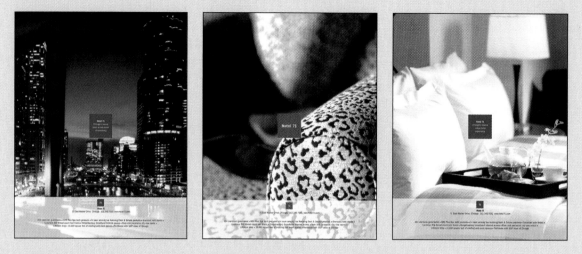

Working closely with hotel management, we developed a brand based on the hotel's aspirations to become a desirable place to stay in Chicago. After identifying which of the hotel's characteristics would be most critical to guests, we defined the ideal Hotel 71 brand experience.

Using this experience as a guide, we began to develop the elements of the brand that would become tools for expressing Hotel 71's values. We specified each of the brand's elements, from its logo to its tagline and editorial voice, then outlined these in a brand guidelines manual to assist anyone creating future materials.

Once we defined the visual and verbal elements of the Hotel 71 brand, we began to design materials that would enhance its brand experience. Our goal was to leave an impression on guests that would encourage them to stay at the hotel again or to recommend it to others. We designed a broad range of items that support the hotel's operations, from minibar items to room service menus, signage, matchboxes, and guest notepads.

Our next step was to make sure everyone knew about Hotel 71. We started by targeting travel professionals such as travel agents and corporate travel managers who recommend lodging options to their clients and associates. In advance of the hotel's launch, we created a Web site that announced Hotel 71's opening to those in the travel industry and offered downloadable photos for the press. We also developed a series of successful travel industry promotions to get people excited and curious about the new hotel.

Once industry insiders knew about the hotel, it was time to introduce Hotel 71 to the rest of the world, including Chicagoans. So we developed a number of marketing pieces ranging from brochures to ads, direct mail pieces, and a Web site. Although we designed most of these items to reach a specific segment of the hotel's audience, we also created some versatile marketing pieces that were appropriate for a range of audiences and purposes.

To differentiate Hotel 71 from commodity lodging, we created brand materials that reinforced why Hotel 71 is a great hotel experience. Bright colors and bold images communicate the hotel's personality and style. All materials leveraged the hotel's advantages, including its:

- Ideal location
- Larger than average rooms
- Penthouse meeting suite with breathtaking views
- Amenities such as spa-quality bath and body products and luxurious linens
- Fun, sophisticated atmosphere
- One of a kind experience

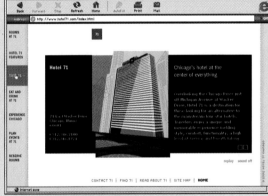

Deliverables

- Brand identity
- Tagline and editorial voice
- Brand guidelines manual
- Business document system
- Ad campaigns for travel industry, consumer, and business audiences
- Web site, including promotional prelaunch site
- Several promotional brochures
- Direct mail postcards
- Incentive items for promotional campaign
- Signage (indoor, outdoor, temporary)
- Guest materials (guest directory, matchboxes, postcards, keycards, jackets, etc.)
- Housekeeping materials (room service card, no smoking sign, repair work sign, linen card, privacy card, etc.)
- Guest forms (doorknob menu, restaurant coupon, package notice, comment form, baggage tag, etc.)
- Gift shop materials (logo, tags, bags, wrapping paper, etc.)

Exterior Signage

We established a complete system of indoor and outdoor signage for Hotel 71. To make people aware that the building housed a new hotel, we designed an illuminated sign that replaced the old Executive Plaza sign on the façade. We also designed permanent signage for the canopy covering the main entrance.

Results

Hotel 71 experienced a successful grand opening and continues to attract guests traveling to Chicago for both business and leisure. Although it faces heavy competition from many new and existing Chicago hotels, Hotel 71 stands out as an option that suits those looking for a well-designed experience in a great location. The hotel was featured in the March 2003 issue of *Condé Nast Traveler* as a place of interest because of its location on the Chicago River.

— Liska + Associates

Figure 5-2 continued. *Hotel 71 Ads. Designer: Brian Graziano. Art directors: Steve Liska and Deborah Schneider. Photographer: Rodney Oman Bradley.*

www.hotel71.com. *Designer: Hans Krebs. Programmer: Hans Krebs. Art directors: Steve Liska and Deborah Schneider. Illustrator: Paul Wearing. Photographer: Rodney Oman Bradley.*

Hotel 71 Incentive items (mouse pad, pen, keychain). Designer: Brian Graziano. Art directors: Steve Liska and Deborah Schneider.

The challenge for Blackburn's Ltd., a packaging design consultancy with extensive experience and international work, was to redesign Lipovitan™ packaging with one objective: to reposition the drink. We can compare the old logo (Figure 5-3) with the redesign (Figure 5-4). As stated earlier, the *brand strategy* is how you are conceiving, creating, and positioning your brand in the marketplace in relation to differentiation, relevance, and resonance.

Key words in the creative brief or positioning statement may help. Write them on a notepad or a desktop sticky note, and keep them nearby as you design. Or draw up a list of words—nouns and adjectives—that can act as a literal reference for the brand's personality.

Many design professionals ask questions that help them to visualize the brand's personality. For example:

• If this brand were a house, what style of architecture would it be?
• If this brand were music, what genre would it be?
• Which textures does this brand conjure in one's mind?
• If this brand were a type of line, which line attributes would it have?

Certainly, you can form your own type of questions that best suit your brainstorming style. What you need to do before designing (which, again, should emanate from the creative brief and positioning statement) is define and fully understand the brand essence—the codification (designation) of the brand's intrinsic qualities—into a main concept. (See Chapters 3 and 4 for further discussion on concepts.)

Considerations When Designing

Every design consideration that goes into any single graphic design or advertising application certainly applies to designing brand applications; for example, choosing fonts for appropriateness, voice, and readability. Beyond the obvious considerations that any thoughtful designer or art director makes, there are those considerations that must factor into designing a single application or an entire brand experience. They are essence and differentiation, relevance and resonance, look and feel, consonance, and typography.

Some of the following information may sound familiar from preceding chapters. It is repeated here—in conjunction with the discussion on designing—so that the relationship between strategy, which to many designers sounds like marketing-speak, and design becomes meaningful.

Essence and Differentiation

Through the design, establish the brand's proprietary voice. "Own" a look, voice, and spirit. Differentiate the brand from the competition using the brand essence, the codification of its intrinsic qualities, as a point of departure. Within the brand essence, there will undoubtedly be qualities that may lead you to a proprietary point of differentiation.

Know the competition as well as the visual conventions employed in the product or service category. Before you begin designing, you should research the competition; know what the competitors' identities look like—their color palettes, types of logos, fonts, formats, and any other visual elements that comprise their brand signatures and visual identities. Unquestionably, there is no point in looking like the competition; imitating the leading competitor's (or competitors') design would inevitably lead people to confuse your brand with the others. Differentiate your brand from the competition. For distinction, it's always good advice to zig when the competition zags.

Differentiation means establishing a visual "attitude." Just as a filmmaker creates a point of view for a film, designers need to do the same for a brand, single application, or entire brand experience. For example, note the visual attitude Pentagram created for EAT™ (Figure 5-5).

Case Study from Blackburn's Ltd.

Lipovitan Overview

Our remit was, firstly, to help communicate and establish Lipovitan's unique position in the crowded energy drink market, and secondly, to create a variety of design concepts based on a cog (an equity previously used by the company) or something entirely new. The chosen design best expressed the desired positioning of the healthy vitamin energizer.

Project Considerations and Design Solution

1. The positioning for a new energy drink

- Positioned between sports drinks (Lucozade™) and nightlife/artificial drinks (Red Bull™)
- An authentic, healthy, and contemporary alternative
- Female bias (Cate Blanchett persona) without alienating males
- Needed to achieve right balance between energy and well-being:
 - The product could not live up to packaging that over-promised health
 - Still needs to look like an energy drink, as it is one!

2. The existing packaging and identity

- Original gold is very busy and confusing—what is the product?
- What does the name mean?
- Name difficult to pronounce
- Cogs are a key part of the design, although the main cog was stretched horizontally and therefore looked wrong (oval cogs don't work!)
- The cogs combined with the aggressive gold, black, and red suggests a motor oil!

3. The new packaging

- Introduce big V to help:
 - With pronouncing the name correctly (Mobil, Cinzano™)
 - Emphasize the vitamin content (hence name meaning)
 - Make visually more distinctive with V in the middle (BRAUN)

- Combine circular cogs:
 - 4 cogs = 4 B vitamins (the analogy of working energy)—the Big Idea
 - It's the interaction of cogs that makes them work
 - They are more visually distinctive (Mickey Mouse™)

- The blue and green colors suggest health, counterbalancing the energy of the cogs.

- The human forms inside the cogs represent different states, from well-being (yoga position) to energetic (running), showing the variety of product uses.

— Blackburn's Ltd.

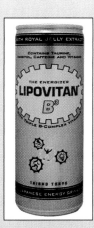

Figure 5-3. *Former Lipovitan Logo.*

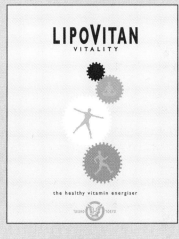

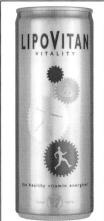

Figure 5-4. *Packaging redesign. Design firm: Blackburn's Ltd., London, U.K. Creative director: John Blackburn. Design director: Matt Thompson. Client: Lipovitan.*

Case Study from Pentagram

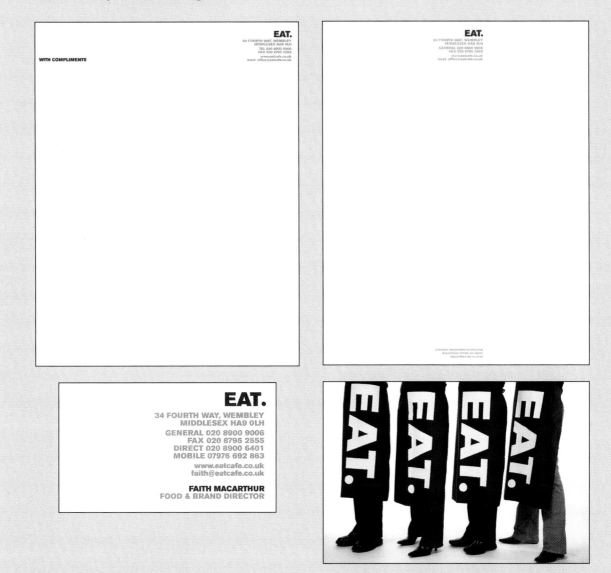

EAT

Since the first outlet opened on Villiers Street in central London, the EAT "brand" has grown considerably, with twenty-five cafés in prime locations in and around central London. Pentagram partner Angus Hyland was appointed to evolve the existing identity and to redefine the EAT brand experience. This project prompted a thorough investigation of the market and the credible points of differentiation between EAT and its competitors. Based on this, a core proposition was developed to guide all ongoing work.

The proposition highlighted the honesty at the heart of EAT's business—a business that is owned by real people (rather than a corporation) who have a genuine passion for real food and drink. Communication of the proposition was achieved by developing a new logotype and design language, with guidelines for its correct and consistent use across all visual and tangible elements of the EAT brand.

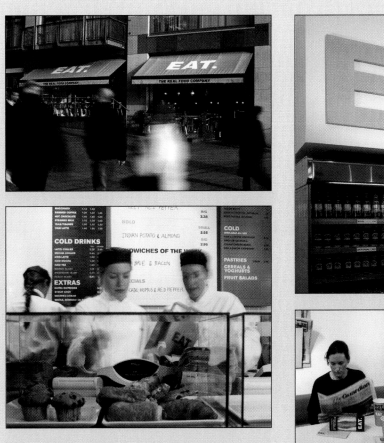

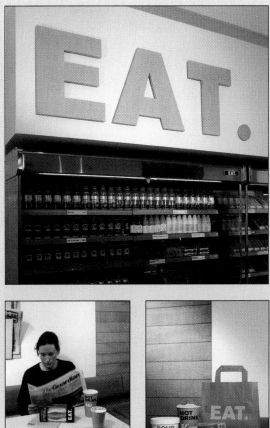

Figure 5-5. *Identity. Design studio: Pentagram, London, U.K.*
Designer: Angus Hyland (partner). Design assistants:
Charlie Smith and Sharon Hwang. Client: EAT.

A new strap line—THE REAL FOOD COMPANY—has also been developed to further suggest the values of the EAT brand.

Hyland and his team at Pentagram developed an all-encompassing brand identity. The new logotype employs a bold sans serif typeface (Akzidenz Grotesk) that communicates the warmth and quality of the brand with clarity and a distinct, contemporary tone. This bold typographical language has been combined with a color palette of warm, natural brown hues, and a range of vibrant minor colors for typography and detailing across food packaging, menu boards, and other collateral.

Graphic implementation was rolled across each one of EAT's twenty-five outlets by Jules Bigg at Fresh Produce, who further developed the language of the Pentagram schematic design concept and applied it to a wide range of packaging, print, and marketing materials. David Collins, at David Collins Architecture & Design, developed the architectural elements of the new concept and handled the implementation of the new brand identity throughout the interiors, shop fronts, and signage of each outlet.

The project was further overseen from start to finish by EAT Food & Brand director Faith MacArthur.

— Pentagram

Often, there are certain traditional color associations with types of products or services, especially with packaged goods, such as cleansers or beverages. For example, deodorant packaging tends to be cool in color, connoting freshness; bottled water labels, also, tend to be cool in color for the same association. Determine if you can break away from the association or if you have to play around it or play into it.

Relevance and Resonance

You must distill all the information that you have gathered into an insight that will resonate with your audience and knit it into your design. In conjunction with figuring out what will differentiate your brand's design, you must also decipher what will be relevant to the audience, to the people using the brand, especially potentially heavy users of the product or service. If a design is meaningful to the audience, your design has a much better shot at *resonance*—to have an impact and produce an emotional response in the audience. In order for a brand to resonate—that is, enjoy an intense and prolonged life that creates positive ripples with an audience—it must be distinguished, meaning easily identifiable and memorable, and relevant to the users' lives. The audience must find value in the brand, find it beneficial, interesting, engaging, sympathetic, and essential, as did the targeted teenage audience for Sony Ericsson (Figure 5-6). Not only does this campaign utilize images that teenagers would find cool, also note that the color palette, font selection, and close-up photography and models' attire all contribute to the appeal.

How does one know what is relevant to an audience? First, go back to the creative brief to determine the audience. Then comes insight and research. A designer can research an audience—the music they buy, the films they see, the styles and brands they wear, the lives they lead. There are marketing research firms that track consumer behavior, tracking products consumers buy, brands of preference, attitudes, communities, lifestyles, and media preferences. They conduct segmentation studies and keep

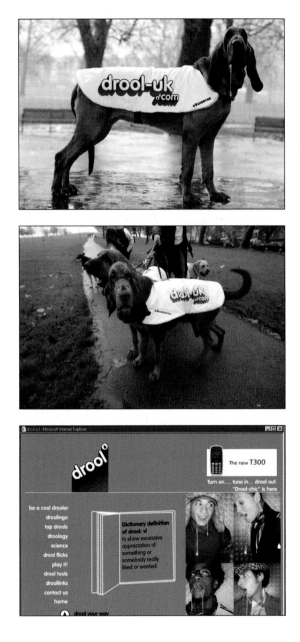

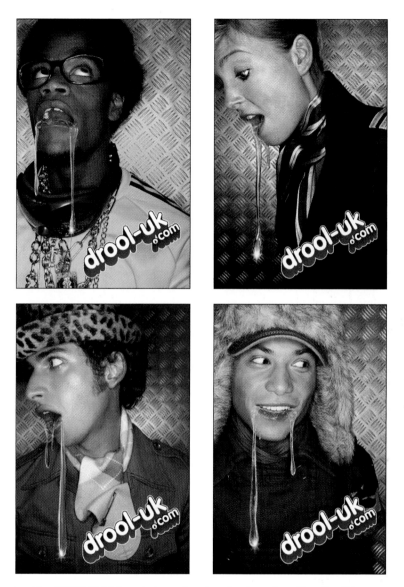

Figure 5-6. *Brand campaign: "Drool" T300 Mobile Launch. Agency: Strawberryfrog, Amsterdam. Client: Sony Ericsson.*

How to turn a businessmen's phone into the hottest fashion accessory for teenagers across Europe:

"If my parents hate it, it must be cool" was the simple piece of reverse psychology that drove record sales for the Sony Ericsson T300 handset.

Knowing that mainstream advertising doesn't penetrate the Net Generation, we devised an offbeat media plan with enough zigs and zags to keep the target intrigued and traditional customers oblivious. The campaign sold the sizzle, not the steak: the new T300 is so cool, it makes you slobber. We seeded the myth to magazines that drooling was a new teenager trend spreading from New York to Europe. This fed buzz, grabbing free press coverage worth 4,000,000 Euros and attracting 1.2 million visitors to a web site dedicated to the culture of drooling. A promotional tie-in with MTV® in 12 countries generated one of the highest response rates in the station's history.

Dog walkers and their canine pals clad in "T300, something to drool about" sweatshirts and dog jackets walked the streets of key European cities for photo opportunities.

To add credibility to staged events and amplify press coverage, we developed a simple dogvertise site for each market and distributed photos of dog walkers and dogs to the press.

— Strawberryfrog

cross-cultural databases. Most advertising agencies and branding firms utilize market research and complement it with their own research. Assessing this research, coalescing it with the strategy, and turning it into a design concept and a "design"—into a color palette and giving it form with lines, shapes, and fonts—and then combining that research with sensibility and inspiration is what is called for. Remember that the brand identity or any brand application is the visual expression of the brand essence of a corporate brand, product or service brand, corporation, organization, branded environment, issue, or social cause.

Look and Feel

If you are designing the logo and/or the brand identity, then you are the one who is responsible for the "look and feel" of the brand's design. The **look and feel** is the broad impression created by the consistency of the design and tagline, preserved by all applications in all contexts, for a brand. That means that any application, in any context, should maintain the brand's general impression, following whatever guidelines are in place for that brand; for example, the identity and promotional applications for Ilse™ (Figure 5-7).

Over time, brand identity equities are accrued. The specific elements of the identification—that is, the brand name, color palette, logo, tagline, unique font—gain a value to the brand's corporate holder or owner, and should be employed.

Going back to design basics, to how design elements communicate visually, can also help maintain a look and feel. For example, if your brand has a carefree personality, then hard-edged, rigid forms may not be appropriate.

What most contributes to look and feel?

- Color palette
- Logo (style, meaning, execution)
- Font choice and typographic treatment
- Characteristics of design elements, such as line characteristics (straight, fuzzy, broken)
- Tagline (which encapsulates one umbrella strategy in a catch phrase)
- Overall image (sophisticated, friendly, sexy, stable, etc.)
- What the audience associates with the entirety of the visual and verbal components

Consonance

In order for an audience to "recognize" an individual brand application, there must be consonance across the applications. Rarely does a viewer experience all brand applications simultaneously, unless in a brand store environment, such as an Apple® computer store. Even then, the viewer might not see the Apple television commercials or web site. A viewer sees packaging in one context, an advertisement in another context, and so on. Unity among applications, among the experiences a viewer has with a brand, needs to be established in order to build the brand in the viewer's mind, as exemplified in the brand identity for Aster™, created by Ideograma (Figure 5-8). However, there must be some variation in order to keep the viewer's attention. A brand application should not have to "reintroduce" itself to the viewer each and every time a viewer experiences one. On the other hand, the viewer should not think, "Oh, I've seen that already; no need to pay attention."

Figure 5-7. *Identity and promotion. Agency: KesselsKramer, Amsterdam. Client: Ilse.* www.ilse.nl.

KesselsKramer created the Ilse character for Ilse media, which was so successful that the character is being used for many purposes in the Ilse media campaigns.

Figure 5-8. *Brand identity. Design firm: Ideograma, Mexico. Client: Aster.*

A merger of several cable companies in the Dominican Republic gave rise to Aster. Ideograma infused Aster's brand identity with daring, transmitted through its intense color palette. They wanted the word "Aster" to be instantly associated with a business that offers information, entertainment, and communication.

To establish **consonance**—consistency across brand applications, also called brand coherence—a designer must consider the following:

• Unity of visual elements
• Coherent color palette
• Repetition of visual elements with enough variation to maintain interest
• Consistent visual look and feel
• Unified brand voice (the writing and the tone of verbal communication)
• Unified general brand or group strategy across applications
• Utilization of brand identity standards manual or guidelines

Typography

A designer specifies fonts for all text and all brand nomenclature. When designing with type for a brand experience, one has several critical decisions and considerations.

• Choosing or designing the font for the logo: the typography can be an existing font, a modified font, or a custom-designed font.
• Choosing or designing the font for the brand signature that will appear with the logo: the typography can be the same font as the logo, a variation from the same font family, or a complementary font—either existing, modified, or custom designed.
• Specifying the font(s) for brand communications and environments other than the basic brand signature.

A designer may commission a custom-designed font for a brand's logo, signature, tagline, and/or stationery system. Or a designer may specify an existing font, or modify an existing font to be used for the brand. If you are designing the logo and brand identity, it is your responsibility to make this initial typographic decision. If you are designing a subsequent application, there may be a standards manual that will specify which fonts may be used in conjunction with the logo and stationery, and for packaging, signage, and environments—for both print and digital applications. If the standards are ill-defined or nonexistent, it is crucial to remember that font choices must be:

• Appropriate to the brand's personality
• Work with the existing font(s) in the logo, signature, and stationery system
• Appropriate to the product, service, or group, in terms of meaning and voice
• Consistent with the look and feel of the brand
• Appropriately readable or legible in context (outdoor board, digital working across platforms, etc.)

Designing an Application for an Existing Brand

When designing an application for a brand, utilizing a logo and identity created by another design firm or ad agency, your application solution must be consistent in look and feel with the logo and brand identity. That doesn't mean your design solution has to parrot previously designed solutions; it means that what you design must be consonant with the current solution and give a like impression to the audience—send the same type of signal. In most cases, an existing design—especially a logo or identity system—comes with a standards manual and guidelines that will help shepherd the look and feel.

How do you know if your design is consistent with the look and feel?

First, in words, evaluate the visual identity's look and feel and brand essence. Evaluate your design concept, too. Make sure the existing solution and your solution are on the same wavelength. Also, measure your design concepts against the strategy, creative brief, or positioning statement. VSA Partners, Inc., has created many brand experiences for the prominent, established brand IBM® (Figure 5-9). VSA comments: "To help the pioneers of the computer age continue to speak like pioneers, VSA has worked to consistently infuse inspiration into every experience of the brand. This means instilling the brand—through clarity, humanity, and wit—everywhere, from print and Internet-based tools to inspirational brand presentations for multiple business groups throughout the company."

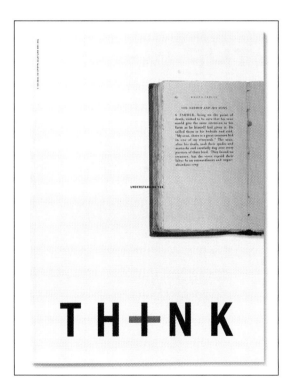

Figure 5-9. *Identity program: "Awakening a giant." Design firm: VSA Partners, Inc., Chicago, IL. Client: IBM.*

VSA has been IBM-compatible for some time now. We team with Big Blue on everything from brand strategy and design to key investor, partner, and corporate communications—the ingredients that are helping IBM evolve its messages and stay relevant in the world's fastest-moving industry.

As the single most impactful technology and consulting firm in the short history of computing, IBM's strategies, investments, and research and development initiatives are intensely scrutinized, both internally and externally. IBM has the ability to sway markets. For this reason, how IBM communicates is as important—if not more important—than what is says.

Our work has involved the 1998–2002 annual reports (print versions, as well as the direction of the online reports), online brand management tools, design consulting for W3 (IBM's intranet), marketing for TheExchange.com (an internal communications exchange), promotions for World Jam (a companywide, 72-hour, online jam session), "Autonomic Computing" (a research document), and Think *magazine.*

VSA's ongoing relationship with IBM Corporate Communications is carrying the IBM brand deeper into the organization and, ultimately, farther into its markets.

— VSA Partners, Inc.

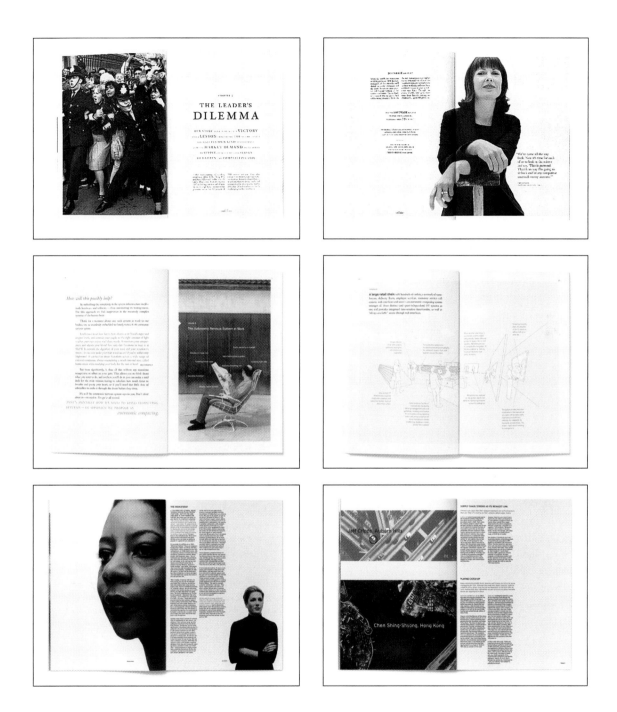

In order to ensure brand harmony—consonance across the brand experience, the coordination of all elements of an identity across an entire line of services, products, or related social causes (and, perhaps, across countries and cultures)—one must orchestrate design efforts, that is, concepts and executions.

Once a brand becomes popular, a company may see fit to introduce a brand extension: a new product or service that shares some of the same core qualities or characteristics of the original brand, but which is a variant, with a different functional benefit, such as a different flavor, a "light" version, a different scent, a different speed, and so on.

Designing a Brand Revitalization

Any major renewal and renovation of a brand, brand identity, and its position in the marketplace is considered a **brand revitalization**. Brands, even established, respected ones, can lose cachet, can be in transition, can become dinosaur-like, or can even, perhaps, have to survive a company mishap or crisis; these brands are good candidates for revitalization in order to thrive in a competitive, fast-changing environment, as exemplified in the conceptual thinking for the Seattle SuperSonics® (Figure 5-10). Hornall Anderson Design Works partnered with the Sonics organization to create a timeless look, composed of the classic attributes shared by the logos of such teams as the Chicago Cubs™, the Green Bay Packers™, and the New York Yankees™, as well as the authenticity represented by great college athletic programs. The strength and honesty behind the Sonics symbol renders these ideals tangible, comments Hornall Anderson Design Works. In this case, it is imperative to renew yet retain some visual equity.

Designing for a Brand Merger

When two companies merge, they need a new identity to signify the newly merged corporation. If both companies are esteemed brands, then many determinations must be made before designing begins. If one or both brands have lost their vitality, then both

Case Study from Hornall Anderson Design Works

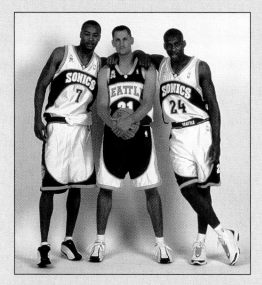

Figure 5-10. *Identity program. Design firm: Hornall Anderson Design Works, Seattle, WA. Art directors: Jack Anderson and Mark Popich. Designers: Jack Anderson, Mark Popich, Andrew Wicklund, and Elmer de la Cruz. Photographers: Alex Hayden and Jeff Reinking (brochures), NBAE photos (stock photography). Copywriters (brochure): Mark Popich, Andrew Wicklund, and WongDoody. Client: Seattle SuperSonics.*

Seattle SuperSonics

The Seattle SuperSonics NBA basketball team was feeling the backlash of a series of season disappointments, including decreased ticket sales and reduced interest by the fans. The team's new owners approached Hornall Anderson to create an overall identity redesign meant to reflect a timeless look in order to generate more excitement for the team among the fans and the players. When the team debuted in 1968–1969, it had no history, so it borrowed the Space Needle—the city's most famous landmark—to provide an identity. The most important goal in the redesign was to get back to the fame of basketball.

The main objective was to once again generate the same interest and excitement for the team as during the team's 1979 championship season and to rebuild an emotional connection with the public. Our job was to create a look, a feel, and a voice that would connect with the fan base.

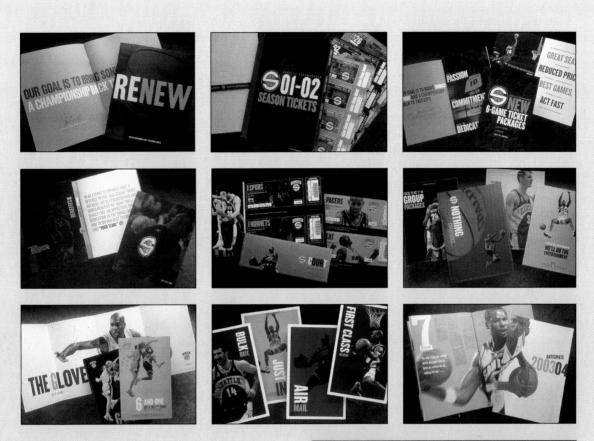

Returning to the green and gold palette evokes the tradition and rich heritage of the SuperSonics, and is reminiscent of the team's 1979 championship season identity. The redesign is a return to fundamentals, both on and off the court. These elements include pride, respect, and hard work, and emphasize the renewal of passion, commitment, responsibility, and respect for the game by both the fans and the players.

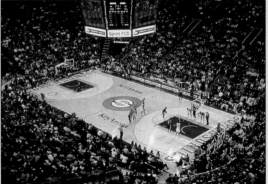

An important element is the return to fundamentals and to focus on the team for who they are, and not see them as an identity that reflects just the city in which they play. The new identity harkens back to their championship season and with it conjures up an emotional connection to their fans.

There has been a very positive response from the owner, the players, and the fan base.

— Hornall Anderson Design Works

brand identities and/or names might be discarded in favor of a new identity. Or if only one brand has lost vitality, then the other brand identity might be redesigned to represent the merger.

The client alone or the client with a creative team may make certain decisions or determinations, such as:

• Name: keep one company name to represent both, merge the names, or find a new name
• Keep one brand identity (the one with more brand equity)
• Merge the brand identities
• Revitalize/redesign one of the brand identities to represent the merger

Both companies will, undoubtedly, have equity in their original brands. A designer must consider that brand equity when designing for a merger. At times, it is important to carry over a visual element. For example, when Paula Scher of Pentagram designed the identity for the merger of Citibank and Travelers Group, she incorporated the "umbrella" of Travelers Group into the Citi™ logo (Figure 5-11).

Figure 5-11. *Identity. Design firm: Pentagram, New York, NY. Client: Citibank.*

The Citi brand identity is for the consumer division of the world's largest financial company.

— *Pentagram*

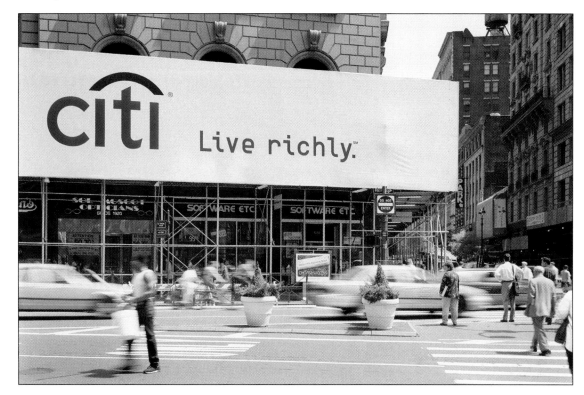

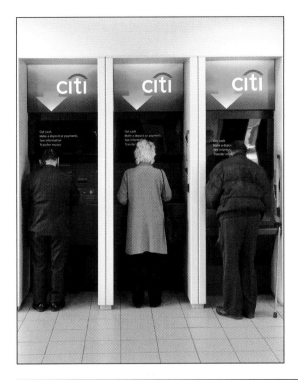

One can consider designing based on:

• Theme
• Imagery
• Synchronicity of type and image and brand
• Brand equity that must be ensured
• Carrying over some visual elements from one or both brands, such as color, font, icon, or pictorial element
• Authenticity
• Color palette merge

To represent the coming together of five international airlines—Lufthansa, United Airlines, SAS Scandinavian Airlines System, Thai Airways, and Air Canada—Pentagram's brief was to create a name and an identity to represent this merger (Figure 5-12). "Both elements had to have immediate and universal appeal and be easily recognizable across cultures, while also alluding to the individual reputation and strength of each member of the alliance," comments Pentagram.

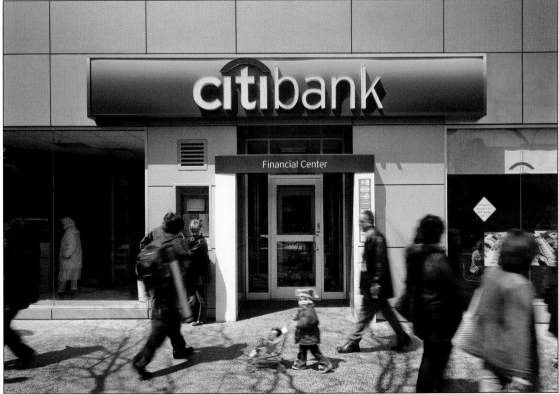

Figure 5-12. *Naming and identity. Design firm: Pentagram, London, U.K. Partner: Justus Oehler. Design assistants: Benjamin Erben, Andrea Speidel, and Giovanni Rodolfi. Client: Star Alliance.*

The name was chosen for a number of reasons. Research demonstrated that stars are profoundly symbolic; they have been used as direction and navigational tools for centuries, and are also universally regarded as symbols of excellence and achievement. Furthermore, an "alliance" is indicative of a number of individual bodies working together for a collective good—precisely the intent of the organization.

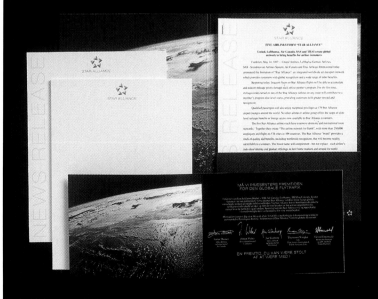

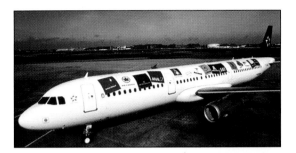

Figure 5-12 continued. *Naming and identity. Design firm: Pentagram, London, U.K. Partner: Justus Oehler. Design assistants: Benjamin Erben, Andrea Speidel, and Giovanni Rodolfi. Client: Star Alliance.*

It was imperative that the visual identity would not only complement the members' own identities, but also be capable of standing alone, remaining distinctive in the visually chaotic environments of airports around the world. It needed to work across a broad range of sizes and materials, from a business card to a retail fascia to an airplane tail fin.

The solution was a striking identity that enhances the quality of the individual airlines for existing customers, projects a contemporary personality to attract a new audience, and transcends language barriers for all.

Star Alliance® launched in 1977, with the identity rolling out across aircraft liveries, ticket offices, check-in counters, and lounges of member airlines, as well as extensive print and promotional programs that included everything from launch advertising to identity guideline manuals.

Pentagram's relationship with Star Alliance is ongoing, as new airlines are incorporated into the system upon joining the Alliance. Recent projects include the development of a new promotional livery for Star Alliance aircraft, an extensive design program which launched in January 2003.

— Pentagram

Designing on a Tight Budget

Not every branding assignment has an enormous budget. For Best Cellars[SM], Hornall Anderson Design Works had to consider a wide audience of wine enthusiasts (Figure 5-13). Since this was Best Cellars's first and only store, there were budget restraints that needed to be taken into account. Even with these limitations, a successful identity program was created, resulting in a positive response from the client's customers.

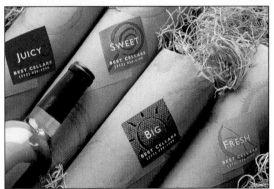

Figure 5-13. *Identity. Design firm: Hornall Anderson Design Works, Seattle, WA. Art director: Jack Anderson. Designers: Jack Anderson, Lisa Cerveny, Jana Wilson Esser, David Bates, and Nicole Bloss. Illustrator: Nicole Bloss. Client: Best Cellars.*

The brand identity for Best Cellars, a New York wine distributor and reseller, was created as a brand for the client's flagship store. They needed an identity that would stand out among their competitors and leave a memorable impression in the minds of their patrons. The intended audience consisted of a mixed clientele— everyone from connoisseurs to novices looking for high-quality, yet economic $10 and less inventory.

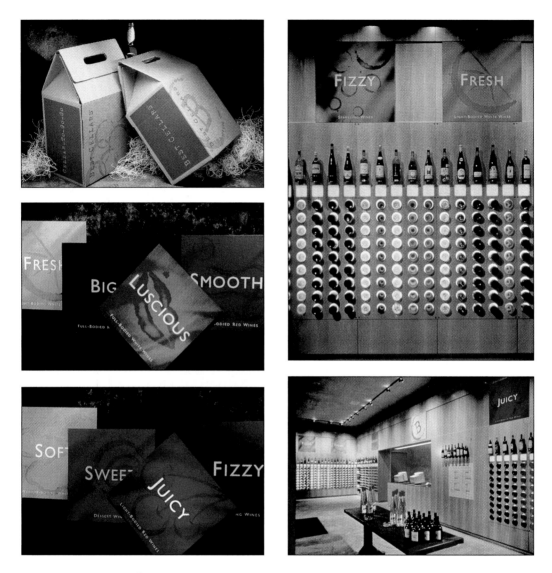

Figure 5-13 continued. *Identity. Design firm: Hornall Anderson Design Works, Seattle, WA. Art director: Jack Anderson. Designers: Jack Anderson, Lisa Cerveny, Jana Wilson Esser, David Bates, and Nicole Bloss. Illustrator: Nicole Bloss. Client: Best Cellars.*

The objective was to convey affordability without compromising taste through a minimalist presentation. As a result, an unpretentious identity was designed using the concept of a wine stain: the ring that occurs when a bottle of red wine has been poured—causing the wine to dribble down the side of the bottle—and then placed on a white tablecloth. This shape defines the "C" of Cellars. The typographic treatment of the "B" complements the roughness of the stain. A series of metaphoric icons were also developed—again using the basic wine stain—to support the identity and to identify eight different categories of wine: Luscious, Fizzy, Juicy, Sweet, Fresh, Big, Smooth, and Soft. Each icon is related to the descriptor: lips for Luscious, bubbles for Fizzy, cherries for Juicy, a lollipop for Sweet, a lemon wedge for Fresh, the sun for Big, water and the moon for Smooth, and clouds for Soft. The icon graphics were expanded to include a set of 30-inch square signs—output as Iris prints and mounted on wooden panels—which were used to categorize the selections. These signs were also reduced to label size and applied to Kraft paper used by Best Cellars to wrap a bottle of wine after purchase.

This identity was applied to a stationery program (made from Kraft stock and two-color application), stickers (made with two colors each), wine bottle-carrier packaging (made from Kraft box stock and one-color application), and in-store graphics/posters (which are Iris outputs in quantities of one each for in-store display).

— Hornall Anderson Design Works

Chapter 6

Designing Visual Language Elements of the Brand Identity

The brand identity is the visual and verbal articulation of a brand, as applied to a single product or service or an extended family of products or services, which includes all integrated graphic design applications; it is also called a visual identity or a corporate identity. A brand identity may also include a claim or tagline and advertising, depending upon the client and design firm or advertising agency.

Defining the brand's spirit and look, along with differentiating it from the competition, are the main goals of the brand identity. For success, efficacy, and sustainability, the brand identity should:

• Be memorable
• Be flexible
• Possess a spirit that is appropriate for the brand and audience
• Express a meaningful message
• Differentiate the brand from the competition
• Be distinctive

Naming a Brand

Naming a brand involves many crucial considerations. What does the name mean? What type of spirit or personality should it convey? How will people react to it? What does the name mean in a specific language to a target market?

A **brand name** is the verbal identity—a proprietary name—for a product, service, or group. Coupled with a tagline and/or descriptor, a brand name becomes the verbal signature of a company's product or service or of a group. It is an intangible asset, optimally adding value to a brand. Without question, the brand name is the main point of reference to any brand and is the main verbal marketing tool. Usually, the name is the one brand element that remains unchanged or, at least, in place for a long period. Logos, often, are periodically updated; however, names usually don't change unless there is a company merger, acquisition, takeover, or the name becomes outdated.

Types of Names

There are several categories of name types that are more or less appropriate for any brand.

Founder's name: named for the company's founder(s), such as Harrods®, London, named for the family name of Charles Henry Harrod; Ben & Jerry's® ice cream named for Ben Cohen and Jerry Greenfield; Levi's® named for founder Levi Strauss; and Martha Stewart® for the brands created by Martha Stewart.

Explanatory: named to best explain or describe the product or service, such as Toys "R" Us®, Petco®, America Online®, American Heart Association®, Coca-Cola®, Give Kids the World®, and Save the Children®.

Expressive or Invented: names that are constructed to have a certain panache or sound, such as Google®, Häagen Dazs®, Yahoo!®, Yumi™, Xerox®, Def Jam® recordings, Earth Share®, Timex®, and Intel®.

Allegorical or Symbolic: names that express their nature through an allusion to an allegory or a symbol to represent a brand, such as Nike® (named for the Greek goddess of victory), Sirius® (named for sky's brightest star), and Apple® Computers.

Case Study from Pentagram

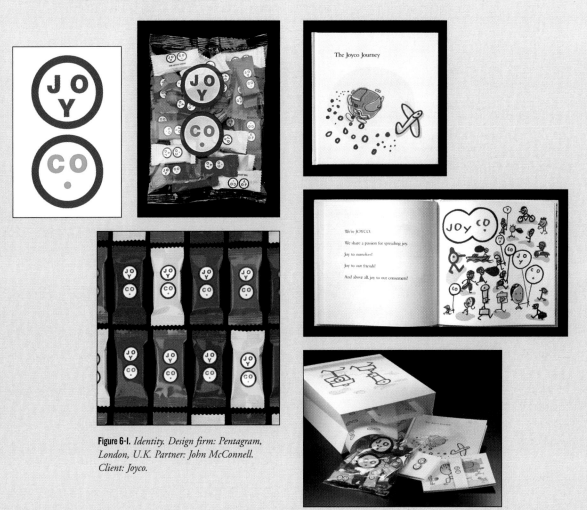

Figure 6-I. *Identity. Design firm: Pentagram, London, U.K. Partner: John McConnell. Client: Joyco.*

Joyco

Pentagram was commissioned to create the new name and brand identity for an international Spanish confectionery group, GC Group (General de Confiteria), who produce and sell a wide range of products, from gums to lollipops and toffees.

The new name, Joyco™, marks an exciting phase in the worldwide development of the group's business and reflects the spirit of the recent changes they have made to the company. Formerly a collection of separate companies with different names and identities in different countries, all the companies will adopt the name Joyco, to become one worldwide family.

Joyco currently have manufacturing facilities in China, India, Mexico, Poland, and the U.S., as well as additional sales offices in Italy, France, the Netherlands, Russia, and Portugal. It was therefore important to choose a name that was suitable for global use and could be pronounced in any language. The name expresses optimism for the future and symbolizes the company's philosophy of providing the customer satisfaction in a fun and enjoyable way.

Case Study from Pentagram

continued

Figure 6-1 continued. *Graphic standards manual. Design firm: Pentagram, London, U.K. Partner: John McConnell. Client: Joyco.*

A graphic standards manual provides the client with guidelines for usage of the identity elements to ensure value and consistency.

The mark is made of two circles placed closely together with the words "JOY" and "CO" making two happy, brightly colored faces, which signifies the joining together and collaboration of the separate companies.

For the launch of the new identity, Pentagram and Javier Mariscal created an imaginative and innovative film, a small book (a spirit guide), a brochure, and a CD-ROM to mark the event.

— Pentagram

Graphic standards manual. Design firm: Pentagram, London, U.K. Partner: John McConnell. Client: Joyco.
This graphic standards manual is presented to the client in a ring binder.

Acronym: a brand name formed from the initials or other parts of several names or words; for example, the following company names: BT® for British Telecom, BMW™ for Bayerische Motoren Werke, KFC® for Kentucky Fried Chicken®, IBM® for International Business Machines, and BP® for Beyond Petroleum®.

Effective Names

There are many ways to make a brand name effective.

- Distinction: a name that characterizes, distinguishes, and differentiates the brand among its competitors.
- Memorable: a name should be worth remembering and sufficiently engaging. Most say a brand name should be easy to pronounce and spell; however, one could make a case for interest over ease.
- Purposeful: a brand name can be meaningful, adding significance, purpose, or cachet to a product, service, or group. A brand name should communicate the personality of the brand and address its target audience.
- Extendable: a name should be capable of growing and changing with the company and possible brand extensions.
- Long-lasting: the name will be viable in the long term.
- Legally owned: the name or domain should be available to be legally registered, owned, and trademarked. It should not legally infringe on any other trademarked name.

Designing a Logo

A **logo** is a unique identifying symbol or wordmark; also called a brandmark, mark, identifier, logotype, logomark, or trademark. A logo represents and embodies everything a brand or company signifies; and a logo provides immediate recognition.

Nomenclature periodically changes; although the term *brandmark* is used by some within the design community, *logo* is the most commonly accepted term among design professionals, clients, and the general audience. (And, it should be noted that although the word logo is most often used to describe the brandmark or mark of a brand, it is shorthand for the word *logotype*, which historically and literally means a wordmark—that is, the brand name spelled out in unique typography.)

Types of Logos

Logos can take the form of a wordmark, a lettermark, a symbol mark, or a combination mark.

- **Wordmark** (also called logotype) is the name spelled out in unique typography or lettering (Figures 6-2 through 6-5).

Figure 6-2. *Wordmark logos.*
*a. Design firm: VSA Partners, Inc., Chicago, IL.
 Client: Brunswick Billiards.*
*b. Design firm: Doyle Partners, New York, NY.
 Client: Barnes & Noble.*
c. Design firm: Pentagram, London, U.K. Client: EAT.

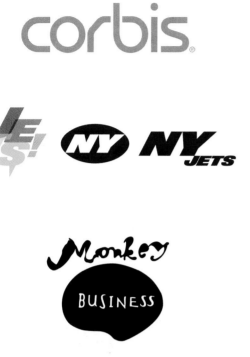

Figure 6-3. *Wordmark logos.*
a. *Design firm: Segura Inc., Chicago, IL. Client: Corbis.*
b. *Design firm: Pentagram, New York, NY.*
 Client: NY Jets.
c. *Design firm: Mattmo Concept | Design, Amsterdam.*
 Client: Monkey Business.
d. *Design firm: Ideograma, Mexico. Client: Impulso.*
e. *Design firm: Gardner Design, Wichita, KS. Client: Chips.*

Figure 6-4. *Wordmark logos.*
a. *Design firm: KesselsKramer, Amsterdam. Client: Ben.*
b. *Design firm: Liska + Associates, Chicago, IL. Client: Capezio Troupe.*
c. *3M™. Courtesy of 3M.*
d. *Design firm: Mattmo Concept | Design, Amsterdam.*
 Client: Kleyne Coophuys.
e. *Design firm: Pentagram, New York, NY. Client: American Folk*
 Art Museum.

Lettermark: a type of logo that is created using the initials of the brand name (Figure 6-6).

Figure 6-5. *Wordmark logos.*
a. *Design firm: Mires, San Diego, CA. Client: Seganet.*
b. *Design firm: Mires, San Diego, CA. Client: Taylor Guitars.*
c. *Design firm: Doyle Partners, New York, NY.*
 Client: The Edison Project.
d. *Design firm: Sibley Peteet Design, Austin, TX.*
 Client: The 401(k) Company.

Figure 6-6. *Lettermark logos.*
a. *Design firm: Liska + Associates, Chicago, IL. Client: RAM.*
b. *Design firm: Mattmo Concept | Design, Amsterdam. Client: BCN.*
c. *Design firm: Gardner Design, Wichita, KS. Client: HfH.*
d. *Design firm: Milton Glaser, New York, NY. Client: CTW.*
e. *Design firm: Gardner Design, Wichita, KS. Client: Diehlman*
 Bentwood Furniture.

Symbol mark is a visual mark that symbolizes the brand and can be formed as a pictorial visual, *or* an abstract visual, *or* a nonrepresentational visual.

• A **pictorial symbol mark** is a representational image that symbolizes the brand or social cause; it relates to an identifiable object (Figures 6-7 and 6-8).

Figure 6-7. *Pictorial symbol mark logos.*
a. Design firm: Gardner Design, Wichita, KS.
 Client: Anastasia Marie Cosmetics.
b. Design firm: Gardner Design, Wichita, KS. Client: Tallgrass Beef.
c. Design firm: Red Flannel, Freehold, NJ. Client: MetLife, Partners
 for Success Program.

Figure 6-8. *Pictorial symbol mark logos.*
a. Design firm: Gardner Design, Wichita, KS. Client: Brain Cramps.
b. Design firm: Gardner Design, Wichita, KS. Client: HOC Industries.
c. Design firm: Gardner Design, Wichita, KS. Client: Dewey-BigDogs.

Chapter 6: Designing Visual Language Elements of the Brand Identity 133

- An **abstract symbol mark** is a type of logo which is a representational visual with an emphasis on the intrinsic form, an extraction relating to a real object, modified with an abstract emphasis (Figure 6-9).

- A symbol mark can also be a nonrepresentational visual, which is a nonpictorial design that symbolizes the brand and does not relate to an identifiable object or person (Figure 6-10).

Figure 6-9. *Abstract symbol mark logos.*
a. *Design firm: Gardner Design, Wichita, KS.*
 Client: Dragon Fly Farms.
b. *Design firm: Gardner Design, Wichita, KS.*
 Client: Big Dog Wearable Line.
c. *Design firm: Red Flannel, Freehold, NJ. Client: MetLife.*
d. *Design firm: Red Flannel, Freehold, NJ. Client: MetLife.*

Figure 6-10. *Abstract nonrepresentational symbol mark logos.*
a. *Design firm: Gardner Design, Wichita, KS. Client: Thermos.*
b. *Design firm: Gardner Design, Wichita, KS. Client: Printmaster.*
c. *Design firm: Gardner Design, Wichita, KS. Client: Refined Technologies.*
d. *(unpublished). Design firm: Red Flannel, Freehold, NJ. Client: Insurance Underwriter.*

Combination mark: a combination of words and symbols (Figures 6-11 through 6-14).

Figure 6-11. *Combination mark logos.*
a. *Design firm: Milton Glaser, New York, NY. Client: Elektra.*
b. *Design firm: Ideograma, Mexico. Client: Aster.*
c. *CBS® Eye Design®. The CBS and CBS Eye Design are registered trademarks of CBS Broadcasting, Inc.*
d. *Design firm: Segura Inc., Chicago, IL. Client: master guo.*
e. *Design firm: Milton Glaser, New York, NY. Client: Rainbow Room.*

Figure 6-12. *Combination mark logos.*
a. *Design firm: KesselsKramer, Amsterdam. Client: Wallie.*
b. *Design firm: Ideograma, Mexico. Client: Comunidad.*
c. *Design firm: Pentagram, New York, NY. Client: United Airlines.*
d. *Design firm: Milton Glaser, New York, NY. Client: Tomato.*
e. *Design firm: Pentagram, New York, NY. Client: Citibank.*

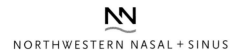

NORTHWESTERN NASAL + SINUS

e//advisors

Enlace

expresso
PAPER

Invitrogen

brentoli
ARCHITECTURE

Figure 6-13. *Combination mark logos.*
a. Design firm: Liska + Associates, Chicago, IL.
 Client: Northwestern Nasal + Sinus.
b. Design firm: Ideograma, Mexico. Client: e//advisors.
c. Design firm: Milton Glaser, New York, NY.
 Client: Brooklyn Brewery.
d. Design firm: Ideograma, Mexico. Client: Enlace.
e. Design firm: Gardner Design, Wichita, KS.
 Client: Connecting Point.

Figure 6-14. *Combination mark logos.*
a. Design firm: Mattmo Concept | Design, Amsterdam.
 Client: Expresso Paper.
b. Design firm: Gardner Design, Wichita, KS. Client: Carlos O'Kelly's.
c. Design firm: Mires, San Diego, CA. Client: Invitrogen.
d. Design firm: Gardner Design, Wichita, KS.
 Client: Brentoli Architecture.
e. Design firm: VSA Partners, Inc., Chicago, IL.
 Client: Cingular Wireless.

Conveying Meaning

Given that a logo identifies an entity or group—corporation, product, service, person, social cause, or issue—it must clearly communicate, through its design, the personality, character, and nature of that entity. Amazingly, an enormous amount of meaning, content, and emotion can be *compressed and articulated* in a logo and perceived by a viewer.

With one glance, a viewer should be able to ascertain and assess a brand by looking at the logo. Although not a designer, today's average viewer has become design savvy by virtue of exposure to a plethora of design applications. Graphic design is ubiquitous in industrialized nations. Everywhere a person turns are graphic design applications or advertisements.

How does a designer begin to convey the brand message through the logo? The place to start is in the design brief or positioning statement. Once you know the strategy and understand the spirit of the brand, you can begin ideation.

Each and every design decision that goes into creating a logo will affect how the viewer perceives the resulting design. If you choose to describe a logo with a scratchy line, that would convey a certain feeling to the audience. Color will affect the communication, as well. If the logo is flat, it will communicate a different message from an illusionistic logo. Symbol marks—pictorial, abstract, or nonrepresentational logos—can take many different forms and evoke different styles or periods. Certainly, the type of forms you choose must be appropriate for your brand, convey the brand spirit, and differentiate it; for example, Milton Glaser's logo for Brooklyn Brewery[SM] (Figure 6-13c), which was applied to their packaging, promotional material, T-shirts, and trucks, and to the front of the brewery. Glaser comments: "The name 'Brooklyn' suggested, among other things, the 'Dodgers®,' the baseball team still associated with Brooklyn many years after they treacherously decamped for Los Angeles. The partners [of Brooklyn Brewery] wanted their label to have a European appearance to differentiate it among popular American beers and to suggest their commitment to a more complex and interesting product. I designed a 'B' that looked as though it belonged on a Dodgers uniform. Actually, the lettering on the real uniforms was quite straightforward, but through some trick of memory, most people recall it as looking like this logo."

> **LOGO POINTERS**
> A logo must:
> - Communicate the brand essence or spirit
> - Be memorable and have graphic impact
> - Differentiate the brand from the competition
> - Work well in small and large sizes
> - Work well in black and white and in color, and in all applications (often, publications are printed in black and white only)
> - Be relevant to the audience
>
> Here are some general standards and guidelines to maximize impact and consistency, thereby ensuring recognition:
> - Dictate the area of isolation (amount of space that must surround the logo and/or brand signature)
> - Dictate the font
> - Dictate the color (when printing in two or more colors or when seen online or on-screen)
> - Dictate the rules for animation
> - Create the artwork files for both print and digital applications
> - Delineate the restrictions and prohibitions, such as reversing the logo to white or using another color, inversion, or stretching
> - Dictate how the logo is used with the brand signature

"A logo's makeup should define and represent a brand's character." — Denise Anderson, director of Marketing Services for Pershing

A logo is the graphic design application that will be a part of every other brand design application. It is the signifier. It is the identifier. It is the two-second "label" or alarm screaming out which brand or company or person or entity you are dealing with. It carries enormous weight and significance and is the keystone of any graphic design plan. Graphic designers create standards and guidelines for the use of a logo on all applications. An **identity standards manual** is a guide containing approved standard graphic elements of the logo, typographic and color palettes, and brand signature; also called a graphics standards manual or brand standards manual. It also provides a range of possibilities and guidelines for the use of fonts in various combinations and in various applications—both print and digital—as well as guidelines on choosing weights, size, numerals, symbols, bullets, and the use of small caps—for both print and electronic applications. Consistent use guarantees immediate recognition in a cluttered marketplace and ensures integrity of meaning.

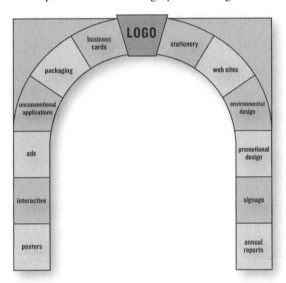

Diagram 6-1. *A logo is the keystone of any graphic design plan.*

For example, here are some pages from the standards manual for the American Red Cross[SM] (Figure 6-15). (Also see Figure 2-1, the graphic guidelines for the Portland Trail Blazers identity and Figure 6-1, excerpt from the standards manual for Joyco.)

Brand Signature Design

The **brand signature** is the combination of the wordmark—the brand's name spelled out in unique typography—and the logo, which can be a symbol mark or a lettermark. It becomes the signature or sign-off for the brand or company. The brand signature can also be made up of the brand name, logo, and tagline or a particular word. For one brand or company, there may be numerous signatures for various divisions of the company or for various purposes and themes. Graphic designers create specific guidelines for the use of the brand signature, delineating proportions, color palette, restrictions and limitations, spacing, heights, and areas of isolation around the logo.

Protection through Trademarks

Trademarks are used by companies to protect their brand assets—brand assets that represent value to the company—through legal protection and registration. Proper and consistent use of trademarks is the key to legally protecting these valuable assets.

A **trademark** is defined as a word, name, symbol, device, or combination thereof that identifies and distinguishes the goods or services of one party from those of others. According to the United States Patent and Trademark Office *(www.uspto.gov)*, "In short, a trademark is a brand name."[1]

According to the United States Patent and Trademark Office: "Any time you claim rights in a mark, you may use the "TM" (trademark) or "SM" (service mark) designation to alert the public to your claim, regardless of whether you have filed an application with the USPTO. However, you may use the federal registration symbol "®" only after the USPTO actually registers a mark, and not while an application is pending. Also, you may use the registration symbol with the mark only on or in connection with the goods and/or services listed in the federal trademark registration."

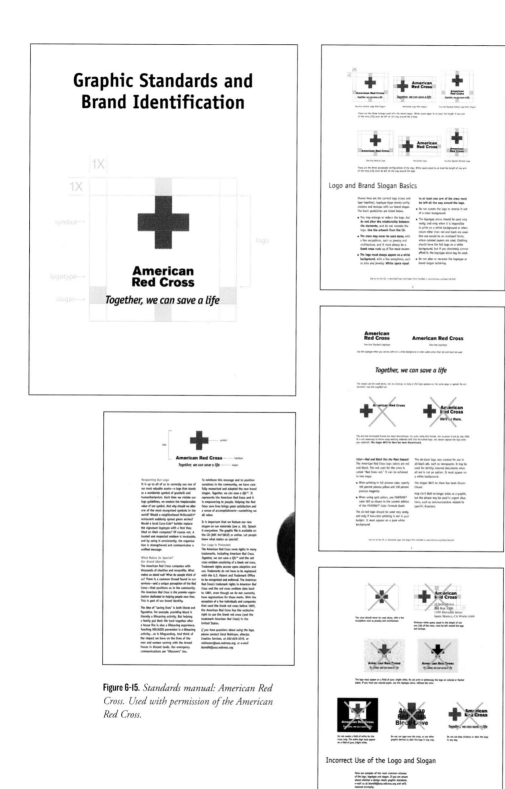

Figure 6-15. *Standards manual: American Red Cross. Used with permission of the American Red Cross.*

The ™ Symbol

The symbol ™ indicates a trademark to "protect words, names, symbols, sounds, or colors that distinguish goods and services from those manufactured or sold by others and to indicate the source of the goods" (*www.uspto.gov*).

The ® Symbol

The symbol ® means that a certificate of registration is held for the specific category and class of the product or service in the country where it is being sold.

The ᔆᴹ Symbol

The symbol ˢᴹ means service mark; it is any word, name, symbol, device, or any combination used to make reference to a brand's unique service. "A service mark is the same as a trademark except that it identifies and distinguishes the source of a service rather than a product" (*www.uspto.gov*).

Color Perceptions and Associations

Color is perhaps the most elusive design element; there are many more variables involved with how people respond to color than with the other visual elements. The perception of color varies greatly from person to person, depending upon culture, physiology, psychology, and exposure to marketing color symbolism. Although, to be sure, we can get a handle on a specific culture's color symbolism and associations, color's wild card manifests itself in both individual response and taste, as well as the challenge of maintaining quality and consistent color reproduction in both print (including light-sensitive outdoor boards) and digital media.

- Color and culture: the symbolism and associations of colors in specific cultures and countries.
- Physiological response to color: the way a particular eye perceives color, and how a person physically responds to color.
- Psychology and color: the way a particular person or cultural group responds to color, and the color associations formed for that person or group.
- Marketing context: the specific color representations that have been established by marketers; for example, in general, orange denotes a tropical flavor as in a beverage, and yellow denotes something lemon-scented, as in cleaning products.

Each culture attributes certain symbolic meanings to colors, and the meanings vary greatly from country to country and even vary between regions within countries. When designing for an international audience, one must be prudent about performing thorough research into color symbolism to avoid any negative connotations.

In certain countries, particular colors have become associated and encoded with marketing context or meaning; for example, green cigarette packaging represents menthol-flavored cigarettes. Green may also mean that a hot beverage, such as tea, is decaffeinated.

The main goals for the color (or color palette) of any brand design is to distinguish the brand in a category and to convey a relevant image to the audience. For example, the color of O's Campus Café is very pertinent to Sibley Peteet's design solution (Figure 6-16).

Case Study from Sibley Peteet Design

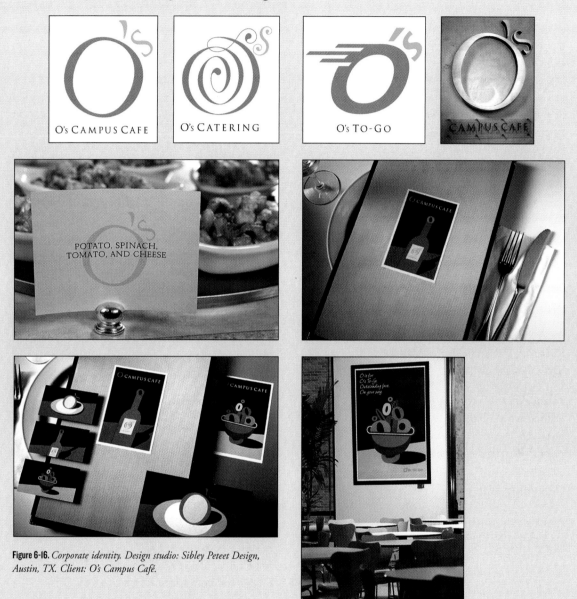

Figure 6-16. *Corporate identity. Design studio: Sibley Peteet Design, Austin, TX. Client: O's Campus Café.*

O's Campus Café

O's Campus Café is located on the campus of the University of Texas, Austin. The concept of the restaurant was to offer something that is smart, healthy, and fresh to the student body. The O implies orange, which represents health and freshness, as well as being the University's color. The significance of the O also provided a not-so-subtle nod to the generosity of the primary benefactor of the new building on the Austin campus, Peter O'Donnell. Three identities were established to differentiate the restaurant's services: O's Campus Café, O's To Go, and O's Catering.

— Sibley Peteet Design

Some designers create custom colors or color palettes for a brand with the hope of distinction. One aim is to utilize a color that other brands do not use, and therefore preempt brands from using it. When a preemptive claim has been established, that color "belongs" to a particular brand and becomes strongly identifiable with that brand. (Certainly, a competing brand could use the same color; however, it wouldn't help to distinguish itself in the marketplace.) "Owning" a color also aids recognition, recall, and brand equity. Some brands legally trademark a color or color palette. When we see a red beverage can, we automatically think of Coca-Cola®. Brands try to "own" a color, just as they own a brand or advertising construct. For example, Coca-Cola "owns" red and goes to great lengths to ensure that the Coca-Cola red is consistently produced on all packaging around the world. To distinguish itself from Coke™, the Pepsi® label is predominately blue.

Another elusive quality of color is how differently it is perceived, depending upon where it is seen and which colors reside next to it. If you've ever studied color theory, you know that the hue or value of a color can appear differently when it is surrounded by other colors that can affect it. Also, another thing to consider is how a color or color palette will look in ink—that is, printed—as opposed to in light—that is, on-screen.

Designing with color

For many designers, marketing executives, and viewers, color is very personal. Most people, whether they are designers or accountants, find some colors more attractive than others. You could show the same logo design printed in two different colors and get very different reactions due to the color choice. Although there are market-driven color associations, many designers rely on their sensibility and intuition when dealing with color and color palettes. Along with trusting one's sensibilities, appropriateness for the brand and audience are paramount considerations when deciding upon a color palette.

Sometimes breaking the laws of color can be the right thing to do. In creating a distinct identity, it's better to be different than to use the right symbolic color. Car rental companies are a perfect example of this. Hertz's color is yellow, Avis is red, and National is green. Each has created its own distinct, yet appropriate, color personality. "Remember, it's okay to be different, but it must be with a clear purpose in mind," advises Richard Palatini, senior vice president and associate creative director, Gianettino & Meredith Advertising.

Since color is so very elusive, as well as personal, one needs to be diligent in several arenas:

- Color marketing denotation
- Cultural meaning and connotation
 A designer must be prudent and conduct careful research.
- Current market symbolism and current trends in the category
 If all deodorants are silver, then don't use silver. Break with the category, while still being appropriate for the product, service, or group. Know the competition's colors. As with type and logos, there seem to be trends and trendy color palettes; whether one designer sets the trend or everyone is designing in retro palettes, it does happen. Avoid following trends; think conceptually about color. Looking like everyone else's design doesn't build brand equity or distinction. Use a color or color palette vastly different from the competition.
- Being creative with color combinations
 People's decisions to buy can be swayed or even reversed by color. Color can be used to create an image and brand personality.

Color in combination with form can be very expressive, as in the work created for Yumi (Figure 6-17), a corporate identity developed for a new fast-food chain specializing in healthy Asian food.

Case Study from Mattmo Concept | Design

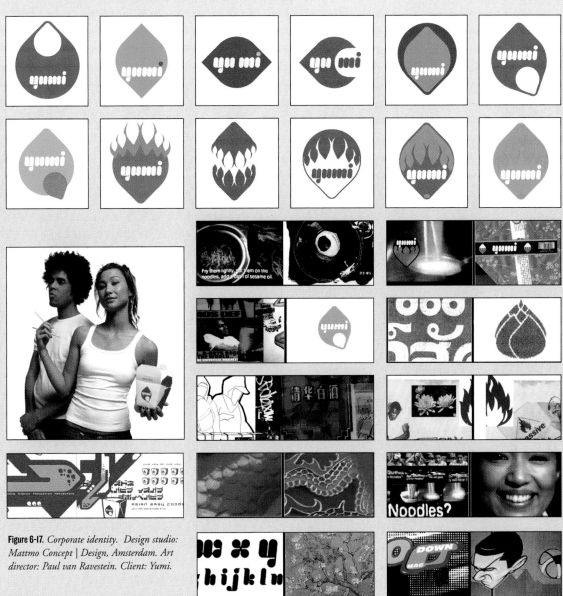

Figure 6-17. *Corporate identity. Design studio: Mattmo Concept | Design, Amsterdam. Art director: Paul van Ravestein. Client: Yumi.*

Yumi

The logo is a combination of fire, a lotus flower, and a leaf. These are the typical icons of the two cultures we joined in the visual language of the Yumi identity. This also holds true for the typography, in which calligraphic Asian signs and graffiti have similar characteristics.

The abstraction of the typography in the name as well as of the form refers to an international, worldly atmosphere. The colors for the logo have been expressly chosen to move away from a Western character. This brand is food with a strong cultural taste, and ingredients with their own identity: East meets West stays best. The best and most appetizing of different cultures are harmoniously combined.

— Mattmo Concept | Design

When a budget allows for more than one color or a color palette, a designer can use one or more colors for the logo, and assign a different color to the brand's tagline or descriptor. If one has a two-color budget, the logo symbol can be the principal color, and the tagline or descriptor is assigned another (supportive) color.

Typography

In the design of a brand identity and brand experience, typography is a key element in visual communication. A large part of a brand's individuality stems from its typography. Unity throughout a brand identity and across the brand experience greatly relies on typography, and a viewer's ability to recognize a brand greatly depends upon thoughtful typography.

Virtually every graphic design application incorporates typography. When designing with type, there are some fundamental concerns that every designer must address. Those are:

- Readability
 How easily text may be read.
- Legibility
 The ease with which text can be understood or recognized.

- Visual Hierarchy
 Typography should contribute to the ordering of information and greatly aid the visual hierarchy; sizes, weights, and alignment may all assist visual hierarchy.
- Context and Flexibility
 One brand may be experienced in a wide variety of venues, such as a web site, packaging, and television commercial; therefore, where the type is seen drives how the type should be designed. Typography should work well in almost all contexts and in a variety of sizes.
- Range
 The identity standards manual should provide a range of possibilities and guidelines for the use of fonts in various combinations and in various applications, both print and digital, as well as guidelines for choosing weights, sizes, numerals, symbols, bullets, and the use of small caps, for both print and electronic applications.
- Display vs. Text
 Display and text type should be distinct. It's best not to use display type, especially special or novelty fonts, as text. In most cases, text type should enable easy reading.
- Size
 A designer's sensibility often dictates size; at other times requirements will dictate the size. There are some federal regulations concerning type size on consumer product packaging, visual communication, and advertising. You should research the regulations for individual countries, and make sure font selections work well in both small and large sizes.

Brand image support

- Character
 The individual characteristics and qualities of a font contribute to its personality, which will communicate on a connotative level to the audience. The font choice should bolster the brand image.

- Compatibility

 Select appropriate fonts to complement the brand signature; that is, letterforms that are visually compatible, interesting, and harmonize with the right tone and voice for the brand.
- Appropriateness

 Choose fonts that are suitable for the brand, project objectives, and audience, and are the right tone and voice for the brand.
- Font selection and combinations

 Choosing one or more fonts from an extremely wide variety of available ones is a difficult task. Some designers utilize classics, the ones that have been workhorses throughout design history, such as Baskerville, Bodoni, Caslon, and Garamond. Give your selection some visual variety to maintain interest; it's best not to have a monotone, flat appearance where everything looks the same. Conversely, keep font selections to a maximum of two faces per piece, usually a serif and sans-serif face, advises Steven Brower, principal at Steven Brower Design. Denise Anderson, director of Marketing Services for Pershing advises: "Choose only two fonts per application and use the variety of weights and styles for variation."
- How type works with an image or images

 One must carefully consider how the type and image interact, how they communicate together to send a message. The type and image should complement each other in one of two fundamental ways: the type and image are similar in form and personality, and they look like they are relatives, as demonstrated by the Yumi identity program (Figure 6-17); or the type and image are purposely different in a particular effect, such as an ironic effect, or a purposeful contrast.
- Type for the logo or brand

 Often, a font will be custom-created for a brand so that the brand is the sole owner of that font; one of its merits is distinction.

Taglines

- "The Toughest Job You'll Ever Love." (Peace Corps)
- "Just Do It™." (Nike)
- "Do you have the bunny inside?™" (Energizer batteries)
- "Savor the World.™" (noodlin')

A **tagline** is a short succinct phrase, catch phrase, or end statement that embodies the broad strategy of a branding program and/or an ad campaign, establishing something memorable, particular, and clear about the brand; along with the name, a tagline is the verbal articulation of a brand. The tagline is also called a brandline, claim, slogan, endline, or strap line. As does a logo, a tagline encompasses and compresses a huge amount of communication into a small bundle—the catch phrase. In the case of a tagline, a great deal needs to be conveyed in a few words; what needs to be communicated is the brand benefit or spirit, which generally acts as an umbrella theme or strategy for a branding program, often including an advertising campaign or a series of campaigns.

When the client's strategy is strongly asserted in the tagline, concepts for graphic design applications and ads may follow suit more easily. If for any reason a design or an ad concept isn't fully communicated, the

TAGLINES MAY BE SUCCESSFUL WHEN THEY:
- are relevant to the audience
- become memorable (for example, "Don't Leave Home Without It.®" American Express)
- can differentiate (for example, Pepsi-Cola differentiated itself from Coca-Cola with the "Pepsi Generation")
- sound conversational, not like a sales pitch (for example, "Got milk?™")
- are adopted into the common lexicon (for example, "Where's the Beef?™" for Wendy's, or "Loose Lips Sink Ships," for The Office of War Information, U.S. Army, U.S. Navy, and the Federal Bureau of Investigation)

tagline can clarify, or round out, the communication, advises Gregg Wasiak, creative director at The Concept Farm. The following taglines help to round out the meaning in any of their applications:

- "See what develops.™" (Polaroid)
- "Friends Don't Let Friends Drive Drunk." (U.S. Department of Transportation)
- "Apathy Is Lethal." (Aids Awareness)

The idea for the tagline sets the platform for the entire branding and advertising campaign; all parts of the brand experience should embody the same spirit and communicate the same strategy.

Point of View

Who is talking? In whose voice is the tagline written? The voice of the company? A friend's voice? Relating to the audience from their point of view rather than the corporation's point of view could be beneficial; it is a good approach, one that might lend relevance to the tagline. Cabell Harris, of Work Inc. advises: ". . . direct, honest, and understated communications." Harris's wisdom could be a mantra for all brand taglines—or any communication, for that matter.

Functional vs. Emotional Benefits

A **functional benefit** is a practical advantage or *functional capability* of the brand, such as a particular ingredient or the speed of the technology.

For example, the former Timex tagline "It Takes a Licking and Keeps on Ticking™" states the benefit of a sturdy timepiece, or "Melts in your mouth, not in your hands," for M&M's® candies. Another example is the concept and tagline for noodlin' "Savor the World" created by Sandstrom Design (Figure 6-18), where Sandstrom focused on the benefit of a restaurant that offers noodles from all over the world.

An **emotional benefit** is an intangible gain derived from using the brand or an affecting feeling consequential to the brand or by appealing to one's sense of social responsibility, such as raising one's self-esteem

Case Study from Sandstrom Design

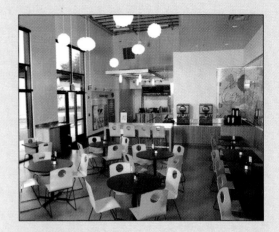

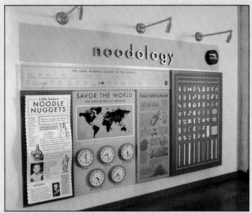

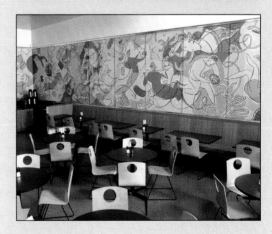

Figure 6-18. *Brand applications. Design firm: Sandstrom Design, Portland, OR. Client: noodlin'.*

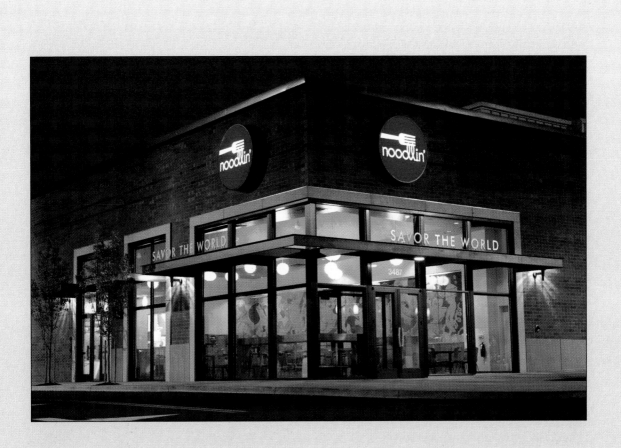

noodlin'

For many years, the Portland area has enjoyed the taste and ambience of a 37-location chain of quality, fast-food Burgerville restaurants. Competing with huge national chains, they have successfully carved out a market niche with high-quality ingredients and customer service. But the market is saturated, and the parent company was looking for a new restaurant concept that would allow them to increase their market share in Portland, and, perhaps, grow outside the area.

Sandstrom Design was hired to assist in the development of this new concept, in the market sector known as fast casual. We discovered an opportunity for an interesting and engaging restaurant concept that focused on the international popularity of pasta, noodles, and rice. Although most markets were fully served by Chinese, Japanese, and Italian restaurants, none provided them with an international assortment of high-quality dishes.

The concept was named noodlin', and a playful and symbolic logo was quickly developed along with the "Savor the World" tagline. Working closely with an architectural firm, Sandstrom Design developed interior graphics and wall murals that were both welcoming and appropriate. We applied the new identity to cups, napkins, signage, menus, and menu boards. We even developed custom displays, take-out bags, and order number cards.

Perhaps the biggest surprise for first-time visitors is the Noodology wall. Parallel to the order counter is a 20-foot display of noodle knowledge. A historical timeline maps major milestones, a chart featuring illustrations of more than fifty noodle varieties, and a quick introduction to the growing and processing of durum wheat used in noodles and pasta is provided for curious visitors.

— Sandstrom Design

by using the brand—such raised self-esteem could be gained by using hair coloring, or feeling altruistic by stopping a friend from driving drunk.

"Just Do It™" (Nike) appeals to one's sense of athleticism and personal best, rather than touting a functional benefit, such as the quality of the craftsmanship or fit, of the Nike line of athletic shoes and clothing. The efficacious tagline "Friends Don't Let Friends Drive Drunk" works because there is an emotional appeal to intervene, to take action in order to prevent a potential tragedy.

When a tagline sounds like a bad advertising sales pitch, it makes the brand seem unrelated to people's needs; it seems extraneous and contrived.

Once you've written a tagline, read it aloud. Does it sound contrived? Does it make sense? Is it punchy? Would you say it in conversation? Would someone easily remember it? Does it establish a strategy and personality? Besides sounding like something you'd say to your friend during a conversation, these lines must do something that is vital to copy and successful advertising: they must embody the strategy of the brand. And successful copy doesn't sound like a sales pitch, it sounds conversational.

The Top Ten Slogans of the Century, according to *AdAge.com/century:*

1. "A diamond is forever.™" (De Beers)
2. "Just Do It.™" (Nike)
3. "The pause that refreshes.™" (Coca-Cola)
4. "Tastes great, less filling.™" (Miller Lite)
5. "We try harder.™" (Avis)
6. "Good to the Last Drop!™" (Maxwell House)
7. "Breakfast of champions.™" (Wheaties)
8. "Does she . . . or doesn't she?™" (Miss Clairol)
9. "When it rains, it pours.™" (Morton Salt)
10. "Where's the beef?™" (Wendy's)

TAGLINE POINTERS
- Aim for specificity—make it specific to the brand; avoid generic claims. Here's a test: If you can use the tagline for other brands, products, or services, then it is too generic.
- Study how people actually use the brand or product or service. Also, don't dismiss functional benefits which may add specificity.
- Say it in the vernacular—avoid clichés or things someone wouldn't say in conversation.
- Research the meaning of your words or phrase or idiom for a worldwide audience. What might work in one language or country, may not work when translated literally into another language for that culture. For example, for Crime Prevention "Take A Bite Out Of Crime™" didn't translate well in Mexico, where the idiom had a negative connotation.
- Make it sound contemporary, not dated. For example, ad agency Kirshenbaum Bond & Partners wrote the new tagline for Timex. The old slogan—"It Takes a Licking and Keeps on Ticking"—was introduced in the 1950s and revived in the 1990s. The new tagline for Timex is: "Life Is Ticking.™"
- Ensure a long enough life span.

Notes

[1] Your country's intellectual property office can help you with the process of developing or registering a trademark, and provide information on how to establish trademark rights.

Chapter 7

Designing Brand Identity Applications: Identification Graphics

There are many opportunities to communicate a brand message, from the visual design of corporate correspondence to the signage used in a branded environment. A good part of branding involves graphic design applications that identify a brand in various ways—stationery and business cards, branded environments and signage, and packaging—with some overlapping promotional purposes.

From stationery to packaging, all experiences a viewer has with a brand must speak the same graphic language, as in the branding for Capezio® Troupe™, where all the materials reinforce Capezio's commitment to providing the highest quality products and responsive service (Figure 7-1).

From the beginning and throughout the life of the brand, all creative professionals involved should be on the same wavelength to ensure resonance and consonance. Some common elements across the brand experience and among applications are:

• Core concept
• Logo
• Tagline
• Color or color palette
• Fonts
• Type sizes and weights
• Abbreviations and titles
• Graphic elements
• Signature
• Illustrative elements
• Photographic elements
• Tone of voice
• Attitude of imagery and copy
• Descriptive writing

Stationery

Stationery is a staple of business communications, formally and visually representing the brand's quality and personality to several audiences, including customers, business partners and contacts, and employees.

When designing stationery, every design decision counts, from the typography to the placement of the contact information. Whether it's the paper weight or the color palette, each aspect of the design is an opportunity to present a consistent brand identity. Usability (for example, enough space for written content) and recognizable brand elements are most important in effective stationery design.

As in any visual communication work, a major consideration is an application's function. Stationery is used as a formal, written corporate communication (either in print or digital format) *and* as a substrate for communication that identifies the brand, parent company, or group.

Components of a Stationery System

• General letterhead (short and long) and general envelope
• Executive letterhead (short and long) and executive envelope
• Digital letterhead (customized variations to meet specific needs of the company)
• Fax cover sheet
• Contracts
• Invoices
• Memos
• Large envelope
• Window envelope
• Mailing label

Maintaining a brand's identity—a unique and identifiable one—is paramount. Establishing guidelines for corporate use ensures that the stationery is one part of an entire cohesive brand experience. Earlier examples of stationery solutions that are part of an entire branding experience were shown for Enlace (Figure 1-7), EAT (Figure 5-5), Star Alliance (Figure 5-12), and noodlin' (Figure 6-18).

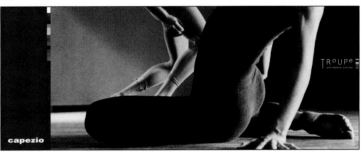

Figure 7-1. *Branding. Design firm: Liska + Associates, Chicago, IL. Client: Capezio.*

Logo. Designer: Tanya Quick. Art director: Tanya Quick.

Stationery. Designer: Fernando Munoz. Art director: Tanya Quick.

Troupe brochure. Designer: Fernando Munoz. Art director: Tanya Quick. Photographer: Avis Mandel. Copywriter: Laurel Saville.

Packaging. Designer: Fernando Munoz. Art director: Tanya Quick.

Capezio has sold shoes and clothing for dance, theater, and athletics for more than a hundred years. In 2001, the company launched a new collection of bodywear, sold to specialty dance clothing retailers. The line includes basic pieces that are available in the customer's choice of fabric and color options. Liska helped Capezio name and define the new brand. We then created a complete program of sales materials, packaging, point-of-purchase materials, and product information for the line. Since Capezio developed Troupe in response to requests for customized orders, we designed order forms that simplified the traditional purchasing process.

— Liska + Associates

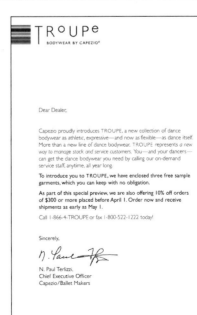

Many clients and designers think of stationery in a conventional way. Others, such as exemplified by the following solution from Rethink—stationery and business cards made up of fifteen removable stickers (Figure 7-2)—and the solution by Unreal shown in Figure 7-3, see stationery as an opportunity to differentiate and involve.

Letterhead

A **letterhead** is a sheet of stationery or digital page with the name and address of the brand, parent company, group, or organization printed on it; most often, it is part of a larger visual identity stationery system with consistent elements—such as the brand name, logo, color palette, and format or any graphic element or verbal component associated with the brand or brand signature—that allow for identification of the brand. Very often, the pertinent information resides at the head (or top) of the page—hence the term letterhead.

For any brand, it is vital to "own" a look and feel, one that is distinctive, such as the solution for 747 AM™ (Figure 7-4) and for Pavlov Productions (Figure 7-10).

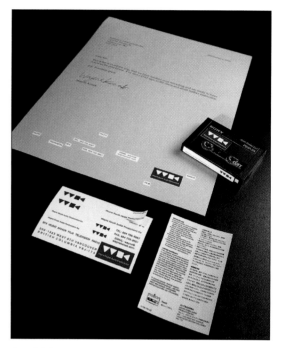

Figure 7-2. *Stationery. Agency: Rethink, Vancouver, British Columbia, Canada. Client: Wayne Kozak.*

Wayne Kozak Audio Productions specializes in audio and sound design for television, radio, and film.

Figure 7-3. *Stationery. Design firm: Unreal, U.K. Designer: Brian Eagle. Client: Three Eyes Limited.*

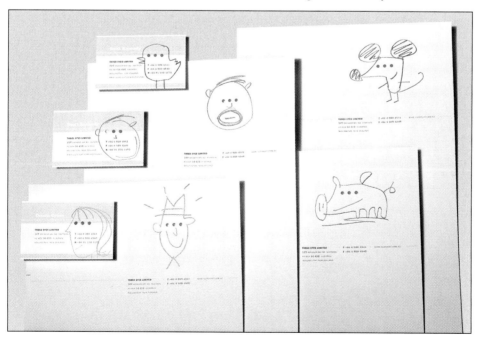

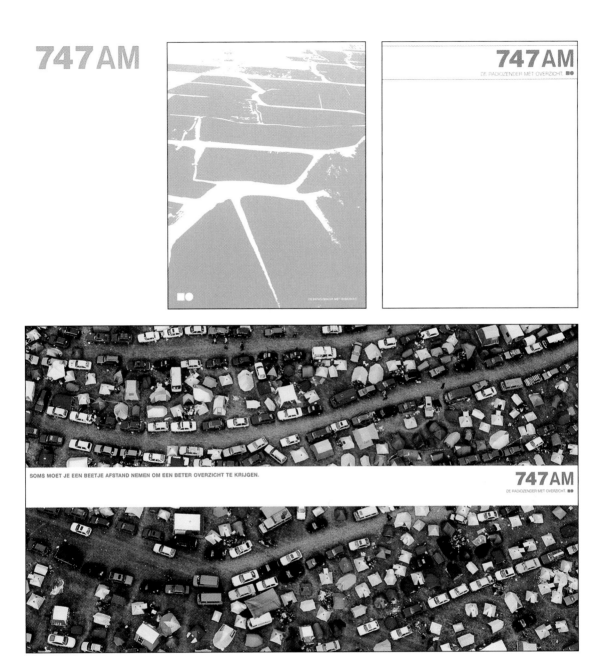

Figure 7-4. *Letterhead and campaign. Agency: KesselsKramer, Amsterdam. Strategy: Barbara Combee and Matthijs de Jongh. Art directors: Erik Kessels and Krista Rozema. Copywriter: Johan Kramer. Client: 747 AM.*

A radio brand was reincarnated in the Netherlands: "Radio 5" became "747 AM." It's not so much a reintroduction as an introduction to a new radio station on the 747 AM frequency.

The campaign presents 747 AM as a radio station that looks at the world from a bird's-eye view. What you see as an aviator is a metaphor for what you hear as a listener.

That way, it becomes clear that the station maintains a distance from the issues of the day in the programs broadcasted, that it offers room for a detour in this age where everybody appears to be hurried, and that it's a place from which you can travel with your eyes closed. 747 AM gives the listener the opportunity to expand his view and see things from a different perspective.

— KesselsKramer

Figure 7-4 continued. *Campaign. Agency: KesselsKramer, Amsterdam. Strategy: Barbara Combee and Matthijs de Jongh. Art directors: Erik Kessels and Krista Rozema. Copywriter: Johan Kramer. Client: 747 AM.*

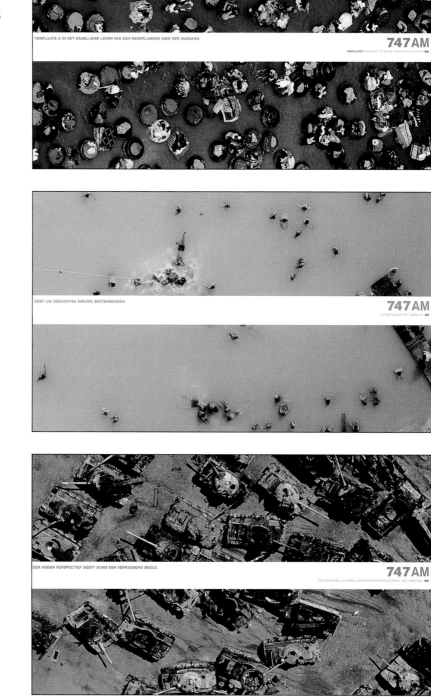

Designing Brand Experiences

Guidelines and Specifications

Providing the client with guidelines for production specifications will ensure that all employees using and ordering stationery will understand and communicate the proper, established brand image.

Some guidelines and specifications to provide the client with are:

- Parameters for the positioning of letter content
- Position, size, and color of logo
- Position of logo in brand signature
- Use of other corporate logos in conjunction with the main brand logo
- Font, color, and alignment of operating corporate unit
- Font, color, and alignment of address
- Letterhead size, both national and international (U.S. standard size letterhead is 8 1/2" x 11")
- Guidelines for second sheet
- Paper stock (content, weight, finish, color)
- Printing method

Paper selection

As a general pointer, it is beneficial to visit paper shows, usually hosted by local design clubs, in order to learn about the latest available papers. Become familiar with a variety of paper companies, including those that offer tree-free papers and recycled paper; for example, the reused materials for the cards that were designed for the Association of Charity Shops by Unreal (Figure 7-5).

Consider the following points in paper selection for letterhead:

- Surface quality and texture
- Compatibility with laser printers
- Paper color in relation to ink colors and brand colors
- Stock availability
- Content: tree, tree-free, or recycled
- Cost
- How the paper takes ink (you must see samples)
- How the letterhead paper coordinates (in surface quality, texture, and color) with the business card paper (business card paper stock will be heavier)

Major printing processes:

- Offset lithography
- Gravure
- Flexography
- Screen printing
- Nonimpact (which includes electronically driven ink-jet)
- Letterpress (although no longer popular)
- Specialty processes:
 - Engraving
 - Embossing
 - Watermark
 - Foil stamping

IMPORTANT POINTS
- Design enough space for letter content
- Provide vital contact information
- Utilize consistent elements within the entire brand identity
- Design a look and feel that is consistent with the entire brand identity and other brand applications
- Design a second sheet which does not need to contain all the information; it can contain the logo and some of the design elements
- The experience with the letterhead should enhance the bond between the reader and the brand
- Make the design relevant to your audience

PRACTICAL CONSIDERATIONS
- Faxes well
- Works well both in print and on-screen and is Internet appropriate
- Ensure paper quality and appropriateness
- Works well in a printer and with black printer ink for text type
- Enough room for content
- Easy to read
- Conforms to regulation sizes for international office use
- Second sheet coordinates well with the letterhead

Process of designing and producing the letterhead

Once the analysis, strategy, and design concepts have been generated and agreed upon, it's time to design and produce the end result. The brand strategy and concept are now expressed in the letterhead design.

The design process entails:

- Identifying the components of the stationery system
- Acquiring the necessary content information
- Designing all parts, both print and digital
- Choosing paper and ink
- Working with the printer to:
 - Manage production
 - Review the proofs
 - Supervise the press run

Business Card

Besides television advertisements that come into your living room, a business card is, perhaps, the most intimate brand design application. Often passed from hand to hand, a business card quickly and directly tells its reader who you are, what you do, with whom you are affiliated, and how to contact you. Even when a business card is enclosed within correspondence, its small size begs intimacy.

A **business card** is a substrate—a small card—on which a person's name, business affiliation, and contact information are printed; most often, the business card is an integral part of a larger visual identity system which adheres to a corporate or company brand look.

Most large corporations or organizations issue both general and executive business cards. Usually, there are small differences between the general business card, used by a large percentage of employees, and the executive card, used by a small executive group; those differences may be in the paper quality, paper color, printing, or, perhaps, the brand signature. General business card paper stock is usually coordinated with

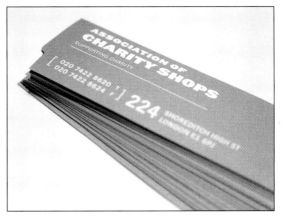

Figure 7-5. *Business cards. Studio: Unreal. Design: Brian Eagle. Client: Association of Charity Shops.*

Brian Eagle utilized reused materials for this stationery. To form a business card, an Association of Charity Shops sticker is applied to a London Underground™ card or to a cut-up cereal packet.

the paper of the general stationery; likewise, executive cards are coordinated with the executive stationery.

It's always interesting—if appropriate for the client—to think about materials, besides paper, that can be employed in communicating the brand essence, as in these following examples that make creative and appropriate use of materials for different solutions (Figures 7-6 through 7-8).

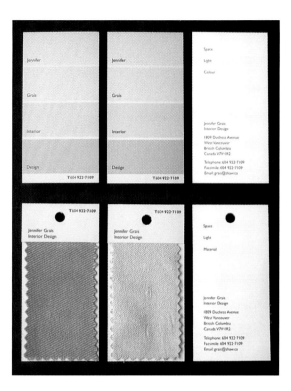

Figure 7-6. *Business card. Agency: Rethink, Vancouver, British Columbia, Canada. Client: Jennifer Grais.*

Here are two business card designs that are completely appropriate for this client.

Figure 7-7. *Business card. Agency: Rethink, Vancouver, British Columbia, Canada. Client: Roger Grais Carpentry.*

These business cards were made from real pieces of sand paper.

Roger Grais Carpentry has been in business for twenty-one years and operates out of North Vancouver.

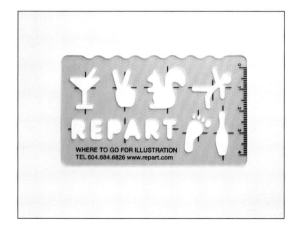
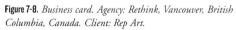

Figure 7-8. *Business card. Agency: Rethink, Vancouver, British Columbia, Canada. Client: Rep Art.*

Rep Art™ is a Vancouver-based agency representing commercial illustrators and photographers from across North America.

Identity Standards for Business Cards

Establishing coherence entails creating identity standards and then employing them consistently. For both general and executive business cards, the standard content guidelines usually include:

• Name
• Job title
• Organizational corporate unit or department name
• Address or office location
• Phone and fax numbers
• E-mail address(es)
• Web address
• Any additional guidelines for digital business cards

Either the client or the designer specifies such elements as the name structure, acronyms, position of professional titles, capitalization, abbreviations, identifier formats, use of reverse side, and any other relevant information with examples.

Since business cards must include critical contact information and the brand logo on a small surface, there is usually no other information included on a card. Limiting the amount of information on a business card can aid a viewer's ability to glean information.

Business Card: Reverse Side

To include more information or graphics, some design a two-sided card, utilizing the reverse side of cards. And although most cards do *not* have printed information on the reverse side, some designers find it a wonderful "canvas" for expanding the brand experience and engaging viewers.

There are many good reasons to employ the reverse side of a card, especially in a global marketplace. A reverse side may hold any of the following information or graphic elements:

• ISO certification (the International Organization for Standardization is a network of the national standards institutes of 148 countries, which coordinates the system of standards for industrial and business organizations of all types, among other things: *www.iso.ch/iso/en/aboutiso/introduction/index.html#two)*
• Translations (international brands and social organizations, in particular, may want translations on the reverse side of cards)
• Additional phone numbers and office locations
• Brand division signature
• Other graphics that are related to the brand experience

Business Card Production Specifications

Providing the client with guidelines for production specifications will ensure that all employees using and ordering business cards will understand and communicate the proper, established brand image. Although some of these points are general, and can pertain to all brand applications, it's important to list all necessary guidelines to maintain consistency throughout the brand identity.

Make sure to provide the client with the following:

• A template that delineates:
 - size and color of logo
 - isolation area around logo
 - font, size, and color of name, title, addresses
 - where the specific content should reside
• Card size for national and international use
• Paper stock for general and executive cards: content, weight, finish, color
• Printing method for front and reverse sides

Branded Environments and Signage

Branded environments and comprehensive signage systems can be coherent and act as an integral part of any brand experience. Thoughtful signage not only provides information and aids means of access, it also reinforces the visual identity and expands the brand experience, such as the brand experience for the American Folk Art Museum (Figure 7-9).

Examples of branded environments and signage include:

• Corporate buildings and other offices
• Research facilities
• Assembly plants
• Wayfinding signs within a corporate structure
• Museums
• Zoos
• Airport terminals
• Retail environments
• Shops
• Restaurants
• Sports stadiums

Signage should reflect the brand personality and utilize key visual elements of the brand identity. The positioning of signage within any environment should be consistent and thoughtfully related to the viewer for ease of readability, maximum visual effect, and access.

The designer—or entire environmental creative team—needs to establish guidelines for use of signage regarding dimensionality and position. For example, can the logo be used as a sculptural or freestanding architectural element? Can the logo be etched or carved into walls or doors? Materials and colors need to be specified, as well.

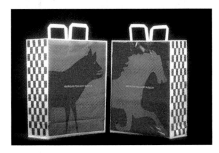

Figure 7-9. *Identity. Design firm: Pentagram, New York, NY. Client: American Folk Art Museum.*

This identity includes a new graphics program designed to accommodate traditional and contemporary forms of folk art, launched with the museum's move to a dramatic new building.

— *Pentagram*

AMERICAN FOLK ART MUSEUM

Packaging

Packaging contains more than a product—it contains the brand essence.

Besides promoting a brand, packaging is functional. **Packaging design** is a graphic design application which operates as the casing, as well as to attract a consumer and to present information; it is an amalgam of two- and three-dimensional design, promotional design, information design, and functionality. Packaging encloses a product and also allows access to the product (enables you to open it easily, pour from it, reclose it, and so on). The user is deeply affected by "how" they will be able to "get into" a package.

Any packaging has several surfaces and all must be considered in the design. Most packaging is displayed on shelves where we see the cumulative effect of several packages lined up next to one another. Packaging is also seen next to competing packaging. Online shopping may change how we react to packaging; however, once we get packaging home, we interact with it. Often, we take pleasure in looking at well-designed packaging. It may seem obvious to state that any well-executed, excellently designed packaging (or web site or any design application) sends a message of overall excellence about a brand to a client. The packaging for Pavlov Productions (Figure 7-10) was so successful that one customer said he hired Pavlov Productions specifically because of the well-designed case.

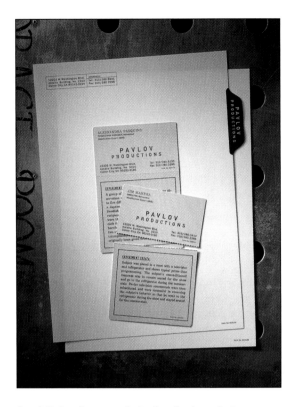

Figure 7-10. *Branding system. Design firm: Sandstrom Design. Client: Sony Productions.*

*Sony**Productions was in the business of developing television commercials for advertising agencies. They were competing with a number of production companies who had the luxury of independence and brand personality, which the name Sony did not provide. They therefore asked Sandstrom Design to develop a new name and branding system for them.*

The name Pavlov Productions was suggested and approved, primarily because of Pavlov's study of behavior modification. The branding system, which includes a full assortment of business papers, marketing materials, and office design, was developed to reflect the Pavlovian world.

Business cards included a tear-off experiment segment, which summarized another study that proved that Pavlov-produced ads were amazingly effective. A series of print ads provided even more detail. We did not design a logo for Pavlov Productions, because it just seemed like Dr. Pavlov would not need one.

IX

WHY PRODUCE AN ORDINARY TELEVISION COMMERCIAL WHEN YOU COULD PRODUCE A VIDEO CONDITIONED RESPONSE?

The next time you begin working on a television commercial, ask yourself what the real goal is. Do you hope to entertain your audience? Do you hope to impress awards show judges? Do you hope to attract the attention of a bigger, more prestigious agency with hopes of obtaining a bigger and more prestigious salary? Unfortunately, none of these goals represent what you should be striving to achieve: TOTAL DOMINATION OF THE CONSUMER'S MIND. You want them mesmerized by your commercial and filled with the irrational desire to possess your product AT ANY COST. You want to achieve a VIDEO CONDITIONED RESPONSE. You want a commercial produced by PAVLOV PRODUCTIONS.

We have brought together some of advertising's most talented directors and applied the tried and true principles of BEHAVIORAL MODIFICATION to their work. The result is a series of advertising messages so powerful that

they become permanently imprinted on the viewer's cerebral cortex, insuring a long-lasting, instinctive response that will have them buying your client's product over and over and over again, without even wondering why they are doing it. Sound intriguing? We thought so. Call 310-280-8941 now and request

a reel of PAVLOV PRODUCTIONS lab samples for viewing today. Play it through three or four times a day for a week. Soon you'll feel compelled to bid us on a job. And you'll probably have no idea why.

IV

LEARN THE SECRETS OF **MIND CONTROL** AND **WIN** THE RECOGNITION YOU DESERVE

We may be stating the obvious to tell you that advertising awards show judges are people too, but, with a few notable exceptions, they are. And that makes them immensely susceptible to the advanced mind control techniques pioneered by PAVLOV PRODUCTIONS. It's our unique method of blending state-of-the-art production know-how with behavioral modification theory that has given us the ability to produce commercials with the highest VCR (Video Conditioned Response) in the industry.

Let's see how this might work to your advantage in a real judging situation. The awards show judges have been sitting in a dark room watching ads for so long that instead of writing down scores they are reduced to making cat calls and obscene gestures at the television monitor. They have begun threatening the person

manning the tape deck. Anarchy is breaking out all over the place.

Now imagine the next spot they see is your commercial, produced with powerful mind control techniques by PAVLOV PRODUCTIONS. A calm descends over the room. Judges watch with looks bordering on rapture. As the commercial ends, they rise as one and vote unanimously to give your ad "Best of Show." They all experience such a feeling of well-being that they adjourn to the bar and spend the rest of the day doing tequila shots and playing Twister. It could happen. In fact, if you produce your next commercial with PAVLOV PRODUCTIONS, we can practically guarantee it will.* So pick up the phone and call 310-280-8941 for a sample reel. And clear off some space on your shelf.

By "practically guarantee" we mean that while we don't exactly guarantee the judges will get drunk and play Twister, we do sort of guarantee it. If you're unsure as to what this means, call us and we'll arrange for one of our behavioral modification experts to make you believe you have a guarantee, which is very nearly as good as actually having one.

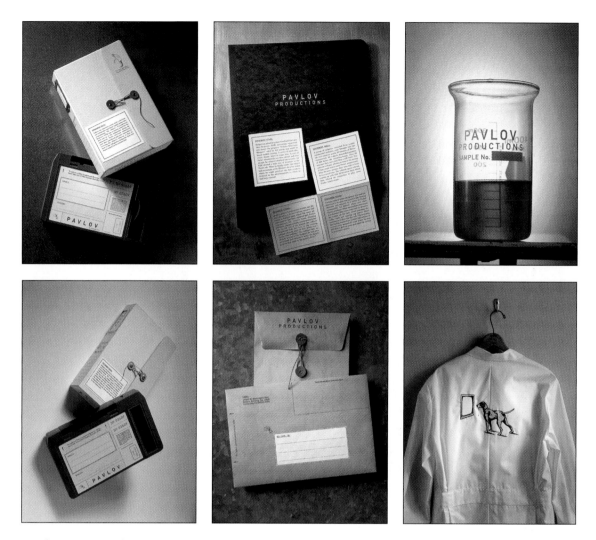

Branding system. Design firm: Sandstrom Design.
Client: Sony Productions.

Perhaps the most impactful piece was the unique videocassette case, which carried the sample reel to creative directors at advertising agencies. They normally received reels in the standard plastic shipping case provided by the manufacturer. Sandstrom Design created a case that could have come from Pavlov's lab. One customer said they hired Pavlov Productions specifically because of the case. "When I saw how great the case was, I figured you would be able to take care of me," he stated.

The complete system also included lab coats for staff with a salivating dog standing before a television screen, and beakers for office glassware with the Pavlov name imprinted on them.

— Sandstrom Design

Packaging is a very important part of the brand experience; some say it is most important since the consumer has close contact with the product when shopping. The following are some examples of packaging that distinguish their brands among the competition with solutions that are relevant to their respective audiences (Figures 7-11 and 7-12).

Case Study from Doyle Partners

Figure 7-II. *Graphic identity. Design firm: Doyle Partners, New York, NY. Client: Martha Stewart.*

Housewares. *The package design explains the product assortment, emphasizes the product design, and is "magnetic" to shoppers in a mass-market environment—Kmart, the second largest retailer in the world.*

Flatware. *Flatware is typically sold in opaque, sealed cardboard boxes. These packages allow consumers to see and feel the actual utensils. A grosgrain ribbon, on the 64-piece set, adds a decorative touch.*

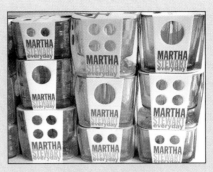

Beverageware. *These four-pack casings are sculpted to maintain maximum strength while clearly revealing the glassware inside. Light shines through, giving shoppers a better appreciation of the design of the product.*

Barware. *This minimalist package lightly frames the product so it can be experienced first-hand—and still meets strict shipping standards.*

Bakeware. *Cooking is fun again. Utilitarian bakeware comes in bright, friendly packaging with recipes and how-to's included with each item.*

Martha Stewart Everyday

Doyle Partners created the graphic identity for the Martha Stewart Everyday™ brand in 1997. Since the launch, we've created extensive packaging, in-store signage, and shopping environments as the brand rapidly grew.

As a brand, Martha Stewart Everyday is equal parts information and inspiration; the package design brings these core concepts to the retail experience. Simple typography, striking colors, and easy, accessible design show each product to its best advantage and enliven the shopping experience. Carefully conceived product photography and information (recipes, how-to's, and references to complementary products) educate and encourage the shopper to enjoy and explore the brand.

In a mass-market shopping experience, the simple authority and exuberance of the Martha Stewart packaging commands consumer attention and trust—and record-breaking sales. In just three years, the program has achieved annual sales of $1.4 billion.

— Doyle Partners

Gadgets. *A wall of over 150 gadgets is tamed and organized for the shopper by a disciplined grid and uniform packaging.*

Paint. *Paint is only paint while it's in the can; as soon as you put it on the wall, it's color. What we're selling here is a palette—colors that go with other colors. The paper used to label the cans communicates the finish of the paint—glossy paper used on cans of gloss paint, matte stock for flat paint.*

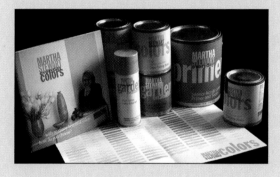

Baby. *Delightfully patterned boxes are not only packaging, but gift boxes (for baby showers) and, once at home, a keepsake box.*

Garden and Grill. *The exuberance and clarity of the Martha Stewart Everyday line was brought outdoors for the garden program. A color-coded system for live plants helps weekend gardeners choose appropriate annuals and perennials.*

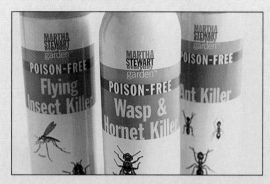

Bug Spray. *Bright colors, simple typography, and etymologically correct illustrations are to the point.*

Seeds. *Design and color organize an array of hundreds of small seed packages. Thoughtful photography gives gardeners a sense of scale—most packages show a hand holding a small bouquet.*

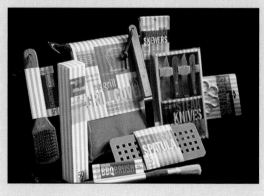

Grill. *Bold stripes on buff-colored paper unify a hard-working product assortment.*

MISSION BELLE
Two-Piece Mission Roofing Tiles from Deleo Clay Tile

Figure 7-12. *Identity and packaging. Design firm: Mires, San Diego, CA. Creative director: Jose Serrano. Client: Deleo Clay Tile.*

Deleo Clay Tile has been offering its throughbody clay roofing tiles to architects and builders for the better part of two decades. Almost from the beginning, Mires has worked closely with the company, building its identity and helping to define its place in the market.

We started by highlighting Deleo's old-world heritage and celebrating the authentic craftsmanship behind every tile. As importantly, we helped the tile manufacturer communicate that its tiles—unlike the great majority of its competitors' tiles—are environmentally safe and friendly.

From there, Mires developed integrated marketing solutions that further solidified Deleo's market niche. Warm, earthy packages reflected the company's attention to detail and purity of product. A sensual "idea book" linked Deleo's rich palette of colors, textures, and shapes to homeowners' lifestyles, helping architects sell their product to clients with new inspiration and focus. Economical shipping boxes permitted the company to put actual product samples directly into the hands of its customers—and converted to handsome point-of-purchase displays to allow for even greater product exposure.

Mires' brand-building strategies and long-standing commitment have helped the company secure a premium niche position and build an unassailable perception of value.

— Mires

Most often, packaging is one part of a large, integrated marketing strategy and media plan, featuring a variety of applications and marketing initiatives, including promotions, new product launches, merchandising, and advertising. Although packaging is part of brand identity design and promotional design, it is a specialized area of the graphic design profession. Packaging designers must be knowledgeable about a range of construction and technical factors; familiarity with and knowledge of materials and their qualities—such as glass, plastic, paperboard, paper, and metal—and with manufacturing, safety, display, recycling, regulatory management, and quality standards, as well as printing are most important. Packaging designers must work collaboratively with others, including chemical, mechanical, and packaging engineers. Designers also may work with a group to develop the basic shape, materials, and structure of the package.

A thorough knowledge of materials also allows designers to select those that will be integral to the design concept, as in the solution for modern organic products™ ("mop"), shown in Figure 7-13. Liska comments: "To accompany mop's marketing materials, we designed a dealer kit that functions as a sales tool for product representatives and as a trial for salon owners interested in the mop line. The self-contained package includes small sample bottles along with a product brochure. It is constructed of an egg carton-like material, in reference to the line's natural, edible ingredient bases."

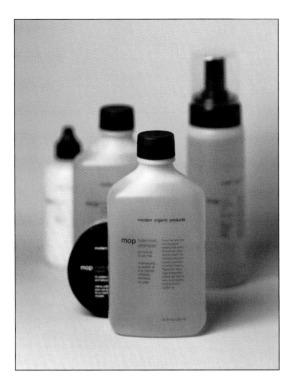

Figure 7-13. *Packaging: modern organic products brand. Designer: Liska + Associates, New York, NY. Art directors: Steve Liska and Marcos Chavez. Client: Revlon.*

Revlon's professional hair care line, modern organic products, is for men, women, and children who prefer products made from natural ingredients. Liska worked with Revlon to define the line's target audience and develop an appropriate branding program that included promotional materials and packaging. We established a visual brand that defines the line as pure and simple.

— Liska + Associates

Relevance and Emotional Connections

Many design experts believe that packaging is *the* make-or-break decision for a consumer who is reaching for a product on the shelf. For example, if food packaging makes someone hungry, such as the design solutions for Chili Chaser™ (Figure 7-14) and Seattle Chocolates™ (Figure 7-15), then it can entice the consumer to buy it.

Several marketing experts estimate that about seventy-five percent of purchasing decisions are made standing in front of the packaging in the store. What makes you notice particular packaging sitting on a store shelf amidst numerous others? It all depends upon the impact of an individual solution and its relevance to an audience. In some cases, it's strong typography, as in the label design for Frank's® RedHot® (Figure 7-16); sometimes it's the excitement of the type plus image, as in the packaging for Sega Dreamcast™, where the mandate was to "Make it hit hard" (Figure 7-17).

Figure 7-14. *Packaging: Chili Chaser. Design firm: Primo Angeli-Fitch. Creative director: Aaron Stapley. Design director: Toby Sudduth. Client: Lava Foods, LLC (Chili Chaser Salsa).*

Figure 7-15. *Identity program. Design firm: Hornall Anderson Design Works, Seattle, WA. Art director: Jack Anderson. Designers: Jack Anderson, Jana Nishi, Heidi Favour, David Bates, Mary Hermes, and Mary Chin Hutchison. Illustrators: Keith Ward (original gift boxes, Truffle bars) and Mary Iverson (spring gift boxes). Calligrapher: Jocelyn Curry (Truffle bars). Client: Seattle Chocolates.*

The marketing strategy for the Seattle Chocolates packaging was to take an existing gift box and their grocery store chocolates and elevate the look to a more upscale, premium packaging to match the premium chocolate product inside. An additional objective was to create a look that could be marketable outside the Northwest region.

The design solution involved reworking the wordmark and giving equal emphasis to the two words "Seattle" and "Chocolates." To ensure the gift box was differentiated from its competitors, we researched materials and box constructions. Hard boxes were too expensive, so we decided to design with the assumption that it would be a folded box. A family look was created by developing a black corrugated bottom to be used on any and all flavors. Each flavor describes its own story on the back of the lids. A combination of tip-ins, hot-stamping, debossing, embossing, and matte and gloss varnishes were used to give the entire package the special feeling it needed for a "gift" box.

The objective for the Seasonal Spring packaging was to extend the 8-ounce main line for the gift boxes. This packaging needed to set itself apart, but retain the same upscale packaging to match the premium chocolate product inside. To distinguish this seasonal packaging from the main line, a multicolored, floral illustration was adapted. The difference with this package was that it contained an assortment of chocolates, rather than just one flavor per package. The same materials were used in the seasonal package's box construction as in the main line. A black matte, corrugated cardboard was used as the box bottom. The lid was printed with matte tinted varnishes.

— Hornall Anderson Design Works

Figure 7-16. *Packaging. Design firm: Primo Angeli-Fitch. Creative director: Richard Scheve. Design director: Peter Matsukawa. Client: Frank's RedHot.*

SUGGESTIONS

Packaging that is sitting on a shelf is in visual competition with the products sitting next to it. It must be attractive and appropriate for its audience and marketplace; information—such as ingredients, net weight, nutritional facts, drug regulations, or product specifications—must be readable. Your objectives are to:

• Make it functional
• Meet regulations
• Research materials and construction
• Consider recycled materials and sustainable design
• Be aware of packaging as the integration of two- and three-dimensional designs
• Consider all sides of the packaging in the design
• Design appropriately for the brand and for the audience
• It should work within a larger visual identity system (if applicable)
• Ensure legibility and clarity of information
• Differentiate it from the competition
• Consider that it will be seen in multiples when on display
• Consider appropriate color associations (national and/or global)
• Coordinate and create consonance of color and design with other flavors or choices in a product line
• Identify its manufacturer, product name, contents, and weight, and provide any other pertinent information

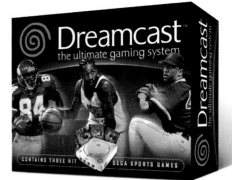

Figure 7-17. *Packaging. Design firm: Mires, San Diego, CA. Creative director: John Ball. Client: Sega.*

With a heritage dating back to the early days of video games, SEGA® earned its reputation as a gaming leader. The highly competitive nature of the industry inspired Sega to redesign its Dreamcast™ packaging. Sega turned to Mires with the mandate: make it hit hard.

First, Mires honed in on Dreamcast's advantage: a built-in modem that enabled Internet-based head-to-head gaming—something the competition didn't yet offer. We then turned to Sega's roots for a powerful visual theme. Delivering a strong dose of the brand's unmistakably edgy, aggressive personality, we left competitors looking pale by comparison.

With the video game industry continuing to heat up, Sega decided to refocus its strategy around software, in a move to transition from a hardware manufacturer to a leading publisher of interactive entertainment. Repackaged by Mires as a bundled product with striking extensions of the original design, Dreamcast sailed off the shelf. And Sega moved into the next phase of its existence.

— Mires

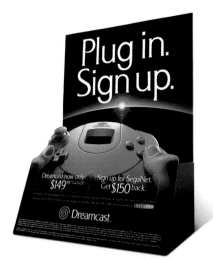

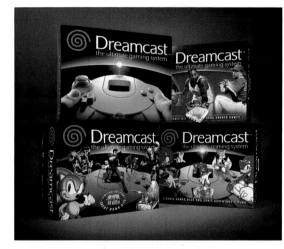

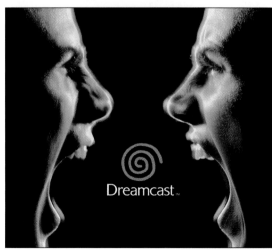

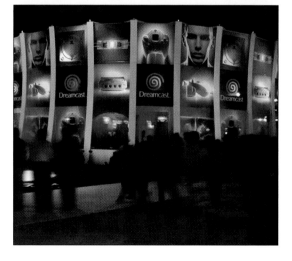

The design concept behind the packaging design must be relevant to the audience, set in the same voice as the larger brand identity, and eye-catching. So many clients opt for looking like the competition that sameness tends to cover entire product categories in packaging. A designer must be prepared to utilize the design brief or strategy statement to defend an innovative concept for packaging design. The solutions by Williams Murray Hamm certainly set apart the brands shown in Figures 7-18 and 7-19.

Marianne R. Klimchuk, associate chairperson of the Packaging Design Department, Fashion Institute of Technology, advises: "Packaging design can influence environmental change, add value to any given product, communicate a specific personality, and yet be marketable to a broad audience. Packaging designers should challenge themselves to develop a new design course."[1]

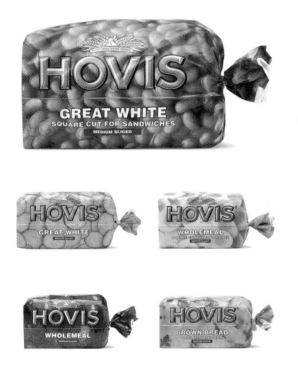

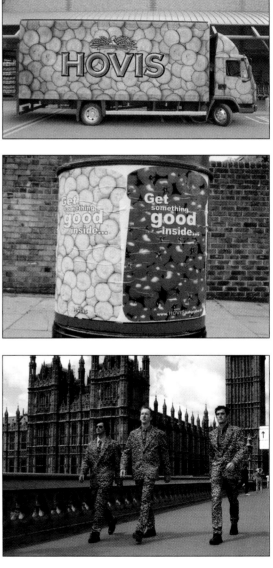

Figure 7-18. *Packaging design. Design firm: Williams Murray Hamm, London, U.K. Client: Hovis.*

Challenging both the category of bread packaging and the rules of convention, this packaging solution surely stands out on the market shelf.

"When the world is zigging, you gotta zag," Hamm said.[2]

In a lecture series entitled "President's Lectures: Integrated Thinking with Creative Luminaries," at the D&AD (a U.K.-based educational charity working on behalf of the international design and advertising communities—www.dandad.org), Williams Murray Hamm suggested that one must see brands across disciplines. Their philosophy advocates that other applications of a brand's identity— whether a web site or poster—are equally critical to the packaging displayed on a market shelf.

Figure 7-19. *Packaging design. Design firm: Williams Murray Hamm, London, U.K. Client: Wild Brew.*

The animal skin sleeve, with a black label (full matte shrink sleeve) for information such as the ingredients, is a fitting concept for the brand name and works well for an entire marketing campaign. Using a different animal print each year will interest the audience, as well as separate Wild Brew™ from the competition.

Notes

[1] Marianne R. Klimchuk, "The Front Panel: Must 'Mono-Culturalism' Mean Monotony?" *Package Design Magazine,* May/June 2004, p. 77.

[2] "RSA rewards new concepts," *Packaging Magazine,* 31 May 2001, *<http://www.packagingmagazine.co.uk/news/design/01_05_31_001.shtml>.*

Chapter 8

Designing Brand Identity Applications: Advertising and Promotional Design

"Today, the technological advances one brand may have over its competitors are copied more easily and faster than a few years ago. Sometimes, the only true difference between rival products is the content and form of their advertising image. From now on, advertising is an intrinsic part of the product itself." — Bill Bernbach

It's not enough for people to be aware of a brand or group. For a brand to be a success—and this may sound obvious—people have to be fond of the brand or group. Ultimately, people have to buy and keep buying the brand for it to be a success. For a group, people have to take some kind of supportive action. The initial "desire" to buy a brand or support a group may come from the graphic impact of the brand identity. The heavier promotion to buy a brand—or the call to action—comes from the advertising and promotional design. The same is true for a group, whether the group is a social organization, arts organization, company, commodity, or social cause; it is the advertising, of whatever kind, that keeps a group, issue, or cause alive in the audience's mind.

If the brand stewards are working in unison, then the advertising agency should be working from a strategy similar to that of the branding group (whether it was a design firm or branding group in an ad agency). There should be a unified message and an integrated solution—where consistency of message, tone, visual appeal, and brand voice is seen in the branding, the advertising, and the promotional applications.

Advertising the Brand

Definitely, there is crossover in the function of brand identity and advertising in establishing a brand's essence and presence—that is, brand building. **Advertising** is the generation and creation of specific visual and verbal messages constructed to inform, persuade, promote, provoke, or motivate people on behalf of a brand.

Both the brand identity and the advertising act to:

• differentiate the brand from the competition in the marketplace
• foster perception of the brand as possessing quality
• keep the brand thriving—that is, anticipate trends, ensure sustainability, and periodically revitalize (or even reincarnate) the brand

Branding is about effectively communicating a brand's value and difference, and creating a desire to buy it; this is where the promotional design and advertising come into *dominant* play. The brand's advertising look and feel is the primary compelling factor that grabs a viewer's initial glance. The amusing ads for Bell Mobility West get our attention and keep our interest long enough to communicate the brand message (Figure 8-1).

Knowing one's audience is paramount when establishing a look and feel that is communicated primarily through the advertising, as in the dramatic Advertising Council public service advertising campaign aimed at teens for Teen Dating Abuse Prevention (Figure 8-2). **Public service advertising** is advertising that serves the public

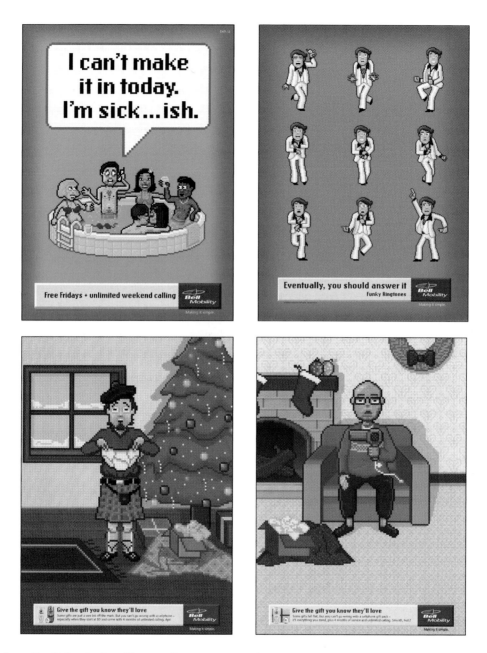

Figure 8-1. *Posters:* Free Fridays, Funky Bell Tones, Bell Scotsman NSP, *and* Hair Dryer. *Agency: Rethink, Vancouver, British Columbia, Canada. Client: Bell Mobility West.*

Copy: *"I can't make it in today. I'm sick...ish. Free Fridays + unlimited weekend calling."*

Copy: *"Eventually, you should answer it."*

Copy: *"Give the gift you know they'll love."*

Bell Mobility entered the British Columbia/Alberta wireless market in 2001 against stiff competition with three other existing cell phone providers. The Bell® brand carries with it a strong reputation for network coverage, call quality, and overall reliability. A dominant force in Ontario, it is their goal to be the challenger brand of choice in the West.

— Rethink

interest. According to the Ad Council *(www.adcouncil.org)*: "The objectives of these ads are education and awareness of significant social issues in an effort to change the public's attitudes and behaviors and stimulate positive social change."

In order for the brand identity, promotional design, and advertising to be effective, of course, the group or the company behind the brand must create a good product or service, support the advertising claims and brand promise, practice sustainability, stay out of trouble, and treat their employees, customers/clients/audience, competitors, suppliers, and partners well.

Sometimes the advertising can be far better than the rest of the branding experience and, consequently, will have less impact on an audience due to a lack of merit across brand experiences; the reverse can also be true. Full impact is then impossible. That's why focused brand management is an imperative.

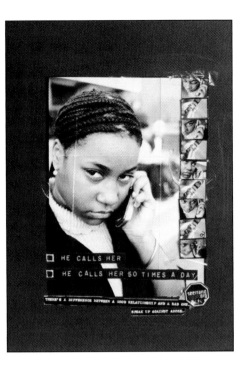

Effective promotional design and advertising for a brand does the following:
- positions the brand to add value (both functional and emotional) to people's lives
- builds branding that is relevant to people's lives
- creates a bond between the brand and the viewer
- endears itself to people
- touches people emotionally
- makes people embrace a brand
- fortifies desire and prompts people to buy and keep buying
- respects its audience
- communicates shared values with its audience
- communicates shared life experiences with its audience, prompting the audience member to think: "Hey, they know me; they know what I want!"
- creates promotional and advertising vehicles that *support one another* and keep the viewer coming back for extra information, tips, help, premiums, and, in some cases, fun

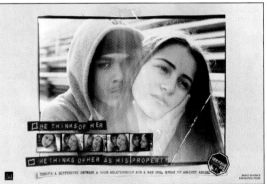

Figure 8-2. *Ad campaign: "He Calls Her." and "He Thinks of Her." Volunteer agency: Hill, Holiday. Issue: Teen Dating Abuse Prevention. Web site: www.seeitandstopit.org. Sponsor organizations: Teen Action Campaign and Family Violence Prevention Fund.*

According to statistics, forty percent of girls aged fourteen to seventeen report knowing someone their age who has been hit or beaten by a boyfriend. The Teen Action Campaign seeks to encourage and empower teens to recognize and reject unhealthy, potentially abusive relationships in their lives and the lives of their peers. By depicting teens in real-life situations, recognizing the warning signs and speaking out against abusive behavior, the campaign provides teens with the tools and resources necessary to "see it and stop it." The goal of the campaign is to change attitudes and behavior before they become familiar, entrenched patterns, and to foster intolerance for abuse.

— The Advertising Council

Why Advertise?

If a brand is not advertised, we may not notice it or we may forget it. There's so much intense competition that a brand cannot depend entirely upon word-of-mouth or rest on its laurels. According to some experts, a brand or social cause must be rejuvenated, or perhaps reborn, frequently in today's capricious marketplace. Even a commodity—such as milk—needs to be fashionably cool to stay alive in the audience's mind, as evidenced by the effective Milk Mustache campaign (Figure 8-3). The campaign has even spread to Great Britain. In 2004, Great Britain's Milk Development Council (MDC)—a generic promotional program for dairy farmers in the U.K.—began offering the GOT MILK?® trademark throughout England, Wales, and Scotland.

"GOT MILK? is a powerful call to action," says John Taylerson, market development manager of the Milk Development Council. "We think it will add great value to our milk marketing efforts."

"GOT MILK? has grown into one of the most successful 'brands' in America," says Jeff Manning, executive director of the California Milk Processor Board. "Its expansion overseas reinforces that GOT MILK? is a property, not a tagline," states the Got Milk? web site *(www.gotmilk.com)*.

Brand and advertising promises

In order to differentiate a brand and to endear it to the consumer, the advertising must do many things at once.

- The advertising tagline should be unique to the brand and embody the brand essence.
- The advertising idea should show off the uniqueness of the brand (notice I said the brand, *not* the product or service, which is most likely a parity good or service).
- The brand should differentiate itself with a promise that the competition is not claiming.
- The advertising must relate to audience desires.
- And, of course, the bottom line of all advertising is the call to action—to create the desire to buy or generate a call to action.

Bonds between brand and audience form for many different reasons, such as a preference for specific brand attributes, viewer response to the advertising and/or the brand identity, brand association, and brand positioning in films and television programming. Every ad, every web banner—every experience a consumer has with a brand—forms and shapes the consumer's perception of the brand.

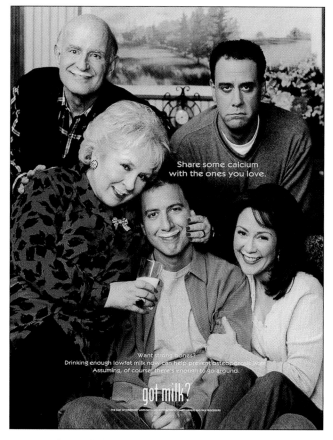

Figure 8-3. *Ad: "Everybody Loves Raymond." Agency: Lowe Worldwide, New York, NY. Client: National Fluid Milk Processor Promotion Board.*

The Milk Mustache campaign features celebrities to endorse milk. Here we see the cast of the hilarious hit series Everybody Loves Raymond.

Advertising Applications

Some advertising acts as the primary communication, such as print advertising for Shimano (Figures 8-4 and 8-5); other ads can support the primary ads, and build the brand. Sometimes outdoor boards reinforce ads that we see in magazines and in newspapers (Figure 8-6) as in the campaign for Telluride®; and still other ads are created solely for billboard display.

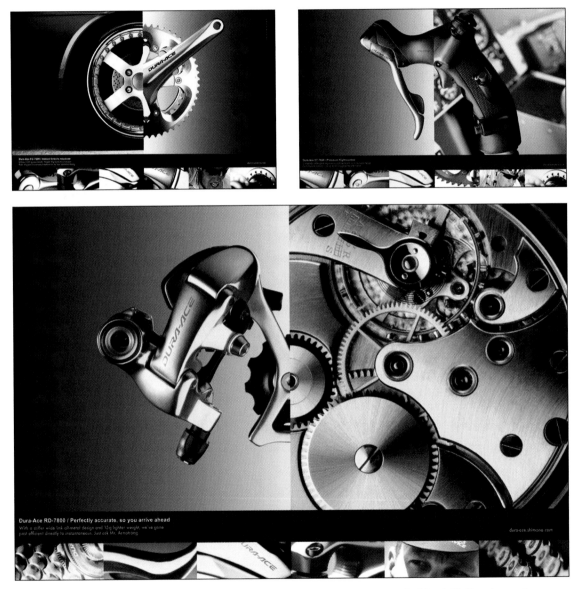

Figure 8-4. *Print campaign: "Dura Ace/Crank," and "Dura Ace/Shifter." Agency: Crispin Porter + Bogusky, Miami, FL. Executive creative director: Alex Bogusky. Associate creative director: Scott Linnen. Art director: Dave Schwartz. Copywriter: Mike Lear. Client: Shimano.*

"Dura Ace/Derailleur." Agency: Crispin Porter + Bogusky, Miami, FL. Executive creative director: Alex Bogusky. Associate creative director: Scott Linnen. Art directors: Dave Schwartz and Tiffany Kosel. Copywriter: Mike Lear. Client: Shimano.

This campaign is aiming at an audience that appreciates a brand with technological expertise.

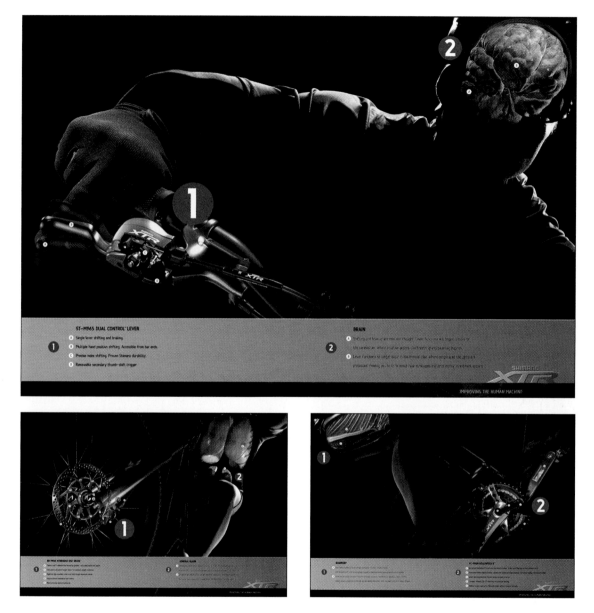

Figure 8-5. *Print campaign: "XTR/Brain," "XTR/Lungs," and "XTR/Quad." Agency: Crispin Porter + Bogusky, Miami, FL. Executive creative director: Alex Bogusky. Associate creative director: Scott Linnen. Art director: Tony Calcao. Copywriter: Rob Strasberg. Client: Shimano.*

Combining Shimano's technological expertise with the excitement of the sport, this campaign continues to aim at both the hearts and the minds of its audience.

ABOVE: Snow bunnies become friends after coincidentally wearing birthday suits.

TELLURIDE, CO – Jessica Hoffman, 27, of Richmond, Virginia and Tiffany Kossel, 32, of Ocean City, Maryland happened to wear the same thing one bright morning on the slopes. Amazingly, the two women remain unaffected by the coincidence.

"Back home, I would have felt embarrassed, maybe even slightly horrified if I ran into someone wearing the same thing as I was," Hoffman said. "But here in Telluride, it feels quite natural. I love it."

"Yes, a tad chilly at the top of the mountain, but natural," Kossel added.

Both ladies later admitted that a little more sunscreen early in the day would have been a good idea.

Since their day on the slopes, Hoffman and Kossel have been seen all over Telluride together, both still sporting what brought them together in the first place.

Witnesses say they are now the best of friends.

Today, unconventional advertising applications are combining principles of promotional design with advertising and media events. **Unconventional advertising** (also called guerrilla advertising or nontraditional marketing) is advertising that "ambushes" the viewer. It appears or is placed in unpaid media in the public environment—places and surfaces where advertising doesn't belong. When effective, applications such as costumed street teams, "dogvertising," stickers, dry-cleaning bags imprinted with ads, calendars, pizza box ads, viral web sites, ads on packs of sports chewing gum, bags that wrap newspapers for home delivery, and urinal mats (Figure 8-7) or any other unusual applications (Figure 8-8) help build brands.

Unconventional applications can be as engaging as the creative minds generating them. In the U.S., the Warner Brothers network included a free DVD of the premiere episode of its new drama *Jack and Bobby* inside *Entertainment Weekly* magazine, as well as running it online for AOL® (America Online) subscribers. For the ABC series *Lost*, the promotional campaign included the distribution of one thousand bottles with "lost" messages inside at beaches in California, New Jersey, and New York.[1]

Engaging an agency or studio to create advertising early on in the branding process is paramount, so that everyone becomes involved in the strategizing from the beginning. That way, a partnership among professionals—among designers, advertising creatives, and client—can develop early on; everyone takes ownership of the strategy and ideas. According to Stuart Elliot, *The New York Times* advertising journalist

Figure 8-6. *Print: "Telluridian Newspaper." Agency: Crispin Porter + Bogusky, Miami, FL. Executive creative director: Alex Bogusky. Creative director: Andrew Keller. Art director: Kat Morris. Copywriter: Ronny Northrop. Illustrator: Doug Jones. Client: Telluride.*

Outdoor ads: "S is for Soul" and "C is for Carverholic." Agency: Crispin Porter + Bogusky, Miami, FL. Executive creative director: Alex Bogusky. Creative director: Andrew Keller. Art director: Kat Morris. Copywriter: Ronny Northrop. Illustrator: Doug Jones. Client: Telluride.

Playing off the look and copy style of children's books, this campaign idea differentiates Telluride from the usual look and sound of the category.

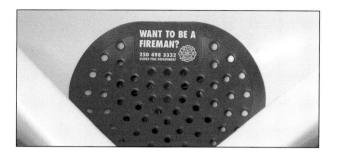

Figure 8-7. *Design: "Want To Be A Fireman?" Agency: Rethink, Vancouver, British Columbia, Canada. Client: Oliver Fire Department.*

Actual urinal mats were placed in washrooms.

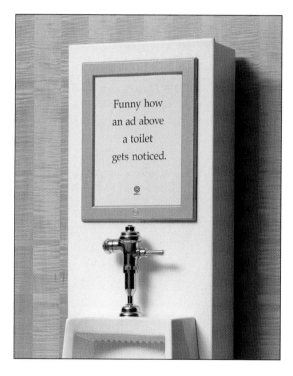

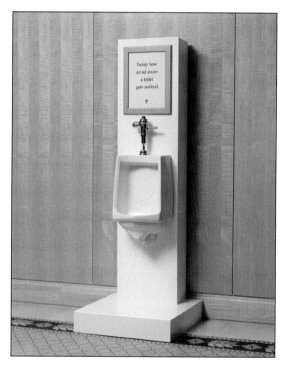

Figure 8-8. *Display: "Toilet." Agency: Rethink, Vancouver, British Columbia, Canada.*

Copy: "Funny how an ad above a toilet gets noticed." Client: NewAd Media.

Toilet and sign were on display in the lobby of the 2002 Lotus Advertising Awards. NewAd provides media solutions for capturing the 18 to 34-year-old market across Canada; their products include Miniboards in their Resto Bar, Health Club and College networks, Backlit Boards, Sourceboards, Video Boards, Postcards, Big Boards, and Event/Sampling.

— Rethink

TYPES OF ADVERTISING MEDIA

CONVENTIONAL MEDIA
- **Broadcast**
 - TV
 - Major network
 - Independent station
 - Cable
 - Radio
 - Network
 - Local
- **Print**
 - Magazines
 - Newspapers
 - National
 - Statewide
 - Local
 - Direct Mail
- **Support Media**
 - Outdoor
 - Billboards
 - Transit
 - Posters

- Ambient
- In-store point of sale
- Taxi ads
- Postings
- Bathroom stalls
- Supermarket carts and floors
- Freestanding inserts
- Costumed mascots
- **New (Digital) Media**
 - Promotional web sites
 - Social cause web sites
 - Web films
 - Web commercials
 - Web banners and floater ads
 - Online guerrilla or viral marketing
 - Home-shopping broadcasts
 - Interactive broadcast entertainment programming
 - Kiosks
 - CD-ROM
 - Internet
 - Intranet

UNCONVENTIONAL MEDIA
- Logos on sidewalks
- Stickers
- Wild postings/snipes (on scaffoldings, temporary walls, etc.)
- Coffee cup sleeves
- Guerrilla: temporary projections on walls
- Stampings (sidewalks, walls, surfaces)
- Room keys
- Street teams

PREMIUMS
- Calendars
- Logo apparel
- Novelty items (pens, mugs, etc.)

OTHER
- Event sponsorship
- Television sponsorship
- Sports sponsorship
- Paid product placement (television programs, music videos, films, theatrical plays)

and critic, more effective work is produced when agencies and clients work together harmoniously.[2] In the case of the introduction of MINI™ into the United States, the agency, Crispin Porter + Bogusky, worked very closely with the client to achieve great success. Besides the print seen in Figure 8-9, Crispin Porter + Bogusky created an extremely integrated campaign for MINI, including unconventional applications and creative digital branding on the *www.miniusa.com* web site.

Television advertising

If commercials are considered films, then their status is elevated. There certainly is more of a chance to get viewers to watch a film than a commercial—and to *appreciate* the brand. Consider that Ridley Scott's four-and-a-half-minute commercial "Thunder Perfect Mind" debuted at the Berlin Film Festival in 2005. "Thunder Perfect Mind," starring Daria Werbowy, was created to introduce Prada's new fragrance. Ridley Scott, an esteemed veteran feature film and commercial director, collaborated on this with his daughter Jordan and Miuccia Prada.

For Chanel Nº 5®, Nicole Kidman starred in a three-minute film directed by the venerated Baz Luhrmann. *Nº 5: The Film* works toward associating the Chanel Nº 5 brand image with the glamour of Hollywood. Following the Luhrmann film for Chanel Nº 5, in some venues, is a twenty-five-minute documentary on the making of the film. There weren't any shots of the Chanel Nº 5 bottle in *Nº 5: The Film*. Other "films" of this

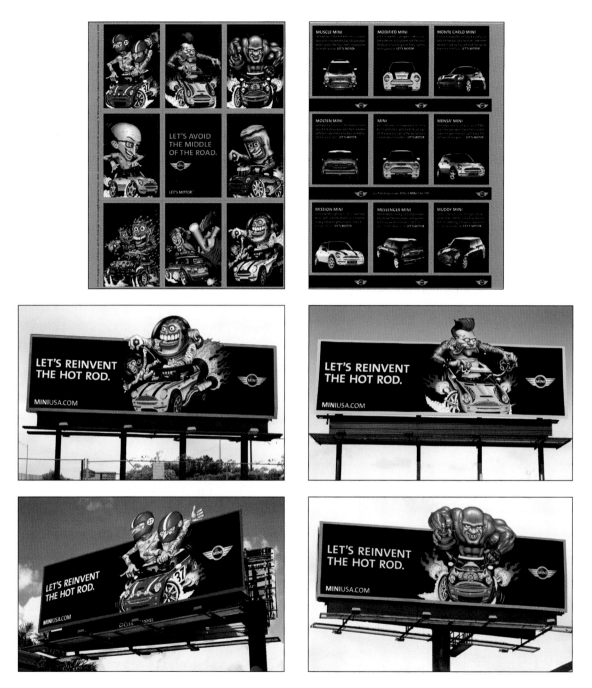

Figure 8-9. *Campaign. Print: "Mavericks/Sticker Insert and Trading Cards." Agency: Crispin Porter + Bogusky, Miami, FL. Executive creative director: Alex Bogusky. Creative director: Andrew Keller. Art director: Kat Morris. Copywriters: Ronny Northrop and Steve O'Connell. Client: MINI.*

Outdoor: "Mavericks." Agency: Crispin Porter + Bogusky, Miami, FL. Executive creative director: Alex Bogusky. Creative director: Andrew Keller. Art director: Kat Morris. Copywriter: Ronny Northrop. Client: MINI. Photo courtesy of MINI division of BMW of North America, LLC.

Both client and agency completely understand the importance of collaboration in creating a distinctive brand voice and appeal for MINI in the American market, with the goal of endearing an unusual vehicle brand to Americans.

advertising genre are Monica Bellucci starring in a commercial for Dolce & Gabbana's fragrance Sicily™, and online, the very successful BMW web films.

In the early days of television, brand executives realized the potential of endearing their brands to consumers by sponsoring entertainment programming. By the 1950s, the Texaco Star Theater, Colgate Comedy Hour, Skippy® brand peanut butter *You Asked For It* television show, Kraft Television Theater, and Hallmark Hall of Fame® were brands that had their own television programs, among many others. (Later on, advertisers purchased separate segments (often in one or two blocks of time) of television shows rather than entire programs.) For example, *Hallmark Hall of Fame*—developed and sponsored by Hallmark Cards, Inc. and featuring Hallmark's signature commercials—creates dramatic specials. In 1951, the first special created especially for television was *Amahl and the Night Visitors*, the first original opera by Gian Carlo Menotti. Viewer response was overwhelmingly positive.

Now, corporations continue to sponsor television programs, as well as sponsoring many other experiences—from sporting events (SoBe™ sponsored the U.S. Open Snowboarding Championships) to theatrical shows. Becoming more popular, paid product placements in television programs and commercial films proliferate, as advertisers fear that viewers are skipping television commercials. This type of embedded advertising—placing products in television shows, films or theatrical plays, or having brands built into the storyline—is called **branded entertainment**; it is also called paid placement, branded, or sponsored entertainment and is also known as "brand-vertising" or "advertainment."

"Creativity used to be 'Think inside the box.' Then it was 'Think outside the box.' Now, there's no box."
— Linda Kaplan Thaler, the Kaplan Thaler Group, Ltd.

In Britain, sponsorship can translate into enhanced programming. The ITV program *Who Wants To Be A Millionaire?*™ is interactive. The interactive application is sponsored by the company BT and allows viewers to play along with the studio contestant. Registered viewers have the opportunity to benefit by competing for prizes. Interestingly, part of the BT's sponsorship includes information graphics that run on the screen; the program also allows viewers to obtain information on BT™ products and services via the technology. BT can obtain immediate feedback and sales leads.[3]

Over the years, animated television characters have made appearances in television commercials. For example, Flintstones's Wilma is the spokescharacter for Dove™ hair care products. Now, there is a reversal: brands have infiltrated television cartoons. One example, an adult cartoon called "Shorties Watchin' Shorties," on Comedy Central℠ in the U.S., includes product placements for three brands: Domino's Pizza®, Red Bull energy drink, and Vans™ sneakers.[4]

Famed actor John Travolta facilitated a product placement for General Motors's Cadillac® in the MGM's film *Be Cool*. Product placement goes all the way back to 1896, according to Jay Newell, an assistant professor at the Greenlee School of Journalism and Communication at Iowa State University. The Sunlight® brand of soap, sold by Lever Brothers (now a company called Unilever), appeared in films by pioneer filmmakers Auguste and Louis Lumière. In his research, Professor Newell also found that in the 1930s, other brands—Buick®, Coca-Cola®, De Beers™ diamonds—were seen as product placements in films produced by major motion picture studios.

Besides paid placements in both peopled and animated television programs, there are brand paid placements in novels, too. The heroine in British chick-lit novelist Carole Matthews's book *The Sweetest Taboo* drives a Ford Fiesta™ due to Ford sponsorship. Commissioned by Bulgari, novelist Fay Weldon promoted the brand in her book *The Bulgari Connection*.

All of these paid placements are attempts to reach cynical, weary consumers through alternate (indirect) means. Not only do advertisers hope that branded entertainment will get through to world-weary viewers, but also that it will generate buzz around the office and among friends. When contestants on an episode of NBC's *The Apprentice*SM television show developed a variation of Burger King's The Angus Steak Burger sandwich, the sandwich was added to the Burger King® menu the next day at over seven thousand restaurants around the United States. That type of branded entertainment hits the viewer/consumer from several angles. As opposed to a traditional television commercial, this type of branded entertainment advertising campaign is somewhat less direct and utilized in the hope of making a (perhaps more "under-the-viewer's-radar") connection with the consumer.

Recording companies and their artists are working cooperatively with advertising agencies and their advertisers to create promotions that serve all parties involved. To get past a consumer's commercial detector, a recording artist will star in a commercial to promote a brand, where the commercial looks, quite intentionally, like the star's current music video.

As marketers continue to steam ahead toward more product placement, critics call for disclosure. An organization called Commercial Alert, co-founded and chaired by Ralph Nader, is a nonprofit advocacy group whose mission is partly to keep the commercial culture within its proper sphere. This group asked the Federal Communications Commission (FCC) and the Federal Trade Commission (FTC) to require on-screen disclosure of embedded advertising—which includes product placement, product information, plot placement, title placement, paid spokespersons, and virtual advertising. This is to ensure that viewers are fully aware of the advertising efforts. The commissions have denied the request.

Building Relationships

Give people a reason to have a relationship with a brand. Understanding one's audience is crucial to creating effective advertising, whether the campaign utilizes traditional print, outdoor and broadcast media, unconventional tactics, or a music video. Their target audiences related with the following campaigns because the creative professionals developed relevant strategies with a clear understanding of how to touch people, as well as how to give people solid motives for choosing the brands. The campaign case study for Chick-fil-A® clearly explains how to give the audience a reason to have a relationship with a brand (Figure 8-10).

Case Study from The Richards Group

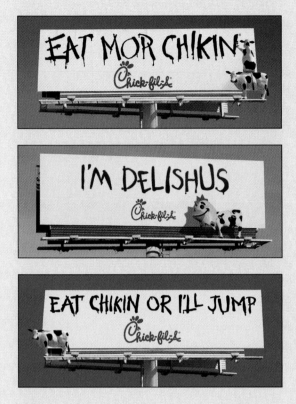

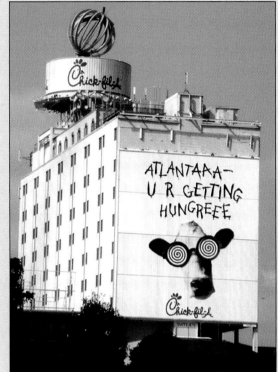

Figure 8-10. *Advertising campaign. Agency: The Richards Group, Dallas, TX. Client: Chick-fil-A.*

Chick-fil-A

Business Situation and Key Issue

Chick-fil-A, a quick-service restaurant chain with over 1,200 stores and $1.4 billion in sales, came to us in 1995. Following their shift from being a mall-based concept to becoming a freestanding restaurant, they were having a difficult time competing with burger chains for fast-food customers.

This difficulty was compounded by the fact that they were outnumbered in store count 15:1 and outspent in media by up to 20:1 by the likes of McDonald's, Burger King, and Wendy's. Also, as an industry, fast foods have promoted deep discounts (99¢ burgers) that have been the dominant marketing message for the past several years; Chick-fil-A refuses to discount their product.

So we needed a way to convince consumers to drive past a gauntlet of value meals and special promotions and pay nearly $3 for a chicken sandwich at a freestanding chicken sandwich shop that was, at best, an afterthought.

Key Strategic Insights

As we studied our core customers, we learned that Chick-fil-A was rich with positive associations. Food, primarily great-tasting chicken sandwiches, was the strongest association. Customers also associated Chick-fil-A with a clean, comfortable environment, well-run operations, great service, friendly clean-cut employees, and strong moral values.

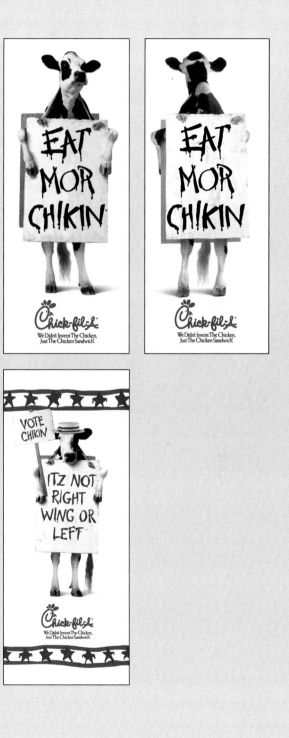

As we dug deeper, we realized that customers had an image of Chick-fil-A as being almost too perfect. Personality traits like finicky, uptight, self-absorbed, and boring came up again and again. Chick-fil-A had succeeded in providing customers with an excellent product and first-rate service, but they had yet to give people any reason to have a relationship with them as a brand.

Creative Strategy

By featuring cows that were trying to talk people out of eating burgers, Chick-fil-A was able to convince fast-food customers that only Chick-fil-A can deliver a chicken sandwich and brand experience to compete with the big burger joints.

Case Study from The Richards Group
continued

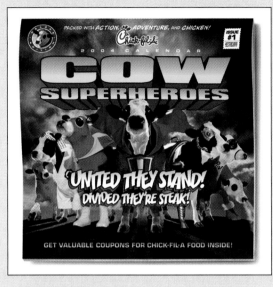

Executional Elements

Our "Eat Mor Chikin" campaign featured cows persuading consumers to stay away from burgers and eat more Chick-fil-A chicken. The campaign rolled out initially as a three-dimensional billboard in 1995. A fully integrated campaign was added in 1996, including television, radio, freestanding inserts, direct mail, in-store point of sale, costumed mascots, and apparel and novelty items.

The campaign has received numerous accolades.

Market Results

Same-store sales have grown an average of 5 percent a year since the cows hit the street in a fast-food category that's been relatively flat. Unaided awareness for Chick-fil-A has also jumped from 15 percent to 29 percent. And we've sold nearly $18 million in "Eat Mor Chikin" merchandise through the units.

All this in spite of Chick-fil-A's $3 price premium, their refusal to discount, their dramatic deficit in ad spending, and the fact that they are closed on Sundays.

— The Richards Group

Figure 8-10 continued. *Advertising campaign. Agency: The Richards Group, Dallas, TX. Client: Chick-fil-A.*

For Diesel™ brand, KesselsKramer has, campaign after campaign, created humorous tongue-in-cheek advertising that appeals deeply to the target audience (Figure 8-11). Renegade Marketing Group's objective was to make HSBC's position as the "world's local bank" tangible, aiming at savvy New Yorkers. Their insights, "Real New Yorkers pride themselves on their local knowledge" and "Taxis are an important part of their lives," led Renegade to the HSBC℠ BankCab program (Figure 8-12).

Donald Diesel doll.

My Little Book of Happy Thoughts *small book.*

Figure 8-11. *Brand campaign: "Your Emotions Are Now Sponsored By Diesel." Agency: KesselsKramer, Amsterdam. Strategy: Matthijs de Jongh. Creative directors: Dave Bell and Johan Kramer. Art directors: Karen Heuter and Krista Rozema. Copywriters: Dave Bell and Dominique Lesbirel. Photography: Carl-Johan Paulin. Production: Pieter Leendertse and Lucie Tenney. Mascot and props: KesselsKramer creative team and Acne International. Production company: Stilking, Prague. Client: Diesel SPA.*

For Spring/Summer 2002, Diesel has introduced its happiest and most colorful collection to date—a collection inspired by the world of traveling fun fairs, where people can experience a kaleidoscope of positive (yet somehow artificially induced) emotions. And how could Diesel claim these upbeat feelings for itself?

Simply by sponsoring all of them.

Not new to this type of sociocultural ironic commentary, Diesel "apes" large multinational corporations whose marketing activities go as far as inducing and guiding their consumers' emotions ("Enter this take-away restaurant and you will be happy," "Drink that soft drink and you will enjoy life," "Wear those sneakers and you will do it"), all for 'successful living.'

So, for one season only, Diesel is now the proud sponsor of the best emotions in the world: happiness, excitement, freedom, pleasure, and more all come under the Diesel sponsorship.

With this sponsorship deal of positive emotions, Diesel also realized it had to put a smiling face to the brand. After in-depth research into the history of positive communication, Diesel has borrowed a device that is employed by large companies who know the best way to commercialize emotions successfully: the mascot.

The mascot's name? Donald Diesel.

Donald Diesel will deliver to the world a mission statement inspired by happiness and commercial success. If you're feeling sad, or you've run out of Prozac, let Donald share with you all the happiness, laughter, fun, and passion that he can.

And it's all sponsored by Diesel, the first brand in the world that is entertainizing™ fashion.

— KesselsKramer

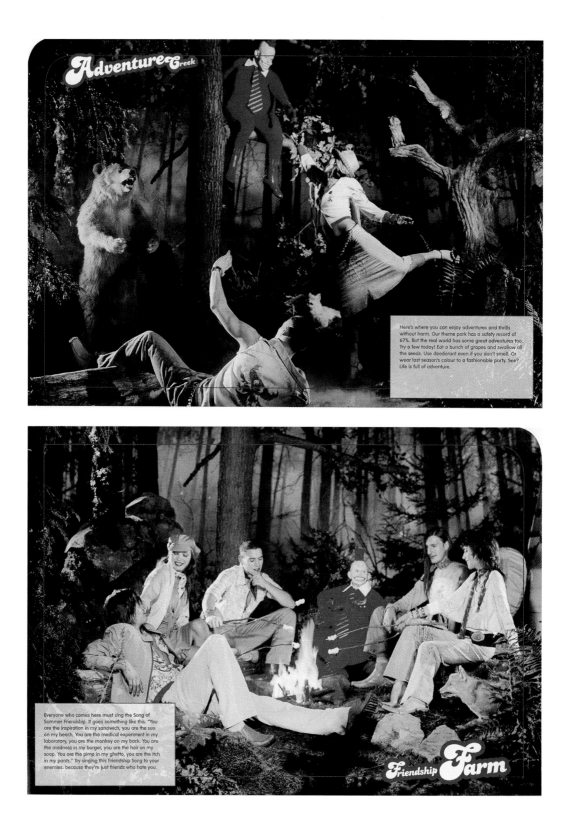

Here's where you can enjoy adventures and thrills without harm. Our theme park has a safety record of 67%. But the real world has some great adventures too. Try a few today! Eat a bunch of grapes and swallow all the seeds. Use deodorant even if you don't smell. Or wear last season's colour to a fashionable party. See? Life is full of adventure.

Everyone who comes here must sing the Song of Summer Friendship. It goes something like this: "You are the inspiration in my sandwich, you are the sun on my beach. You are the medical experiment in my laboratory, you are the monkey on my back. You are the madness in my burger, you are the hair on my soap. You are the pimp in my ghetto, you are the itch in my pants." Try singing this Friendship Song to your enemies; because they're just friends who hate you.

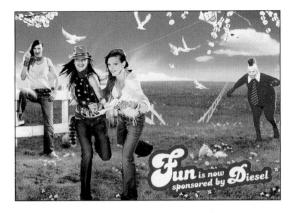

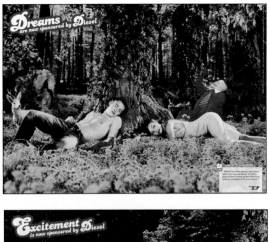

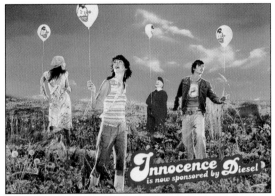

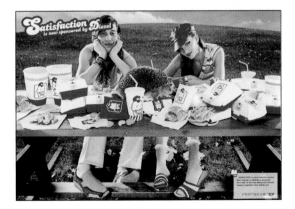

Figure 8-11 continued. *Brand campaign: "Your Emotions Are Now Sponsored By Diesel." Agency: KesselsKramer, Amsterdam. Strategy: Matthijs de Jongh. Creative directors: Dave Bell and Johan Kramer. Art directors: Karen Heuter and Krista Rozema. Copywriters: Dave Bell and Dominique Lesbirel. Photography: Carl-Johan Paulin. Production: Pieter Leendertse and Lucie Tenney. Mascot and props: KesselsKramer creative team and Acne International. Production company: Stilking, Prague. Client: Diesel SPA.*

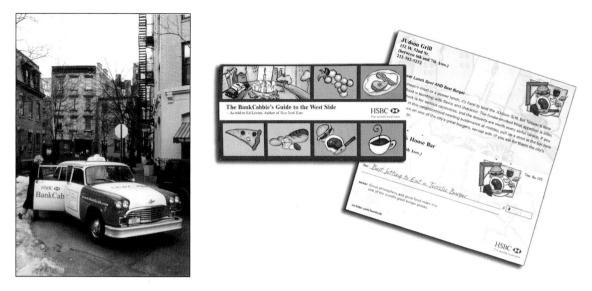

Figure 8-12. *Brand campaign: BankCabbie Search and BankCabbie Guide. Agency: Renegade Marketing Group, New York, NY. Client: HSBC, BankCab program.*

Renegade orchestrated a search for the most knowledgeable New York City cabbie. The search culminated in the BankCabbie's coronation, which was a major press event with television, radio, newspaper, and online coverage. The HSBC BankCab was available to give lifts to people who were HSBC accountholders or those willing to open an account.

BankCabbie guides, designed to look like checkbooks and identifying an eclectic blend of Manhattan eateries, were distributed by Renegade's guerrilla street teams dressed in BankCabbie attire. There was also a microsite, BankCab.com, to support all aspects of the program, designed to encourage visitors to expand their relationship with HSBC.

Designing Advertising to Meet Brand Needs

Every ad attempts to influence—someone, somehow. And every ad or promotional application, whether it's a poster or a logo-stamped pizza box, has two main audiences: the brand users and the undecided. One ad or one promotional may sway a viewer, though it is usually the cumulative effect of the brand experience that converts the majority of the undecided. To generate a trial of Citibank's c2itSM electronic money transfer service, Renegade demystified this online service by bringing c2it directly to the community with captivating activities at cultural events (Figure 8-13). To help overcome fears and build trust, Renegade has helped c2it engage the various targets in their respective communities.

Whether you're working with a new carrier of content or a traditional one, brand identity applications, advertising, and promotional design applications should work in seamless concert. Based on this, they should:

- Cooperatively communicate a brand message where one plays off the other
- Have a similar feel and meaning
- Possess *the* deliberate and definite brand voice
- Work in harmony to present a consistent brand look and feel
- Have similar tone and voice in all verbal communications
- Support each other—either directly or indirectly

Figure 8-13. *Brand campaign: c2it. Agency: Renegade Marketing Group, New York, NY. Client: Citibank.*

As a late entrant into the online money transfer business, c2it faced a number of acquisition hurdles, including entrenched competitors and difficult to reach, culturally-diverse target audiences. Renegade has worked closely with c2it to create new acquisition models for Asian Indian, Hispanic, European, and Filipino-born prospects.

— Renegade Marketing Group

Advertising Campaigns

A brand advertising campaign concept should be elastic enough to accommodate several ads, and your design solution should be expandable; that is, it may be necessary to create many ads for one campaign, based on a central thought.

The brand core concept, brand essence, and advertising idea should be communicated through the design of a campaign where the iconic quality of the brand is captured.

What makes a campaign work?

- Viewers will make a visual and/or verbal connection to the brand.
- Each individual ad continues to build the brand.
- It is unique to the brand.
- The idea makes sense for the brand.
- The advertising idea or theme is elastic. You can create many ads based on the original theme.
- The main thrust of the idea could work across all media.
- Each successive ad maintains viewer interest and continuity.
- It increases awareness and the emotional bond with the target audience.

> **When brand advertising works, it:**
> - **feels fresh**
> - **makes you remember the brand message**
> - **leaves a positive perception of the brand**
> - **is ethical**

Advertising creatives, more than ever before, are experimenting with the nature of ads. The days of thinking that television will carry the entire brand message are over—or, at least, they should be. Depending upon formulaic thinking to determine the choice of the main media or of how an ad looks leaves little room for originality of brand spirit or for experimentation. Besides, viewers don't want sameness; they want either no advertising or advertising that entertains and informs, such as the engagingly atypical campaigns for CGEY® (Figure 8-14) and UPC® (Figure 8-15), or as Strawberryfrog puts it: "How frog thinking made people fall in love with TV all over again."

NOTICE I could tell you what's happening next. But then I'd have to kill you. —THE ECONOMY

NOTICE I could tell you what's happening next. But then I'd have to kill you. DEFY THE ECONOMY www.DefyTheEconomy.com CAP GEMINI ERNST & YOUNG

Figure 8-14. *Campaign. Agency: Strawberryfrog, Amsterdam. Client: CGEY.*

Challenge: Define a role for a global, complex, low-interest IT consultancy and in the process help it stand apart from the competitive pack.

Our campaign sought to unite the top management of retrenching corporations against a common foe: The Unpredictable Economy. We wanted to ignite a new spirit in the marketplace, of embracing volatility and enjoying it. So we personalized the Economy as a buffoon and showed people how to defy him.

Our client told us it was "the most persuasive CGEY advertising in nineteen campaigns."

— Helen Blake, CMO, CGEY

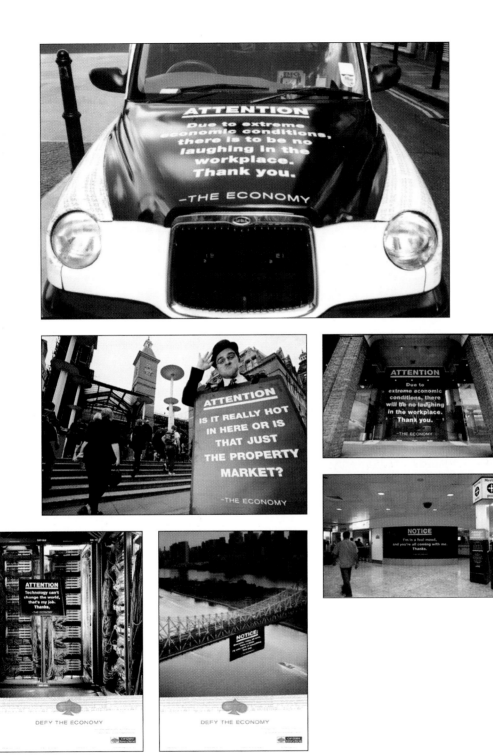

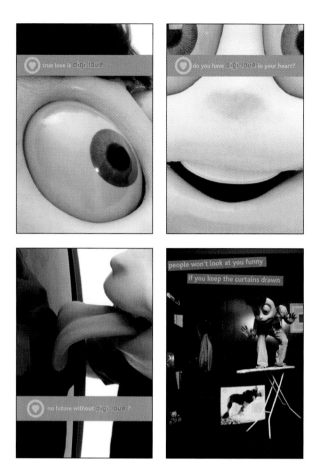

Figure 8-15. *Campaign. Agency: Strawberryfrog, Amsterdam. Client: UPC Digital.*

UPC, a low-visibility cable television company, was launching a digital platform—a technology that consumers feared was complex, expensive, and unreliable. This presented Strawberryfrog with a double challenge: to thrill people about a service they weren't interested in, from a brand they didn't trust.

Even though it had become unfashionable to say so, we sensed that people were still enthralled by television. To exploit this love affair, we created Flint, a wide-eyed character who lived for whatever was on the box. A character so likeable, his face became a sales tool. The advertising concept underpinning our campaign was "Digi-Love"—a tagline that encapsulated UPC's business mission: to bring together technology and desire, revolutionary product and superior customer service.

— Strawberryfrog

Promotional Design

Some visual communication professionals consider advertising to be promotional design; advertising has the highest degree of promotion among all types of graphic design. **Promotional design** is graphic design that functions to introduce, sell, or promote products, ideas, or events. Promotional design includes:

- Posters
- Web sites
- CD covers
- Brochures
- Web banners
- Press kits
- Special kits
- Giveaways
- Wearables (T-shirts, caps, ties, etc.)
- Invitations
- Announcements
- Merchandise catalogs
- Guerrilla applications
- DVDs
- Music videos
- Unconventional applications
- Any other possible ingenious application used to promote brands

Promotional design can encompass an enormous range of solutions and be executed in a variety of media, such as the intensely unique brochure for Anni Kuan (Figure 8-16) or hangtags for a retailer (Figure 8-17).

Figure 8-16. *Letterhead, business card, and brochures: "Ella," "Horse," "Iron," and "Josh." Design firm: Sagmeister Inc., New York, NY. Concept: Stefan Sagmeister. Designers: Matthias Ernstberger, Joshua Gurrie, Julia Fuchs, and Hjalti Karlsson. Photography: Tom Schierlitz, Bela Borsodi, Matthias Ernstberger, Julia Fuchs, and Ella Smorlatz. Client: Anni Kuan.*

Anni Kuan is my girlfriend. That means that whatever we do for her, it better damn well work. I would not want her to spend money for printing (which is tiny, but still . . .) and postage on something that does not improve her business.

It also means that we basically do what we want (and think is good for her).

The reason for doing all these newspaper items came completely out of her tiny budget. Before we took over her graphics, she had sent out a single 4-cent postcard to all her buyers. A very friendly designer mentioned this Korean newsprint place in New York. They literally can print a 32-page paper for the price of a postcard. So that is what we do now every season.

The cheap newsprint, which is rarely still employed in the fashion world, became part of Anni Kuan's identity. For us, it's a pleasurable job because of the tight limitations: it has to be on newsprint, maximum two colors (and then only red, orange, or blue), it has to look good in a rough halftone dot, and it should be different from previous mailings since the mailing list stays roughly the same.

The feedback has been great. She meets and talks to many people on the mailing list, and the buyers always praise the mailer, put the plastic horse on their computers, and ask for additional copies. Many designers (who are not on her mailing list, but are potential customers) know her brand only from the award books.

— Stefan Sagmeister

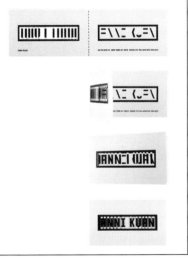

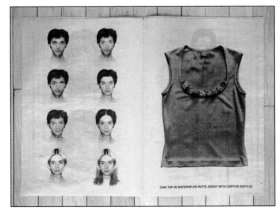

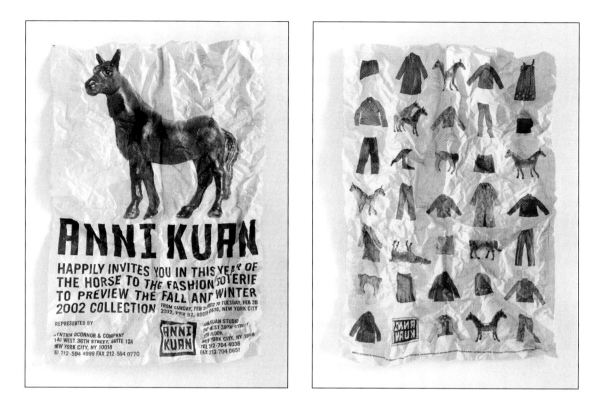

Figure 8-16 continued. *Letterhead, business card, and brochures: "Ella," "Horse," "Iron," and "Josh." Design firm: Sagmeister Inc., New York, NY. Concept: Stefan Sagmeister. Designers: Matthias Ernstberger, Joshua Gurrie, Julia Fuchs, and Hjalti Karlsson. Photography: Tom Schierlitz, Bela Borsodi, Matthias Ernstberger, Julia Fuchs, and Ella Smorlatz. Client: Anni Kuan.*

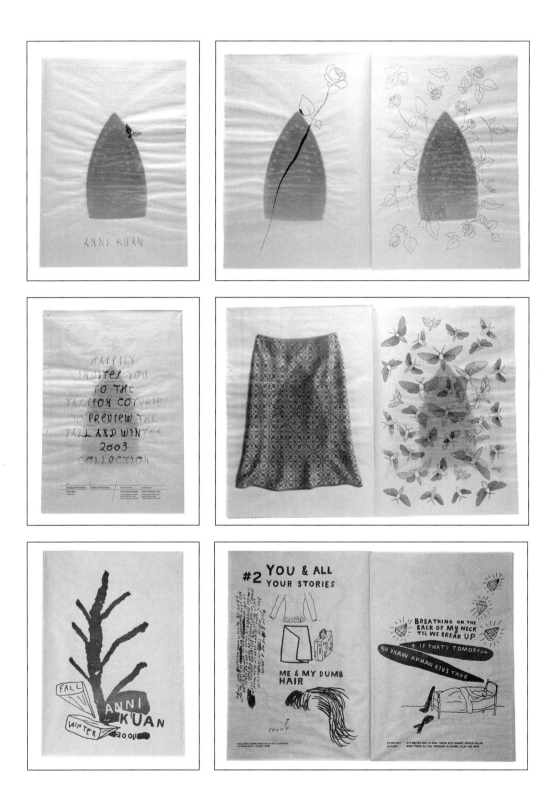

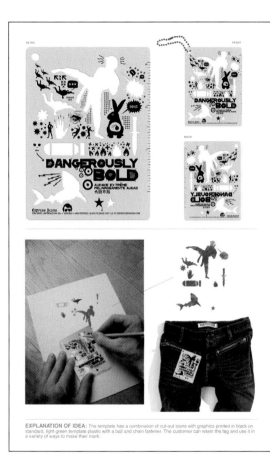

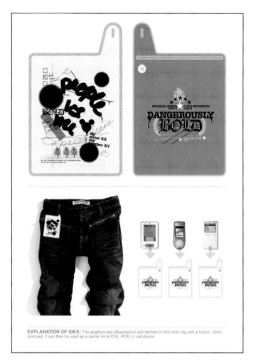

EXPLANATION OF IDEA: The graphics are silkscreened and stiched on this cloth tag with a button. Once removed, it can then be used as a carrier for a PDA, IPOD or cell phone.

Figure 8-17. *Hangtags. Design firm: Segura Inc., Chicago, IL. Client: Express.*

Express commissioned external esteemed graphic designers to design hangtags for each range of jean on sale, with the goal of adding a good amount of attitude to the brand, using creativity as a point of differentiation for the brand. Derek Ungless, EVP of marketing at Express commented: "It does differentiate us from other brands as big as us that have more corporate, basic-looking programs. It has attitude."[5]

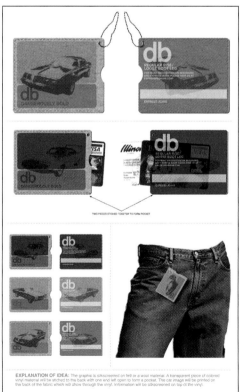

EXPLANATION OF IDEA: The graphic is silkscreened on felt or a wool material. A transparent piece of colored vinyl material will be stiched to the back with one end left open to form a pocket. The car image will be printed on the back of the fabric which will show through the vinyl. Information will be silkscreened on top of the vinyl.

What is the goal of promotional design? Mike Quon of Designation in New York responds: "My main goal in creating successful communications is to get people's attention. Goals and measuring success vary; sometimes they are difficult to quantify. When speaking about or discussing what constitutes good design, it is very subjective. Most goals usually are to boost sales and help to create good corporate image." Quon's extensive skills as art director, graphic designer, and illustrator enable him to solve a great variety of promotional problems.

Promotional design solutions can be elaborate, containing several design pieces that act as one promotion, as in the direct mail solution for Broadway Tech Centre, a huge, comprehensive and integrated campus comprising extensive office premises and a warehouse area (Figure 8-18), or the extensive paper promotion for Curious Paper Collection® by Viva Dolan (Figure 8-19). Since 1991, Viva Dolan has been the exclusive branding/design agency for ArjoWiggins Fine Papers in North America. Viva Dolan formulated strategy and branding for the company. When designing for a professional audience of graphic designers and art directors, the solution must be particularly creative since the people who are the audience for the paper promotions are so creative themselves.

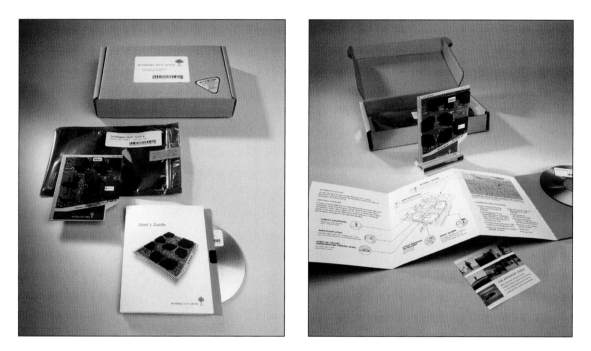

Figure 8-18. *Direct mail. Agency: Rethink, Vancouver, British Columbia, Canada. Client: Broadway Tech Centre.*

This is a promotional piece for a high-tech office development packaged like a piece of computer hardware. The circuit board and chips are actually a scale model of the site and buildings. The brochure is designed like a users guide.

Figure 8-19. *Promotional design. Curious fake annual report 2001, cover and inside. Design firm: Viva Dolan Communications and Design Inc., Canada. Creative director: Frank Viva. Designer: Frank Viva. Headlines: Frank Viva. Writer: Doug Dolan. Photographer: Found art. Illustrator: Frank Viva. Copyright: Viva Dolan Communications and Design Inc. Client: ArjoWiggins.*

Curious stationery. Creative director: Frank Viva. Designer: Dominic Ayre. Writer: Doug Dolan. Copyright: Viva Dolan Communications and Design Inc. Client: ArjoWiggins.

Conqueror English/English dictionary (opposite page, top). Creative director: Frank Viva. Designer: Frank Viva. Writer: Doug Dolan. Illustrator: Clip art. Copyright: Viva Dolan Communications and Design Inc. Client: ArjoWiggins.

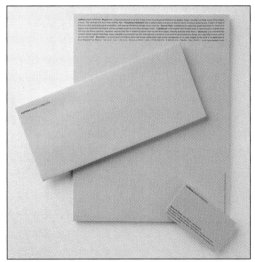

Curious swatchbooks 2002 (opposite page, middle left). Creative director: Frank Viva. Designer: Frank Viva. Writer: Doug Dolan. Photographer: Ron Baxter Smith. Copyright: Viva Dolan Communications and Design Inc. Client: ArjoWiggins.

Curious swatchbooks 2003 (opposite page, middle right). Creative director: Frank Viva. Designer: Frank Viva. Writer: Doug Dolan. Photographer: Ron Baxter Smith. Illustrators: Frank Viva and Seth. Copyright: Viva Dolan Communications and Design Inc. Client: ArjoWiggins.

Curious buttons (this page bottom), tattoos, and ream wrap (opposite page bottom). Creative director: Frank Viva. Designer: Frank Viva. Writer: Doug Dolan. Photographer: Ron Baxter Smith. Copyright: Viva Dolan Communications and Design Inc. Client: ArjoWiggins.

In 1999 the company made the decision to introduce several European product lines into the U.S. and Canada. Rather than stretch limited resources in relaunching brands with no legacies on this side of the Atlantic, we recommended bringing all six under one umbrella: the Curious Paper Collection. This consolidation strategy was subsequently adopted worldwide, with Viva Dolan acting as the lead branding and design firm.

— Viva Dolan Communications and Design Inc.

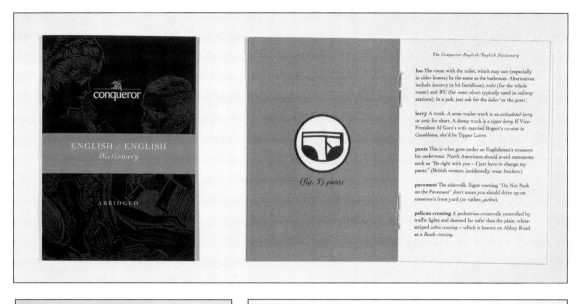

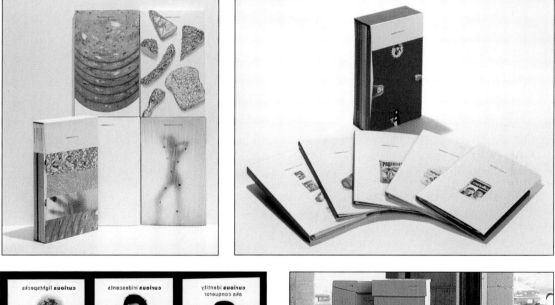

As a design or advertising application, posters can serve many purposes. Depending upon the purpose, one could consider a poster to be an advertisement, a promotional design, or art (many people hang posters in their homes). On behalf of the Canadian Cancer Society, Rethink's ads grab our attention with a humorous visual/verbal message (Figure 8-20). Carlos Segura creates posters that get our attention; posters are part of a larger identity and promotion for Segura's T26 (Figure 8-21).

Figure 8-20. *Poster: "Sumo." Agency: Rethink, Vancouver, British Columbia, Canada. Client: Canadian Cancer Society.*

Copy: "Sumo Wrestlers Singles Night. What if bars only catered to the minority? When it comes to smoking, many do."

Poking fun at bar promotions, Rethink is making a good point to help make British Columbia smoke free.

Figure 8-21. *Identity and promotion. Design firm: Segura Inc., Chicago, IL. Client: T26 Digital Type Foundry (www.t26.com).*

For T26, Segura Inc. created comprehensive branding that includes advertising, newspapers, catalogs, packaging, postcards, posters, special kits, and wearables (T-shirt and tie).

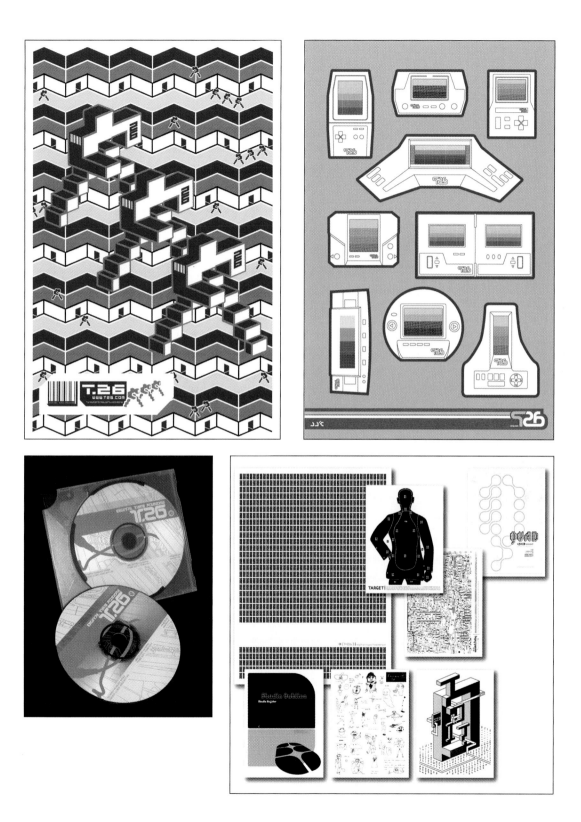

Figure 8-21 continued. *Identity and promotion. Design firm: Segura Inc., Chicago, IL. Client: T26 Digital Type Foundry* (www.t26.com).

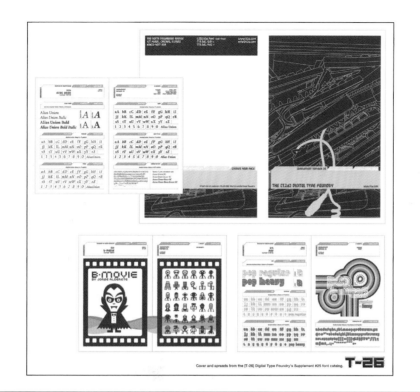

Cover and spreads from the [T-26] Digital Type Foundry's Supplement #25 font catalog.

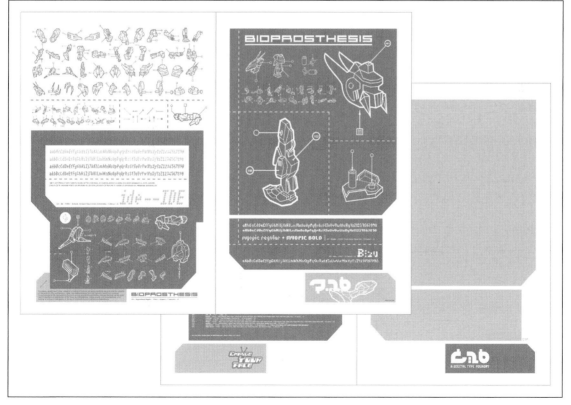

As we watch moving graphics, we often forget the impact they have, and that they—including trailers and openers—are promotional applications as much as informational. As part of an ongoing collaboration with RES Media, Trollbäck + Company executed a comprehensive branding campaign for the international digital film festival RESFEST ℠ 2002 (Figure 8-22). The campaign includes a trailer and opener for the popular festival, as well as banners, T-shirts, programs, logos, and other branded items.

Ever since the enormous success of the "I want my MTV™" campaign created by legendary George Lois in 1982, music videos have become an indelible part of the entertainment industry, not to mention pop culture. A music video—a short film utilized as a visual representation of a song or music—can also be considered a promotional device for a recording artist or film. Launched in 1981, MTV ℠ (Music Television) originated the concept of continuous-format music video programming. Promotional videos became requisite for most popular recording artists. When a designer creates a music video, the promotion can be a minifilm.

Self-promotional design can take various forms— from single-format printed postcards to Web-based films (Figure 8-23). Hillman Curtis's video promo for his book *MTIV* is nonlinear. In an interview with *Flashstreamworks.com* magazine, Curtis states, "I took nine cuts of a forty-five-second promo and exported each clip to a common folder, then scripted up a random player . . . the user can choose to watch the promo in its linear form or hit the random button and have it play back in a very different order. The story is the same, for the most part, but the way the user feels about that story changes depending on the playback order."[6]

Figure 8-22. *Branding campaign: RESFEST Open.*

Trailer. Design company: Trollbäck + Company, New York, NY, and Los Angeles, CA. Co-directors: Antoine Tinguely and Laurent Fauchere. Director of photography: John Turk.

Opener. Design company: Trollbäck + Company, New York, NY, and Los Angeles, CA. Co-directors: Antoine Tinguely and Laurent Fauchere. Director of photography: Chris Haak. Actor: Greg Slagle.

Trailer and opener music company: Sacred Noise, New York, NY. Music: Michael Montes. Client: RESFEST.

RESFEST branding revolved around the burning umbrella logo, a metaphor for how accidents can inspire ideas. Going directly against the grain of last year's campaign and the DV aesthetic in general, the trailer for the festival was intentionally structured like a bombastic Hollywood film trailer. Shot in Digibeta, it was blown up to 2K with many shots re-created in postproduction and animated in After Effects®. Three different executions were created: one for the United States, one for the United Kingdom, and a generic version.

— Trollbäck + Company

Figure 8-23. *Self-promotion:* MTIV.

Description: Self-promotion piece for the launch of Hillman's new book MTIV: Process, Inspiration and Practice for the New Media Designer *(New Riders Press, 2002). Studio: Hillman Curtis. Creative director: Hillman Curtis. Designer: Hillman Curtis. Cinematographer: Christina Curtis. Producer: Homera J. Chaudhry. Client: Self.* © *hillmancurtis, inc. www.hillmancurtis.com*

Cause-Related Marketing

Cause-related marketing, or cause advertising, is a particular category of public service advertising that is used to raise funds for nonprofit organizations, which is run in paid media and is sponsored by corporations. What differentiates cause-related marketing from public service advertising is that some type of commercial nature is maintained by affiliation with a corporation or by promoting a corporation's brand. Cause-related marketing enables companies to partner with a charity to promote an image, product, or service.

> **Cause-related marketing could help a brand by:**
> - reinforcing its standing as a socially responsible brand
> - building trust with its current audience and potential audience
> - increasing brand equity through engaging its audience on a genuine level
> - showing that the company gives back to society

Corporations are embracing the idea of taking action on behalf of social causes while promoting their brands—companies such as Ralph Lauren, Starbucks, Procter & Gamble, Ben & Jerry's, and Timberland. To ensure respect for their efforts, companies must live up to their promises of contributing to promoted causes, as well as acting ethically toward their employees, audience, and partners, working toward sustainable design practices, and respecting environmental concerns.

Cynics may think cause-related marketing is simply another way for brands to enhance their own images. Certainly, it helps brands' images. However, cause-related marketing is in no way frivolous. For example, in Britain during 2003, Cancer Research U.K. was the top charity to benefit from cause-related marketing programs; forty-eight percent of consumers reported an actual change in behavior because of a cause-related marketing initiative, according to Business in the Community in 2003.[7] (Business in the Community is a unique movement in the U.K. of seven hundred member companies, with an additional sixteen hundred companies participating in their programs and campaigns: *www.bitc.org.uk*.)

If consumers respond positively to such marketing tactics (or negatively—even boycotting those corporations and brands that do not donate), it could pressure more corporations to adopt causes and give more generously. Consumers have much more power to effect change than most think. Watchdog groups help tremendously; however, each individual can make his or her voice heard by voting for support of causes by brands.

Digital Advertising and Promotional Design

Networked appliances and media have become ubiquitous. Mobile phones with text messaging and e-mail access, CD-ROMs, kiosks and other electronic exhibit systems, interactive posters, intranets, extranets, digital marketing, and rich-media banners are as commonplace as print and broadcast media. Countless interactive vehicles for communication offer endless possibilities for accessing information, and we are constantly being entertained at every turn—either by our mobile phone or an in-store kiosk or any of the above examples. These newer vehicles allow for even more contacts with a brand and brand experiences, where the interaction between the viewer and the brand may be all the more intimate due to portability and size. Wireless formats may allow brands to be presented in new and/or personalized ways.

The Internet has also changed business and the way we gather information. Globally—24/7—one can check in on a corporate web site, browse online for a car, research a social cause, find information on a disease, or check out a viral or entertaining promotional web site at any time. Very often, thematic web sites are part of a larger branding effort, and are extensions or supports for other advertising and marketing.

For several years, Mattmo Concept | Design has been responsible for the concept, design, and implementation of Hewlett Packard's online activities (Figure 8-24). The thematic web sites designed by Mattmo Concept | Design are an extension of direct marketing and radio and television campaigns.

Figure 8-24. *Web site: www.hphomework.nl. Design firm: Mattmo Concept | Design, Amsterdam. Client: Hewlett Packard.*

The online product launches that are created by Mattmo are frequently used in Hewlett Packard's marketing mix. In addition to the branding and transaction sites, thematic web sites are developed per country. These sites can be accessed via HP™ branch solutions, HP Euro, and HP Homework. The Hewlett Packard online activities also receive high-quality support.

— Mattmo Concept | Design

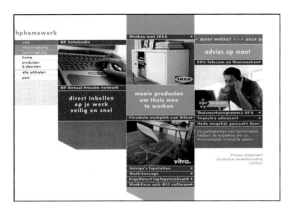

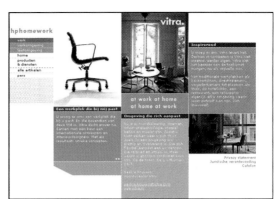

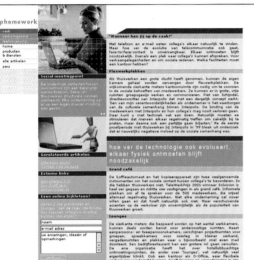

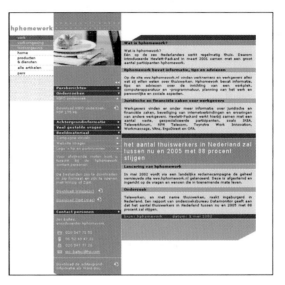

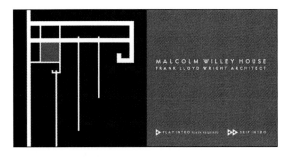

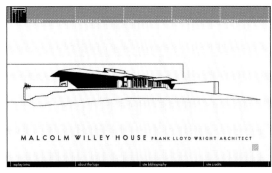

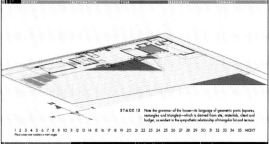

Figure 8-25. *Identity and selected web pages. Design firm: Design Guys, Minneapolis, MN. Art director: Steve Sikora. Designers: John Moes and Kelly Munson. Programmer: Kelly Munson. Client: The Malcolm Willey House (www.thewilleyhouse.com).*

This web site was intended to do three important things: create a comprehensive source of information about the house and its history, put it into the historical context of Frank Lloyd Wright's career and events of the times, and chronicle the ongoing restoration of the house in extreme detail.

As with any medium, knowing one's audience is critical, for example, the audience for the web site for Frank Lloyd Wright's Malcolm Willey House (Figure 8-25).

Offering unparalleled opportunities, the Internet allows a brand to build consumer loyalty, while fostering emotional connections with an audience. Usually other media, such as print or television advertising, will support online efforts, and can effectively drive people to the Web. Or other media can form an integrated campaign.

As a branding tool, the Web is young. Its potential can only be imagined. Web sites—in their most fundamental role—are a base for building online relationships with an audience. Having a home base, a corporation, brand, or group must think beyond "home base," that is, beyond having just an overview or corporate information online. A web site can act as a host to an array of interesting branding vehicles, whether it's for a brand, a group, or a social cause. Interestingly, for audiences who hold some disdain for advertising and brand promotions hurled at them on television or in traditional advertising and promotional venues, the Web—whether it's with a blog or a web film—allows this type of viewer to *seek out* the advertising.

**USING THE WEB ENVIRONMENT
AS A BRAND-BUILDING TOOL**
- Usability of the Web site is paramount.
- Make it easy for users to find information.
- Use a consistent hierarchy of information.
- Respect the user's time.
- Provide a consistent Web environment.
- Communicate core values in the web site look and feel and through all visual and verbal elements.
- Communicate the brand's distinctive personality.
- Web site and other web applications should coordinate with the overall brand look and feel.

BASIC VISUAL ELEMENTS FOR THE WEB
- Maintain brand identity standards.
- Maintain integrity of the logo (the logo is always the most identifiable brand visual element).
- Keep consistent positioning of basic site elements.
- Keep consistent use of other visual identity elements, including the color palette and fonts.
- Maintain verbal communication consistent with other brand applications.
- Provide Web standards and guidelines, technical guidelines, and templates to the client.

- Imagery should reflect the brand essence and communicate clearly and with impact; imagery should be meaningful to a global audience—it should communicate across cultures.
- Animation must be consistent with brand identity guidelines and standards.
- Use trademarks properly (the ™ or ® symbol following brand names); proper use of trademarks protects brand assets and helps to coordinate across media.
- Fonts and typography should be consistent with the brand identity. Incorporate font and typography guidelines for the Web into any standards manual for clients. (The Web may require slightly different guidelines for type.) Specify fonts and families for text, titles, graphics, headers, lists, charts, secondary fonts, and headers with embedded brand names. Make recommendations for best on-screen legibility. Specify case, italics, and alignment.
- All verbal communication should be well-written and organized for user ease, and reflect the appropriate style and tone for the brand or group.
- Utilize sound and movement appropriately for audience and download time.
- Make sure all image preparation is to Web standards.

Web Films

We've already seen some highly successful Web applications, such as the BMW Films—a series of short online films, available for downloading and streaming, directed by venerable film directors, such as John Frankenheimer, John Woo, and Tony Scott. BMW knows its audience very well and realized that their viewers would know the well-respected directors of the films.

The central character of the films, played by Clive Owen, is a "mysterious and charismatic driver for hire. Over eight riveting films, directed by and starring some of Hollywood's top talent, the driver dodged endless perils and always got the job done without losing his cool," states the BMW Films web site *(http://usa.bmwfilms.com)*. Of course, the hire uses his expert driving skills in a BMW. To further ingra-

tiate people, a collector's edition DVD of the film series is available. BMW Films has partnered with Dark Horse Comics® to present *The Hire* comic series—picking up where the films left off—which are available for purchase.

To announce their respective debuts, these online films were supported by other media, such as print advertisements and television commercials. However, beyond the support media, viewers had to seek out the films. Ideally, one wants the audience to seek out the promotional branding, rather than pushing it at the viewer. What's more, if people view these web films as entertainment rather than advertising, then the opportunity for an emotional connection between the viewer and the brand is much higher. That's why this entire concept is so strategically undeniable.

If viewers come to the online marketing vehicles that are entertaining, then the brand has a much greater chance of getting through to the viewer who has grown accustomed to and jaded by traditional advertising tactics.

Specialty Web Sites

Whether it's a social networking web site, viral marketing, or a parody site, relationships between users and a brand, group, or cause can prosper online, unlike the more fleeting experience in a retail environment or watching a television commercial. For example, the United State's largest advertiser, Procter & Gamble, is promoting its Secret® Sparkle™ deodorant on the social networking web site *MySpace.com*. It is an experimental promotion using music stars' personal profiles. Essentially, a profile of the highly successful American singer/actress Hilary Duff is featured on the *MySpace.com* home page, accompanied by logos for Secret Sparkle, an extension of the Secret® brand.

Chris De Wolfe, chief executive at *MySpace.com* in Los Angeles, said, "As the peer-to-peer marketing takes over, word spreads very quickly throughout the site. My thousand friends see Hilary's profile and see the branding and request to be her friend."[8]

MySpace.com site is advertiser supported and, therefore, free to its users. It has an ardent fan base, who obviously enjoy the integration of blogs, instant messaging, user forums, music, classified listings, groups, and other user-created content.

Pursuing new marketing methods, ones that foster peer-to-peer marketing, is critical for winning some audiences. You have to go where the audience is—if they're online, then that's your vehicle. Of course, there are concerns about privacy; will marketers want to track a user's communication among friends and online contacts?

Renegade Marketing Group created viral marketing for Panasonic that completely engaged its target audience (see Figures 9-5 and 9-6 in Chapter 9). Their main objectives were to extend the offline SYS (Save Your Summer) experience that Renegade created, capture names and build relationships, and position Panasonic® as a cool, hip brand with younger consumers. To meet these objectives, Renegade Marketing Group created a multitiered online experience including a very engaging fictitious, parallel site called *PeopleAgainstFun.org*, which was the viral marketing component.

Another popular entertaining web site is *www.subservientchicken.com* created by Crispin Porter + Bogusky to promote Burger King's TenderCrisp™ chicken sandwich. Visitors see someone dressed in a chicken suit through a type of simulated webcam view; visitors type commands and the chicken does as they command. This is a very, very soft sell, since the specialty sandwich isn't touted, although there is a link to the Burger King web site. The look and feel of the site contribute to its viral stance—it's not a polished-looking brand web site or promo; it looks alternative or pirated.[9]

Ironically riding the consumer backlash against intense branding efforts, some brands and groups are co-opting parody to engage either the youth market, the fringe audience, the jaded, or just the visitors who are looking for comic relief (which should never be underestimated). WongDoody, the ad agency for Alaska Airlines, created the airline's parody site *www.skyhighairlines.com*. Some other companies hosting specialty sites are Best Buy and Lions Gate.

Specialty web sites can be housed on corporate web sites. An excellent example is Nike ID™, where a visitor can customize or individually design his own footwear online at *Nike.com*. On the *Apple.com* site at the iTunes™ store, visitors can "Be an iTunes Celebrity" by publishing their own playlists as an iMix™ in the music store—thereby allowing friends to browse the artists and songs on their lists. These sites allow visitors to "create" or interact, which is very inviting to many audiences.

Ad Blogs

The term **blog** is derived from the term "web log," which is, in many varieties, an online journal where someone records thoughts and opinions that may inspire comments from readers. Some people use blogs as open diaries. Others use a blog as a home base for commentary on a specific topic, with Web resource links to related areas of concern. It didn't take long for brands to use the blog format to attempt to communicate directly with their respective audiences. As Seth Stevenson points out, "From a marketing perspective, blogs make perfect sense. They are cheap to produce, immersive, and interactive. It's easy to measure their readership and response rates. For small companies, blogs are a quick and dirty promotional tool that cuts out the middleman; for big companies, blogs are a tool of humanization—an informal, chatty, down-to-earth voice amid the din of bland corporate-speak."[10] For brands appealing to young audiences who embrace the Web, blogs are a natural way for a brand to attempt to connect with them, to find out what they think about a brand, and to generate word-of-mouth buzz and media interest and coverage.

Shortly after blogs were adopted by brands, paid advertising began to appear on blogs. "Blogs are attracting significant audiences that create unique and valuable opportunities for advertisers," said Jarvis Coffin, president and CEO of *Burst!* "Advertisers, in turn, can create value and opportunity for the blogosphere through careful and appropriate sponsorship that supports this remarkable medium and nurtures its passion."[11]

Content-Rich Offerings

Some brands are partnering with content providers to offer visitors vital information and research resources. For example, Microsoft Network partnered with content providers to launch a specialized health site *(http://health.msn.com)*. The content comes from esteemed institutions such as the Mayo Clinic and Harvard Medical School. Other partners in *MSN Health & Fitness* include Healthwise®, a nonprofit medical encyclopedia resource, and iVillage℠, a women's community site, among others. The site has interactive tools, such as diet calculators, among its features, along with content and search functions.

The web site explains: "*MSN Health & Fitness* is a comprehensive, interactive resource providing information, tools, and support for the health-conscious consumer. At *MSN Health & Fitness,* we have two primary objectives: 1. To provide our users with deep information to answer health and fitness questions both big and small, and 2. To make this information both easy to find and easy to use. Through partnerships with award-winning content providers, *MSN Health & Fitness* seeks to provide to our users the highest quality content and tools."

Dr. Anthony Komaroff, editor in chief of Harvard Medical School's consumer health publications, said the partnership would help get the institution's advances out to millions of people. "Pairing our content with the easy-to-use search tools of MSN ensures that people will be able to quickly find the health information they're looking for on anything from illnesses to diets," Komaroff said, in an *Adweek* interview with Celeste Ward.[12]

In a highly competitive online environment, many businesses are offering new benefits—including content-rich web sites to enhance their appeal. Financial service companies, such as Citigroup, The Vanguard Group, and E*Trade, are offering content and interactive financial/investment tools (such as stock quotes, retirement calculators, and investment tutorials) that they believe will satisfy their investors' needs.[13] Interestingly, the challenge on the Web is to provide content in a very, very timely fashion. Unlike designing a brochure-ware web site (web sites thought of as online brochures), this necessitates dedicated web site professional teams on a permanent and constant basis. Knowing what the visitor wants, and anticipating user desires, is all-important when offering such content.

If a user finds an online experience interesting, informative, or hopefully engaging, he or she will stay and *buy into the brand experience*. A user may even e-mail a link to a friend, which is optimal. It must be noted that a brand experience that one seeks out is preferable, as opposed to brand experiences that are pushed at the viewer, such as floater ads or web banners. New media vehicles allow for even more contacts with a brand and brand experiences. In order to be effective, those experiences, like all other brand experiences, must be positive.

A brand and a group is represented by a web site. If a site design is cluttered, amateurish looking, or carries no visual impact or interest and doesn't function well, the brand or organization may seem likewise. If the design and concept of the web site are well-conceived, functional, and intriguing, the public perception of the company may be positive.

Notes

[1] Stuart Elliot, "In a Bit of Creative Recycling, an Ad for a Television Show Becomes an Element of the Show," *The New York Times*, Friday, 26 November 2004, Business section, sec. C, p. 2 , col. 1.

[2] Stuart Elliot, "A survey shows slight gains in how agencies and marketers relate, but there is room to improve," *The New York Times,* Friday, 8 October 2004, Business section, final edition, sec. C, p. 3, col. 3.

[3] Julien Favre, "Focus: iTVi's Interactive TV Agenda," *iTVi,* 20 February 2003, *<http://www.iemmys.tv/itvi/archive/feature/February%202003%20-%2017.html>.*

[4] Stuart Elliot, "Product Placement Moves to Cartoons," *The New York Times,* Thursday, 21 October 2004, Business section, sec. C, p. 10, col. 1.

[5] Helen Waters, "Designers Commissioned to Create Denim Hang Tags," *IDANDA.net*, 31 July 2003, *<http://www.idanda.net/brand.php?article=111>.*

[6] "Hillman Curtis Talks About the Future of Web Video," *FlashStreamworks.com,* Sunday, 10 October 2004, *<http://www.flashstreamworks.com/archive.php?post_id=1097422120>.*

[7] Cancer Research U.K., *<http://www.cancerresearchuk.org/getinvolved/corporatepartnerships/crm/>.*

[8] Nat Ives, "Pitch to Online Crowd Mixes Pop Stars and Personals," *The New York Times*, Friday, 3 December 2004, The Media Business section C, p. 6, col. 1.

[9] Nat Ives, "Entertaining Web Sites Promote Products Subtly," *The New York Times,* 22 December 2004, Business section C, p. 2, col. 1.

[10] Seth Stevenson, "The Blogo Ad," *The New York Times Magazine,* Sunday, 12 December 2004, p. 56.

[11] "BURST! Media Begins to Sell Advertising on Blogs," *BURST! Media,* 4 January 2005, *<http://www.burstmedia.com/release/pressreleases/pr_01_04_05.htm>.*

[12] Celeste Ward, "MSN Introduces Health Site," *Adweek.com,* 4 January 2005, *<http://www.adweek.com/aw/iq_interactive/article_display.jsp?vnu_content_id=1000745758>.*

[13] "StreamingMediaIQ Launches Buyer's Guide," *Publish.com,* 3 March 2004, *<http://www.publish.com/article2/0,1759,1757832,00.asp>.*

Chapter 9

Behind the Brand

An integrated brand experience entails weaving a common thread or voice, seeming like one voice across all brand experiences. To be interesting, each application must be somewhat varied; *however*, the brand essence, style, and voice must be consistent across applications.

When applications for any brand or group are done in isolation, there is a far greater chance of dissonance. To ensure consonance—that singular voice that the public recognizes as belonging to the brand—someone must be in charge of all the brand experiences. Someone must coordinate marketing initiatives and create a focused effort to shepherd the brand, otherwise we see what Denise Anderson calls a "soft spot" in the entire branding process, where the important job of brand stewardship is relegated to the brand manager or someone on the client side who hasn't studied visual communications.

Certainly, it is in the best interest of any brand to have a consistent voice across all applications, to create consonance. A brand is a huge company asset—it has value, which means profits, and the company must tend to its brand. A company needs to have a brand asset management team or hire a branding specialist to make the important and necessary company commitment (dedicated funds, research, development, and creative work) to the brand.

Diagram 9-I. *An integrated brand experience entails weaving a common thread or voice, seeming like one voice across all brand experiences.*

"When designed correctly, the brand experience should feel completely seamless and natural for its audience. It should touch the audience on an emotional level and should inspire their trust." — Steve Liska

Design Management: Commitment to the Brand

Denise Anderson

Business strategist, design director, graphic designer, entrepreneur, and educator are some of the words to best describe Denise Anderson. Her finely tuned analytical ability, penetrating perception, creativity, and visual versatility are the natural result of her twenty years experience in the business of design, branding, and business development. In addition to her vast professional experience, Anderson holds a master's degree in design management from Pratt Institute in New York.

"Years before I was a designer, I owned a Baskin-Robbins™ ice cream store. According to my contract with Baskin-Robbins, the store's operating hours had to be from 11 A.M. until 10 P.M., 365 days a year. Since it was not feasible for me to work all those hours, I trained employees to scoop ice cream, make sundaes—basically keep my business open and running. I trusted that the people I employed would care for my precious investment while I was not minding the store. To my knowledge, most of my employees were responsible, and some seemed to care as much as I did.

What occurred at Baskin-Robbins is analogous to what I experience as a designer. When designing a brand identity for an organization, I invest my time, expertise, and creative talent. I make sure that the design objectives align with my client's business goals. When completed, I deliver a strong brand identity that improves the organization's image, helps the organization communicate more effectively with its customers, and provides a competitive advantage amongst competitors. But, just as I entrusted my valuable ice cream store to employees, I hand over the brand identity to my client—a business professional who (probably) thinks design is only an 'output' and not a key business asset that needs shepherding, an asset that requires facilitating consistency beyond the perfunctory brand standards manual, if you will.

Some of my larger clients do have a 'keeper of the identity,' such as a design director or marketing manager, who knows how to oversee the brand identity, but often, large and smaller businesses that do not make the connection between 'design' and the 'brand' may, on a whim and without hesitation, change things—like a logo's color to match the interior of the newly decorated living room of the CEO.

In addition to not being able to sustain brand identity cohesiveness, organizations are absolutely missing the potential *power of design*. I call this miscalculation 'the soft spot'—that area surrounding the brand and brand identity that infiltrates each business function which is called integrated design management. It is what is needed to harness the power of design and eliminate that enervating soft spot. Effective management of design requires an integrated approach, linking the specific contribution of design specialists (the special power of design think™: idea generation, creativity, specialized problem-solving, differentiating the parity of goods and services, and implementing concepts) with those of other professionals in the organization. Early integration of design with other expert functions (technology, marketing, finance, etc.) can greatly reduce the incidence of problems at a later stage. If a client realizes that an effective brand identity is invaluable, that 'design think' can work for the entire organization and work extremely well, then a cross-functional team can reduce costs, generate revenue, or create opportunities for an organization. And we'd see more successful business stories. No matter what, someone with the right expertise has to mind the store."

— Denise Anderson, director of Marketing Services for Pershing

Case Study from Olson

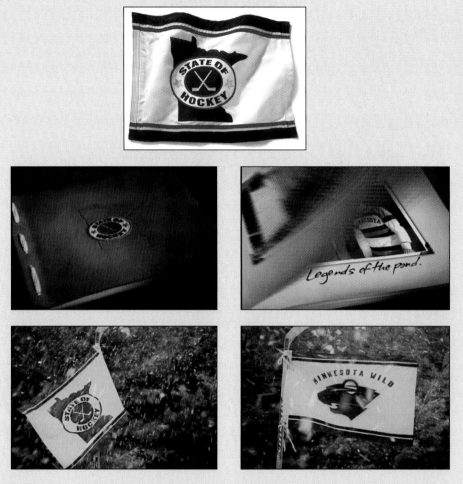

Figure 9-I. *Brand: Minnesota Wild™, "The State of Hockey*SM*." Agency: Olson, Minneapolis, MN.* © 2004

Minnesota Wild

To successfully launch a professional hockey team in St. Paul, we had to devise a method to convince thousands of mourning Minnesota hockey fans to return to professional hockey, after being disillusioned by the North Stars moving to Dallas in 1992. We believed the only way to connect with them was to make every fan feel like they were part of the team, and that the team was nothing without them. The fans were #1.

We created the "State of Hockey"—a name and icon that positioned the team as something born out of the love of the game, rather than a franchise born in an NHLSM boardroom. We wanted every interaction the fans had with the brand to mean something special. To initiate this bond, we created the State of Hockey flag and anthem, an opening night video, a thank-you campaign to the fans, and two direct-mail pieces that asked people to renew their season tickets and sign up for the Wild Warming House (the Wild's season ticket waiting list).

Moving further away from the past and trying to unite the fans and players as one, Year III in the State of Hockey revolved around The Team of 18,000. When the Wild took to the ice, there weren't just six players, there were 18,000. The State of Hockey still had a home in all of the branding and advertising elements, but that year's focus revolved around The Team of 18,000.

2000-2001 (the inaugural season)

- State of Hockey Flag
 - The symbol of the Wild brand. To lead the team out onto the ice, the State of Hockey flag is skated out onto center ice by a local youth hockey player before every game.

- Opening Video
 - The video played before each game that ties the nostalgic Minnesota hockey past to the Minnesota Wild of today:
 A shot of the *Frozen Moments* book cover
 A shot of the *Frozen Moments* book opening up
 A shot of the State of Hockey flag (State of Hockey side)
 A shot of the State of Hockey flag (Minnesota Wild side)

- Thank-You Poster
 - One of four posters seen throughout the arena, all stating "One by one. Thanking every fan."

- Season Ticket Renewal
 - Instead of just signing their name by their credit card number, fans received a fan contract asking them to sign on as part of the team for another year.

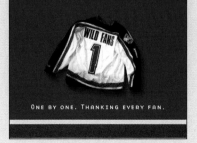

WILD FAN, LAVONNE SICARD.
THANKS FOR YOUR SUPPORT LAVONNE.

ONE BY ONE. THANKING EVERY FAN.

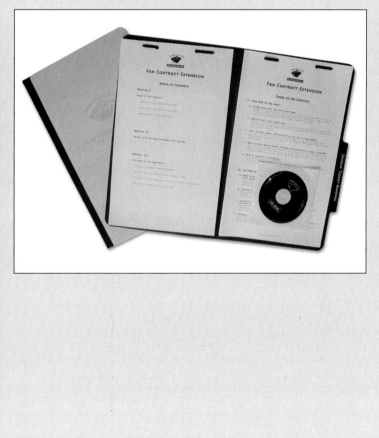

Case Study from Olson
continued

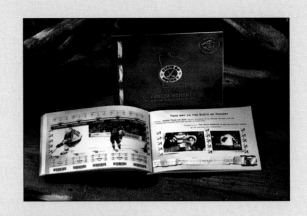

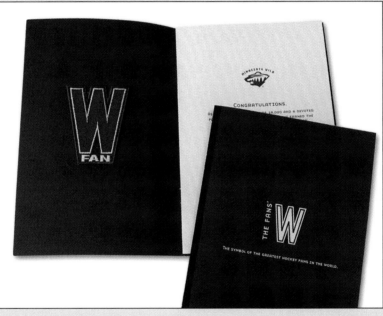

2001-2002

- 2001-2002 Season Tickets
 - *Frozen Moments: A Season in the State of Hockey*
 Each group of five tickets is tied to a historic moment in a week from Minnesota's hockey past with a moment in a week from the Wild's inaugural season. Fans could keep their ticket stubs to create a photo book of memories. The back of every other page in the *Frozen Moments* ticket book contained placeholders for each ticket and at the top read "This week in the State of Hockey."

- Season Ticket Renewal
 - Instead of receiving a "C" for captain or "A" for assistant captain, fans received a "W FAN" patch that they earned for being part of the team. The patch was contained in a Fan Handbook, which included everything from cheering techniques to the location of where the W FAN patch should be attached to the Wild fan sweater.

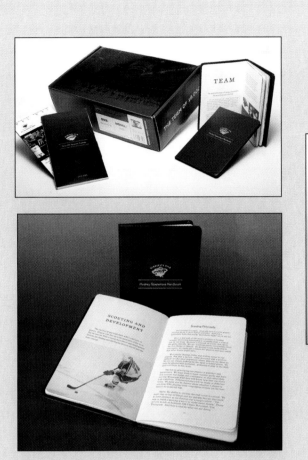

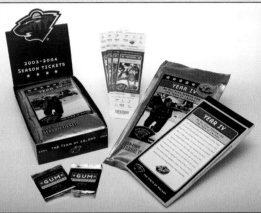

2002-2003

- 2002-2003 Season Tickets
 - The tickets and the Hockey Operation Handbook came in a box resembling a hockey skates box. The tickets focused on bringing the fans and players together as members of The Team of 18,000. Real Wild fans were photographed to mimic action poses of the players and coaches.

- Hockey Operations Handbook
 - The general manager Doug Risebrough and coach Jacques Lemaire had a plan to build a consistently winning franchise. This isn't something that happens in a year or two, so the Hockey Operations Group wanted to explain this long-term plan to fans before they set their expectations too high. The book focused on the Four Principles of the Minnesota Wild: Team, Passion, Preparation, and Honesty.

2003-2004

- 2003-2004 Season Tickets
 - Complete with a stick of gum, the tickets were packaged in a foil wrapper to look like a pack of hockey trading cards. The tickets themselves focused on fans and players being Team of 18,000 All-Stars since the 2004 All-Star game was at the Xcel Energy Center in 2004.

— Olson

Case Study from Mustoes

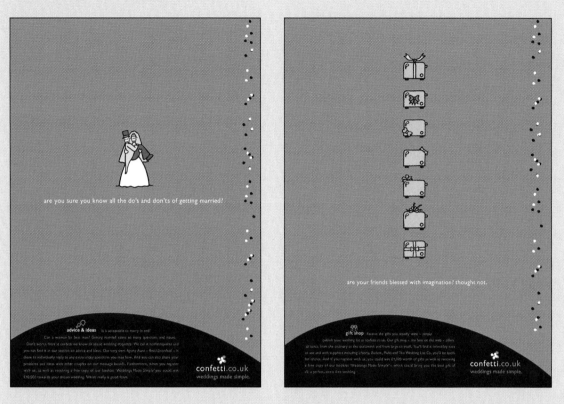

Figure 9-2. *Brand campaign: Confetti.co.uk. Agency: Mustoes, London, U.K. Client: Confetti.co.uk. Market: Online wedding and party planning. Media: Press and radio.*

Confetti.co.uk

What was the challenge facing the brand?

To build a brand from scratch in six months in a highly demanding marketplace with a very limited budget; also to reach two target audiences—consumers and suppliers—and prove that the branded business could succeed to encourage future investment from venture capitalists.

Whose behavior did you need to affect?

- Engaged couples, particularly the bride who tends to be responsible for the bulk of the wedding organization
- Suppliers or companies who would supply the content and products to ensure that Confetti.co.uk became a "destination site"

What was your insight?

Brides want and need someone to help them plan and organize their weddings. Nowadays, most modern brides aren't still living at home, and many are paying for their own wedding, which means they're less likely to consult their family on everything for their big day. They lead busy lives, work full time, and are likely to be living in a different location from where they are getting married. Consequently, planning a wedding is a bit of a minefield; they're unlikely to know what needs to be done, or where to start, and probably don't have the time or knowledge as to where to find the relevant information. They need someone who can help—Confetti.co.uk, the bride's "virtual mother."

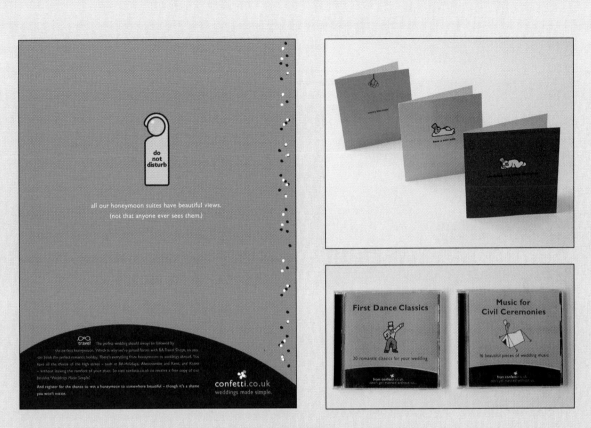

Did you do anything in particular to arrive at this insight?

Qualitative research with brides-to-be—especially those who had used the site when it was first set up, prior to the advertising being developed—was utilized.

How did you execute this strategy?

Rather than fall into the common dot.com advertising trap of merely driving awareness of the site, we clearly communicated the brand benefit to ensure that those who were recently engaged visited the site. We positioned Confetti as the web site that takes the stress out of organizing a wedding, and communicated it in a light-hearted, modern, and fun way, summed up with the line "Weddings made simple."

The print layouts were minimalist to emphasize Confetti's simplicity and modernity, using purple to make it memorable. We used Graham Norton as the Confetti spokesman in the radio ads; he was fun, lively, down to earth, and perfect in the role of the modern bride's mother—and able to give impartial advice, as he personally had no vested interest in weddings.

Because we needed to drive awareness of Confetti's launch quickly, we used a mixture of print media. National press provided coverage and created a broadcast feel, the obvious wedding magazines reached the consumer target in "planning mode," and additional ads in *Hello!* and *OK!* started to "get under the radar"—perfect due to proximity to coverage of celebrity weddings, often used for inspiration and ideas. We reinforced the brand message through radio, which is ideal for reaching the "engagees" on their way to and from work.

As this audience are keen web users, online banners—the ideal way to help direct people to the site—were also deployed.

As the relationship with Confetti continued, we successfully developed this design look to encompass such diverse areas as brochures, greeting cards, and cuff links.

Case Study from Mustoes

continued

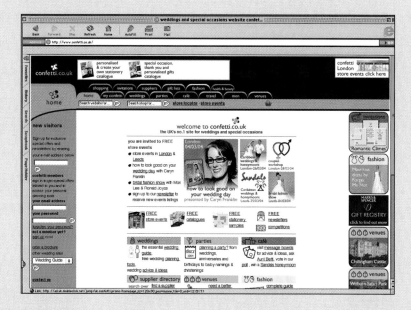

What evidence do you have for success?

- Confetti.co.uk was one of the youngest start-ups to enter the "e25" (one of 25 companies out of 500 reviewed by *Management Today*, and rated by Bain & Co. as being most likely to succeed).

- By March 2000 (six months before advertising launch), Confetti had 33,070 wedding profiles (a detailed database on engagees), 8 percent higher than its annual target, and higher than Mintel's estimations of wedding list databases held by retailers such as Argos (28,000), Debenhams (23,000), and M&S (18,000). Prior to the advertising launch, an average of 267 new wedding profiles were coming onto the site each week; this rose to an average of 1,342 profiles per week when the advertising broke. When these consumers responded to an online questionnaire, 66 percent of them claimed to have visited Confetti.co.uk as a result of seeing advertising—60 percent of this group claiming that it was because of Confetti's press advertising.

- With 7,500 wedding suppliers on the site by March 2000, Confetti was one of the most comprehensive and fastest growing wedding supplier databases. Prior to the launch of the advertising, an average of 164 new suppliers signed up to Confetti per month; this rose to an average of 427 per month during the advertising period. "I first became aware of Confetti.co.uk through its press advertising in the national media; hence, the Confetti/BA travel shop was born."— Stephen Dickey, British Airways.

- By March 2000, a Taylor Nelson study of unmarried couples that were aware of any Internet sites showed that Confetti's brand and advertising awareness had reached 23 percent and 17 percent, respectively. This compared favorably with their two main competitors, WebWedding *(www.webweddings.co.uk)* and WeddingGuideUK.com *(www.weddingguide.co.uk)*, which both achieved brand and advertising awareness levels of 3 percent and 0 percent, respectively.

- Among the key target audience—unmarried working women aged 20 to 45—Confetti achieved brand and advertising levels of 46 percent and 35 percent, again way ahead of WeddingGuideUK.com (8 percent and 6 percent, respectively) and WebWedding (5 percent and 0 percent, respectively).

Mustoes are still designing greeting cards, merchandise (CD covers, cufflinks, wedding stationery), and specific, events-related online advertising banners for Confetti. The original ads have been refreshed and are used in key wedding publications, as well as online, and now in Confetti's first store on Tottenham Court Road. Mustoes helped Confetti launch their first retail store and are still assisting in the development of their "brick and mortar" presence.

— Mustoes

Case Study from VSA Partners, Inc.

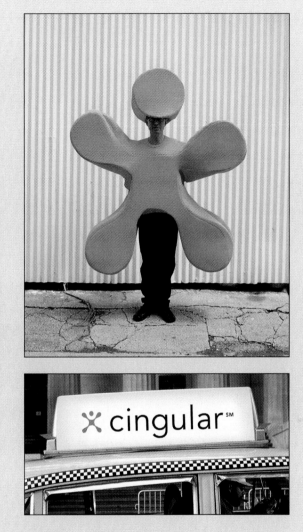

Figure 9-3. *Brand merger: Cingular Wireless, "A Name That Stands Alone." Studio: VSA Partners, Inc., Chicago, IL.*

Cingular

When BellSouth and SBC Communications merged their eleven existing wireless properties in 2000, the result wasn't just the nation's second-largest wireless company—it was also the nation's most relevant wireless brand.

This wasn't by accident. Early on, BellSouth and SBC asked VSA to develop their new company's brand—from strategy to name to visual identity. To make the company stand out in an already crowded, over-communicated marketplace, VSA positioned the company as the "refreshing alternative" in the wireless industry and focused on technology as an enabler of human communications: a single source for interaction and individualized services; products and services as a channel for personal expression; and a means for individual achievement. No matter what form technology may take, Cingular[SM] promised to make it understandable, usable, and valuable in your life.

Case Study from VSA Partners, Inc.

continued

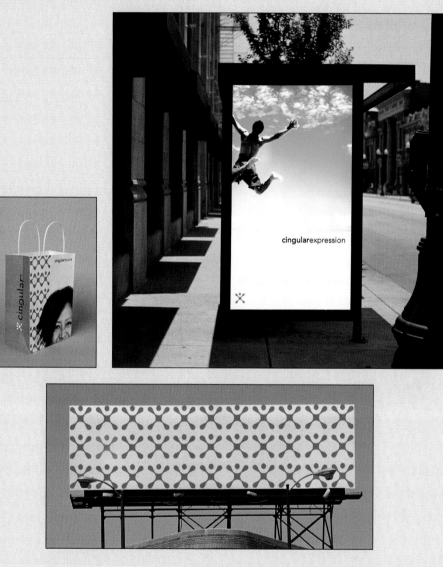

Figure 9-3 continued. *Brand merger: Cingular Wireless, "A Name That Stands Alone." Studio: VSA Partners, Inc., Chicago, IL.*

This brand positioning led VSA and its client to the "Cingular" name. In a nationwide marketplace where its peers' names bring to mind The Phone Company[SM], "Cingular" offered simplicity that was differentiating. The graphic identity of the new company followed the same logic, capturing the essence of the company through its human form and feel—simple, playful, enabling—and lending itself to a powerful retail presence.

Today, the Cingular name and identity are everywhere. But more than pervasiveness, the value of the brand is built on a relevant, resonant message in a consumer-unfriendly marketplace.

— VSA Partners, Inc.

Case Study from Mires

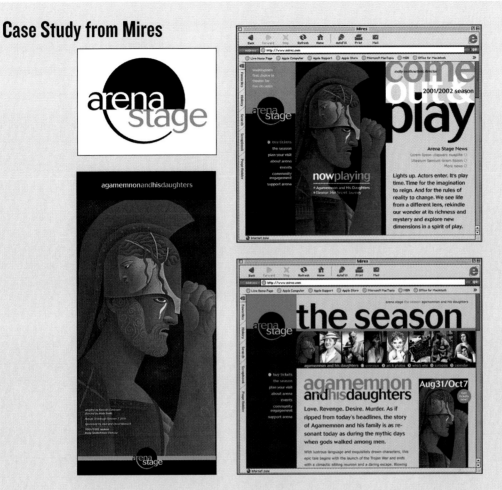

Figure 9-4. *Brand revitalization: Arena Stage, "The nation's leading regional theater." Design firm: Mires, San Diego, CA. Creative director: Scott Mires. Client: Arena Stage.*

Arena Stage

Nearly five decades of critical and commercial success had earned Arena Stage a reputation as "America's regional theater." But with a new crop of theaters claiming their share of Washington, D.C., audiences, management knew it needed a bold plan to recapture its base. Could it go beyond attracting audiences with popular shows—and build passionate loyalty to the institution itself?

Yes, if the theater could put its own powerful and unmistakable visual signature on all of its productions, and infuse its donor packages, subscription brochures, and programs with more of a shared sense of spirit and purpose.

Because Arena's place in the nation's capital called for a world-class presence, original works were commissioned that brought forth the soul of each production. Expressive and bold, these images re-energized the media, the staff, and a new generation of theatergoers. A graphic program, anchored by a distinctive logo referencing Arena's theater-in-the-round, provided the supporting continuity.

By opening night, Arena was repositioned as the nation's leading regional theater. By the end of the season, it had amassed the highest-grossing sales in its history, and record numbers of new donors had pledged their support, reversing a six-year decline. In its second season, subscription renewal and acquisition rates continued to climb. Firmly re-established today, Arena Stage is a vital cultural institution and a vibrant institutional brand.

— Mires

Case Study from Mires

continued

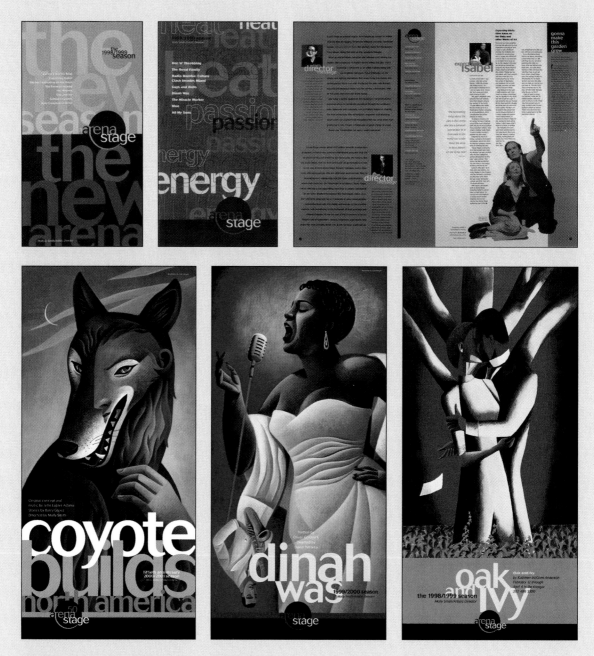

Figure 9-4 continued. *Brand revitalization: Arena Stage, "The nation's leading regional theater." Design firm: Mires, San Diego, CA. Creative director: Scott Mires. Client: Arena Stage.*

the women

High society comes to low blows in this wickedly-feminine enclave of Park Avenue wives. With Mary, Sylvia, Nancy, Peggy and Edith and their epic array of maids, society friends, children and pedicurists, we learn that all's fair in love and at the bridge table. When marital infidelity rudely plays its hand, the wives head for Reno to salvage their pride and settle their divorces. Sizzling gossip and scintillating *bon mots* abound as the women come to recognize that husbands may come and go, but some friends can be a curse for life!

hot 'n throbbing

Case Study from Renegade Marketing Group

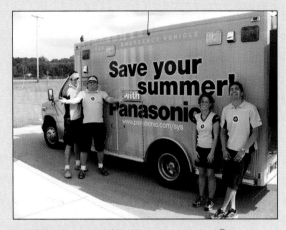

Figure 9-5. *Unconventional brand campaign: Panasonic®, "Save Your Summer." Agency: Renegade Marketing Group, New York, NY.*

Panasonic

Objectives:

- "Coolify" the Panasonic brand
- Drive traffic to *Panasonic.com* and capture consumer names

Target:

- Young audio/video enthusiasts (heavy buyers and influencers)

Sharp:

- Target is from Missouri ("show me")

Solution:

- Panasonic Fun Emergency Vehicles delivered a "summer saving" experience with karaoke, instant DVD recordings, and jaw-dropping product demonstrations.

For more than six years, Renegade has been working with Panasonic to help "coolify" their brand, both online and off. In 2003, we launched three Fun Emergency Vehicles that traveled around the country creating richly rewarding brand experiences. On a mission to "save your summer," each vehicle was equipped with a karaoke station which recorded performances instantly on DVD, a hot new Panasonic technology. Panasonic "rescue teams" ensured that summers were saved across the country.

One Fun Emergency Vehicle was dedicated to the Hispanic market, delivering a culturally appropriate experience *("Dale vida a tu verano").* Visiting a variety of venues, including retailers, Major League soccer games, and MLS Futvolito events, Hispanics showed their enthusiasm for this program by buying more Panasonic products than ever before.

The "Save Your Summer" promotion also captured the interest of the press, generating coverage on television, radio, print, and the Internet. All of this activity served to drive prospective Panasonic customers to *Panasonic.com/sys.*

Objectives:

- Extend the offline "Save Your Summer" promotion to the SYS experience
- Capture customer names and build relationships
- Position Panasonic as a cool, hip brand with younger consumers

Target:

- Young audio/video enthusiasts (heavy buyers and influencers)

Sharp:

- Be irreverent, humorous, and engaging, and they'll tell all their friends

Solution:

- A multitiered online experience, including highly targeted online media, an irreverent match-and-win sweepstakes, and a fictitious, parallel universe called *PeopleAgainstFun.org*

Online Media

Given the popularity of instant messaging among the target audience, partnering with Yahoo's IMvironment proved to be a brilliant idea, generating millions of quality impressions and a record low cost per click to the Panasonic web site. The SYS promotion was also supported with

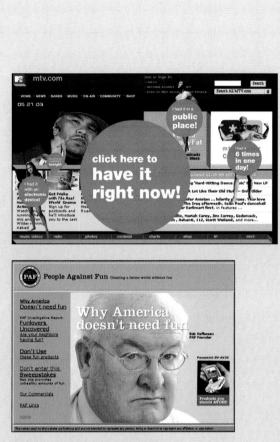

Figure 9-6. *Online promotion: Panasonic. Agency: Renegade Marketing Group, New York, NY.*

rich-media banners like the EyeBlaster that ran on *MTV.com* and helped Panasonic capture thousands of valuable names for on-going relationship building.

Viral Component

The boffo People Against Fun web site turned marketing upside down as Bob Pafferson and his PAF organization encouraged visitors to avoid fun and the excessive levels of fun that Panasonic products provide. Mr. Pafferson's efforts attracted the attention of thousands who, in turn, let all their friends in on the joke.

"You can't just say you're fun. You have to prove it," says Gerry Eramo, general manager, Interactive, Panasonic Consumer Electronics Company.

— Renegade Marketing Group

Chapter 10

The Ethics of Branding

What are the Ethics of Branding?

Becoming a good designer entails more than the ability to produce effective branding solutions—it entails working by an ethical code of professional behavior. How do we know what is ethical? Does it mean relying on our own good sense, on general consensus, or winging it every time we take an action? First, let's generally define ethics. In this passage from *The Philosopher's Way*, Professor John Chaffee explains terms:

"'Ethics' and 'morals' are terms that refer to the principles that govern our relationships with other people: the way we ought to behave, the rules and standards that we should employ in the choices that we make. The ethical and moral concepts that we use to evaluate these behaviors include 'right' and 'wrong,' 'good' and 'bad,' 'just' and 'unjust,' 'fair' and 'unfair,' 'responsible' and 'irresponsible.'"[1]

What, therefore, is ethical design practice? The only answer is a multifaceted one—one as complex as being a responsible citizen of the world. Behaving ethically means taking responsibility for one's actions, and it means the full realization of the impact of those actions on others, both positively and negatively.

To design responsibly, we must consider several factors, most notably:

• The Audience
• The Message
• The Client
• The Design

The Audience

In all of our work, we ought to consider the audience's welfare. This is an ethical imperative. As a designer, your challenge is to act by a code that deeply respects and thoughtfully considers the audience—their dignity, freedom, liberty, cultures, health, safety, right to know, and sense of worth. These are the "shoulds." The "should nots" include a laundry list of unethical behavior. In order to distance branding and advertising from the early taint of hucksterism, psychological manipulation, and treating audiences like "suckers," branding and advertising professionals must communicate truthfully and respectfully, eliminating puffery and deceit.

Do people view hair coloring as the science of color or as an esteem enhancer? Do people want to do business with banks that are cast primarily as efficient, friendly, or stable? Using research and insights into what and how people think gives the branding expert an edge on how to cast a brand. Keep in mind, though, that any consumer insights should be used to connect to people, not to manipulate them.

If the visual communication professions (and our clients) were to agree upon a code of conduct, that would certainly aid best practice. The International Association of Business Communicators' (IABC) ethics statement, which they post on their web site *(www.iabc.com)*, is exemplary; it emphasizes responsibility to the audience. Here is a passage:

"Because hundreds of thousands of business communicators worldwide engage in activities that affect the lives of millions of people, and because this power carries with it significant social responsibilities, the International Association of Business Communicators developed the Code of Ethics for Professional Communicators.

The Code is based on three different yet interrelated principles of professional communication that apply throughout the world.

These principles assume that just societies are governed by a profound respect for human rights and the rule of law; that ethics, the criteria for determining what is right and wrong, can be agreed upon by members of an organization; and that understanding matters of taste requires sensitivity to cultural norms.

These principles are essential:

- Professional communication is legal.
- Professional communication is ethical.
- Professional communication is in good taste.

Recognizing these principles, members of IABC will:

- engage in communication that is not only legal, but also ethical and sensitive to cultural values and beliefs;
- engage in truthful, accurate, and fair communication that facilitates respect and mutual understanding; and
- adhere to the following articles of the IABC Code of Ethics for Professional Communicators.

Because conditions in the world are constantly changing, members of IABC will work to improve their individual competence and to increase the body of knowledge in the field with research and education.

Articles *(www.iabc.com/members/joining/code.htm)*:

1. Professional communicators uphold the credibility and dignity of their profession by practicing honest, candid, and timely communication and by fostering the free flow of essential information in accord with the public interest.
2. Professional communicators disseminate accurate information and promptly correct any erroneous communication for which they may be responsible.

3. Professional communicators understand and support the principles of free speech, freedom of assembly, and access to an open marketplace of ideas—and act accordingly.
4. Professional communicators are sensitive to cultural values and beliefs and engage in fair and balanced communication activities that foster and encourage mutual understanding.
5. Professional communicators refrain from taking part in any undertaking which the communicator considers to be unethical.
6. Professional communicators obey laws and public policies governing their professional activities and are sensitive to the spirit of all laws and regulations and, should any law or public policy be violated, for whatever reason, will act promptly to correct the situation.
7. Professional communicators give credit for unique expressions borrowed from others and identify the sources and purposes of all information disseminated to the public.
8. Professional communicators protect confidential information and, at the same time, comply with all legal requirements for the disclosure of information affecting the welfare of others.
9. Professional communicators do not use confidential information gained as a result of professional activities for personal benefit and do not represent conflicting or competing interests without written consent of those involved.
10. Professional communicators do not accept undisclosed gifts or payments for professional services from anyone other than a client or employer.
11. Professional communicators do not guarantee results that are beyond the power of the practitioner to deliver.
12. Professional communicators are honest not only with others but also, and most importantly, with themselves as individuals; for a professional communicator seeks the truth and speaks that truth first to the self."

The Message

Designers and art directors are image makers. And the images we fabricate have both denotative and connotative messages. How we represent reality—the connotation of "constructed" messages—affects people. We must scrupulously dissect those fabrications for negative undercurrents. Constructed messages can easily carry negative messages about age, race, ethnicity, gender, and religion. They can also be violent, stereotyped, sexist, belittling, demeaning, and foster prejudice or violence. The portrayal of others carries responsibility. Often, we don't scrutinize or think about ramifications. For example, a renowned designer is deeply regretful for having used the image of a corpse on a CD cover. He now realizes the connotations of the image that aroused many viewers in a way he had not expected nor desired.

John Bowers writes with great clarity: "We are responsible for the ways we address issues and transmit ideas, concerns, and information. While there are few guidelines for acting responsibly, continued growth, critical self-reflection, and openness to others can nourish the process."[2]

As visual communicators, creative professionals are the makers of visual representations of ideas and reality. Here are some thoughts to move toward a more responsible effort:

- Design both transmits and affects content.
- In a glutted global marketplace, the proliferation of brands should not compel designers to abandon responsibility in order to get the consumer's attention at any cost.
- A representation of reality is neither natural nor passive, but an artificial construct that carries and communicates meaning with societal consequences.
- Negative stereotyping must be avoided at all costs and must be recognized even when veiled.

The Client

Both legally and ethically, designers have obligations toward their clients.

The AIGA (American Institute of Graphic Arts) has released a series of brochures outlining the critical ethical and professional issues encountered by designers and their clients. The series, entitled "Design Business and Ethics," examines the key concerns a designer faces. Here is an excerpt:

"Ethical Standards

A professional designer does not work on assignments that create potential conflicts of interest without a client's prior consent. A professional designer treats all work and knowledge of a client's business as confidential. A professional designer provides realistic design and production schedules for all projects and will notify the client when unforeseen circumstances may alter those schedules. A professional designer will clearly outline all intellectual property ownership and usage rights in a project proposal or estimate. Clients can expect AIGA members to live up to these business and ethical standards for professional designers. Through consistently professional work, AIGA members have documented substantial bottom-line contributions to corporations and organizations." For more information and case studies about how professional designers have produced excellent business results, visit *www.aiga.org*.

The Design

We use the term **sustainable design** to describe design that incorporates environmental matters, also called eco-design, green design, or design for the environment. Sustainable design is not to be confused with how some branding experts use the term "sustainability" to mean building longevity into a brand identity, to maintain a long life in a changing marketplace.

Here's a bit of background that will help in putting sustainable design in perspective.

Since 1992, when the U.N. Conference on Environment and Development Earth Summit was held in Rio de Janeiro, we have made modest progress through the work of many scientists, business people, activists, political leaders, and world citizens in an attempt to preserve our environment and have a fairer view of how actions affect all people and ecosystems. Incremental steps toward sustainable design aren't enough, though; we need to practice sustainable design. We need to take a big leap—operating in ways that are environmentally sustainable, encouraging judiciousness. In 2001, Kofi Annan, Secretary General of the United Nations, eloquently stated our goal: "Our biggest challenge in this new century is to take an idea that seems abstract—sustainable development—and turn it into a reality for all the world's people."

The summit pointed out these directives:

- Scrutinize patterns of production for toxic waste.
- Seek alternative sources of energy to replace the use of fossil fuels, linked to global warming.
- Rely on public transportation systems in order to reduce vehicle emissions causing air pollution.
- Examine and address the growing scarcity of water.

For more information, see *www.un.org/geninfo/bp/enviro.html.*

Historically, it has been proven that inflicting harm on the environment contributes to a society's collapse. We can only deplete natural resources, cause erosion, and deforest to a point; we can only negatively act upon the environment—pollute, damage, generate huge amounts of garbage, ravage—until the environment is no longer hospitable. Jared Diamond, author of *Collapse: How Societies Choose or Fail to Succeed*, points out in an article "The Ends of the World as We Know Them" that there are five groups of interacting factors that hold relative importance in contributing to historical collapses: "the damage that people have inflicted on their environment; climate change; enemies; changes in friendly trading partners; and the society's political, economic, and social responses to these shifts."[3]

Essentially, the sustainable design protocol is a call to dramatically change our behavior, to look to the needs of everyone, as well as to future generations. It is a call to suspend greed, recklessness, overuse, narcissism, nationalism, and unfairness. It is a critical call to respect the environment that sustains us all. Eco-efficiency is an imperative.

The role of visual communication professionals

What is the role of visual communication professionals in sustainable design?

Sustainable design enhances brand integrity through the adoption of safe and ethical practices. It begs industry to integrate ecological materials to create print, packaging, promotional applications, and unconventional applications that are entirely safe for people and the environment, as well as good for the economy. Edwin Datschefski, the founder of Biothinking International and Imagination!, developed the cyclic/solar/safe methodology for assessing the environmental performance of products and processes *(www.totalbeauty.org).*

Sustainable design involves troubleshooting for potential hazards and wastefulness, while attempting to optimize function and minimize negative effects. The three main areas of concern are:

- Materials: utilize recyclable materials, compostable organic materials, or continuously cycled minerals

- Energy: utilize renewable energy sources, such as solar, conventional hydroelectric power, wood, waste, geo-thermal, wind, and photovoltaic energy
- Pollution: manufacturing processes and materials that are nontoxic to air, water, and earth

It will take rethinking in order to practice sustainable design, make prudent use of natural resources, and effectively protect the environment. Sustainable design is an entire study in and unto itself. This points toward the need for all of us to become aware of sustainable design.

As designers, we must consider the materials we use. Consider deeply how the materials affect (deplete, pollute, add unnecessary refuse, waste) the world environment. We can make choices to use environmentally friendlier materials and inks, reduce packaging materials to essentials, and use recycled materials. Yes, costs go up when practicing sustainable design in the short run. In the long run, though, the cost will not be destroying the environment. We must preserve our environment. All of our actions have consequences.

Brand Influence on Society

Some faiths have a heritage of condemning self-indulgence in favor of humbleness. Secular critics condemn ardent consumerism on the grounds of ostentatious living, misguided satisfaction, as well as placing emphasis on "spending and getting" rather than on "giving and saving." Clearly, some find materialism objectionable; while many, with disposable income, find consumerism positive. Criticism—always—tempers; it is a good modifier, often spurring examination. Critics and advocacy groups are very important; they expose and unveil.

Rather than "throwing the proverbial baby out with the bath water," perhaps we can find a middle ground where branding works very positively toward several interrelated goals. As always, branding helps drive global economies. Without consumer spending, there would be a rippled negative effect on employment throughout the world.

Branding democratizes luxury and "having." Owning brands equalizes people. In *Living It Up*, James B. Twitchell, professor at the University of Florida, points out that people share branding and advertising, that "We share branded things."

The same skill set used to promote brands is used to promote social causes, organizations, and charitable groups. Advertising agencies and the creative professionals employed by them donate time and talent to create public service advertising. Innumerable public service advertising campaigns have greatly benefited society. To view impressive case histories of current and historic campaigns, visit the Advertising Council web site *(www.adcouncil.org)*.

The graphic design community is a generous, intelligent, and kind one. A recent Icograda survey reported that ". . . ninety percent of designers do pro bono work. Almost a third do it on a regular basis, and sixty-one percent do it occasionally for causes they consider worthy."

"But if business is to make the world a better place, we also need to step outside our own comfort zone, share resources, and take a new perspective."[4]
— Kevin Roberts, CEO Worldwide, Saatchi & Saatchi

When Bob Isherwood, Worldwide Creative Director, Saatchi & Saatchi, delivered his keynote address at the Kean University "Thinking Creatively" conference in 2004, he spoke passionately about the Saatchi & Saatchi Innovation in Communication Awards which fund "world-changing ideas." This biennial global competition recognizes and rewards inventors whose creations have the potential to revolutionize communication among people, groups, business and professional organizations, artists and their audiences, and even nations. The award is designed to provide revolutionary ideas with the visibility and marketing support necessary to have world-changing impact. Ideas funded include Dr. David Irvine-Halliday's "Light Up The World"—a humanitarian initiative whose chief goal is to provide affordable light to villagers in the developing world, by the innovation of a white LED (light-emitting diode) form of lighting. The diodes consume only one watt of power (*www.saatchi.com/innovation/*).

Giving Back to Society

Creative professionals give back to society. Brands (meaning their corporations) also ought to give back, via grants, funding research, charitable gifts, and cause-related marketing. We can urge companies to do so by supporting those that donate. The "good life" needs to extend to all people through good works, giving, and education. Big business can make it so. Many companies' actions positively impact society. Some actively work toward environmental protection, energy conservation, and consumer safety by conducting or funding research, getting involved in their communities, and conducting business ethically. For example, the General Mills company has a corporate heritage of giving, dating back to the 1800s. In 2002, General Mills gave away $65 million to a wide range of causes. "Throughout General Mills, the message is loud and clear that good corporate citizenship doesn't end with the bottom line—community involvement is reflected in performance reviews for top executives," says Christina L. Shea, president of the General Mills Foundation. "We take as innovative an approach in giving back to our communities as we do in our business."[5]

Whether it's the company that gives, such as Ben & Jerry's, General Mills, and Procter & Gamble, or the individuals who own the companies, such as Bill and Melinda Gates, Oprah Winfrey, and Michael and Susan Dell, giving back is critical.

Best-case scenario

Corporations need to work by established ethical codes to eliminate greed and recklessness. Creative professionals can urge clients to take ethical routes. Of course, they can only urge others. Certainly, creative professionals can practice ethically, acting as role models for other professionals. Visual communication professionals, too, need to adopt a professional code of ethics. Sustainable design must be adhered to in order to preserve our planet. Creative solutions and truth can and should coexist. We can practice ethically and follow sustainable design protocol. As visual communication professionals, we must stand firm in our ethics. Susan Cotler-Block, chairperson, Communication Design, Fashion Institute of Technology in New York, reminds us that "Responsible design is the only possible design solution."

The choices we make give our lives significance; the choices one makes defines one's character. And every decision affects the planet and others in their pursuit of happiness and significance. As individuals, we are part of a society, and our responsibility is not only to ourselves, but to the larger community. As the great philosopher Jean-Paul Sartre observed, ". . . if we grant that we exist and fashion our image at one and the same time, the image is valid for everybody and for our whole age. Thus, our responsibility is much greater than we might have supposed, because it involves mankind."[6]

Notes

[1] John Chaffee, *The Philosopher's Way: Thinking Critically About Profound Ideas* (Upper Saddle River, NJ: Pearson Custom Publishing, 2005), p. 226-227.

[2] John Bowers, *Introduction to Two-Dimensional Design: Understanding Form and Function* (Hoboken, NJ: John Wiley & Sons, Inc., 1999), p. 102.

[3] Jared Diamond, "The Ends of the World as We Know Them," *The New York Times,* Saturday, 1 January 2005, p. A13.

[4] Kevin Roberts, *Lovemarks: The Future Beyond Brands* (New York, NY: Powerhouse Books, 2004), p. 209.

[5] Michelle Conlin and Jessi Hempel, with Joshua Tanzer and David Polek, "Special Report–Philanthropy 2003. *Business Week's* first annual ranking of America's most philanthropic companies: The Corporate Donors," *Business Week Online, <http://www.businessweek.com/magazine/content/03_48/b3860616.htm>*.

[6] Jean-Paul Sartre, translated by Bernard Frechtman, *Existentialism and Human Emotions* (New York, NY: Philosophical Library, 1957), p. 16.

Glossary

abstract symbol mark: a type of logo which is a representational visual that is an abstracted design and relates to a real object, but which has been modified with an abstract emphasis.

advertising: the generation and creation of specific visual and verbal messages constructed to inform, persuade, promote, provoke, or motivate people on behalf of a brand.

audience: whoever is on the receiving end of a brand experience, brand advertising, or social cause communication—whether it is a large number of people or an individual.

blog: derived from the term "web log," which is, in many varieties, an online journal where someone records thoughts and opinions that may inspire comments from readers.

brand: a proprietary name for a product, service, or group (company, organization, corporation, or social cause or issue). On a more multifaceted level, a brand is the sum total of all functional and emotional assets of the product, service, or group that differentiate it among the competition.

brand architecture: the analysis of the company's brands and their interdependencies, including structuring how all their values can be maximized at every level of the company and throughout the strategic positioning of the brand.

brand construct: a conceptual strategic platform that has been systematically planned and developed for a brand.

brand essence: the combination of the essential points or aspects of a brand condensed into a central core conception, which is brought to life through the branding concept and the visual articulations of the concept.

brand experience: an individual audience member's experience as he or she interacts with a brand—every time he or she interacts with that brand.

brand extension: applied to a new product, service, or group with a different benefit or feature that is related to the existing brand (and extends the range of the existing brand); the target audience may be different.

brand harmonization: the coordination or harmonization of all the elements of a brand identity across experiences.

brand identity: the visual and verbal articulation of a brand or group, including all pertinent design applications; also called corporate identity or visual identity.

brand name: the verbal identity—a proprietary name—for a product, service, or group. Coupled with a tagline and/or descriptor, a brand name becomes the verbal signature of a company's product or service or of a group.

brand promise: the functional and emotional advantage and value pledged to the user.

brand revitalization: any major renewal and renovation of a brand, brand identity, and its position in the marketplace.

brand signature: the combination of the wordmark—the brand's name spelled out in unique typography—and the logo, which can be a symbol mark or a lettermark. It becomes the signature or sign-off for the brand or company. The brand signature can also be made up of the brand name, logo, and tagline or a particular word.

brand stewardship: shepherding the brand; also called brand management.

brand strategy: defines the brand's personality and promise, differentiates the brand from the competition by defining the brand's positioning, and codifies the brand essence; it is a conceptual plan providing guidelines—for both client management and creative professionals—to drive all brand applications from identity and packaging to advertising. Essentially, the brand strategy is how you are conceiving, creating, and positioning your brand in the marketplace to achieve differentiation, relevance, and resonance.

brand team: the unconventional collection of designer(s), art director, copywriter, media expert, strategic expert, and, perhaps, the client.

brand voice: a consistent tone established in all verbal and visual communication.

branded entertainment: embedded advertising, which refers to the act of embedding products in television shows or films, novels, and plays; also known as "brandvertising" or "advertainment."

branded environment: a visual identity that is formulated, applied, constructed, and tailored to a three-dimensional physical space for a variety of environments and for a variety of purposes, including to educate, entertain, endear, inspire, or promote.

branding: includes the entire development process of creating a brand, brand name, brand identity, and in some cases, brand advertising.

business card: a substrate—a small card—on which a person's name, business affiliation, and contact information are printed; most often, the business card is an integral part of a larger visual identity system which adheres to a corporate or company brand look.

cause-related marketing: a particular category of public service advertising that is used to raise funds for nonprofit organizations, which is run in paid media and is sponsored by corporations; also called cause advertising.

combination mark: a type of logo which is a combination of words and symbols.

concept: also called an idea in advertising, it is the unique thinking behind a brand, setting its visual style and (often) uniting its visual identity and applications. A core concept usually communicates the strategy (creative brief), brand spirit, or style; it can also create or highlight an emotional or a functional benefit that distinguishes a brand, endears it to the audience, and motivates the viewer to run out and buy the product, use the service, or act on behalf of a social cause, issue, or group.

consonance: consistency across brand applications; also called brand coherence.

creative brief: a strategic plan—a type of map— that both the client and design firm, or advertising agency, agree upon and from which the creative team works as a strategic springboard; it is also called a design brief or creative work plan.

creatives: graphic designers, design directors, art directors, interactive designers, writers, and creative directors who work in branding design firms, advertising agencies, or graphic design studios in conjunction with the brand company's marketing professionals.

design brief: a strategic plan—a type of map— that both the client and design firm, or advertising agency, agree upon and from which the creative team works as a strategic springboard; it is also called a creative brief or creative work plan.

differentiation: to establish a difference between your brand and the competition, to create a position or a niche in the market; particularly important for parity goods or services.

digital branding: utilizes digital media—that is, on-screen—to form, launch, and strengthen relationships between a brand and the users.

diversified (or customized) brand strategy: adjusts and tailors the brand experience for cultural differences among its various global target audiences.

emotional benefit: an intangible gain derived from using the brand or an affecting feeling consequential to the brand.

focus groups: a targeted group of people (potential audience) gathered by market researchers to "critique" the work the creative team has created.

functional benefit: a practical advantage or *functional capability* of the brand.

identity standards manual: a guide containing approved standard graphic elements of the logo, typographic palette and color palette, and brand signature; also called a graphics standards manual or brand standards manual. It also provides a range of possibilities and guidelines for use of fonts in various combinations and in various applications, both print and digital, as well as guidelines on choosing weights, size, numerals, symbols, bullets, and use of small caps, for both print and electronic applications.

letterhead: a sheet of stationery or digital page with the name and address of the brand, parent company, group, or organization printed on it; most often, it is part of a larger visual identity stationery system with consistent elements, such as the brand name, logo, color palette, and format or any graphic element or verbal component associated with the brand or brand signature that allow for identification of the brand.

lettermark: a type of logo that is created using the initials of the brand name.

logo: a unique identifying symbol or wordmark; also called a brandmark, mark, identifier, logotype, logomark, or trademark.

look and feel: the broad impression created by the consistency of the design and tagline, preserved by all applications in all contexts, for a brand.

monolithic brand strategy: one that presents the brand the same way in all markets.

packaging design: a graphic design application intended to function as casing, as well as to attract a consumer and to present information; it is an amalgam of two- and three-dimensional design, promotional design, information design, and practicality.

parity goods and services: products that are equivalent in value.

pictorial symbol mark: a type of logo which is a representational image that symbolizes the brand or social cause; it relates to an identifiable object.

positioning statement: a succinct written statement that defines the strategic plan by delineating the strategic concept and demarcating the vital characteristics of the brand and the marketplace; also called a strategy statement.

promotional design: graphic design that functions to introduce, sell, or promote products, ideas, or events.

public service advertising: advertising that serves the public interest.

sustainability: the ability to maintain a long, fruitful life in a dynamic marketplace.

sustainable design: design that incorporates environmental matters, also called eco-design, green design, or design for the environment (not to be confused with sustainability).

symbol mark: a type of logo that is a visual mark symbolizing the brand and that can be formed as a pictorial visual, an abstract visual, or a nonrepresentational visual.

tagline: a short succinct phrase, catch phrase, or end statement that embodies the broad strategy of a branding program and/or an ad campaign, establishing something memorable, particular, and clear about the brand; along with the name, a tagline is the verbal articulation of a brand, and is also called a brandline, claim, slogan, endline, or strap line.

target audience: a specific group of people or consumers targeted for any brand application or experience, whether it's a brand identity, traditional or unconventional brand advertising, public service advertising, or entire brand experience.

trademark: a word, name, symbol, device, or combination thereof that identifies and distinguishes the goods or services of one party from those of others, which is legally registered so that it is exclusive to the company.

unconventional advertising: advertising that "ambushes" the viewer; also called guerrilla advertising and nontraditional marketing. It appears or is placed in unpaid media in the public environment—places and surfaces where advertising doesn't belong.

wordmark: the name spelled out in unique typography or lettering; also called logotype.

Selected Bibliography

Aitchison, Jim. *Cutting Edge Advertising.* Singapore: Prentice Hall, 1999.

———. *Cutting Edge Commercials.* Singapore: Prentice Hall, 2001.

"Anheuser-Busch Does Product Placement in New Bar Show." *Madison + Vine.com.* 19 May 2005. *<http://www.adage.com/madisonandvine/>.*

Bedbury, Scott, with Stephen Fenichell. *A New Brand World: 8 Principles for Achieving Brand Leadership in the 21st Century.* New York: Viking, 2002.

Berger, Warren. *Advertising Today.* New York: Phaidon Press Ltd., 2001.

Bond, Jonathan, and Richard Kirshenbaum. *Under the Radar.* New York: John Wiley and Sons, Inc., 1998.

Boorstin, Daniel J. *The Decline of Radicalism: Reflections on America.* New York: Random House, 1969.

Bowers, John. *Introduction to Two-Dimensional Design: Understanding Form and Function.* Hoboken, NJ: John Wiley & Sons, Inc., 1999.

Browne, Alix. "Scent of a Movie." *The New York Times Magazine.* Sunday, 20 February 2005, p. 47.

"BURST! Media Begins to Sell Advertising on Blogs." *BURST! Media.* 4 January 2005. *<http://www.burstmedia.com/release/pressreleases/pr_01_04_05.htm>.*

Cancer Research U.K. *<http://www.cancerresearchuk.org/getinvolved/corporatepartnerships/crm/>.*

Chaffee, John. *The Philosopher's Way: Thinking Critically About Profound Ideas.* Upper Saddle River, NJ: Pearson Custom Publishing, 2005.

Conlin, Michelle, and Jessi Hempel; with Joshua Tanzer, and David Polek. "Special Report–Philanthropy 2003. *Business Week's* first annual ranking of America's most philanthropic companies: The Corporate Donors." *Business Week Online.* *<http://www.businessweek.com/magazine/content/03_48/b3860616.htm>.*

Cronin-Lukas, Adriana. "It's not a red herring." *The Big Blog Company.* Tuesday, 10 August 2004. *<http://bigblogcompany.net/archives/000398.html>.*

Curtis, Hillman. *MTIV: Process, Inspiration and Practice for the New Media Design.* New York: New Riders Press, 2002.

Diamond, Jared. "The Ends of the World as We Know Them." *The New York Times.* Saturday, 1 January 2005.

Edwardes, Charlotte. "Every second counts in $42m three-minute 'film'." *London's Sunday Telegraph.* 22 November 2004. *<http://www.smh.com.au/articles/2004/11/22/1100972313772.html?oneclick=true>.*

Elliot, Stuart. "Burger King Takes a Product From TV to the Table." *The New York Times.* Friday, 21 January 2005, Business section, sec. C, p. 8, col. 1.

———. "Greatest Hits of Product Placement." *The New York Times.* 28 February 2005, Business section, sec. C, p. 8, col. 1.

———. "In a Bit of Creative Recycling, an Ad for a Television Show Becomes an Element of the Show." *The New York Times.* Friday, 26 November 2004, Business section, sec. C, p. 2, col. 1.

———. "In what may be a risky move, Wendy's will bring Dave Thomas back to its campaign." *The New York Times.* Monday, 20 May 2002, Business section, p. C9.

———. "Mercury, a division of Ford Motor, tries an online campaign in an effort to create a cooler image." *The New York Times.* Thursday, 30 December 2004, Business section, p. C3.

———. "Musicians Market Brands to Sell Their Latest Music." *The New York Times.* Tuesday, 24 May 2005, Business section, p. C6.

———. "No More Same Old: Advertisers Want Something Different." *The New York Times.* Monday, 23 May 2005, Business section, p. C1-C8.

———. "Product Placement Moves to Cartoons." *The New York Times.* Thursday, 21 October 2004, Business section, sec. C, p. 10, col. 1.

———. "A survey shows slight gains in how agencies and marketers relate, but there is room to improve." *The New York Times.* Friday, 8 October 2004, Business section, final edition, sec. C, p. 3, col. 3.

Favre, Julien. "Focus: iTVi's Interactive TV Agenda." *iTVi.* 20 February 2003. *<http://www.iemmys.tv/itvi/archive/feature/February%202003%20-%2017.html>.*

"First Things First Manifesto 2000." *Émigré. <http://www.emigre.com/ArticleFTF.php>.*

Garfield, Bob. "Reebok Fiasco." *Adreview.com.* 29 April 2002. *<http://www.adreview.com/article.cms?articleId=888)>.*

———. "Remembering Dave Thomas and Regretting an Obnoxious 1989 Column." 14 January 2002. *<http://www.adreview.com/article.cms?articleId=873>.*

Gertner, Jon. "The Power of the PowerBar." *The New York Times Magazine.* Sunday, 26 December 2004, p. 16.

Goodrum, Charles, and Helen Dalrymple. *Advertising in America.* New York: Abrams, 1990.

Haberman, Clyde. "Paying for Art, But Instead Getting Ads." *The New York Times.* 28 December 2004.

"Hallmark: An American Dream Becomes An American Institution." *Hallmark.com.* January 2004. *<http://pressroom.hallmark.com/Hmk_corp_history.html>.*

Heller, Steven, and Elinor Pettit. *Graphic Design Timeline.* New York: Allworth Press, 2000.

"Hillman Curtis Talks About the Future of Web Video." *FlashStreamworks.com.* Sunday, 10 October 2004. *<http://www.flashstreamworks.com/archive.php?post_id=1097422120>.*

Ives, Nat. "Entertaining Web Sites Promote Products Subtly." *The New York Times.* 22 December 2004, Business section, sec. C, p. 2, col. 1.

———. "Marketing's Flip Side: The 'Determined Detractor'." *The New York Times.* 27 December 2004, Business section, sec. C, p. 1, col. 3.

———. "Pitch to Online Crowd Mixes Pop Stars and Personals." *The New York Times.* Friday, 3 December 2004. *<http://www.nytimes.com/2004/12/03/business/media/03adco.html?ex=1103079718&ei=1&en=a8245a2291908ca1>.*

Klimchuk, Marianne R. "The Front Panel: Must 'Mono-Culturalism' Mean Monotony?" *Package Design Magazine.* May/June 2004, p. 77.

Landa, Robin. *Advertising by Design.* Hoboken, NJ: John Wiley & Sons, Inc., 2004.

———. *Thinking Creatively.* 2nd ed. Cincinatti, Ohio: HOW Books, 2002.

Leth, Jan. "The Nature of Online Advertising: It's dialogue, not monologue." *Print.* November/December 2000, LIV:VI.

Lois, George. *Sellebrity.* New York: Phaidon Press, 2003.

———. *What's The Big Idea?* New York: Plume, 1991.

McCarthy, Michael. "Ad Track: Wendy's works viewers' love for Dave." *USA Today.* 21 August 2000.

McDonough, John, and Karen Egolf, eds. *The Advertising Age Encyclopedia of Advertising.* 3 vols. New York: Fitzroy Dearborn, 2003.

Meggs, Philip B. *A History of Graphic Design.* 3rd ed. Hoboken, NJ: John Wiley and Sons, Inc., 1998.

———. *Type and Image: The Language of Graphic Design.* New York: Van Nostrand Reinhold, 1989.

Meskill, Judith. "MySpace.com tops Friendster.com in Nielsen NetRatings?" *The Social Software weblog.* 1 March 2004. *<http://socialsoftware.weblogsinc.com/entry/1264838737315795/>.*

Roberts, Kevin. *Lovemarks: The Future Beyond Brands.* New York: powerHouse Books, 2004.

Roth, Hayes. "Wielding a Brand Name." *Landor.com.* 19 October 2001. *<http://www.landor.com>.*

Rothenberg, Randall. "The Advertising Century." *AdAge.com.* *<http://www.adage.com/century/rothenberg.html>.*

"RSA rewards new concepts." *Packaging Magazine.* 31 May 2001. *<http://www.packagingmagazine.co.uk/news/design/01_05_31_001.shtml>.*

Safire, William. "The Way We Live Now: 4-10-05: On Language; Brand." *The New York Times Magazine.* 10 April 2005, Sunday, late edition, final, sec. 6, p. 20, col. 1.

Sartre, Jean-Paul. Translated by Bernard Frechtman. *Existentialism and Human Emotions.* New York: Philosophical Library, 1957.

Sell and Spin: A History of Advertising. A&E Home Video. 1999.

Stevenson, Seth. "The Blogo Ad." *The New York Times Magazine.* Sunday, 12 December 2004, p. 56.

"StreamingMediaIQ Launches Buyer's Guide." *Publish.com.* 3 March 2004. *<http://www.publish.com/article2/0,1759,1757832,00.asp>*.

Sullivan, Luke. *Hey Whipple, Squeeze This: A Guide To Creating Great Ads.* New York: John Wiley & Sons, Inc., 1998.

Twitchell, James B. *Living It Up: America's Love Affair with Luxury.* New York: Simon & Schuster, 2003.

Uchitelle, Louis. "We Pledge Allegiance to the Mall." *The New York Times.* 6 December 2004, Economy & Government section, sec. C, p. 12, col. 1.

Ungless, Derek. "Who, What, Where, Why: Express." *IDAND.net.* 1 July 2003. *<http://www.idanda.net/brand.php?article=111>*.

Walker, Rob. "Consumed: The Good, the Plaid and the Ugly." *The New York Times.* 2 January 2005.

———. "Consumed: The Hidden (in Plain Sight) Persuaders." *The New York Times.* 5 December 2004.

———. "Consumed: Sole Mate." *The New York Times.* 19 September 2004.

Ward, Celeste. "MSN Introduces Health Site." *Adweek.com.* 4 January 2005. *<http://www.adweek.com/aw/iq_interactive/article_display.jsp?vnu_content_id=1000745758>*.

Waters, Helen. "Designers Commissioned to Create Denim Hang Tags." 31 July 2003. *<http://www.idanda.net/brand.php?article=111>*.

Subject Index

M

monolithic brand strategy, 16

N

nonrepresentational symbol marks, 134

P

packaging
 beginnings of, xxii
 definition of, 161, 167
 design objectives, 170
 relevance and emotional connections, 168, 172
parity goods and services, 4
pictorial symbol marks, 133
positioning statement, 34
promotional design
 definition of, 198
 and digital advertising, 213, 217, 218–220
 goals of, 203
 types of, 198, 206, 210
public service advertising (PSA), 176, 178

R

resonance, 110

S

signage, 159, 161
stationery
 components of the system, 150
 design process, 156
 guidelines and specifications, 155
 letterhead, 152
 paper selection, 155
strategy. *See* brand strategy; branding process
studios. *See* Brands, Groups, Creative Professionals,
 Agencies, and Studios Index
sustainability, 26
sustainable design, 245–246
symbol marks
 abstract symbol marks, 134
 nonrepresentational symbol marks, 134
 pictorial symbol marks, 133

T

taglines
 definition of, 145
 examples of, 145, 146, 148
 functional vs. emotional benefits, 146, 148
 point of view, 146
 pointers, 148
target audience, 5–6
trademarks
 beginnings of, xxi
 definition of, 138
 symbols, 140
trust, of brands, 55–57
typography
 designing, 115
 logos, 144–145

U

unconventional advertising, 182

V

visual communication professionals. *See* creatives

W

wordmarks, 130–132

Brands, Groups, Creative Professionals, Agencies, and Studios Index

Wheaties, 148
Whitsitt, Bob, 32
Wicklund, Andrew, 118–119
Wieden+Kennedy, 49
Wild Brew, 173
Williams Murray Hamm, 172, 173
Winfrey, Oprah, 247
Wong, Paul, 39
WongDoody, 118–119, 219
Woo, John, 218
Work Inc., 146
Wright, Frank Lloyd, 216, 217
Wright, Joe, 50–51

X

Xerox, 126

Y

Yahoo!, 126
Yahoo's IMvironment, 238
Yankees, 118
Yumi, 126, 142, 143, 145